ALSO BY JEAN STROUSE
Alice James: A Biography
Morgan: American Financier

FAMILY
ROMANCE

FAMILY ROMANCE

John Singer Sargent AND THE Wertheimers

JEAN STROUSE

FARRAR, STRAUS AND GIROUX

NEW YORK

Farrar, Straus and Giroux
120 Broadway, New York 10271

Printed in the United States of America
First edition, 2024

Library of Congress Cataloging-in-Publication Data
Names: Strouse, Jean, 1945– author.
Title: Family romance : John Singer Sargent and the Wertheimers /
 Jean Strouse.
Description: First edition. | New York : Farrar, Straus and Giroux, 2024. |
 Includes bibliographical references and index.
Identifiers: LCCN 2024017382 | ISBN 9780374615673 (hardcover)
Subjects: LCSH: Sargent, John Singer, 1856–1925. | Wertheimer family. |
 Wertheimer family—Portraits. | Jews—Great Britain—Portraits. |
 Jews—Great Britain—Biography. | Artists and patrons—
 Great Britain—Biography. | Great Britain—Biography.
Classification: LCC ND237.S3 S77 2024 | DDC 759.13—dc23/
 eng/20240620
LC record available at https://lccn.loc.gov/2024017382

Our books may be purchased in bulk for promotional, educational, or
business use. Please contact your local bookseller or the Macmillan
Corporate and Premium Sales Department at 1-800-221-7945, extension
5442, or by email at MacmillanSpecialMarkets@macmillan.com.

www.fsgbooks.com
Follow us on social media at @fsgbooks

10 9 8 7 6 5 4 3 2 1

Contents

Wertheimer Family Tree

Samson Wertheimer (b.

m. 1. Frumet Veronica Brilin (1658 –1715)
(six children)
|
Eldest son of Samson: Wolf Simon (1681–1765)
|
Isaac (1709–1762)
|
Samson (??–1808)
|
Jechiel (1771–1849)
|
Samson (b. Fürth, Bavaria, 1811, d. London, 1892)

1. Charles (1842–1911)

2. Asher (1843–1918)

amily Tree

Vorms, Rhineland–Palatinate, 1658, d. Vienna, 1724)

n. 2. Merle Magdalena Schiff (c. 1677–1726)
(one child)

n. Leah Eleanora Oppenheimer (1695–1742) (ten children)

n. Zimle Caecilie Gomperz (1721–1761) (ten children)

n. Edele Greilsheim (six children)

n. Rale Wolfsheimer (two sons)

n. Helena Cohen (1818–1879) (two sons)

n. 1. 1860, Frederika Flachfeld (1842–1904) (four children); m. 2. 1904, Elizabeth Jessica Trautz
|
a. Twins: John (1860–1888); and
b. Julia (1860–1930) m. 1878, Moritz Dunkelsbühler (five chidren)
c. Henrietta (1862–1939) m. 1881, Morris Davis
d. Isador Emanuel (1863–1893) m. 1892, Maud Mary Hammack

n. 1871, Flora Joseph (1846–1922) (ten children)
a. Edward (1873–1903) m. 1902, May George Levy
b. Ena (1874–1936) m. 1905, Robert Moritz Matthias (1874–1961) (five children)
1. John Matheson (1906–1963) m. 1937, Ludmilla Krassin
2. Diana Henrietta (1908–1987) m. 1936, Pierre Soyer de Bosmelet
Children: Gentien, Hélène, Robert
3. Anthony Robert (1910–1973) m. 1940, Cecily Mary Agnes Hughes
Children: Victoria, Julian, Raymond, Camilla
4. Betty (1912–1986) m. Robert Guillaumet. Children: Francoise, Brigitte
5. David Frederick Archibald (1913–1992) m. 1949, Katherine Mary Koppelo (1922–2022). Children: Robert, Jonathan, Katherine, Diana, Caroline
c. Alfred (1876–1902)
d. Betty (1877–1953) m. 1. 1889, Euston Abraham Salaman (1871–1916);
m. 2. 1917, Major Arthur Ricketts (1874–1968)
e. Hylda (1878–1938) m. 1905, Henry Wilson Young. Child: Ian Asher David Wilson Young
f. Essie (1880–1933) m. 1905, Eustace Henry Wilding. Children: Morinda, Peter, Ann
g. Conway (1881–1953) m. 1917, Joan Cecily Young
h. Almina (1886–1928) m. 1915, Antonio Pandrelli Fachiri
i. Ferdinand (1888–1950)
j. Ruby (1889–1941)

Introduction

Early in 2001, I happened to see an exhibition of paintings by John Singer Sargent at the Seattle Art Museum. I was doing some work in Seattle, and finding Sargent there was a welcome surprise.

He had made brief appearances in the two biographies I had written—one, of Alice James, the younger sister of William and Henry James; the other, of the financier and art collector J. Pierpont Morgan. My publisher had reproduced part of a Sargent painting, *The Breakfast Table*, on a paperback edition of *Alice James*. All these figures—Sargent, Morgan, the Jameses—were Americans who lived transatlantic lives between the 1850s and early 1900s, and their worlds occasionally intersected. Sargent and Henry James were neighbors in London and good friends; the artist's portrait of the writer is a masterpiece. Having published his novel *The Portrait of a Lady* in 1881, James wrote a few years later: "There is no greater work of art than a great portrait—a truth to be constantly taken to heart by a painter holding in his hand the weapon that Mr. Sargent wields."

The exhibition in Seattle was called *John Singer Sargent: Portraits of the Wertheimer Family*. Who were the Wertheimers? According to introductory wall text, the father of the family,

Asher, was a London art dealer of German Jewish descent who had commissioned portraits of himself and his wife in 1897 to honor their twenty-fifth wedding anniversary. Artist and patron became friends, and over the following decade, Sargent—at the height of his career—painted the couple's ten children as well, individually and in groups. He did several of the Wertheimer women twice.

All twelve portraits were on view in Seattle, along with photographs, a Wertheimer genealogy, and other Sargent paintings and drawings. One photograph showed Sargent and two of the Wertheimers paused on a lawn during a game of croquet. Apparently, the artist had open invitations to Asher's London town house and his country retreat in Berkshire.

Within a few minutes I was entirely captivated—by the paintings, a sense of the stories they might tell, and a great many questions.

What had drawn Sargent to this family? How had they met? I associated him with portraits of British aristocrats and Boston Brahmins, not with Jews. Did he have other Jewish patrons and friends?

Why was the painting of the eldest Wertheimer son, Edward, unfinished?

What became of the elegantly dressed second son, Alfred, looking like an Edwardian aesthete with one hand on a stack of books? Why were there glass flasks on a wall beside him?

A lovely pencil sketch of the eldest daughter, Ena (Helena), was inscribed,

> Jan 25 '10
> to Ena philoprocree
> John S. Sargent

Philoprocree? The caption on a nearby photograph identified her as Ena Wertheimer Mathias. Many of the exhibition items were cred-

ited to the collection of a Mrs. David Mathias. Which meant there were living descendants. Where were they?

Some of the paintings seemed to allude to works by earlier masters. Was Sargent playing with the history of portraiture in this series for a knowledgeable art dealer/patron?

Additional wall text said that Asher's father, Samson, had emigrated in the 1830s from Bavaria to England, where he founded the family art-dealing business. Several generations earlier, one of their ancestors had been court factor, also called court Jew, to the Holy Roman Emperor Leopold I in Vienna. What was a "court Jew"?

Were Sargent and Asher drawn together in part by shared outsider status in Victorian and Edwardian England, despite their professional success? One, the leading portrait painter of the era—an American expatriate, lifelong bachelor, connoisseur of music and dance as well as art—was a cosmopolitan nomad. The other, a renowned expert on art with a lofty clientele and a luxurious style of life, lived in a culture that regarded Jews as ineradicably "other," and art dealing, no matter how illustrious, as mere "trade."

In these portraits and photographs, the Wertheimers' faces looked distinctively Jewish and, to me, familiar. My own Jewish ancestors had left southern Germany for America at about the time Samson Wertheimer left there for England.

The exhibition had been organized by New York's Jewish Museum and opened there in 1999. It then traveled to the New Orleans Museum of Art and the Virginia Museum of Fine Art, Richmond, before finishing its American tour in Seattle. By the time I left the Seattle Art Museum that day in 2001, with the exhibition catalogue, I wanted to know more about all these people, although I was not looking to write a new book. The catalogue contained excellent essays and a short work of fiction, but there appeared not to be a wealth of information about the art dealer and his family. I went home to New York, took a full-time job, and continued to wonder about Sargent and the Wertheimers.

⌒

About ten years after first seeing these paintings, I wrote to the leading authority on Sargent, Richard Ormond, who is, among other things, the artist's great-nephew and the coauthor, with Elaine Kilmurray, of the superb nine-volume Sargent catalogue raisonné. I asked him if he thought it might be possible to write a book about Sargent and the Wertheimers. He replied that the story seemed fascinating but would probably be difficult to tell, since few Wertheimer letters or documents survive.

Then, in the early spring of 2012, I discovered online a "John Singer Sargent Virtual Gallery," created by a woman named Natasha Wallace. One of Asher's great-grandsons had replied to a question on the website about one of the Wertheimer portraits in 2004. He gave his name, Julian Mathias, and his email address.

We began to correspond, then spoke at length by phone. Julian, a retired banker, put me in touch with a number of his relatives, and in October 2012 I went to see him in England. He recounted many stories about the family and gave me three thick files of letters and documents to copy. He thought the Wertheimer firms' business records had been destroyed, but checked with the firm of solicitors who had handled the estates. No luck.

Next, on a perfect English October day of alternating rain and sun, I visited Julian's aunt Kay Mathias at her house in the rural county of Kent. The American-born widow of Ena Wertheimer Mathias's youngest son, David, Kay (Katherine) was ninety, the oldest surviving member of the family. She owned many of the objects I had seen in the Seattle exhibition and others as well, including a Louis Quinze–style armchair in which Asher Wertheimer's wife, Flora, had posed for one of her two Sargent portraits.

Kay and I spent the day talking—her memory was very sharp—

and looking through photographs, letters, and a handwritten Wertheimer pedigree book. She readily identified people in the photographs, told me new stories, added details to those I'd been gathering. She had owned Sargent's pencil sketch of Ena, as well as several watercolors the artist had given to various Wertheimers, but she and her children had sold them. First, however, she had had them all photographed; the photos were on the walls in her house.

Another Wertheimer descendant, Yolanda Chetwynd, provided more information, including a lengthy unpublished memoir by her grandmother, Ena's eldest daughter, Diana.

It was beginning to seem as if there might be enough material for a book.

I thought it would be easier to learn about Sargent than about the Wertheimers, and in many ways it was. There were outstanding critical studies, exhibition catalogues, hundreds of paintings, thousands of letters. Yet to my surprise, no definitive biography. In 1927, two years after Sargent died, his friend Evan Charteris had published a short biographical account. A barrister and arts administrator, Charteris had the immense advantage of firsthand knowledge of his subject as well as access to the artist's sisters and their papers, and he was able to quote extensively from Sargent's early letters to childhood friends. His book included a memorial tribute by one of them, the writer Vernon Lee.

Other biographies, published in the 1950s and '80s, had serious limitations. By far the most accurate and comprehensive source for information about the painter and his work is the Ormond and Kilmurray catalogue raisonné.

Sargent—reserved, elusive, deeply private—neither kept diaries nor saved his correspondence. His own letters were widely dispersed among the recipients' descendants and in libraries on both sides of the Atlantic.

Early on I learned of two troves of his letters to good friends—

one in Oxford's Bodleian Library, the other at the Isabella Stewart Gardner Museum in Boston. The letters at Oxford, written to Lady Elizabeth Lewis, had been digitized; I ordered scans. Lady Lewis came from a prominent Jewish family in Germany and had married one of England's leading solicitors, Sir George Henry Lewis. Sargent painted portraits of them both. He attended concerts with Lady Lewis, co-hosted musical evenings at her house, and sent her more than two hundred frank, entertaining letters. In one, he described all the people "I have forgotten I was to paint this spring" as a "meteor shower." In another, he sounded not unlike Oscar Wilde: "What a tiresome thing a perfectly clear symbol would be." And he mock-complained to her, as he worked on Asher's large commission between 1897 and 1908, of being in a state of "chronic Wertheimerism."

The archive at the Isabella Stewart Gardner Museum also had about two hundred Sargent letters. Mrs. Gardner, the daughter of a wealthy New Yorker and the wife of a Boston businessman and philanthropist, was an avid art collector who bought several works by Sargent and commissioned him to paint her portrait. The museum she built for her collections was an extravagant Renaissance-style palazzo on Boston's Fenway, called Fenway Court during her lifetime. Sargent often visited her there and occasionally advised her about purchases. Late in 1898 he told her that Asher had recently acquired a fine collection of Dutch pictures and was sending his son Edward to America with some of them. At Asher's request, Sargent introduced Edward to Mrs. Gardner by mail; on his own he suggested she might find among these paintings "some new toys."

Learning to read Sargent's handwriting is somewhat like learning a new language: nearly impossible at first, easier as you go along. I was making headway with these letters, turning occasionally for help to Richard Ormond and Elaine Kilmurray (she is particularly adept at deciphering passages in French). And I was finding Sargent's voice immensely appealing.

In his 1985 book *Footsteps: Adventures of a Romantic Biographer*, Richard Holmes describes the biographical process as a "haunting . . . an act of deliberate psychological trespass, an invasion or encroachment of the present upon the past, and in some sense the past upon the present . . . [It is] a continuous living dialogue between [subject and author] as they move over the same historical ground."

Holmes followed in the physical footsteps of some of his subjects. He took the walking trip, accompanied by a donkey, that Robert Louis Stevenson had taken with *his* donkey in the Cévennes mountains in 1878. He stayed in the Italian towns Percy Bysshe Shelley had lived in for the last months of his life. "I mark my beginning as a professional biographer," Holmes writes, "from the day when my bank bounced a cheque because it was inadvertently dated 1772." In trespassing on the lives of Sargent and the Wertheimers, I've inadvertently dated my own checks and correspondence 1898, or 1923.

As is clear from its title, *Family Romance* is not a biography of one person but a group portrait, of Sargent, the Wertheimers, and their social worlds. It includes sketches of the main characters' colleagues and friends—among them Monet, Picasso, Diaghilev, Henry James, Isabella Stewart Gardner, Ottoline Morrell, Bernard Berenson, Roger Fry, and numerous Rothschilds and Sassoons.

Their footsteps traced paths from Habsburg courts in early-eighteenth-century Vienna to fascist Italy in the twentieth. They took me to Austria, Germany, Italy, Boston, Chicago, and frequently back to England. To collections of Sargent paintings on both sides of the Atlantic. To histories of Jews in Europe and Britain. To Asher Wertheimer's London houses, altered but still there, and along his daily walk to his galleries in New Bond Street, spaces now occu-

pied by luxury clothing shops. To Sargent's light-filled house in Chelsea. To grand estates in Buckinghamshire that had belonged to Ferdinand and Alfred de Rothschild. To a great many libraries and archives. And, again and again, to see Kay Mathias in Kent.

The adventure of "haunting" and being haunted by these figures also took me deep into the nineteenth-century art world and the political and economic turmoil that radically altered people's lives over the course of that century. A decline in "old" aristocratic wealth and privilege, along with a rise in "new" (often American, sometimes Jewish) fortunes, reordered the transatlantic social landscape and created dynamic international markets for art. The Wertheimers were key players in that drama. Sargent brilliantly portrayed it.

Another leg of the journey led to a storage facility in London's East End, where ten of the Wertheimer portraits are kept. The Tate, which has owned nine since the 1920s and acquired the tenth in 1996, has stored them off-site for most of that time.

I had made an appointment to see the paintings, and on the scheduled day traveled by underground, bus, and foot to a heavily guarded compound behind a gatehouse. After passing through checkpoints and a series of locked doors, I arrived at the storage area—several large rooms in which people were examining paintings, moving them, preparing them for loans.

Ten is the maximum number of pictures one is allowed to request, and I had asked for ten. The woman assigned to help me, whose name was Sarah, was eight months pregnant; this was her last day of work before maternity leave. The paintings are stored vertically in huge racks that pull out of their units on fixed tracks. The first one I looked at—of Flora, Asher Wertheimer's wife—had been taken out and propped against a wall, but most of the others

remained in their racks, which meant I had to bend my head to the side or climb a scaffolding ladder to study them. It was thrilling to see the portraits again, now that I was planning to write about them.

The pearls in Flora's choker look like single taps of Sargent's brush. The color of a small jade dragon on a table beside her echoes her pallor. Her chair, which I'd recently seen in Kay Mathias's living room, seems to enthrone her.

The figure in *Asher Wertheimer* has much more life than I remembered, and more color: several reds in the face and hands, green-brown eyes, tones of white and yellow in the forehead. Holding his coat open in an expansive gesture, the art dealer looks self-possessed and astute.

In another of the portraits, Ena wears a long black cloak and plumed hat. Light from above falls on the hat's white ostrich feathers, on lace ruffles at Ena's neck and wrist, on her face turned back over one shoulder, laughing. Velvety grays define the shapes and folds of her cloak.

After examining the paintings for three hours, I asked Sarah how much time had been allotted for my visit. "Thirty minutes," she said.

At one point I learned that a Wertheimer descendant had sold a packet of Sargent letters through Sotheby's in 2003. A specialist at the auction house agreed to forward an inquiry to the buyer, who turned out to be GH, an American art dealer with galleries in Tennessee and Maine.

By email I told Mr. H. that I was writing about the Sargent Wertheimer portraits and would very much like to see the letters.

He asked: "Will photocopies suffice, or do you need to see the originals?"

JS: "Photocopies will be fine."

GH: "Would you transcribe them for me?" I realized that, like most people, he couldn't read Sargent's handwriting.

JS: "Of course."

There were about forty letters and cards, some just a couple of lines declining or accepting invitations, others more substantial. Sargent rarely dated his correspondence, although the contents sometimes contain clues. The letters were in no particular order, had been separated from their postmarked envelopes, and some of the photocopies were faint. Still, they clarified a number of questions, provided new information, and offered vivid glimpses of Sargent's interactions with various Wertheimers, primarily Ena. The packet also included a handwritten note to Ena from Auguste Rodin, in French.

After sending GH my transcripts, I realized that he was going to sell them with the letters. It was too late to impose conditions. I asked him to let me know who bought them. Years went by with no news of a sale. Probably there was no market. I considered making an offer but assumed my interest would drive up the price. In any case, I had the xeroxes and the transcripts.

The principal Sargent dealers are Warren Adelson and Elizabeth Oustinoff, of Adelson Galleries in New York. I asked Elizabeth, who knew GH, why he had not sold the letters. She said he was waiting for my book to be published.

More years went by. Then, in the spring of 2022, Richard Ormond sent me news of an upcoming auction of Sargent letters in Maine. The auction house's website indicated that the letters were to Wertheimers, "with transcripts," and named a floor price. Mystified, I wrote again to Elizabeth Oustinoff, who said that GH had died; his estate was selling the letters. I registered for the auction.

Although it was possible to bid online, I chose to work with the auction house by phone, following the sale in progress on the website as this lot number approached. When it came up, I bid the floor price. The woman on the phone asked if I had seen the letters.

"Yes. I did the transcripts."

Another bidder offered a few hundred dollars more. I raised my offer. My phone adviser thought the other bid had been a mistake by someone who was after a different lot. There were no further bids. Sold.

When the letters arrived a couple of weeks later, in glassine sleeves clipped into loose-leaf binders, I found not only my transcripts but my entire correspondence with GH. Also, records of his purchase from Sotheby's, a list of the prices at the pound-to-dollar exchange rate in 2003, and a handwritten notation of the price he paid: more than I just had. One item had been removed before the auction: the note to Ena from Rodin.

Of course I had already read and quoted from the letters, but this was different. Having spent so much time with these people in my imagination—in what Richard Holmes called "a continuous living dialogue between [subject and author] as they move over the same historical ground"—it felt intensely intimate to hold actual pages of their own dialogue. Several of the letters deal with serious matters; tragic things happened in this family. Most are lighter in tone. And they all convey the texture, ease, and warmth of the Sargent-Wertheimer bonds.

One day the artist told Ena he could not attend a party to which they had both been invited since he had a long-planned dinner with Rodin that night, but he hoped to get away in time to stop by later in the evening, "& if I do I shall crawl in on all fours straight to you." In the same note: "I am watching my chance to give your husband a sitting. Why won't some of my sitters' portraits get finished? I have tried giving my nephews' mumps to some of them."

Richard Ormond once said at a symposium, "Sargent is celebrated as a painter of light. Actually, he is a painter of shadows." Actually, he is both.

The stories of Sargent and the Wertheimers are suffused with light and shade—with incandescent talent, singular beauty, glittering friendships, wealth, secrets, conflict, bigotry, loss, early death. The Wertheimer portraits met with acclaim and rancor when they were first exhibited between 1898 and 1908, and again in the 1920s. Then they were stored out of sight for decades. And, surprising as it seems in light of Sargent's current popularity, he was effectively "canceled" for much of the twentieth century. *Family Romance* traces those arcs.

If shared "outsider" status was an element of the Sargent-Wertheimer friendship, it was probably not the essential ingredient. For one thing, Sargent moved fluently across social, national, artistic, and linguistic boundaries; his work was in high demand; England claimed him as a British painter. For another, in spite of the hostility directed at some of the Wertheimer portraits, as well as at the sitters themselves on occasion, members of the family displayed a high social confidence that may have had to do not only with their cultural and financial success and the well-known assimilationist tendencies of German Jews but also with an ancestry that led back to one of the wealthiest, most powerful Jewish figures in early-eighteenth-century Europe.

ARRIVALS

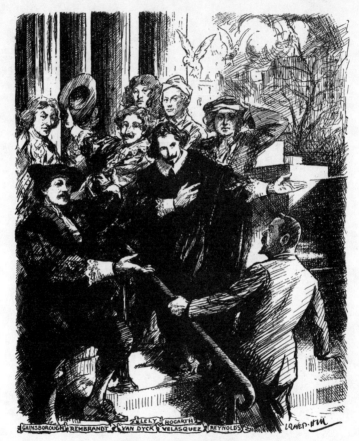

THE YOUNG MASTER.

CHORUS OF OLD ONES (*to Mr. J. S. SARGENT, R.A., at the National Gallery*). "WELL DONE. YOU'RE THE FIRST MASTER TO BREAK THE RULE AND GET IN HERE ALIVE."

Cartoon appearing in *Punch* when nine of Sargent's Wertheimer portraits went on display at the National Gallery in London.

(Punch Cartoon Library / Topfoto)

Wertheimer's Gift

On January 17, 1923, the British satirical magazine *Punch* published a cartoon called "The Young Master," in which seven Old Master painters—among them Rembrandt, Velázquez, Van Dyck, Gainsborough, and Reynolds—stand at the entrance to London's National Gallery on Trafalgar Square to salute a newcomer. The younger man, seeing this illustrious crowd on his way up the gallery steps, starts back in surprise. The caption: *"Chorus of Old Ones (to Mr. J. S. Sargent, R.A., at the National Gallery).* 'WELL DONE. YOU'RE THE FIRST MASTER TO BREAK THE RULE AND GET IN HERE ALIVE.'"

The occasion for the cartoon was an exhibition of nine portraits by John Singer Sargent depicting the members of one family. Commissioned by the eminent London fine art dealer Asher Wertheimer, the paintings presented Asher himself, his wife, Flora, and their ten children, singly and in groups. Wertheimer had pledged them to the National Gallery "for the benefit of the nation" in 1916. Working on this commission for a decade, Sargent had sighed to Lady Elizabeth Lewis about his "chronic Wertheimerism." Asher, for his part, said he only regretted there were not more Wertheimers for Sargent to paint.

The paintings went on display that January in the National Gallery's Room 26, along with grand-manner English portraits by Reynolds, Gainsborough, and Lawrence. Both Sargent and Asher Wertheimer knew a great deal about the history of art, and this exhibition appears to have been exactly what Asher had in mind: that his prodigiously gifted friend be amply represented among the great artists of the past in England's premier national collection—a point underlined by *Punch*'s "Young Master" cartoon. And that Asher's own family—wealthy, London-born Jews of German descent—be represented there as well, among the Anglo-Saxon aristocrats and notables portrayed by earlier masters.

"These are more than a group of family portraits," wrote the critic for *The Times* just before the exhibition opened, "and something besides a little set of great masterpieces of painting." The review went on:

> They illustrate an epoch and a set in that epoch. The beauty of most of the subjects, the character of all, their obvious wealth, their abounding ability and life, the exquisite works of art, pets, and accessories . . . with which they are surrounded, make documents which the historian will prize, and perhaps the satirist will not disdain to pick at.

And it concluded, "The set is an acquisition of almost incalculable value to the national collections and a great monument to the genius who painted it."

The crowds on opening day were so large that it was difficult to see the paintings. The turnstiles counted two thousand people—three times the usual number for January—"and the visitors comprised all classes of the community."

Two of the Wertheimer portraits are among Sargent's finest: the picture of Asher, and the one of his two eldest daughters, Ena (Helena) and Betty (Elizabeth).

Asher, standing in Sargent's London studio dressed in black, seems to emerge from mysterious dark space. He could be a figure by Velázquez or Frans Hals. Raking light from above left falls on his balding forehead, flushed cheeks, full red lips, starched white collar; on the gleam of a gold watch chain on his waistcoat, his left hand holding a cigar, and, near his knees, the bright pink tongue of his black poodle, Noble. The energy and confidence in his bearing offer a sharp contrast to some of the improbably elongated British aristocrats Sargent painted, who look as if cold water rather than blood might run through their veins. A glint of amusement in Asher's eyes suggests that he and the artist knew just what they were doing, and that they were having fun. Sargent allegedly said that every time he painted a portrait he lost a friend. In painting Wertheimer's portrait, he gained one.

When *Asher Wertheimer* first appeared at the Royal Academy's annual exhibition, in 1898, the critic for *The Athenaeum* called it "a masterpiece on which all artistic eyes have been fixed since the opening day," praising its "profound and courageous sense of humour" and "extraordinary simplicity of technique." The review concluded, "Happy is the man whose portrait has been painted thus."

For the dazzling *Ena and Betty, Daughters of Asher and Mrs. Wertheimer*, Sargent posed the sisters in the family drawing room. Dressed in evening gowns, they seem about to step out of the picture into the night and into their lives. Ena, the elder and taller of the two—and Sargent's favorite—radiates vitality, her chin raised, lips parted, color high. The rustle of satin skirts is practically audible; the bodice's deep décolletage barely covers her ample figure. Her left hand rests on the finial of an eighteenth-century Chinese jar lustrous with gilt highlights—the Wertheimer house was filled with

such fine decorative objects—and her right arm circles her sister's waist as if offering her to the world like a doll.

Betty, three years younger than Ena, looks quieter and more demure, in crimson velvet, with a matching clip of roses in her hair. Sargent's technical virtuosity and sense of play are in full effect here as he extends the long line of Betty's turned-out right arm with the downstroke of her open fan. A medical student responded to public criticism of this limb by photographing twenty arms and proving Betty's to be anatomically correct.

Seeing this painting at the 1901 Royal Academy exhibition, the *Times* reviewer called it "instinct with life . . . For sheer strength, whether of realization or execution, there is nothing here to compare with this picture." A later critic applauded the "exuberant physical force and twentieth century chicness of [the] brilliant sitters."

Two days before the exhibition of his Wertheimer portraits opened in 1923, Sargent stopped by the National Gallery to watch the hanging with his friend Sir Philip Sassoon. Both over six feet tall, the men made a striking pair. Sassoon, thirty-five, svelte and clean-shaven, was a baronet, a member of Parliament, and an art collector who came from an extremely wealthy family of Iraqi Jews. Sargent, about to turn sixty-seven, looked ruddy and robust, with gray-blue eyes, a thick salt-and-pepper mustache, and a full beard almost entirely white. His genial bulk attested to his "Gargantuan" appetite. An acquaintance had recently said he looked as if he might burst.

The artist seemed "greatly satisfied with the disposition of the portraits," noted a reporter at the gallery, who heard him say to Sassoon as they left, "I feel quite puffed up."

Sargent used the word *quite* here in the British sense, meaning "somewhat" or "fairly," unlike the American *quite*, which means

"fully" or "completely." *I feel quite puffed up* is slightly self-mocking—not really boasting, or only a little. Yet Sargent wasn't British. Like two other renowned Victorian-era artists, James McNeill Whistler and Henry James, he had lived in London for decades but was American. When he was elected in 1894 to the Royal Academy of Arts—England's premier institute of artists and architects, founded under King George III in 1768—Sargent told Whistler: "As to the question of nationality, I have not been invited to retouch it and I keep my twang. If you should hear anything to the contrary, please state that there was no such transaction and that I am an American." He declined an offer of a knighthood in 1907 since it would have required him to give up his American citizenship.

Although *Punch*'s "Young Master" cartoon congratulated Sargent for being, in 1923, the first artist to get into the National Gallery alive, he had done it before. His grand Impressionist painting of young girls lighting paper lanterns in a garden at dusk, *Carnation, Lily, Lily, Rose,* had belonged to the Tate—an annex of the National Gallery—since 1897. Sir Joseph Joel Duveen, the Dutch-born co-founder of another art-dealing firm, had given Sargent's bravura painting of the actress Ellen Terry as Lady Macbeth to the Tate in 1906. A portrait of the Oxford classics professor Ingram Bywater had been donated to the Tate by Bywater's widow in 1914. And the Liberal politician Thomas Lister, 4th Baron Ribblesdale, presented his own Sargent portrait to the main gallery on Trafalgar Square in 1916. The Wertheimer gift brought the number of Sargents in England's national collections to thirteen.

In commissioning twelve family portraits, Asher Wertheimer became Sargent's greatest private patron. He installed most of the paintings in the dining room of his town house on London's Connaught Place, where the artist was such a frequent guest that the room came to be known as "Sargent's Mess."

Asher pledged nine of the twelve portraits to the nation. He had

given one to his eldest daughter as a wedding present and held two others back. His pledge stipulated that he and his wife would keep the paintings during their lifetimes; once ownership passed to the National Gallery, he said, he hoped all nine would be kept on view there together.

Formally acknowledging this pledge in 1916, the gallery's keeper (chief curator), C. H. Collins Baker, told Asher that his board of trustees would ordinarily insist it could not guarantee any action by a future board, but felt that "in the case of an offer so important and so munificent as yours . . . it must make an explicit expression, not only of its great sense of obligation to you, but also of its recommendation that this group of pictures shall be accepted by whatever Board may be in office when your bequest takes effect."

Another accolade came from the director of the Tate, Charles Aitken. Mr. Wertheimer "good humoredly explains his exceptional generosity by his difficulties in trying to divide his Sargent groups fairly among his large family," Mr. Aitken good-humoredly explained, concluding that giving to the nation "what is not readily divisible is an improvement on the famous judgment of Solomon himself." Further, Aitken saluted Wertheimer's "intelligent discrimination" in commissioning "the finest works of . . . one of the pre-eminent painters of the age" and pledging them to England while the artist was still alive, thereby saving the nation the trouble and expense of purchasing these "masterpieces" after Sargent died.

That autumn Lord D'Abernon, a National Gallery trustee and another Sargent patron, asked Asher whether he would be willing to lend the paintings to the gallery right away. "I regret to say," Wertheimer replied, "that I cannot see my way to do this, as I intend remaining in town until the Spring of next year and were I to do so, it would necessitate dismantling my rooms."

Asher died two years later, in August 1918, leaving a sterling reputation and an estate that would be worth about $140 million

today.* His will repeated the terms of his pledge to the National Gallery and its trustees: Flora would have the "use and enjoyment" of the paintings for the rest of her life. After her death, "I desire but without imposing or intending to impose any binding legal obligation on them that the said Trustees shall keep the said portraits and exhibit them together in one room at the National Gallery."

Flora died in early December 1922. The paintings were immediately transferred from Connaught Place to the gallery in Trafalgar Square.

While Sargent's American citizenship did not figure in reactions to the National Gallery's 1923 exhibition of Wertheimer portraits, the sitters' Jewish identity did. The painting of Asher, in particular, has elicited a range of responses focusing on the art dealer's ethnicity ever since it first appeared, serving for more than a century as a cultural Rorschach test. His expression, with its slight smile and penetrating gaze, has been read as warm, wise, benevolently amused—and also as calculating and sly. Great portraits lend themselves to multiple interpretations, and this one is a powerful case in point.

To Anglo-Saxon eyes on both sides of the Atlantic, Jews looked foreign, exotic, "Oriental"—markedly different from themselves.

* Comparing the relative values of British pounds and American dollars over time is difficult, since they change, and long-term inflation has made both currencies worth much less now than they were in the nineteenth and early twentieth centuries. I have relied throughout on the economic history website MeasuringWorth.com, which calculates values based on changes in the Consumer Price Index. Still, none of these measures is exact.

For most years between 1890 and 1918, which frame the Sargent-Wertheimer story, the value of a British pound in American dollars was $4.86. I have generally rounded that up to five dollars and often give the then-current dollar value in parentheses after a figure in pounds. When offering an estimate of the (much larger) figure in 2024 dollars, I have specified accordingly.

Not all the comments on the "type" were hostile. About Asher's portrait, a writer who knew him well wondered "whether, since the time of Rembrandt there has been any more striking rendering in paint of . . . the Jew with a capital 'J.'" Another said Sargent's Wertheimers "will justly stand for the modern Jew, his wife, his sons and daughters, who in the business and social worlds of the late nineteenth and early twentieth centuries have played so large a part."

Yet an American who saw *Asher Wertheimer* in Sargent's studio said the sitter appeared to be "pleasantly engaged in counting golden shekels." And a British member of Parliament urged the authorities to store the nine "repulsive" portraits out of sight. These comments give voice to the centuries of attitudes toward Jews reflected in, to give brief examples, Shakespeare's *Merchant of Venice*, Dickens's *Oliver Twist*, and George Eliot's *Daniel Deronda*. After Eliot's title character rescues a mysterious young woman on the verge of drowning herself in the Thames, he asks her if she is English. Her reply: "I am English-born. But I am a Jewess." She is silent for a moment, then asks, "Do you despise me for it?"

Her remarks capture the acute double consciousness described nearly thirty years later by the African American sociologist and historian W. E. B. Du Bois in *The Souls of Black Folk* (1903). The experience of being regarded as "other" by a dominant culture, wrote Du Bois, "is a peculiar sensation . . . this sense of always looking at one's self through the eyes of others, of measuring one's soul by the tape of a world that looks on in amused contempt and pity."

Some of the Wertheimers' friends reportedly took offense at Sargent's portrayal of Asher. That Asher himself did not was not foreordained. He and Flora disliked the companion portrait of her, and Sargent painted her again six years later.

The House of Commons held a debate about the Wertheimer bequest on March 8, 1923. Sir John Butcher, the Conservative member of Parliament from York, asked the chancellor of the exchequer about the terms on which the National Gallery had accepted the gift. Had the trustees committed "to keep all these eleven portraits permanently on exhibition," Butcher wanted to know—and was there a precedent "for exhibiting the works of a living artist in the National Gallery?"

The chancellor, Stanley Baldwin—who became prime minister two months later—corrected Butcher about the number of portraits: there were nine, not eleven. He went on to say that the bequest had come with no formal conditions, although "the testator expressed the wish that it might be found possible to exhibit the pictures at the National Gallery." The gallery trustees "highly appreciated the generosity of the gift," noted Baldwin (House members cheered), and considered the Trafalgar Square site "more appropriate" for the current exhibition than the Tate would have been.

Baldwin then addressed Butcher's second question: "While the usual practice is against exhibiting work by living artists, no rule exists which debars the trustees from this course. Indeed, they have done so from time to time for the last sixty years." Baldwin gave as examples work by the foreign artists Henri Harpignies, Matthijs Maris, Henri Fantin-Latour—and "Watts and Sargent among British artists." Again, no acknowledgment that Sargent was American.

Although the National Gallery did not in fact have a rule against showing work by living artists, just about everyone—including the artist who drew the "Young Master" cartoon for *Punch*—thought it did. After Sargent died, in April 1925, a memorial tribute in *The Times* claimed that his Wertheimer portraits were "the only pictures by a living artist that have ever been exhibited in the National Gallery."

Another point of opposition to Asher's bequest was its size. The

commission and gift were indeed large, which played to the stereo-
type of Jews going in for excess. Sir John Butcher, having thought
there were eleven paintings, pressed on: "Is there any room in the
National Gallery in which nine full-sized portraits of one family
by one artist can be exhibited?" Another MP interjected to ask
whether the chancellor might arrange for a portrait of Butcher to
go on display, which met with laughter.

Next, the MP for Oxford, Sir Charles William Chadwick Oman,
the Chichele Professor of Modern History at the university, ad-
dressed a damning question to Baldwin: "Can the right hon. gen-
tleman manage that these clever, but extremely repulsive, pictures
should be placed in a special chamber of horrors, and not between the
brilliant examples of the art of Turner?"

The day after this debate took place, the painter Walter Sickert,
who had published a cleverly titled essay criticizing "Sargentola-
try" in 1910, wrote a letter to the editor of *The Times* that appeared
on March 13, 1923:

> Sir:
> The answer elicited from the Chancellor of the Exche-
> quer by Sir J. Butcher's question of Thursday on the ac-
> ceptance by the Trustees of the National Gallery of the
> Wertheimer portraits is satisfactory in the sense that we
> now know where we are. "No rule," it appears, "exists"
> which debars the Trustees from exhibiting in Trafalgar-
> square works by living artists.

A rule that *did* prohibit showing work by living artists ought to
be made at once, urged Sickert: "Critical considerations are entirely
out of place in discussions on this subject. The classification of art-
ists into living and dead is at least uncontroversial. It will never do
to leave the Trustees of the National Gallery at the mercy of the
'wishes' of future 'testators.'"

It may not be irrelevant that a Sickert painting had been offered to the National Gallery in 1915 and rejected. The director, Sir Charles Holroyd, had asked the keeper to "tell the Trustees that I think it is a very good Sickert—but the question is whether he is important enough . . . I think not; but as an old friend of the artist perhaps I am a prejudiced judge."

From across the Atlantic, *Time* magazine reported that the "extremely unflattering, scrupulously accurate" Wertheimer portraits were the talk of London; that their display in the National Gallery had made Sargent "a classic in his own lifetime"; and that "Now a strong group in the House of Commons seeks their removal."

The "problem" presented by the Wertheimer gift was to an extent solved by another family of Jewish art dealers. In 1908, Sir Joseph Joel Duveen donated twenty thousand pounds to build five new rooms at the Tate for paintings left to the National Gallery by the artist J. M. W. Turner. The Turner bequest—about three hundred oil paintings, many unfinished, and nearly twenty thousand sketches and drawings—remains the largest gift of art the gallery has ever received. It stipulated that new exhibition space for the paintings be built within five years of the artist's death. Turner died in 1851, but for various reasons no gallery was constructed. Most of the paintings had been in storage at the National Gallery and the British Museum for more than half a century.

The Duveen funding promised to meet Turner's condition, although at the Tate rather than the gallery in Trafalgar Square. Officially the National Gallery of British Art, the Tate had opened in 1897 on the site of the former Millbank Prison with funding from a wealthy sugar merchant, Sir Henry Tate. Known as the Tate from the start, it did not formally take that name until 1932. The elder Duveen, Sir Joseph Joel, died in 1908, but his son Joseph, later Lord Duveen of Millbank, made additional contributions, and the Tate's Turner Wing opened in 1910. Eight years later, Joseph

Duveen pledged twenty-five thousand pounds to create galleries for modern foreign art at the Tate ("long overdue," said *The Times*), then increased the offer to thirty thousand pounds to build an adjacent room for work by Sargent.

The Sargent and the Modern Foreign Galleries at the Tate opened in June 1926. The ceremony honoring the event, presided over by King George V, took place in the Turner Wing. Sargent's Wertheimers ended up near the nation's "brilliant examples of the art of Turner" after all—but that is getting ahead of the story.

Sargent's Paintbrush

One of Sargent's biographers said he was "at home everywhere, and belonged nowhere." Born in Italy to American parents in January 1856, the artist grew up in Europe and did not set foot in the United States until he was twenty. His father, FitzWilliam Sargent, was a Philadelphia physician from an old New England family; his mother was the former Mary Newbold Singer. After their first child died at the age of two, the couple went to Europe hoping to restore Mary's health and spirits, and stayed for the rest of their lives. Mary's mother traveled with them. They were living in a rented house near the Ponte Vecchio in Florence when John was born. His grandmother called him *fra Giovanni*.

Like a few other relatively privileged Americans in the mid-nineteenth century, the Sargents reversed the migrations of their ancestors to steep themselves in the culture of the old world. Mary Singer Sargent, an avid amateur painter and musician, had a small inheritance from her father, and her mother contributed to the household upkeep. FitzWilliam, who said they had "no superfluity of means," kept hoping to return to the United States, his medical work, and relatives in Philadelphia and Boston. Mary's desire to stay abroad won out.

The family traveled constantly for economy, mild weather, new experience: to France, Switzerland, Germany, Austria, England, Italy, Spain. The death of Mary's mother in 1859 increased their means, but Dr. Sargent never stopped worrying about money. John was a year old when his sister Emily was born in Rome. An accident a few years later damaged her spine, leaving her "a good deal deformed," reported her father. Two more children died before the arrival of another girl, Violet, in 1870. Emily's injury, and the deaths of three babies under the age of two, left the Sargents with a keen awareness of life's fragility. John and Emily remained especially close for the rest of their lives; she, too, became a painter.

Henry James, reflecting years later on his own family's restless travels abroad, described himself and his siblings as having been "hotel children," perpetually uprooted, finding no sense of continuity in anything beyond the family itself. The same could be said about the Sargents. The seeds of this itinerant immersion in Europe's arts, languages, and history had their fullest fruition in the imaginations of the future novelist and the future painter.

The Sargents in their travels befriended two other families of international wanderers, the British Pagets and the Spanish-Cuban del Castillos, with children just John's age: Violet Paget and Ben del Castillo. Violet, who later took the masculine pen name Vernon Lee in order to be taken seriously as a writer, virtually adopted the Sargents. She recalled spending long afternoons with John in Nice when they were ten, painting, reading, conversing on "elevated topics." In Bologna, the pair made a pilgrimage to the city's renowned Academy of Music, where Violet studied eighteenth-century musical scores and John copied portraits of composers and performers.

In Rome in 1868–69, Mrs. Sargent showed her son's drawings to the artists who made up the expatriate American "colony" there, and took the children all over the city. Violet remembered exploring

"dark, damp little churches, resplendent with magic garlands and pyramids of lights . . . chilly galleries, where, while the icy water splashed in the shells of the Tritons . . . , the winter sunshine, white, cold, and brilliant, made the salt-like marble sparkle."

The parsimonious Pagets ordered tin boxes of dinner from a local "cookshop" in Rome, reported their daughter, while the Sargents in their "many-windowed" house above the Piazza di Spagna "kept a white-capped *chef* and gave dinner parties with ices." If the Sargents had "no superfluity of means," they evidently had enough for a gracious life.

John learned Italian and French, some German and Spanish, and was a gifted pianist who might have had a career in music. He sketched and painted constantly, copied Michelangelo in the Sistine Chapel, enrolled in Florence's Accademia di Belle Arti. Years later, Max Beerbohm said that walking through the streets of Florence with Sargent taught him more than any guidebook about the essential qualities of the city.

Dr. Sargent wanted his son to join the navy, a prospect that appealed to neither his wife nor the boy, who overruled him. The family moved to Paris in 1874 so that John could study in the art capital of the world. "I am sorry to leave Italy," he told Violet— "that is to say, Venice, but on the other hand I am persuaded that Paris is the place to learn painting in. When I can paint, *then* away for Venice!"

Paris was his first settled home. He enrolled in the École des Beaux-Arts, which emphasized academic tradition, and joined the atelier of the society portrait painter Charles-Émile-Auguste Durand, who styled himself Carolus-Duran. Carolus forbade his students to make academic preparatory drawings on paper. Instead, he taught them to load up brushes with paint, to define shapes and figures with broad planes of color, to work directly on canvas in layers of wet oils, which requires spontaneity and speed. He urged them to look

closely at Rembrandt, Hals, Van Dyck, and above all, *"Velázquez, Velázquez, Velázquez, étudiez sans relâche Velázquez"* (ceaselessly study Velázquez).

Sargent was inhaling influences. He studied Velázquez in Madrid and Hals in Haarlem. Making the rounds of Paris galleries and exhibitions, he revered the modernist Édouard Manet, whose painterly use of broad, loose brushstrokes he came to share.

During two weeks of exams at the École des Beaux-Arts in the fall of 1874, he wrote from Paris to Ben del Castillo:

> Caro il mio ben . . . *
>
> The épreuves de Perspective et d'Anatomie are over; I wish I might say as much for the Dessin d'Ornement . . . The supreme moment is one of twelve hours wherein we must make a finished drawing of the human form divine . . .
>
> We look forward with much pleasure to your flying visit next Xmas. Please take pains to inject your eye with belladonna [from the plant deadly nightshade, which dilates pupils] that we may judge if your description is as accurate as it is amusing . . .

In 1876, Sargent visited the United States for the first time, traveling with his mother and sister Emily. They spent four months on a wide circuit from Canada to Washington, DC, meeting relatives, visiting Chicago and Niagara Falls, and stopping in Philadelphia to see the Centennial Exhibition, America's first international world's fair. In Newport, Sargent painted a portrait of Charles Deering, a young naval officer who became one of his lifelong patrons and friends.

His worldliness may have shocked some of his new American

* Sargent is playing here with a line from Christoph Willibald Gluck's opera *Orfeo ed Euridice*, *"Che farò senza il mio ben?"* (What will I do without my dear one?)

acquaintances. Not long after returning to Europe, he wrote to Ben del Castillo from Capri:

> If it were not for one German staying at the Marina, I should be absolutely without society and he is in love and cannot talk about anything but his sweetheart's moral irreproachability. We are going over to Sorrento in a day or two to visit her, and I have agreed to keep her husband's interest riveted to Vesuvius, Baiae, Pozzuoli and other places along the distant opposite shore.

Emily Sargent described her brother's Paris routine: "he works like a dog from morning till night," leaving for the atelier right after breakfast, returning home briefly for dinner, then "off again to the Life School after ten."

In 1877, three years after the Sargents moved to France, the Paris Salon selected John's portrait of a fellow American expatriate, Fanny Watts, for its prestigious annual exhibition. Founded in 1667 under Louis XIV, the Salon was named for its initial venue, the Salon Carré in the Louvre. Showing work there was a critical measure of artistic success. Sargent, just twenty-one in 1877, had paintings at the Salon every spring for the next ten years.

Self-portraits—studies of a model who is always at hand—run through the work of artists from antiquity to the present. Rembrandt, who captured his own coarse features and interior depths with equal genius, turned the self-portrait into "a major means of artistic self-expression" and "self-portraiture into an autobiography," observed the English art historian Kenneth Clark.

Though Sargent was admired for his "sensory revelation of character," for "dragging the truth out of a man's superficial personality,

for good or evil," he had no interest in autobiography. He did just three self-portraits in oil, all on commission, plus three charcoal sketches, one pencil drawing, and a study in pen, ink, and wash. The oil paintings are beautifully executed, but the sitter looks guarded and remote in them all. He wears starched wing collars, neckties, jackets, vests, angling his shoulders to his right, facing slightly left. The final one, done in 1906 for the Vasari Corridor of artists' self-portraits in the Uffizi Gallery, has something forbidding about the mouth, and the eyes open no window on the soul.

William Dean Howells, after reading a book by the father of Henry James called *The Secret of Swedenborg*, remarked that the author had "kept it." The same might be said about Sargent's portraits of Sargent.

The painter William Rothenstein and Sargent did lithograph sketches of each other in 1897. Rothenstein's Sargent, holding a cigarette between his lips, looks wary, but his eyes are alive. Sargent's Rothenstein hunches over a desktop easel, possibly working on his Sargent sketch.

Rothenstein drew verbal pictures as well. He recalled being immediately aware, on first meeting the older artist, "of something large and dignified in his nature . . . which set him apart and commanded respect." And, "I think of his huge frame, of his superb appetite, his constant consumption of cigars; of his odd shyness too, and his self-consciousness, of his decided opinions expressed with a Jamesian defensiveness."

The younger painter offered professional detail about his shy friend at work:

> When he painted the size of life, he placed his canvas on a level with the model, walked back until canvas and sitter were equal before his eye . . . He drew with his brush, beginning with the shadows, and gradually evolving his fig-

ure from the background by means of large, loose volumes of shadow, half tones and light, regardless of features or refinements of form . . . He painted with large brushes and a full palette, using oil and turpentine freely as a medium. When he repainted, he would smudge and efface the part he wished to reconstruct, and begin again from a shapeless mass.

Sargent's admirers regarded him as heir to Velázquez, Van Dyck, Manet, and grand-manner English portrait artists. Henry James thought his early paintings offered the "slightly 'uncanny' spectacle of a talent which on the very threshold of its career has nothing more to learn."

Dissenters found the artist's work retrograde, derivative, superficial, too stylish—and its creator too successful. They included, to varying degrees, Whistler, Degas, Pissarro, Mary Cassatt, and Walter Sickert. The influential critic Roger Fry appointed himself chief prosecutor.

Not in dispute was the quality of Sargent's gifts—his eye, draftsmanship, tactile use of pigment; his rich, deep darks and incandescent lights; his ability to capture character. At the end of the twentieth century, the critic Michael Kimmelman reflected both sides of the long-term critical divide, writing: "We all want to do something, almost anything, as adeptly as John Singer Sargent handled a paintbrush . . . [W]hen you're dealing with skill on this level, its appeal becomes nearly erotic . . . He was the gold standard during the Gilded Age. But he invented nothing; he changed nothing."

Portraits are intrinsically theatrical—"always predicated, even in the private realm of domesticity, on the presence of a spectator,"

writes the art historian Michael Fried. Sargent, at once spectator and stage director, often chose flamboyant figures, extravagant gestures, character revealed in style—and amplified them.

After visiting Madrid in 1879, he traveled south to Morocco and rented a small house in Tangier. Enthralled by the brilliant North African light, he began work on a painting he completed in Paris the following year, *Fumée d'Ambre Gris*. In this haunting meditation on white, ivory, gray, shadow, and sunlight, a woman in layered white robes stands in a courtyard holding a mantle over her head to catch smoke from ambergris burning in a censer at her feet. Ambergris, derived from sperm whales, has long been considered an aphrodisiac. The figure was probably a model, as she wears makeup and no veil.

Also in Paris Sargent chose a huge canvas—eleven feet wide, almost a stage—to paint a flamenco dancer he had seen in Spain. The picture's title, *El Jaleo*, is the name of a dance, *el jaleo de jerez*, and also means "racket" or "ruckus"—the flamenco chorus of claps and shouts. Footlights illuminate the woman's profile, arms, and heavy white skirt while casting spooky shadows on the wall. She leans back at a steep angle, the rhythm of staccato lights and darks accentuating the scene's intensity. In contrast to the sensual silence of *Fumée d'Ambre Gris*, there is a wild fury in *El Jaleo*. Critics found the painting thrilling, audacious, morbid, bizarre—and reminiscent of Goya.

Sargent's first formal portrait, exhibited at the 1879 Salon, was of his teacher, inscribed in French, "to my dear master M. Carolus-Duran, his affectionate pupil/John S. Sargent. 1879." This tribute simultaneously announced his artistic lineage and placed him on the Paris stage. He had posed the charismatic dandy seated at an asymmetrical tilt, leaning to his right and slightly forward as if about to rise and speak, frilled white shirt cuffs bright against a fawn-colored jacket, Legion of Honor rosette in his lapel. Sargent drew attention to the older painter's articulate hands, the left askew

against a thigh, the right loosely holding a carved wood cane. Following the lessons of this master and Velázquez, he gave the figure volume and weight with tones of color, capturing a powerful physical *presence*. Edmond de Goncourt reported Degas asking, "with spirit, 'have you seen Carolus's cuffs and the veins in his hands, filled by the beat of a Venetian pulse?'"

Carolus probably introduced Sargent to the subject of another spectacular early portrait, *Dr. Pozzi at Home* (1881). The father of modern French gynecology, Samuel-Jean Pozzi made revolutionary advances in women's reproductive health, initiating the use of antisepsis and anesthesia, and served as surgeon to the stars of the Parisian beau monde. He was an outrageously attractive aesthete who collected art, translated Darwin into French, and belonged to the circle around Proust and the poet/dandy Robert de Montesquiou. The actress Sarah Bernhardt, one of his lovers, called him "Dr. God." Sargent called him a "very brilliant creature" and portrayed him looking like a sexy cardinal or pope in a full-length scarlet dressing gown against a room of deeper reds, alluding to portraits by Velázquez (*Pope Innocent X*) and Van Dyck (*Cardinal Guido Bentivoglio*).

"The symphony of reds is insistent and visceral (a gesture to the sensational aspects of his medical practices)," observes the Sargent expert Elaine Kilmurray—"but the flashiness is offset by the refinement of his finely drawn surgeon's hands, exquisitely pleated white shirt and delicately embroidered slippers." *Dr. Pozzi* was the first Sargent painting to be shown at London's Royal Academy. Some British critics praised the artist's audacity and skill; others found the picture excessively stylish, arrogant, "French."

A few years later, Sargent wrote from Paris to Henry James: "You once said that an occasional Frenchman was not an unpleasant diversion to you in London, and I have been so bold as to give a card of introduction to you to two friends of mine. One is Dr. S. Pozzi, the man in the red gown (not always), a very brilliant

creature! & the other is the unique extra-human Montesquiou." A
third Frenchman, Prince Edmond de Polignac, joined the group in
London.

Proust drew on aspects of all three men for characters in *À la
recherche du temps perdu*. James, writes his biographer Leon Edel,
"spent two days with three of Proust's characters . . . It was a case
of a great novelist consorting unknowingly with the real-life mate-
rial of a novelist of the future."

Early on, Sargent took unconventional approaches to depicting
children. One of his first patrons, the French playwright Édouard
Pailleron, commissioned paintings of himself and his wife, then
another of their son and daughter. The girl hated the process: she
refused to sit still, fought Sargent over her clothes and hair, later
complained that she had had to endure an unlikely eighty-three sit-
tings and that his studio was a mess. Apparently she also disliked
her brother, and though the siblings share a bench in the eerily lit
Pailleron Children (1880), they perch there, each alone. She sits up-
right, tense and glaring, hands planted at her sides. The boy's body
arcs sideways as he regards viewers over one shoulder, his face ap-
prehensive and closed. More than one critic saw in this obdurate pair
the children of Henry James's ghost story *The Turn of the Screw*.

Two years later, Sargent's friends Edward and Mary Louisa
Boit, a wealthy Bostonian couple living in France, commissioned
a painting of their children. The artist posed the four girls asym-
metrically in the spacious entrance to their Paris apartment. His
Daughters of Edward Darley Boit (1882) is less a portrait—two
of the girls stand in background shadows, we barely see one of the
faces—than a haunting study of silence, secrets, isolation, vaulting
darkness, oblique light. Large Japanese vases tower over the fig-
ures. Three of the girls face the viewer, the youngest most directly
as she sits on a rug in the foreground with her doll.

Daughters pays explicit tribute to *Las Meninas*, Velázquez's
great painting of the young Spanish infanta attended by her

maids, which Sargent had copied at the Prado in 1879. He adapts the original's palette and sense of mystery, its tall verticals dwarfing human subjects, its deep-plane mirrors and windows, and the central figure, a young girl looking straight at us. One missing element: Velázquez had inserted an image of himself at an easel, paintbrush in hand. No cameo for Sargent.

In her excellent book on this painting, *Sargent's Daughters*, Erica Hirshler notes that avant-garde French artists including Manet, Degas, and Monet were experimenting with settings, poses, and light effects as they redefined the portrait, "creating disjunctions and ambiguities that expressed the new tensions of life." And that *The Daughters of Edward Darley Boit*, "with its emptiness, unusual disposition of figures, and deliberate lack of a relationship between the girls, also vibrates with this distinctly modern unease."

⟨⟩

Sargent had been exploring modern tensions as he gained acceptance in the art world: his *El Jaleo, Dr. Pozzi, Pailleron Children*, and *Daughters of Edward Darley Boit* were edgy and bold. Then, in 1884, he took a risk that profoundly changed his life.

Fascinated by the stunning profile and theatrical self-presentation of Virginie Amélie Gautreau, the Louisiana-born wife of a wealthy French banker, he painted her portrait without commission, hoping it would bring him further recognition. It did, although not the kind he wanted. The picture shocked Paris, taking artist and subject by surprise.

Madame Gautreau was a new modern type, a "professional beauty" known for being known. Her appearance was a work of artifice, her body the canvas. Vernon Lee called her "that peacock woman." Sargent described her powdered skin as the color of "lavender or blotting-paper" and "chlorate of potash-lozenge," but he marveled at her "most beautiful lines." From her country house in

Brittany he reported struggling with her "unpaintable beauty and hopeless laziness."

He invited Oscar Wilde to visit his Paris studio as he worked, saying, "You will see my sitter who looks like Phryne"—a famous courtesan in ancient Greece known for her beauty and impiety. His portrait focuses on Madame Gautreau's arms, shoulders, neck, and breasts, on her sharp profile, elaborate makeup, haughty pose. It accentuates the torque of her right arm and her plunging décolletage, with one strap of her black dress slipping off a shoulder.

Uncharacteristically anxious as he finished the picture, Sargent kept making changes and expecting the Salon to turn it down. On opening day, *le tout Paris* filled the gallery. The response was worse than the artist had feared. Viewers laughed, recoiled, pronounced the picture a horror, despicable, strange. One of Sargent's friends thought la Gautreau looked "decomposed." Several artists praised the painting's daring and style; the critic Louis de Fourcaud called it a masterpiece of art and social commentary. But they couldn't outroar the mob.

In Manet's *Olympia* (1863), the subject of an earlier art world scandal, the artist posed his favorite model, Victorine Meurent, as a nude courtesan reclining on a bed like Titian's *Venus of Urbino*. She rests one hand between her legs, as does Titian's Venus, and has a cool, challenging expression in her eyes. Standing beside her, a Black servant (Laure, also a frequent Manet model, identified only by her first name) proffers a lavish bouquet, most likely a gift from a wealthy client. "Olympia" could be looking at that admirer, at the artist, at the future. The scandal had less to do with her nude body, an eternal subject of art, than with modernity—the painting's flat surface, artifice, staging; Manet's depiction of the female gaze as active force; his representing the goddess of love as a "lady of the night."

The *Madame X* scandal twenty years later was quite different, although also in part about artifice and staging. Virginie Gautreau was part of the Parisian beau monde—or aspiring to be—and the

French recoil had at least as much to do with her as with the artist's portrayal. Sargent originally titled the painting *Madame **** to protect her identity, although no one in fashionable Paris would have failed to recognize her. A foreign-born social climber, self-promoter, reputed sexual adventurer, she—her image—seemed to represent all the invasive forces threatening the social order of fin-de-siècle France. Sargent's American heritage may have added to the fire.

Virginie and her mother called on the artist in tears. The mother begged him to take the picture down, saying, "My daughter is lost—all Paris mocks her . . . She will die of grief." Sargent said it went against Salon precedent to retire a picture, but he did try to take this one back temporarily to repaint the offending strap in the "proper" vertical position; Salon authorities refused.

Madame Gautreau, having praised the finished portrait, now disavowed it and went into seclusion. After the exhibition closed, Sargent did repaint the strap, kept the picture on view in his studio, and had himself photographed with it there. Thirty-two years later, in 1916, he sold it to the Metropolitan Museum in New York, saying, "I suppose it is the best thing I've done." He asked the Met to disguise the subject's name again, and the iconic portrait has since been known as *Madame X*.

With demand for his portraits collapsing after this debacle, Sargent, now twenty-eight, thought he might have to give up art altogether and go into music or business. Whistler and Henry James had been urging him to move to England for some time, and by 1885 the prospect seemed attractive. He spent that summer and the next with a group of painters and writers at a village in the Cotswolds called Broadway, working outdoors under the powerful influence of Claude Monet.

Monet recalled their first meeting at Paul Durand-Ruel's Paris

gallery in 1876, when Sargent rushed up to him exclaiming, "Is it really you-you-Claude Monet?" The leading French Impressionist, then thirty-five, and his twenty-year-old admirer became friends over the next several years. Monet spoke little English; they communicated in French. On a visit to Monet's house in Giverny, probably in the summer of 1885, Sargent did an oil sketch, *Claude Monet Painting by the Edge of a Wood*, which he kept for the rest of his life. His vantage point behind the older artist doing what he himself is doing—painting *en plein air*—affords a view of Monet's canvas, most likely *Meadow with Haystacks near Giverny*. Later, Sargent did a portrait of Monet, bought four of his pictures, and promoted his work to American collectors.

In the Cotswolds in 1885, Monet began working on his large picture of two girls lighting paper lanterns in a garden. Intent on capturing the evanescent effects of twilight on faces, pinafores, paper, and flowers, he had only a few minutes each evening to work. Edmund Gosse described the excitement about the painting's progress in "the whole of our little artist-colony" at Broadway: everything—easel, canvas, girls dressed in white—had to be set up each afternoon before the group's game of lawn tennis. At the first hint of sundown the game stopped, the whole party rushed to the garden, the artist

> took up his place at a distance from the canvas, and at a certain notation of light ran forward over the lawn with the action of a wag-tail [a long-tailed bird], planting at the same time rapid dabs of paint on the picture, and then retiring again, only with equal suddenness to repeat the wag-tail action. All this occupied but two or three minutes, the light rapidly declining,

and the tennis game resumed.

This was Monet's method: painting outdoors directly from nature, waiting for the light effects he wanted. Sargent's progress was

slow due to a late-season start, slim margins of time, unreliable weather, occasionally reluctant children, and the new "Impressionist" direction of this work. As he struggled, he turned for advice to Monet and to John Everett Millais, whose 1856 *Autumn Leaves* the influential art historian and critic John Ruskin had called "the first instance of a perfectly painted twilight."

The following summer Sargent went back to Broadway to continue work on this meditative scene. He called it *Carnation, Lily, Lily, Rose*, the title of a popular song. The Royal Academy bought the painting in 1887 with funds designated for new art created in Britain, and gave it to the Tate, the National Gallery of British Art, when it opened ten years later.

Édouard Manet died in 1883. The two paintings that had received the most attention at the previous year's Salon were his last major work, *Bar at the Folies-Bergère*, and Sargent's flamenco painting, *El Jaleo*. At the Manet studio sale, Sargent bought *Portrait of Mademoiselle Claus*, a preparatory study for *Le Balcon*, and in January 1885, he attended a memorial banquet in Paris along with Monet, Degas, Rodin, Renoir, Zola, and others. Four years later, when an American collector threatened to buy and export Manet's still-controversial *Olympia*, Monet and Sargent led a campaign to raise twenty thousand francs (they each subscribed one thousand) to acquire the picture for the French government. It is now at the Musée d'Orsay.

The friendship between Sargent and Monet lasted for more than two decades. Ultimately, the American turned away from Impressionism's optical mixes of pure color and its emphasis on texture and pattern over form and structure to work more in the Velázquez/Carolus vein, with free, fluid brushstrokes, strong modeling, vivid realism, and sharp contrasts of light and shade. Monet later recalled that Sargent, asking him for a tube of black paint one day at Giverny, had been astonished to learn that his host had none: "Then I can't paint, he cried, and added, How do you do it!"

Like Henry James, Sargent was comparing Europe and America, chronicling dramatic social change, portraying "new" women. And the novelist proved enormously instrumental in introducing the painter to social and cultural worlds in England, as well as to patrons on both sides of the Atlantic. In October 1887, James published an appreciation of his fellow countryman's work in *Harper's New Monthly Magazine*, where he identified the "slightly 'uncanny' spectacle" of Sargent's early talent. The acutely observant writer described the experience of looking at the work of this acutely observant artist: "In Mr. Sargent's case the process by which the object seen resolves itself into the object pictured is extraordinarily immediate. It is as if painting were pure tact of vision, a simple matter of feeling." It was here that James declared: "There is no greater work of art than a great portrait—a truth to be constantly taken to heart by a painter holding in his hands the weapon that Mr. Sargent wields."

While he decorously allows that the brush may be mightier than the pen, James knew that art was not "a simple matter of feeling." Sargent's technical skill and acute eye were in some ways a curse, giving rise to the widely held impression that it was all too easy. On the contrary, writes the art historian Marc Simpson, the painter "labored over his work. He plotted his major canvases at length, often scraped away days if not weeks of effort, sometimes made second versions of a finished composition when the traces of the campaign appeared too evident. He strove hard, successfully, to make the result seem effortless."

A recent cleaning and close examination of several Sargent portraits, including some of the Wertheimer pictures, also challenges the notion of effortless virtuosity. The art historians who

conducted this 1998 study found evidence of extensive alterations, modifications, rubbings out, fresh finishing touches sometimes even after a painting had been framed, as the artist worked out "the fine balance" of his compositions. Hog-hair bristles buried deep in the paint attest to Sargent's method, described by Edmund Gosse and others, of backing away from his subject until he saw exactly what he wanted, then "attacking" the picture with his brush.

He primed his plain-weave canvases all the way to the edge, then cut the fabric to fit stretchers of various sizes, folding margins over the backs in case he changed his mind. He used this tacking margin to enlarge his 1902 *Lord Ribblesdale*.

Not immune to criticism, and well aware of the charge that his work was all surface, Sargent sent an appreciative note to Mariana Griswold Van Rensselaer, an American who had praised two of his portraits in 1890. "Very few writers give me credit for insides so to speak," he wrote: "I am of course grateful to you . . . for it would seem that sometimes . . . I hit the mark." He added a postscript: "I feel as if I ought to have written a much longer letter to give you any idea of how much pleasure and what kind of pleasure you have given me."

Another credit for "insides" came from an unlikely quarter. An aspiring portrait painter in an early P. G. Wodehouse story finds that he has inadvertently depicted ugliness in a child. "Something's gone wrong with the darned thing," he tells Bertie Wooster; "without knowing it, I've worked that stunt that Sargent used to pull—painting the soul of the sitter. I've got through the mere outward appearance, and have put the child's soul on canvas."

Democratic America in the middle of the nineteenth century was breathing what the critic Robert Hughes called "thin aesthetic air."

It had no real history of collecting art, no grand repositories on the order of the Louvre, the Vatican, or the British Museum, no private collections assembled by monarchs and merchant princes. In the economic boom after the Civil War, affluent Americans traveled to Europe in record numbers and fell in love with the visual arts. They also fell in love with Sargent, who conferred on his Gilded Age compatriots the cachet of European sophistication and taste.

Henry James introduced Sargent to Isabella Stewart Gardner, the Boston collector who became one of his most steadfast patrons and eventually installed many of his paintings, including *El Jaleo*, with the Old Masters in her museum, Fenway Court. He painted her portrait when he visited the United States for only the second time, in 1887. For this enigmatic image, he posed her standing before a wall of Venetian gold brocade: the fabric's circular pattern gives her a halo; pearls encircle her neck and waist; her arms, shoulders, and clasped hands form yet another loop. Mrs. Gardner was no beauty—Sargent rather cruelly said her face looked "like a lemon with a slit for a mouth"—but his portrait captures her forthright character and strength. Her husband and several critics hated the painting. She kept it in a private room for the rest of her life.

As soon as Fenway Court opened, in April 1903, Mrs. Gardner invited Sargent to stay. For a month that spring he was artist in residence, with a small guest room on the ground floor and a studio on the third.

Other Americans began to commission Sargent portraits as well. The artist told the New York businessman and collector Henry Marquand: "My going to America to paint Mrs. Marquand's portrait was a turning point in my fortunes for which I have most heartily to thank you." A few years later the Metropolitan Museum engaged him to do the formal portrait of its president—Henry Marquand.

And during another long visit to America, in 1890, Sargent accepted a commission to create murals for a new Boston Public Li-

brary, just then being designed by the architects McKim, Mead & White. He worked on the project for the next thirty years.

In London in 1887, Sargent took a three-year lease on a studio Whistler had previously occupied, at 13 Tite Street, Chelsea (the number was later changed to 33). Oscar Wilde lived across the street. Sargent eventually bought the studio and the house next door, number 31, and lived there for the rest of his life. After his father died and his sister Violet married Louis Francis Ormond, a Swiss businessman, the artist's mother and sister Emily took a flat near him at 10 Carlyle Mansions, Cheyne Walk. Still, impermanence seemed to be his permanent condition: he continued to travel widely, and said as late as 1894 that he was only "vaguely" living in London.

The models he hired for his work on the Boston library murals included two Italian brothers, Luigi and Nicola d'Inverno. Nicola stayed on for more than twenty years as the artist's valet, studio assistant, travel manager, and general manservant. Inevitably, there has been speculation about an intimate relationship, yet no evidence for that has surfaced. In recollections published after Sargent died, d'Inverno wrote, "The world calls him a great, I know him to be a good, man."

Though American patrons and friends helped Sargent move beyond the *Madame X* scandal, he had not yet made a significant mark in England. Two portraits of British women shown in 1893, *Lady Agnew of Lochnaw* and *Mrs. Hugh Hammersley*, effectively launched his London career.

The exquisite Lady Agnew, in white satin with a lilac-colored sash defining her narrow waist, tilts her head slightly to look up at the artist from under perfect brows. Sargent told a friend he did some of his best work quickly—Lady Agnew in six sittings. Re-

viewing the Royal Academy exhibition that year, one critic said this painting "tops everything."

Mrs. Hammersley, the wife of a banker, leans forward from her perch on a sofa like a squall of vital energy. Sargent had more trouble with her than with Lady A.—Mrs. H. described coming to four or five sittings a week for two months.

"As to Mr. Sargent," wrote his friend Clementina Anstruther-Thomson, "London is at his feet. Mrs. Hammersley & Mrs. [George] Lewis are at the New Gallery, Lady Agnew at the Academy. There are no two opinions this year. He has had a cracking success. Mrs. Hammersley has just sat down on that peach coloured sofa for *one* minute she will be up again fidgeting about the room the next . . . but *meanwhile* Mr. Sargent has painted her!! . . . dressed like some alert springing flower."

When Sargent was elected an associate of the Royal Academy a few months later, *The Sunday Times* credited *Lady Agnew*.

Tumultuous social change marked the four decades of Sargent's life in England, from the 1880s to the 1920s. Many British aristocrats experienced sharp declines in the wealth, status, and political power their families had maintained for generations. Among the factors contributing to this reversal of fortune were new technology, the growth of industry and manufacturing, shifting flows of capital, and a long agricultural depression.

Railroads opened up vast farmlands across the United States after the Civil War, just as new harvesting machinery expanded crop production and steamships accelerated ocean transport. Cheap grains imported from the Americas began to flood British markets in the 1870s, causing domestic grain prices to collapse, land values and rent rates to plunge, and the cost of farm labor to rise. As a result, several of the landowners who had been among the wealthiest

elite in the world's richest nation for most of the nineteenth century found themselves with blue blood, large estates, castles full of art, and very little income. The introduction of estate taxes in 1894 steepened the decline.

At the same time, immensely wealthy bankers and industrialists were emerging on both sides of the Atlantic—Bernard Berenson called them "squillionaires."* And to an extent, the composition of the British elite was changing. Members of the landed gentry who did not rely solely on agricultural income—who adapted to modern market forces, invested in urban properties, mineral-rich lands, foreign enterprise—managed to retain significant wealth. Moreover, parts of the old guard formed strategic alliances with "new" capitalists, particularly with powerful bankers who were themselves acquiring land and titles, assuming positions of political leadership, and adopting aristocratic values.

The Baring banking family had ascended to the upper reaches of British society in the eighteenth century. In the nineteenth, the financiers gaining similar access and stature included Jews— Rothschilds, Montefiores, Montagus, Hirsches, Sir Ernest Cassel. The Prince of Wales, later Edward VII, brought several of these figures into his inner circle. Unlike his mother, whose name, fairly or not, came to define the Victorian era as straitlaced and repressive, the prince loved the elegance and luxury that characterized

* Highly successful business figures in Britain during this period included William Pirrie and John Ellerman (shipping), the Guinness family (brewing), John Dewar (distilling), Thomas Lipton (tea), Jeremiah Colman (mustard), Ludwig Mond (industrial chemicals), John Lea (Worcestershire sauce), the Sassoon family (originally textiles and commodities). Discoveries of gold and diamonds in South Africa, coupled with new extraction techniques, created a group of millionaires who came to be called "Randlords" after the South African currency—among them Cecil Rhodes, Alfred and Otto Beit, Max Michaelis (a distant cousin of the Wertheimers), Julius Wernher, Sigismund and Ludwig Neumann. And the American Gilded Age included, among many others: Cornelius Vanderbilt (railroads), John D. Rockefeller (oil), Andrew Carnegie (steel), Henry Clay Frick (coke and steel), J. Pierpont Morgan (banking), Henry Havemeyer (sugar), Charles Deering (farm equipment), Peter Widener and William Elkins (streetcars—they were known as the "Traction Twins").

his Edwardian age. Members of his "Jews' Court" often met his steady need for cash.

Yet even with that royal endorsement, and even though Britain's liberal political culture allowed for measured assimilation of its Anglo-Jewish minority, a profound sense of the "otherness" of Jews was never absent from British national life. One of the prince's mistresses, Daisy Greville, Countess of Warwick, offered a (deliberately?) comical reflection on the chasm between "us" and "them," recalling that she and her friends

> resented the introduction of the Jews into the social set of the Prince of Wales, not because we disliked them individually, for some of them were charming as well as brilliant, but because they had brains and understood finance. As a class we did not like brains. As for money, our only understanding of it lay in the spending, not the making of it.

She added, helpfully, that "society's prejudice was not limited to Jews; it extended to artists, writers, musicians, lawyers."

The contrasting trajectories of British and American fortunes during these years gave rise to a flourishing transatlantic marriage market. Celebrated weddings that brought new American wealth to titled European families included Jennie Jerome and Lord Randolph Churchill, Consuelo Vanderbilt and the 9th Duke of Marlborough, Anna Gould and Count Boni de Castellane, Mary Leiter and Lord Curzon. Some well-known fictional versions of these unions are the heiress Maggie Verver and her impoverished Italian prince in Henry James's late novel *The Golden Bowl*, and the Earl of Grantham and his rich American wife, Cora Levinson, in Julian Fellowes's *Downton Abbey*.

When Sir William Harcourt, the Liberal chancellor of the exchequer whose lineage traced back to the Plantagenets, implemented the graduated estate tax in 1894, he famously sighed: "We are all

Socialists now." Four years later, announcing his son's engagement to Pierpont Morgan's favorite niece, Mary Burns, the elder Harcourt (whose second wife was American) wrote to the British politician Joseph Chamberlain (also married to an American), "It is another link in the American alliance. We are all Americans now!"*

In America as well as England, old money took a dim view of new wealth. As Harvard was looking to build a library on campus in 1912, an obvious potential donor was the retired steel magnate Andrew Carnegie, an immigrant Scot who was giving millions to build libraries across the United States. Joseph Hodges Choate, president of the Harvard Alumni Association, vetoed the idea on the ground that the college was "too dignified to have a Carnegie Library" and would not want "inevitably attached to Harvard for all time Mr. Carnegie's name." After the recent Harvard graduate Harry Elkins Widener went down with the *Titanic* that April, his mother agreed to build the new library in his name.

And all of them—dukes and earls whose status and power were fading, and wealthy bankers and industrialists living like lords—wanted Sargent to paint their portraits.

The momentous social changes that frame Sargent's career created dynamic markets for art, as aristocrats long on ancestry, land, houses, and heirlooms yet strapped for cash sought to trade with plutocrats who had exactly the opposite problem. In order to preserve estates for future generations, Britain had strict laws of entail

* The lucrative American alliance often helped England preserve its heritage. The Harcourt family seat, Nuneham Park in Oxfordshire, was badly in need of repair, and after Sir William died in 1904, Morgan gave his niece and her husband an interest-free line of credit to restore the property, telling them not to worry about paying it back. Two years later he persuaded Henry Clay Frick to sell him Joshua Reynolds's portrait of Mary, Countess Harcourt, which had been painted at Nuneham, and presented it to the couple.

that prevented heirs from selling family property, especially land. Declining landowner fortunes in the last third of the nineteenth century, however, led to a loosening of those restrictions, and an 1882 "Settled Land Act" allowed for sales of some inherited assets.

Art, unlike land and houses, was portable, and its prices were rising as property values fell. The Old Master paintings, ancestral portraits, furniture, and decorative objects that had passed down through noble families were exactly what the fin-de-siècle art markets wanted. Yet those markets were risky. High prices invariably attract swindlers, and expertise about art was just beginning to develop, along with standards for authentication. An aristocratic pedigree was a strong guarantor of quality in "old" art, and wise dealers bought at the dispersal sales of great estates. In the process, they came to serve as discreet brokers between noble families looking to sell treasures and aspiring collectors who had means but little knowledge or taste. The ability to certify value in this lofty marketplace put an honest dealer in an extraordinarily powerful position. Which is where the Wertheimers come in.

Merchants of Art

A number of extraordinary Jewish émigrés left the Franconian re-gion of Bavaria during the first half of the nineteenth century. In 1844, a young man named Julius Ochs traveled from the town of Fürth to the United States, where his son Adolph eventually took over a failing newspaper and turned it into *The New York Times*. At about the same time, three sons of a cattle merchant in Rimpar went to Alabama and then New York, where they founded Lehman Brothers. Levi Strauss left Buttenheim in 1847 and invented blue jeans in San Francisco. And Asher Wertheimer's father, Samson, quit Fürth for England in 1839 and became "one of the kings of the London art trade."

Named after an illustrious ancestor and the biblical slayer of Philistines, Samson Wertheimer was born in Fürth in 1811. Ger-many was not then a unified country but a loose confederation of sovereign states. Catholic Bavaria had been persecuting and expel-ling Jews for hundreds of years, yet Fürth in the sixteenth cen-tury began to allow Jewish resettlement, and Samson's forebears moved there from Vienna in the eighteenth. By 1800 Fürth had the largest, most prosperous Jewish community in the region. Its members were active in small-scale manufacturing, cattle markets,

decorative crafts, and trades, although subject to high taxes and severe restraints. Samson's father worked as a dealer in mirrored glass, an uncle traded old brass and pewter, and a cousin made gilded and silvered papers.

The French Revolution and the reign of Napoleon had brought a degree of emancipation to Germany's religious minorities, but only a degree. An edict issued in 1813, two years after Samson Wertheimer's birth, granted partial citizenship to Bavarian Jews but restricted where they could live and imposed tight limits on their populations. Each state registered all the Jewish families in its towns, then held them to that number. Fürth, with 536 families by the time the census was completed in 1819, was not allowed to have 537—which meant that only one son in a family would be allowed to inherit the "privilege," marry, and have children. Faced with these and other severe constraints, half of Bavaria's young Jews departed for more tolerant places.

Nuremberg, just six miles from Fürth and Bavaria's second-largest city after Munich, had long been a major crossroad for European trade and a leading center of science, humanism, and the arts, particularly fine metalwork. Albrecht Dürer was born into a family of master goldsmiths there in 1471. Jews in the early nineteenth century, forbidden to live in Nuremberg, had to pay tolls to enter and exit, hire escorts, and leave before dark. Still, the young Samson Wertheimer may have studied or worked there—he became a highly skilled artisan in bronze.

And he may have known a Fürth resident named Gabriel Davies, who owned a "curiosities" gallery in London run by his adult children. In 1819, Davies warned his daughter, Sarah, not to let a British client know she was "a Jewess." Sarah married an Englishman, John Coleman Isaac, who joined the Davies firm. From Fürth, he and his father-in-law sent cabinets, armor, china, snuffboxes, jewelry, bronzes, clocks, Venetian glass, and paintings to London. Isaac ordered custom-built Gothic furniture in Fürth, and told Sarah in

1835 that he had just bought "two *real* pictures by Canaletto, cost £5." The financial markets were rocky. From Frankfurt-am-Main in 1833, Isaac reported that "a great many Jews are ruined here with the stocks," and from Fürth in 1835 that business was "dreadful."

Samson Wertheimer left for England four years later. He may have traveled first to Greece. A small wax-relief portrait said to be of him as a young man belongs to his descendants. The figure has a medal pinned to his lapel, and the medal itself, on a blue ribbon edged in white, is attached to the back of the frame. Its inscription reads, in Greek: "To the Bavarian Volunteers" on one side, and "Otto King of Greece" on the other. Under the medal, a note typed in English with no date says: "SAMSON WERTHEIMER Fought in the Hellenic War of Liberation in Macedonia against the Turks 1829 was awarded the Iron Cross for deeds in the Field." The Greek Revolution in Macedonia ended with a loss in 1822, however, when Samson was eleven.

A friend of Wertheimer descendants found the wax portrait in a shop and recognized the name. The young man depicted has a strong chin, an aquiline nose, and close-cropped dark hair. There is no other image of Samson to help confirm or challenge the figure's identity.

Greece did win its long war of independence against the Ottoman Empire in 1832, with the help of European allies. Bavaria's philhellenic King Ludwig sent his sixteen-year-old son, Otto, to govern the newly sovereign state with a Royal Bavarian Auxiliary Corps and an army of volunteers. Otto awarded the bronze medal that is attached to this wax portrait to volunteers in 1837.

The Bavarian army did not welcome Jews, regarding them as detrimental to the state. Still, voluntary military service may have appealed to a young man wanting to demonstrate patriotism and physical prowess, as well as to earn decent pay and experience the world beyond Fürth. Most of the volunteers saw the sea for the first time on the way to Greece. Searches in German and Greek archives

find no Samson Wertheimer among the Bavarian forces, but the records are incomplete. If he did go, his metalworking skills may have been an asset to the logistics center at Nafplion, which made gun parts, buckles, sabers, and swords for the troops. And the venture may have strengthened his resolve to leave the German states for good.

He traveled to England via Antwerp with his cousin Samson Goetz, the maker of gilded and silvered papers. The journey took six months; the cousins arrived in December 1839. Samson Goetz went on to New York. Samson Wertheimer's certificate of arrival gives his profession as "merchant." Like many new immigrants then and since, he settled in the East End, near the Tower of London. In 1841 he was living on Red Lion Street, Spitalfields, and working as a "bronze factor" (broker or trader). His neighbors included potato salesmen, tailors, undertakers, jewelers, and smiths.

Samson married Helena Cohen, also from Fürth, at the Great Synagogue in Duke's Place, London, in June 1841. German Jews had founded the synagogue in 1690, shortly after Oliver Cromwell unofficially allowed "Israelites" to return to England from the exile ordered by Edward I in 1290. By the 1840s, about thirty-five thousand Jews lived in England, more than half of them in London. The name *Wertheimer* appears in various documents as Wirtheimer, Wertheimber, Wirthmann, Westheimer, Westreiner; *Samson* as Simon, Simson, Samuel, Sampson; *Helena* as Henrietta and Genendel, her Hebrew name.

The young couple had two sons: Charles, born in 1842, and Asher, born in October 1843—by which time Samson had moved his family to Greek Street in Soho. He opened a shop there with six craftsmen he recruited from Paris and continued to work in bronze and ormolu (gilded bronze—from the French *bronze doré d'or moulu*, gilded with ground gold). His trade card from the 1840s enumerates his skills—"Manufacturer of Ornamental Mounts for Cabinets, Tables, Vases, &c., &c. in Bronze and Or Moulu"—and

lists his services as "Embossing, Chasing, Cleaning, Engraving, Gilding, Lacquering, and Silverplating."

Then, in the early 1850s, the Wertheimer family and business moved farther upscale to Mayfair, settling permanently at 154 New Bond Street. Since the late eighteenth century, Bond Street has been a prime location for sellers of luxury goods who cater to residents of the surrounding affluent neighborhoods. The original Bond Street ran between Piccadilly and Burlington Gardens; in the early 1700s, New Bond Street extended it north to Oxford Street.

The Wertheimer surname traces back to the family's origin in the small Baden town of Wertheim. The ancestor for whom Samson had been named was a distinguished financier who served as "court factor" or "court Jew" to three Holy Roman Emperors in Habsburg Vienna: Leopold I and his sons Joseph I and Charles VI. This Samson, the wealthiest, most powerful Jew of his time, came to be known as the *Judenkaiser*—emperor of the Jews.

Born in Worms in 1658, he moved to Vienna at age twenty-six to work with his wife's relative Samuel Oppenheimer, then the reigning court factor. There were as yet no formal banks or standardized state-issued currencies, and individuals with sterling credit and access to capital performed essential banking functions for royal courts. After Samuel Oppenheimer died in 1703, Samson Wertheimer succeeded him as the kaiser's chief financial agent. Leopold waged long wars against the Ottoman Empire and France, requiring his bankers to raise enormous sums of money. In addition, Samson reorganized industries, carried out diplomatic missions, negotiated marriage settlements, and financed treaties. In gratitude for these services, Leopold presented him in 1703 with the imperial "chain of grace"—a medallion on a heavy gold chain—along with a portrait of himself and one thousand gold

ducats (nearly two hundred thousand dollars today). A few years later, Samson and his eldest son took part in the coronation of Leopold's son Charles VI at Frankfurt's Roman Catholic cathedral, where Charles gave them another chain of grace.*

Imperial sentinels guarded Samson Wertheimer's residence in Vienna's Kärntner Straße; he had several other houses and estates as well. His court factor privilege protected his family and households from the extreme restrictions imposed on Jews throughout the Habsburg lands. Moreover, he was a distinguished Talmudic scholar, chief rabbi of the Holy Roman Empire, and honorary rabbi of Hungary, Prague, Kraków, Eisenstadt, and Worms, as well as a generous philanthropist, patron of arts and education for Jews, builder of schools and synagogues, funder of scholarly publications, and protector of his coreligionists. When Johann Andreas Eisenmenger's ferociously anti-Semitic tract *Entdecktes Judenthum* (*Judaism Unmasked*) appeared in Frankfurt in 1700, Samson persuaded Leopold to confiscate copies and prevent further publication.

The *Judenkaiser* arranged for his children to marry into other wealthy or scholarly families—Oppenheimer, Eskeles, Bermann, Kohn, Behrens, Pösing, Kann. Since the world of the Jewish elite was very small, succeeding generations intermarried extensively, not unlike royal families. Joshua Teplitsky, an American scholar of Jewish history, has called this practice "tactical endogamy."

A portrait of the ancestral Samson, painted in about 1700, has been lost, although three copies survive. In the one likely to be earliest and most accurate, which belongs to family descendants in Israel, the sitter looks serene and wise, with a long, pale face, brown eyes, neatly trimmed mustache and beard. He wears a skullcap, black robes, a squared chambray clerical collar. Seated at a desk beside two large books, he holds a quill pen in one hand, a letter

* Leopold had married his Spanish niece and cousin Margarita Teresa, the central figure in Velázquez's *Las Meninas*. Her sister Maria Teresa married their double first cousin Louis XIV—keeping the royal blood and genetic miscues in the family.

in the other, with documents and his official seal on the desk. In the other two copies, his beard and hair are scraggly, his eyes less engaged, and a devil's head—a typical anti-Semitic icon—has been added to the arm of his chair. In the version now on permanent loan at the Austrian Jewish Museum in Eisenstadt, he wears one of the thick gold chains awarded him by the kaisers. The third copy, without the chain, is at the Jewish Museum of Vienna.

After this Samson died in 1724, his eldest son, Wolf, took over the business, overexpanded, and went bankrupt when Bavaria refused to repay large sums he had lent to the state. He received partial recompense at the end of his life. One of Wolf's sons, Isaac, moved to Fürth, where, three generations later, Asher Wertheimer's father was born. Georg Gaugusch, the author of a "Who Was Who" (*Wer Einmal War*) of Viennese Jews, characterizes later Wertheimer generations as mostly upper middle class even though no longer wealthy, since they came from an important family. A few were ennobled. One became Joseph Ritter (Knight) von Wertheimer; others received the title Edler (Noble) von Wertheimstein. In 1907, Rózsika Edle von Wertheimstein, a champion tennis player, married the British banker and entomologist Charles Rothschild.*

Art markets, like financial markets, know no national boundaries. Both tend to migrate away from political chaos and toward the prospect of high yields. And culture flourishes in times of material abundance—in ancient Egypt, early imperial China, classical Greece and Rome, the Ottoman Empire, Renaissance Italy,

* The brothers Pierre and Paul Wertheimer, who financed and went into partnership with Coco Chanel in 1924, were not descended from Samson: their forebears were living in Alsace when he was court factor in Vienna. Nor was Maurice Wertheim, the New York banker, art collector, and father of Barbara Tuchman. Their lineages probably all trace ultimately back to the town of Wertheim in Baden.

the seventeenth-century Netherlands, eighteenth-century France, nineteenth-century Britain, the twentieth-century United States.

"For the Fine Arts, London is now much and deservedly distinguished," announced a British guidebook in 1802, referring to the French Revolution and Napoleonic Wars with droll understatement as "the commotions on the Continent." Those tumultuous events "operated as a hurricane on the productions of genius," continues *The Picture of London for 1802,* "and the finest works of ancient and modern times have been torn out of their old situations." The newly available treasures quickened international interest in the French decorative style and in what the architect and botanist J. C. Loudon called "the furniture of the great." British collectors snapped them up.

The combination of Britain's wealth, overseas territories, victory over Napoleon, industrial strength, and access to most parts of the globe by sea was making London the financial capital of the early-nineteenth-century world and the center of the international art trade. The opulent grandeur of ancien régime décor, though at odds with British restraint, reflected the nation's new stature as heir to great cultures of the past.

Well-known collectors set the tone for England's embrace of the style sometimes called "Tous les Louis." George IV displayed the splendor of the Bourbon courts in his London residence and the private apartments at Windsor Castle. Other early connoisseurs included the 10th Duke of Hamilton, the 4th Marquess of Hertford, William Beckford, and Horace Walpole, son of the eighteenth-century prime minister Sir Robert Walpole.

By the time Samson Wertheimer arrived in London in 1839, the cachet of fine French furniture was firmly established. In addition to fabricating many of its features in work of his own, he began buying original "productions of genius" as well, at sales in Britain, Russia, and on the Continent. By 1854, though speaking English with a strong German accent, he had become a naturalized British

citizen and held a royal warrant as a dealer in china, curiosities, and antiquities—the warrant an invaluable endorsement for tradespeople who had supplied goods or services to royal households for at least five years. Samson's stationery bore the royal coat of arms and the phrase, "By special appointment to the Queen."

On January 25, 1858, he took part in celebrations honoring the marriage of Queen Victoria's eldest daughter, "Vicky," to Prince Frederick of Prussia. Buildings all over London set out gaslit displays that night. "Messrs. Wertheimer, cabinet makers and decorators," put up "a brilliant star," reported *The Morning Post.* Others paying tribute along New Bond Street included Mr. Hancock, "jeweler to the Queen," Mr. Charles Asprey, "dressing and travelling case maker" (an early Asprey specialty), and Mr. Mabey, "purveyor of turtle."

Among Samson's early notable clients were the brothers Lionel and Anthony de Rothschild. Several decades after the first Samson Wertheimer financed Habsburg rulers in Vienna, Mayer Amschel Rothschild in Frankfurt served as court factor to Crown Prince Wilhelm, later Wilhelm IX of Hesse-Kassel, and founded one of the world's great international banking dynasties. Of his five sons, one remained in Frankfurt; the others established banks in London, Paris, Vienna, and Naples. The Rothschild symbol was and still is five arrows.

Mayer Amschel's third son, Nathan Mayer, established N. M. Rothschild & Sons in London in 1811. Following the pattern of Britain's landed gentry, English Rothschilds acquired large country estates on which they built or renovated houses, raised horses and dogs, took up hunting, steeplechasing, and farming, created elaborate gardens, held lavish weekend parties, and surrounded themselves with art. So many family members settled in Buckinghamshire that the county came to be known as Rothschildshire.

Samson Wertheimer, by coincidence or design, specialized in just the kinds of decorative and fine arts the Rothschilds were collecting. In 1858, he sold Nathan Mayer's son Anthony a Dresden

porcelain box and veneered wood stand for twenty-seven pounds. For some reason he did not submit a bill—perhaps he thought it indecorous to request payment from such a wealthy man, or that Rothschild would eventually remember. Finally, in 1860, he sent a bill with a handwritten note saying, "Mr. Wertheimer requests immediate payment as he does not give 2 years' credit." On the bill, Sir Anthony wrote an entertaining reply: "If Mr. Wertheimer would have called with a stamp receipt he would have been paid & Sir A. R. begs to inform Mr. Wertheimer that he does not wait for credit either for 2 years—or for one day—as he is not accustomed to buy goods if not able to pay for them. A. Rothschild." He enclosed a check for twenty-seven pounds.

Three years later, Anthony's brother Lionel bought more than five hundred pounds' worth of furniture from Samson. Lionel had been elected to represent the City of London in the House of Commons in 1847, but members of Parliament were required to swear "on the true faith of a Christian," which Lionel refused to do. He was elected repeatedly and continued to reject the oath. Several attempts to change the requirement failed.

For hundreds of years Britain had imposed legal restrictions, called civil disabilities, on people who did not belong to the Anglican Church—among them Roman Catholics, Protestant Dissenters, and Jews. Catholics were freed from most "disabilities" in 1829. Jewish emancipation proceeded more slowly. Between 1830 and 1871, Jews gained the rights to conduct retail business in the City of London, practice law, hold municipal office, vote (adult males only), and attend elite universities. In 1858, Parliament passed a "Jewish Disabilities Bill"—formally the Jews Relief Act—which allowed entering MPs to forgo the Christian oath. Lionel de Rothschild became the first practicing Jew to serve in Parliament. His son Nathaniel entered the House of Lords in 1885. (Benjamin Disraeli, an MP, chancellor of the exchequer, and the only British prime minister to have

been born Jewish, was baptized in the Church of England at age twelve, in 1816.)

The Wertheimers remained preferred dealers to the Rothschilds for the rest of the century and into the next. The families also developed personal bonds. Lionel de Rothschild's sons Alfred and Leopold served as the executors of Samson's estate. Their Austrian cousin Ferdinand was one of the Wertheimers' principal clients and the godfather of Asher's youngest son, Ferdinand. Asher and Flora may have named another child after a Rothschild as well.

Like the royal warrant, Rothschild patronage signaled to art markets the value of dealing with Wertheimers. Samson raised his professional profile in other ways as well. He exhibited his wares and abilities at highly popular world's fairs, beginning with the Great Exhibition of 1851 at the Crystal Palace in Hyde Park. The catalogue of an 1862 International Exhibition of Arts and Industries in South Kensington describes "Mr. Wertheimer of New Bond Street" as among the most valuable contributors—a "large importer of the choicest productions of the best fabricants of the Continent," with an "extensive collection of *objets de luxe*." The objects chosen for illustration in the catalogue were not imports, however, but works by Wertheimer's own hand. His console table in the style of Pierre Gouthière, the master bronze chaser and gilder in the courts of Louis XV and XVI, won a prize. *The Morning Post* pronounced it "without exception, the finest work of the kind in the building," and also praised Samson's cabinet of inlaid woods with ormolu mounts modeled on those made by André-Charles Boulle, royal cabinetmaker to Louis XIV.

That Samson knew the work of these masters intimately enough to create impeccable models of his own, as well as to import originals and fashion hybrids of antique pieces and his own designs, underscores his strong position in the expanding British market.

It seems surprising now that collectors who could afford the real

things preferred copies, yet interest in authentic period pieces was just emerging. Wealthy patrons looking to emulate French style without sacrificing comfort, luxury, or modern convenience could have the best of old design and new craft. The higher cost of contemporary work added to its prestige.

Samson received a singular royal commission in 1874 when the Duke of Edinburgh—Alfred, the second son of Queen Victoria and Prince Albert—married the Romanov Grand Duchess Maria Alexandrovna, the second and only surviving daughter of Tsar Alexander II. The couple chose Wertheimer to redecorate rooms for their residence, Clarence House, the neoclassical mansion adjacent to St. James's Palace designed in the 1820s by the Regency architect John Nash for the Duke of Clarence, later William IV.*

Reporting on the renovation, *The Sunday Times* noted that Wertheimer's work on the duchess's boudoir and reception room bore "brilliant evidence to his skill": he had installed pieces of his own in the manner of Gouthière and Jean-Henri Riesener, the finest cabinetmaker of the Louis XVI period, and made "Marie Antoinette" chairs with the newlyweds' monograms "fancifully intertwined." He lined walls in olive-green silk and adapted modern conveniences to French style with "singular delicacy"—tucking the tops of drapes behind valences, concealing picture wire in wall moldings, mounting buttons for an electric bell in finely chased ormolu. Altogether, concluded *The Times*, "the apartments are 'interiors,' as painters would term them, of such regal magnificence as Mr. Nash might delight to picture."

* In the twentieth century, Princess Elizabeth lived at Clarence House with the Duke of Edinburgh until she became queen in 1952. It served as the London home of her mother between 1953 and 2002. Prince Charles and Camilla, Duchess of Cornwall, lived there beginning in 2003, and chose to remain at Clarence House rather than move to Buckingham Palace after Charles became king in 2022.

Samson's sons, Asher and Charles, attended University College School in London between 1853 and 1856. It had been founded in 1830 by the nonsectarian London University, which became University College London, on Gower Street in Bloomsbury, in 1836. Oxford, Cambridge, and the elite boarding schools were then open only to members of the Church of England; the egalitarian University College, which accepted dissenters, nonconformists, Catholics, Jews, agnostics, and atheists, was known as the "godless institution in Gower Street."

The lower school took day students only, mostly from middle-class families, for fifteen pounds per year. One of the first English academies to offer science and modern languages, it had no religious teaching, no compulsory courses, and no corporal punishment. It did have a playground and a gym, and offered classes in writing, drawing, fencing, dancing, and gymnastics.*

Asher studied in Paris after he left University College School. Then, in the early 1860s, his father sent him to St. Petersburg, where Russian collectors were selling European art. Tsar Alexander II had freed the country's twenty-three million serfs in 1861, partly to forestall a peasant revolt. The aristocracy was forced to sell land to its former workers and pay for farm labor that had previously cost nothing. Several landowners sold art to raise capital, and they continued to sell, as Asher continued to buy from them, for decades.

Not all of Asher's strengths as he learned the art trade were cerebral. One day in October 1869, he was walking on the beach at Ramsgate, a resort town on the coast of England where the English Channel meets the North Sea, when he heard a cry for help. Diving into the water, he swam out to a woman who appeared to

* Among those who attended the school in the 1840s and '50s were the future statesman Joseph Chamberlain, Richard D'Oyly Carte (theatrical impresario and hotelier), Edward Nicholas Coventry Braddon (Australian politician, premier of Tasmania), Edward Levy-Lawson (proprietor of *The Daily Telegraph*), George Faudel-Phillips (lord mayor of London), Myer Salaman (ostrich feather merchant), and Hermann Adler (chief rabbi of the British Empire).

be drowning. A crowd gathered to watch what one report called the "Gallant Rescue," and cheered as the pair reached the sand. The London-based *Jewish Chronicle* pronounced it "an agreeable circumstance to find that our race shows evidence of muscularity as well as of intellect, for Mr. Wertheimer, by being a powerful swimmer, was enabled to rush to the rescue of this drowning person and to save her life at the risk of his own."

Further "evidence of muscularity" surfaced a few months later when Asher and Charles got into a fight at a Soho pub. Their antagonist, Major Robert Gordon Hope Johnstone, had recently been in prison for bankruptcy and would be charged in 1871 with swindling a man out of £10,500. The fracas at the pub started when Johnstone, who was six feet four inches, accused the brothers of being "no gentlemen," then hit one of them. Charles smashed a drinking glass on the bar and used it to strike back. Asher followed suit, slashing Johnstone's face. The major kept attacking until one of the Wertheimers beat him with a stick "loaded with two inches of lead." That they had brought this weapon to the pub suggests they were expecting trouble.

In early May 1870, the brothers appeared in court with their solicitor, George Henry Lewis. Major Hope Johnstone did not show up, but his solicitor threatened assault charges against the Wertheimers. Mr. Lewis said his clients were prepared to meet any charge, and that he would issue countercharges against Johnstone, who, as his own lawyer admitted, had struck the first blow. By the end of May all charges had been dismissed and the matter was reported as having been "arranged."

The Wertheimers had found the right lawyer. They may have been related to Lewis's first wife, the Frankfurt-born Victorine Kann, who had died giving birth in 1865. Lewis, on his way to becoming the leading solicitor of his generation, represented at various times the Treasury, the Stock Exchange, Lloyd's of London,

the Prince of Wales, Oscar Wilde, Whistler, and Sargent. He was a
renowned keeper of society secrets. Wilde called him "the best
in London. Brilliant. Formidable. A man of the world. Concerned in
every great case in England. Oh, he knows all about us—and for-
gives us all."

Asher Wertheimer married Flora Joseph on March 22, 1871. He was
twenty-seven, she twenty-four. The wedding took place at her res-
idence in Maida Vale. Theirs was the first marriage performed un-
der the auspices of London's newly consecrated Central Synagogue
in Great Portland Street, for Anglo-Jews living in the West End.
Samson gave the couple two thousand pounds and the leasehold on
a building at 113 New Bond Street as a marriage settlement, to be
held in trust until his death.

Flora came from a dynasty of art dealers. Her maternal grand-
father, Jacob Falcke, had emigrated from Prussia, settled in Great Yar-
mouth, on England's northeast coast, and opened galleries there and
in London, offering "curiosities" and arts. He had nineteen children.
After he died, his widow continued the business as Hannah Falcke &
Sons in Oxford Street. Their daughter Sarah, Flora's mother, mar-
ried the art dealer Abraham Joseph. Three of Flora's uncles—Isaac
and David Falcke, and Frederick Davis—had galleries in Bond Street
at about the time Samson arrived there in the 1850s. Flora's brothers,
Felix and Edward Joseph, also became important dealers and collec-
tors, as did her cousin Charles Davis. Her father died a year before
she married Asher. Felix retired as a dealer and devoted the rest
of his life to collecting. Edward opened a gallery at 158 New Bond
Street, which Asher eventually took over.

Once Asher and Charles had established their own professional
identities, Samson came to be known as Old Wertheimer, and after

Flora's brothers entered the field, their father was called Old Joseph. The Falckes, Josephs, Davises, and Wertheimers bought art at many of the same sales and sold to many of the same clients.

A number of nineteenth-century art-dealing firms were, like these, multigenerational family businesses. P. & D. Colnaghi, the world's oldest commercial gallery, started as a print specialist in the late eighteenth century, continued with family-member partners until the early twentieth, and was eventually sold to a series of other dealers. The Durand-Ruel family in Paris began representing artists in 1839. Thomas Agnew & Sons opened its first gallery in London in 1860 and remained a leader in the field until 2013.

And a number of the families in the art trade were Jewish, although not the Agnews, Colnaghis, or Durand-Ruels. Leading nineteenth-century Jewish firms included—in addition to the Wertheimers and Flora's relatives—Durlacher, Duveen, Goldschmidt, Sedelmeyer, Seligmann, and Wildenstein. Some began, as Samson had, by offering a range of services and wares, then grew more specialized to meet the rising demand for authentic works of fine and decorative art. In the process, they helped modernize the market.

Several factors may account for the relatively high incidence of Jews in dealing art. Over centuries of diaspora, Jewish people lived all over the world, often spoke several languages, usually had Yiddish or hybrid dialects such as Ladino (Judeo-Spanish) or Judeo-Persian in common, which meant that even strangers could exchange information, resources, and credit. Faced with severely limited economic opportunities, many Jews earned livings however they could—as shopkeepers, moneylenders, pawnbrokers, peddlers, traders. At the low end of the social scale, opening "old curiosity" and "bric-à-brac" shops was a natural extension of selling secondhand goods. From cultures that valued education and literacy, even in poverty, Jews tended to gravitate to fields in which knowledge conferred distinct

advantages—commerce, finance, medicine, science, law. Dealing in art was just such a domain.

Moreover, the early-nineteenth-century art markets had few established rules or barriers to entry. Able neophytes could learn from observation, travel, family networks, exhibitions, auctions, apprenticeships, and a range of new periodicals and books. The French writer Edmond de Goncourt offered acid reflections on the changing trade in 1877:

> I am greatly astonished by the revolution that has suddenly been worked in the habits of the new generation of bric-à-brac dealers. Yesterday they were scrap mongers . . . Today they are gentlemen dressed by our tailors who buy and read books and have wives as distinguished as the wives in our own circles, gentlemen hosting dinners served by servants wearing white cravats . . . Trade—and this trade in particular—is no longer, in the person of the seller, in a position of inferiority vis-à-vis the buyer, who on the contrary seems beholden to the seller.

S. Wertheimer and Sons

Asher and Flora Wertheimer spent their 1871 honeymoon at the Victorian-Gothic Duke of Cornwall Hotel in Plymouth, on England's southwest coast. Then they moved into 21 Cornwall Terrace, one of the white stucco mansions overlooking Regent's Park, designed in the early 1820s by Decimus Burton and John Nash, that are still among the most beautiful houses in London. Number 21, at the eastern end of Cornwall Terrace, had three main stories and an attic, a ground floor of rusticated stone, gracious bays, shallow porches, cast-iron balconies, a portico entrance with Corinthian columns, and a garden pavilion at the back.*

The couple's first child, a girl named Sarah after her maternal grandmother, was born there in February 1872 but died eighteen months later. Flora had seven more children at Cornwall Terrace between 1872 and 1881, and an additional four, including another who died before age two, after the family moved to Connaught Place. In all, she gave birth to twelve children in sixteen years,

* A luxury developer restructured most of Cornwall Terrace in the early twenty-first century, converting eighteen of the houses into eight: the combined numbers 20 and 21, advertised as a "Super-Prime Ambassadorial Residence" with indoor pool and spa, sold for seventy-eight million dollars in 2013.

none of them twins. She and Asher had large houses, ample means, and plenty of hired help: in 1881, a cook, two housemaids, and three nurses. Some nineteenth-century couples used birth control, natural or mechanical, to limit the size of their families; the philoprogenitive Wertheimers evidently did not. Their large brood attests to their prosperity, Flora's health, Asher's virility, and an active intimate life.

While Asher and Charles both became successful art dealers, they made starkly different choices throughout their lives. Charles married a distant cousin from Bavaria named Frederika Flachfeld in 1860, when they were both eighteen. Frieda, as she was called, soon gave birth to twins. Rather than take a house of their own, the couple moved in with Charles's parents at 154 New Bond Street. Two more children arrived in quick succession, but by the time Asher married Flora in 1871, Charles had left his family in the care of his parents and was living with a seventeen-year-old named Sarah Hammond in a rooming house near St. Pancras. According to a Wertheimer descendant, whenever Asher's children misbehaved, they were threatened with being sent to live with "wicked Uncle Charlie."

Samson had his hands full after Charles decamped. In his sixties, he assumed responsibility for his elder son's wife and young children while continuing to expand his business. His wife, Helena, died in 1879. She was buried in the West Ham Jewish cemetery in East London. In her memory, Samson gave the Central Synagogue a set of embroidered velvet curtains for the ark containing the Torah scrolls. The couple had previously donated a pair of English silver Torah finials inscribed with the Jewish calendar date, using Helena's Hebrew name: "Mr. Samson and Mrs. Genendel Wertheimer, [5]637 [1876–1877]."

The Daily Telegraph later observed that Samson and his sons

had been "thoroughly Anglicized in thought and action," yet they retained clear identifications with Judaism. Asher and Charles were affiliated with the Central Synagogue and were buried at the Willesden Jewish Cemetery in northwest London.

The Anglo-Jewish aristocracy, sometimes called "the Cousin-hood," included Rothschilds, Sassoons, Montefiores, Goldsmids, Montagus, Cohens, and Samuels, and it set standards for its less-affluent brethren. The historian Eugene C. Black claimed that during the period from 1880 to 1920, "The vast majority of British Jews accepted, with token qualifications, the philosophy and values [the elites] had sought to impart—pride in being Jewish, anglicization, self-help and upward mobility." They became "English people of the Jewish persuasion."

Black's generalization certainly applied to assimilating Jews such as the Wertheimers, who did regard themselves as "English people of the Jewish persuasion." Contrary to Black's assertion, however, this group did not constitute the "vast majority." Immigrants quadrupled the nation's Jewish population between 1880 and 1914, from 65,000 to 260,000. The values of the elites may have been more widely shared after the 1920s, as impoverished East European Jews moved increasingly out of the East End and into the middle class. Earlier, the Wertheimers and other wealthy Jews assumed some responsibility for helping their less fortunate coreligionists abroad, and they supported efforts to define an Anglo-Jewish identity.

In 1882, as a wave of anti-Semitic violence swept through Imperial Russia, prominent Anglo-Jewish figures organized international relief measures and raised funds for victims and refugees. The Liberal politician Sir Julian Goldsmid made the largest contribution to a fund set up in London. Next came Samson Wertheimer. Younger men, including Charles and Asher, gave lesser amounts.

Asher served on the general committee of an Anglo-Jewish

exhibition mounted as part of Queen Victoria's Golden Jubilee cele-
brations in 1887. Held primarily at the Royal Albert Hall and open
to the public for three months, the well-attended display presented
nearly three thousand objects that illustrated the history of Jews
in Britain, emphasizing at once their identification with the nation
and their distinct place within it. Asher was also a "guarantor" of
the endeavor and a minor lender of items for display—an early-
eighteenth-century silver-gilt amulet of Spanish design and two
embroidered cloths used in synagogue services. The red velvet ark
curtains Samson had given the Central Synagogue in memory of
his wife were on view as well.

Decades after the French Revolution and Napoleonic wars had torn
some of "the finest works of ancient and modern times" out of
their "old situations," as the 1802 British guidebook described it,
a different kind of disruption precipitated another massive reallo-
cation of art. As Britain's agricultural depression sent the fortunes
of many landed families into steep decline, the inheritors of those
fortunes began to put their ancestral collections up for sale. And
newly wealthy plutocrats eager to own "the furniture of the great"
sent prices soaring, which provided further inducement to sell.

Ferdinand de Rothschild reflected on these changes in a mem-
oir: "The mania for old art has shifted from the descendants of the
old to the founders of the new families, who owing to the greater
means at their command have been enabled to possess themselves
of many of the treasures which for long periods had remained in
undisturbed security."

Samson Wertheimer, now trading as S. Wertheimer and Sons,
had been transferring art from "old" to "new" families for some
time, and in 1882 he raised his game. That summer, not long after

the Settled Land Act allowed heirs to sell property that had been entailed, the justly celebrated collections of Scotland's Hamilton Palace went up for auction at Christie, Manson & Woods in King Street.

The collections had been assembled earlier in the century by the 10th Duke of Hamilton and his father-in-law, William Beckford, both leading purchasers of the arts of eighteenth-century France. The 12th Duke, Hamilton's grandson, had more interest in horse racing, yachting, gambling, and drinking than in art. Having incurred more than one million pounds in debt, he decided to trade much of his inheritance for cash. The Hamilton Palace auction, described half a century later as "the most important art sale ever held in this country," took place over four weeks and brought in £397,562 (about $2 million at the time).

An editorial in *The Times* on opening day mocked the enduring national rage for all things Marie Antoinette, declaring it "the very highest *chic* to possess any relics of the ill-fated Queen." When one of these relics, a delicate Riesener writing table stamped with Marie Antoinette's cipher, was brought into the auction room, the crowd broke into applause. *The Times*, citing the Roman satirist Juvenal on "profligate extravagance," went on: "If Juvenal had been present at the auction rooms in King-street yesterday, he would have seen the man who gave six thousand sesterces [Roman coins] for a mullet [a fish] outdone by another who gave six thousand pounds sterling for a writing table."

The man who gave six thousand pounds for the writing table was Samson Wertheimer, acting on behalf of Ferdinand de Rothschild, whose neo-Renaissance château in Buckinghamshire was nearing completion. Samson's Hamilton Palace purchases for Ferdinand also included a Riesener fall-front *secrétaire* made for Louis XVI, antique Egyptian porphyry vases, and a pair of Louis XIV Boulle armoires. He was buying for other Rothschilds as well: Ferdinand's

sister ("Miss Alice"), their cousin Alfred, and Barons Edmond in Paris and Mayer Carl in Frankfurt.

While the Rothschilds patronized a number of dealers, their reliance on Wertheimer was so widely recognized that in 1887, when Samson paid ninety-nine hundred guineas for a portrait of Madame de Pompadour by François Boucher, *The Times* reported that he was acting for Ferdinand. A few days later a correction appeared: "Mr. S. Wertheimer, of 154, New Bond-street, asks us to state that the portrait . . . was bought by Mr. Wertheimer on his own account."

On his own account, Mr. Wertheimer had previously bought eight decorative Boucher panels of children at play. Known as the *Arts and Sciences* series, they are now in New York's Frick Collection.*

By the early 1880s, Samson's reputation had crossed the Atlantic, and he was acting for Vanderbilts as well as Rothschilds at the Hamilton Palace sale. Heirs of the shipping and railroad magnate "Commodore" Cornelius Vanderbilt exemplified the voracious eclecticism of the American Gilded Age. William Kissam Vanderbilt, a grandson of the Commodore, and his wife, Alva, were

* Museums and private collectors around the world own works of fine and decorative art that had passed through the hands of Samson, Asher, or Charles Wertheimer. The museums in the United States include, in addition to the Frick Collection: New York's Metropolitan Museum of Art; Boston's Museum of Fine Arts; the Isabella Stewart Gardner Museum, Boston; the Art Institute of Chicago; the National Gallery of Art, Washington, DC; the Philadelphia Museum of Art; the Huntington Museum in San Marino, California; the Taft Museum of Art in Cincinnati, Ohio; the Worcester Art Museum, Massachusetts. In Great Britain: the British Museum, the National Gallery of Art (London), Tate Britain, Waddesdon Manor in Buckinghamshire, the National Galleries of Ireland and Scotland, the Ashmolean Museum at Oxford, the Fitzwilliam Museum at Cambridge, Kenwood House (the Iveagh Bequest) in Hampstead, London. Also the Gemäldegalerie in Berlin; the Musée du Louvre, Paris; Mauritshuis, The Hague.

avid builders of houses and collectors of art, particularly the arts of eighteenth-century France. Looking for an expert to bid for them in England and vouch for the quality of their acquisitions, they chose Samson Wertheimer.

On Fifth Avenue, the couple built a limestone-clad mansion modeled on French châteaux that took up the entire block between Fifty-second and Fifty-third Streets. To celebrate its completion in 1883, Alva held a costume ball that gave free rein to the royalist fantasies of New York's new wealth: she dressed as a Venetian princess accompanied by live doves, her husband as the Duc de Guise. William's brother Cornelius II (who built his own château farther up Fifth Avenue) came as Louis XVI. There were sixteen more Louis XVIs, eight Marie Antoinettes, seven Mary Queen of Scots, one King Lear, one Queen Elizabeth, assorted Valkyries and Scottish lairds—and former president and Mrs. Ulysses S. Grant in ordinary evening dress.

Edith Wharton, speaking for a more discreet aesthetic, wrote to her colleague Ogden Codman, Jr., "I wish the Vanderbilts didn't retard culture so very thoroughly. They are entrenched in a sort of *thermopylae* of bad taste, from which apparently no force on earth can dislodge them."

Still, the William K. and Cornelius II Vanderbilts filled their houses with paintings and decorative objects of high quality, many acquired through the Wertheimers. Alva had set her heart on two Hamilton Palace pieces designed by Riesener for the private rooms of Marie Antoinette: a drop-front desk and its companion commode, both made of ebony with seventeenth-century Japanese lacquer veneers, ormolu mounts by Gouthière, and the queen's monogram in the friezes. Flora Wertheimer's uncle Frederick Davis bought the desk for £9,450. Samson secured the commode, also for £9,450. "Such a price was never before given for a piece of furniture," reported *The Illustrated London News*—let alone twice. Both pieces were shipped across the Atlantic and installed in William and Alva Vanderbilt's Fifth Avenue house.

Alva also wanted a Rembrandt "of the first grade." In an unpublished memoir she recalled traveling to Scotland to see a painting "called the Jewish Bride," which she claimed was "considered one of the best, if not the best Rembrandt in existence." Yet she thought the price too high and instead bought "the painting known as *The Moldavian Chief* another Rembrandt of great interest and excellence. This together with a Boucher and two Van Dycks, I purchased in London from Wertheimer, the great art critic."

Though not a critic, Samson continued to buy art, furniture, and tapestries for the Vanderbilts in New York—and for their Newport mansion, Marble House, where Alva modestly aimed to "improve" on Versailles. And raising her obsession with the nobility to cruel heights, she forced her only daughter, Consuelo, to marry the nearly bankrupt Charles Spencer-Churchill, 9th Duke of Marlborough, in 1895. That highly publicized, unhappy marriage lasted about ten years. Not long before the couple separated, Sargent painted an august formal portrait of them with their children to hang near Sir Joshua Reynolds's 1778 portrait of the 4th Duke and *his* family in the Churchills' Blenheim Palace.*

Marital discord was in the air. Consuelo's parents divorced in 1895. William K. kept the art and furniture, and left most of it to New York's Metropolitan Museum of Art at his death in 1920. Among the works acquired through Samson that went to the Met: Boucher's *Toilette of Venus*, the Riesener commode from Hamilton Palace, and the Rembrandt portrait Alva called *The Moldavian Chief*, also known then as *Man in Oriental Costume*, later as *The Noble Slav*, now as *Man in a Turban*.

At the end of the Hamilton Palace sale, Samson had spent more

* Sargent painted almost as many Vanderbilts as he did Wertheimers—ten—although not in one nuclear family and not commissioned by a single patron. Most of those portraits are now at Biltmore, the massive "château" George Washington Vanderbilt II built in the early 1890s in Asheville, North Carolina. Also at Biltmore are Sargent's paintings of the estate's architect, Richard Morris Hunt, and landscape designer, Frederick Law Olmsted, both commissioned by George W.

than any other buyer, acquiring forty-four lots for nearly £60,000 (then about $300,000). That dealers were the principal purchasers at this landmark auction highlighted distinctive changes in the art market, as did the dominance of new kinds of collectors. The ultimate beneficiaries of the dispersal included many more bankers and industrialists than aristocrats. Moreover, in the mounting alarm about foreigners buying up art from Britain's private collections, the National Gallery acquired thirteen Hamilton Palace paintings, including Velázquez's *Philip IV of Spain in Brown and Silver*, for a total of £21,719—which would be about $3.2 million today.

Perhaps in appreciation of all that England had made possible for him, Samson made a magnanimous gesture in 1891. He had recently acquired a solid gold ceremonial vessel decorated with jewels and richly enameled panels depicting scenes from the legend of St. Agnes. Made in the late fourteenth century for the French royal family, it had migrated to British royals (who added Tudor roses to the cup's stem during the reign of Henry VIII), then to Spain, where it remained for nearly three hundred years; back to France in 1883, and finally again to England via Samson Wertheimer. The British Museum's keeper of medieval antiquities, Augustus Wollaston Franks, worried about prowling American collectors: this was exactly the kind of gorgeously wrought object with New Testament themes and princely provenance that Pierpont Morgan loved, and for which he was willing to pay almost any price. Wertheimer, "with great public spirit," offered the cup to the British Museum for the price he had paid, £8,000. Franks secured £2,830 from the Treasury and raised the rest from private donors, including himself and Samson at £500 each.

The Royal Gold Cup remains on permanent display at the

museum, which published a pamphlet about it in 1924: "As a rare historical relic, and as an example of the finest medieval craftsmanship, this ancient possession of the Kings of France and England must always rank among the greater treasures of the British Museum."

Samson died on January 25, 1892. He left an estate valued at £382,810 (nearly $2 million then, about $66 million now). His will, administered by Alfred and Leopold Rothschild, gave his disposable property to his two sons in equal shares, although the wedding gifts Samson had put in trust for Asher and Flora were specifically exempted. Charles's share, by contrast, would be reduced by his marriage settlement and some of the costs Samson had incurred supporting his elder son's wife and children for two decades. To accentuate the point, Samson's will repeated the exclusion of Asher's marriage settlement.

Among Samson's assets were several leases on posh Mayfair real estate. Most of the leaseholds were renewable forever and therefore equal to freeholds, which made them extremely valuable. In addition to 154 and 113 New Bond Street, the properties included 95 and 164 New Bond Street, 27 Brook Street, and 13, 14, and 15 Avery Row.

In March 1892, Christie's sold the contents of Samson's gallery, drawing crowds of collectors, dealers, and spectators. *The Times* noted that while no dealer's stock was without weak spots, "Messrs. Wertheimer have always been fastidious buyers, and there is surprisingly little in the collection that can be set down as common or ordinary." The yield from the sale came to £57,120.

Even after he became a leading dealer, Samson had kept a workshop in Grosvenor Mews and continued to list his firm in trade directories as bronzists, cabinetmakers, boulle cutters, and ormolu manufacturers. Christie's held a second auction for the workshop tools.

Samson was buried at the West Ham cemetery alongside his wife. Once the firm of S. Wertheimer and Sons dissolved, each son went his own way. Asher took over the lease on the premises at 154 New Bond Street and extended his father's business into the twentieth century. Charles, who had moved to 21 Norfolk Street, Park Lane, filled his house with fine art and traded from there.

Eight months after Samson died, British newspapers ran notices of a book about the man for whom he had been named. Titled *Urkundliches aus dem leben Samson Wertheimers* (Documents from the Life of Samson Wertheimer), it had been assembled by the historian David Kaufmann and published, in German, in 1891. Dr. Kaufmann, a professor at the Budapest Rabbinical Seminary, had also published a biography in German in 1888. Its title in English would be *Samson Wertheimer, Court Factor and Chief Rabbi (1658–1724), and His Children.*

When George Eliot's idealizing, philo-Semitic novel, *Daniel Deronda*, appeared in 1876, Kaufmann wrote a rapturous review. He sent a copy to Eliot and pointed out a few errors she had made about Jewish affairs. She thanked him warmly, corrected the mistakes, and told him that his essay would be printed in English by her publishers under the title *George Eliot and Judaism: An Attempt to Appreciate "Daniel Deronda."* In it, Kaufmann laid out his ardently nationalist views on the history and destiny of Jews, and declared, "It is to an English Christian authoress that the historian of culture must assign the glory of having grasped these ideas most profoundly." Eliot had perceived "with the prophetic eye of genius . . . the fundamental questions of Judaism, and invest[ed] them with a poetic charm."

The sparse Wertheimer records contain no mention of anyone reading *Daniel Deronda*—which of course does not mean no one did—or of Samson in London reading Kaufmann's biography of his ancestor. It may have been at about this time that someone, probably Asher, commissioned a Wertheimer "pedigree book," beginning

with the court factor and extending into twentieth-century generations. In the dramatic nineteenth-century reconfiguration of the British elite, newly wealthy families were eager whenever possible to trace their lineage back to ancestors of distinction. The Wertheimer book, a huge volume, immaculately handwritten in black and red ink, now belongs to Asher's descendants.

HARMONY AND DISCORD

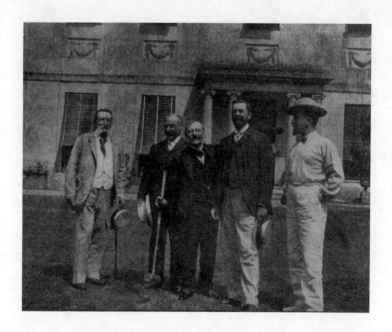

On the lawn at Temple, the Wertheimers' country house in
Berkshire. Left to right: an unidentified guest, Asher Wertheimer,
Antonio Mancini, John Singer Sargent, Edward Wertheimer.

(Collection of the late David and Katherine Mathias)

Artist and Patron

By 1884, Asher had moved his family to 8 Connaught Place. Built early in the century, the handsome house had five stories, tall arched windows, a slate roof, a colonnaded portico, an elevator, and adjacent stables. The Wertheimers had four more children there, in 1884, 1886, 1888, and 1889; the first one died. Twenty-five people now made up their household: Asher, Flora, ten children, Flora's sister Elizabeth Joseph, and twelve servants—maids, nurses, governesses, two manservants, a cook. And many dogs.

A remarkable mix of titled aristocrats and wealthy Jews lived along Connaught Place, a hyphen of a street that runs between Stanhope Place and Edgeware Road just above the northeast corner of Hyde Park. Lord and Lady Randolph Churchill were at number 2—Winston was the same age as the Wertheimers' eldest daughter, Ena. Alexander James Beresford Hope, a politician, author, and heir to a banking fortune, lived at number 1 with his wife, a daughter of the Marquess of Salisbury. The 12th Duke of Hamilton, from whom Samson bought much of the Hamilton Palace collection in 1882, had been born in Connaught Place. The director of the Wallace Collection, Sir John Murray Scott, was at number 5. The Jewish financier and philanthropist Frederick David Mocatta lived at

number 9, the banker Edward Raphael and his family at number 4. Constance Rothschild Flower, Lady Battersea, moved to number 10 after her husband died in 1907.

Asher and Flora celebrated their silver wedding anniversary in 1896. To mark the occasion, the expert on paintings of the past turned to the leading portrait artist of his own time. How the two men met is not clear. They had a number of mutual friends, and Sargent may have frequented Asher's Bond Street gallery.

The sittings—and Sargent's "chronic Wertheimerism"—began in 1897, when Sargent was forty-one, with Asher posed against a dark Japanese screen in the artist's Tite Street studio. Sargent's major portraits now appeared at the Royal Academy almost as soon as he finished them. The first two Wertheimer paintings, of Asher and Flora, were shown there in May 1898.

Portraits have historically been markers of privilege—the province of royalty, nobility, leading figures in the military, politics, religion. And from the outset, the Old Masterly portrayal of a middle-class businessman with distinctively Jewish features aroused antipathy. An 1898 *Punch* cartoon of *Asher Wertheimer* exaggerated the sitter's nose and paunch, and gave him tiny hands, a diabolical grin, a rumpled pin-striped suit; his dog looks cross-eyed and goofy. "Asher" is saying, "What only *this* monish [money] for that shplendid dog. Ma tear it is ridic'lush!"

The critic Christian Brinton, describing the range of Sargent's sitters in 1906, may have meant Asher in a reference to the Greek god of wealth: "To-day comes a savant, a captain of industry, or a slender, troubled child. Tomorrow it will be an insinuating Semitic Plutus; next week may bring some fresh-minted Diana, radiant with outdoor bloom."

It was the young American architect I. N. Phelps Stokes who saw the unfinished portrait of Asher in Sargent's studio and said the figure seemed to be "pleasantly engaged in counting golden

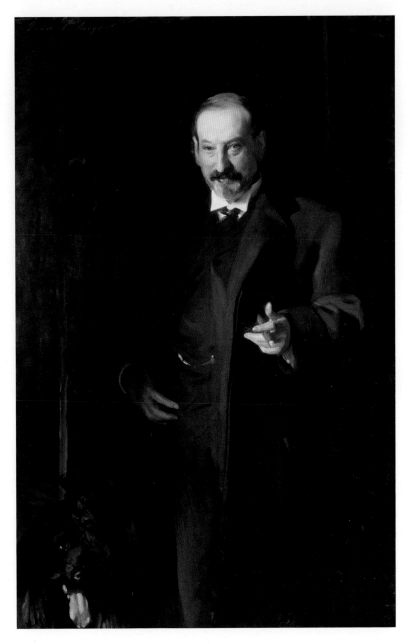

Asher Wertheimer, 1898.
Oil on canvas. (Tate. Presented by the widow and family of Asher Wertheimer
in accordance with his wishes, 1922. Photograph: Tate)

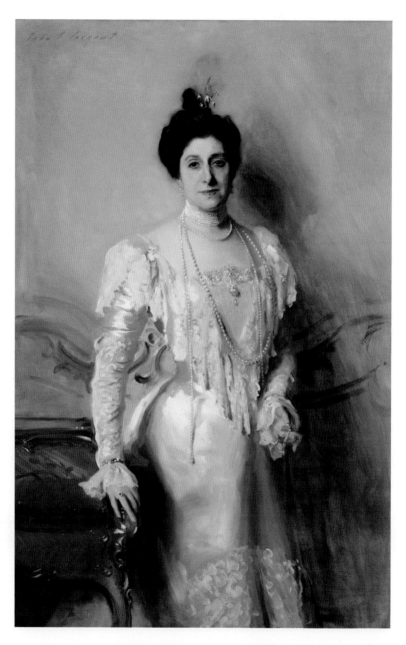

Mrs. Asher Wertheimer, 1898.
Oil on canvas. (The New Orleans Museum of Art: museum purchase in
memory of William H. Henderson, 78.3)

Mrs. Asher Wertheimer, 1904.
Oil on canvas. (Tate. Presented by the widow and family of Asher Wertheimer
in accordance with his wishes, 1922. Photograph: Tate)

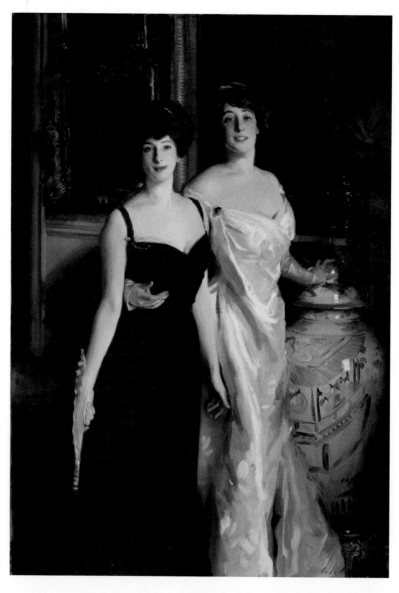

Ena and Betty, Daughters of Asher and Mrs. Wertheimer, 1901.
Oil on canvas. (Tate. Presented by the widow and family of Asher Wertheimer
in accordance with his wishes, 1922. Photograph: Tate)

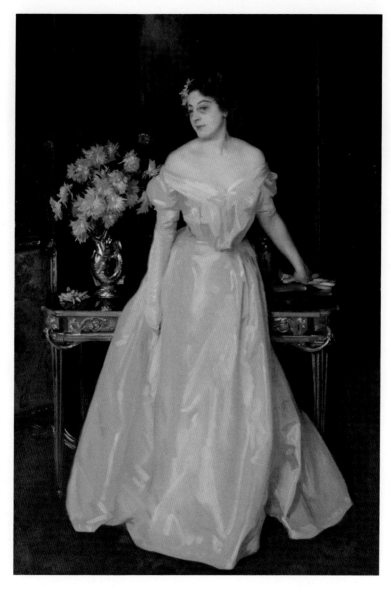

Hylda, Daughter of Asher and Mrs. Wertheimer, 1901.
Oil on canvas. (Tate. Presented by the widow and family of Asher Wertheimer
in accordance with his wishes, 1922. Photograph: Tate)

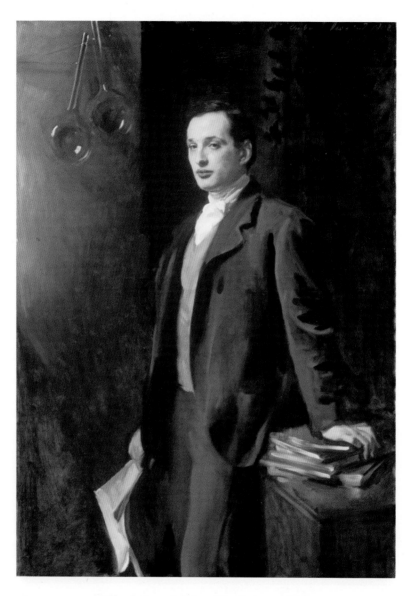

Alfred, Son of Asher Wertheimer, 1902.
Oil on canvas. (Tate. Presented by the widow and family of Asher Wertheimer
in accordance with his wishes, 1922. Photograph: Tate)

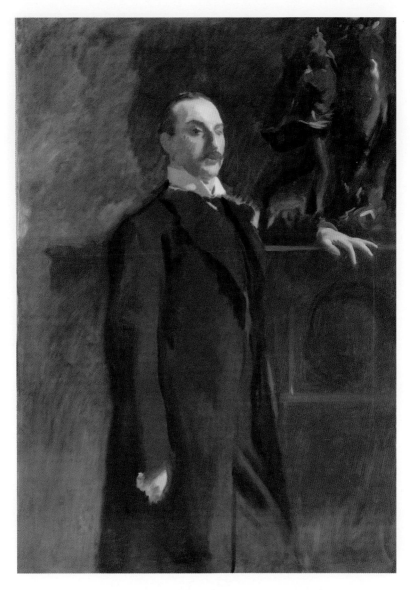

Edward, Son of Asher Wertheimer, 1902.
Oil on canvas (unfinished). (Tate. Presented by the widow and family of
Asher Wertheimer in accordance with his wishes, 1922. Photograph: Tate)

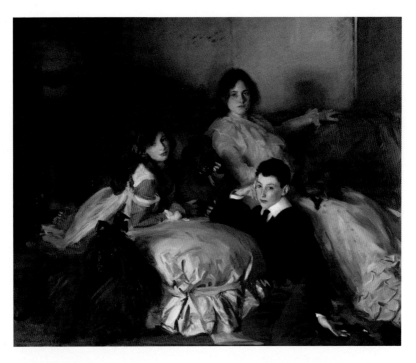

Essie, Ruby and Ferdinand, Children of Asher Wertheimer, 1902.
Oil on canvas. (Tate. Presented by the widow and family of Asher Wertheimer
in accordance with his wishes, 1922. Photograph: Tate)

shekels." Henry Adams, apparently thinking the artist had nailed his subject to a cross, told a friend: "Sargent has just completed another Jew, Wertheimer, a worse crucifixion than history tells us of."

Another Jew?

All his life Sargent was drawn to people and cultures other than his own. What fired his imagination was visual drama, which he found abroad in Spanish dancers, Breton oyster gatherers, Venetian bead stringers, Arab nomads. He also found it in Paris—Carolus-Duran, Dr. Pozzi, the Boit children, Madame Gautreau. In England—girls lighting paper lanterns in a garden, Ellen Terry as Lady Macbeth, the exquisite Lady Agnew. And he found it in Jews, many of whom became his good friends.

With the Wertheimer portraits, he was trying out painterly techniques, searching for the fresh visual language he wanted. A large Jewish family offered an attractively modern, dynamic subject—a rich opportunity to capture personal and social change. One critic noted that in this series the artist seemed "to be painting for his pleasure rather than to satisfy indignant relatives or committees."

Sargent also seemed to be painting for his own pleasure with his 1889 portrait of the singer Isidor George Henschel. Born in Breslau to Polish Jews, Henschel was also a pianist, composer, and the first conductor of the Boston Symphony Orchestra. His face, in Sargent's hands, appears to glow, lips on the verge of smiling, eyes turned upward as if toward a conductor or a choir of angels.

A visitor to the Tite Street studio one day pointed to a picture of a society hostess and asked the artist how he could paint like *that*, when (indicating *Henschel*) he could paint like *this*. Sargent replied simply, "I loved Henschel." When the musician's wife saw the picture she said, "How beautiful! It's George having arrived in heaven."

Two of Sargent's other early Jewish subjects were George Henry Lewis, the solicitor who had represented the Wertheimer brothers against Major Hope Johnstone after their bar brawl in 1870, and Lewis's second wife, Elizabeth. George Lewis had studied at University College London and joined the law firm founded by his father and uncle, Lewis & Lewis (the family name was originally Loew). According to a publication called *Celebrities at Home*, his "wide and accurate acquaintance with every phase of wickedness" made the name of his law office "a terror to malefactors."

Lewis defended Sargent after a bizarre incident in 1891 that, like the Wertheimer case, involved a physical fight. Sargent, an ardent amateur equestrian, one day rode his horse into a field of winter wheat in Gloucestershire, infuriating the farmer who owned the land. The painter apologized and offered to pay damages, to no avail. For two days he brooded over the episode, then went back to the property, challenged the man to a physical fight, and won. The farmer sued. Lewis negotiated a legal settlement that concluded with Sargent paying £50 ($250).

A few months later, the artist did a portrait of Lewis' wife, Elizabeth. Max Beerbohm said of her: "Good books, good plays, good pictures, and, above all, good music were for her no mere topics of conversation, but vital needs of her nature." Her father, the German businessman Ferdinand Eberstadt, had been the first Jewish mayor of Worms. One of her nephews, Otto Kahn, joined the New York investment firm Kuhn, Loeb, became a well-known patron of the arts, and is said to have been the model for the Monopoly board game's top-hatted "Rich Uncle Pennybags." Another nephew, Ferdinand Eberstadt, worked on Wall Street with Dillon, Read & Co., founded his own investment firm, and served as a significant policy adviser to the United States government. The Lewis house in Portland Place was a celebrated cultural salon.

The royal family conferred a knighthood on Lewis in 1892 and a baronetcy ten years later. Sargent painted *Sir George Lewis*, with

his graying muttonchops, a luxuriant fur collar, and a pearl tie pin, in 1896, and remained close to the couple for the rest of his life. He often spent New Year's Eve with them, did portraits of their grown children, and organized musical parties with Lady Lewis. Before one evening at Portland Place, he proposed to alternate the pianist, Adriano Ariani, with chamber players—"Otherwise I fear people will fidget at so much piano, especially as he displayed at his concert that tiresome trick of 'roaring' like an asthmatic horse at every climax."

Sargent's fine but unremarkable Lewis portraits did not arouse much comment on the sitters' ethnicity. Another 1896 picture—*Mrs. Carl Meyer and Her Children*—did. His Meyers, painted a year before the first two Wertheimers, and not unlike them, look Jewish—and rich. Carl Ferdinand Meyer, a German-born financier, worked with the London Rothschilds, the De Beers mining company, and the National Bank of Egypt. Mrs. Meyer, Adèle, was a society hostess and arts patron. In the portrait, precariously posed on a gilded Louis XV love seat, she wears ribbons, lace, and voluminous pink satin skirts. A rope of pearls circles her neck, tucks under a black sash at her waist, descends the length of her gown, and pools at her feet. Her right hand reaches back to her children, the boy in a velvet jacket, the girl in a cloud of translucent sleeves. Adèle's feet rest on a stool, yet she looks as if she might at any second slide off the sofa in all that slippery satin. A *Punch* cartoon has the children gripping her arm, crying, "Hold up, mother; it's only like the switchback!"

Seeing the Meyer painting at the Royal Academy in May 1897, one reviewer declared, "Never was construction stronger, light purer, life keener, unity more absolute, or execution franker than in this astonishing work." And Henry James applauded Sargent's "knock-down insolence of talent and truth of characterization . . . he expresses himself as no one else scarce begins to do in the language of the art he practices."

Yet even praise for this portrait underlines how alien and exotic Jews looked to Anglo-Americans. James went on to describe the Meyer children's "shy olive faces, Jewish to a quaint orientalism, faces quite to peep out of the lattice or the curtains of a closed seraglio or palanquin." Others skipped the praise and focused on the wealth. To *The Spectator*, "even Mr. Sargent's skill has not succeeded in making attractive these over-civilized European Orientals. We feel that these people must go to bed in satin and live upon ices and wafer biscuits." In Boston, where the painting was shown in 1899, a journalist ventured that "$10,000 was not much for a multi-millionaire Israelite to pay to secure social recognition for his family."

The journalist's calculation was high. At about this time, Sargent told Elizabeth Lewis that since he was "full" of commissions and hated to work under pressure, he was planning to charge one thousand guineas per portrait, "in order to have fewer to do." A guinea was worth a little more than a pound sterling, and in the late 1890s a thousand pounds equaled slightly less than five thousand dollars. Which suggests that the "multi-millionaire Israelite" paid about five thousand dollars in 1897, not twice that. In any case, Sargent's pricing strategy failed. His affluent clients were more than willing to pay. An undated Max Beerbohm cartoon shows the by-now portly artist peering out the window of his studio in alarm at a queue of fashionably dressed ladies, with uniformed bellhops holding places in line for more.

Flora Wertheimer, in the companion portrait to Asher's, wears an ivory gown with lace trim and important jewelry: diamonds in her ring, bracelets, earrings, and hair; a choker of pearls and another long strand that loops twice around her neck before one end gathers in her hand and the other falls past her hip. Sargent's lustrous pearls seem to *contain* light. Flora rests a hand on a Louis XV desk with ormolu mounts, probably supplied by her husband. A study

in tones and textures of white next to the rich darks of *Asher*, the picture lacks its pendant's vital force. Where Asher seems intensely alive, Flora looks beautiful but muted and still.

Critics admired the painting when it was shown at the Royal Academy in 1898, yet the Wertheimers had reservations. A descendant says Flora thought it made her look "too rich," although she had chosen (or agreed) to wear the lace and jewels. In the 1890s, before the development of cultivation techniques, natural pearls were extremely rare and expensive.*

Perhaps Flora minded the inevitable comparisons to the painting of Mrs. Carl Meyer, another wealthy Jewish woman in ropes of pearls. Or she and Asher may have thought Sargent had failed to capture her essence—that the picture was, as the illustrator W. Graham Robertson said about the portrait of his own mother, "a brilliant, superficial likeness." Whatever the reasons, Flora later gave this painting to one of her daughters; it was ultimately sold and now belongs to the New Orleans Museum of Art. Sargent painted Flora again six years later.

Had the artist praised for his "sensory revelation of character" depicted Asher as "too Jewish" and the 1898 Flora as "too rich"? Asher's wet red lips and the lolling tongue of his dog could summon the trope of carnal appetite long attributed to "the Jew." Flora's luxe accoutrements could read as Jewish excess, as did the size of the Wertheimer commission.

If Sargent, consciously or not, shared the reflex anti-Semitism evident on both sides of the Atlantic, it appears to have been min-

* As an illustration of how dramatically values change over time, the jeweler Cartier in 1917 traded a double-stranded Oriental pearl necklace for the mansion at Fifty-second Street and Fifth Avenue that has been the firm's headquarters ever since. Both house and necklace were then valued at $1.2 million. Cultured pearls arrived on the market in 1921, and the necklace eventually sold for $180,000. The Cartier building, renovated and expanded in 2016 on a prime spot in one of the world's costliest cities, had a market value of about $122 million in 2022–23.

imal. He asked Asher to lend his portrait to the American section of the 1900 world's fair (Exposition Universelle) in Paris, and wrote in thanks: "The number of pictures that one can show is so limited by the small space that the French have granted to other nations that unless an artist can show his best work he might as well not be represented at all. Your consent makes me feel very much happier about the whole thing."

The other "best works" he showed were *Mrs. Carl Meyer and Her Children* and a portrait of M. Carey Thomas, the president of Bryn Mawr College.* Presenting two paintings of Jews at the height of France's bitterly contentious Dreyfus affair may have signaled Sargent's alliance with supporters of the Alsatian Jewish military officer who had been falsely convicted of treason and imprisoned in 1894. Captain Alfred Dreyfus was tried and sentenced again in 1899 despite new exonerating evidence. With foreign newspapers urging their countries to boycott the world's fair, the president of France pardoned Dreyfus, but not until 1906 did intense political pressure bring about the prisoner's release and full acquittal. He was eventually reinstated in the French army, where he served throughout the First World War.

In some London circles Sargent came to be known as a painter of Jews. A poet who saw the artist's portrait of Lady Sassoon, the former Aline de Rothschild, at the Royal Academy in 1907, told a companion: "He paints nothing but Jews and Jewesses now and says he prefers them, as they have more life and movement than our English women."

* In 2001, the Montclair Art Museum in New Jersey mounted a centenary reprise of the American section from the 1900 Exposition in 2001. The show traveled to the Musée Carnavalet in Paris, where an American journalist noted that as of 1900 it would be another fifty years before the United States established itself as the world center of contemporary art. "The unexpected near future," she wrote, "lay in the Spanish pavilion of the 1900 fair where a young painter in a new black corduroy suit on his first visit to Paris came to see his 'Last Moments,' a gloomy work hung far too high. No one noticed, but Pablo Picasso had come to town."

Cynics said Sargent painted Jews for financial reasons, although by the late 1890s he had more commissions than he wanted, with up to three sittings a day, and was trying to cut back.

In all, he did about 630 oil portraits and 700 charcoal portrait drawings. Roughly 70 of the sitters in those 1,330 images were Jewish—around 5 percent, not a high proportion. And he did several of the Wertheimers, Lewises, and Sassoons more than once, which further reduces the percentage. Still, that the leading chronicler of transatlantic high society chose to portray Jews was sufficiently striking to elicit comment. (For a list of Sargent's Jewish sitters, see Supplement A.)

Another line of Sargent criticism pointed to the commercial nature of portraiture, arguing that an artist paid to render people's likenesses has to please them rather than answer purely to his own imagination. Portrait painters, in this view, are merely hired hands. Yet Sargent often did not please his subjects.

W. Graham Robertson quoted "a timid aspirant" saying, "It is positively dangerous to sit to Sargent. It's taking your face in your hands." Clearly "Madame X" found it dangerous. Isabella Stewart Gardner kept her unflattering portrait in a private room. Another Sargent friend, the actor and stage manager Henry Irving, destroyed his with a knife. Alice Mason, an American expatriate who said the artist made her look like a murderess, also took knife to canvas, altering the mouth. Mary Cassatt declared his painting of her brother "dreadful." And the Wertheimers were not satisfied with the 1898 Flora.

Sir George Sitwell, a wealthy Conservative MP who commissioned a family portrait, complained that Sargent refused to take direction and would only suit himself. Sitwell tried constantly to interfere, demanding, among other things, a realistic rendering of

his thirteen-year-old daughter's crooked nose—a cruelty the artist ignored, instead making the paternal nose crooked and Edith, the pale, awkward girl in a scarlet dress, the most interesting person in his *Sitwell Family*, which she was. Unfortunately for Sir George, all three of his children grew up to be writers. Osbert, the middle son, reported that his father loved the painting despite Sargent's defiance since it depicted the family as rich. Edith mocked the elaborate deceptions both her parents staged for the portrait and declared herself "white with fury and contempt, and indignant that my father held me in what he thought was a tender paternal embrace." Reviewers compared the painting unfavorably with *Ena and Betty Wertheimer* at the Royal Academy in 1901: chilly aristocratic marionettes vs. exuberant life forces.

As Sargent was finishing his 1907 portrait of Lady Sassoon, some of her relatives came to see it in his studio. The next sitter to arrive found him irate. "It seems," he fumed, "there is a little something wrong with the mouth! A portrait is a painting with a little something wrong about the mouth!" He joked about the incident for the rest of his life, once telling Lady Lewis, "When you came yesterday I was in the most crucial moment of a sitting, doing the tiny little something not quite right about the mouth—and could not even run down to thank you for the books."

Other sitters applauded his penetrating gaze. In *Robert Louis Stevenson and His Wife*, the consumptive writer looks like a giant vertical spider, pacing, nervously tweaking his mustache, separated by a dark open doorway from Mrs. S., who reclines on a sofa dressed as an Indian princess and practically falls out of the picture. She told her mother-in-law: "Anybody may have a 'portrait of a gentleman' but nobody ever had one like this. It is like an open box of jewels."

Sargent's childhood friend Vernon Lee described sitting for a portrait in a single three-hour session, the artist "talking the whole time and strumming the piano between whiles . . . The sketch is,

by everyone's admission, extraordinarily clever & characteristic . . . considerably caricatured, but certainly more like me than I expected anything could [be]—rather fierce and cantankerous."

With many of his sitters—among them friends such as Lee, Stevenson, and Asher Wertheimer, and also theatrical dandies, a Spanish dancer, a "professional beauty," attenuated aristocrats—Sargent took elements of caricature beyond stereotype to essence, giving the images indelible accuracy and force.

The art historian Trevor Fairbrother observes that in *Asher Wertheimer* the artist did not "hedge his attraction to the personality"— and that the sitter's "Jewishness, masculine self-confidence, entrepreneurial power, and sensuousness all radiate from the picture." Although that vivid "Jewishness" set off alarms, Sargent also did not "hide his fascination with Wertheimer's barreling, rather sexy swagger, which argues for an admiring response rather than a cruel caricature." The warmth and respect in Asher's eyes "testify to deep trust and firm friendship," Fairbrother concludes: "Moreover, the depiction of the smiling black poodle Noble—the happiest pet in all of Sargent—is too improbable to be anything other than the most felicitous sign."

Jews in Victorian and Edwardian England, regardless of their professional success, would never be considered "one of us," not even when they regarded themselves as thoroughly British. The historian Peter Stansky gives a wry twist to Eugene Black's line about assimilating Jews, describing Philip Sassoon as "an Englishman of the Jewish persuasion (no matter how comparatively unpersuaded he might be)."

In light of the aspirations of many English Jews, it may seem surprising that Asher did not object to Sargent's depiction of him. On the contrary, he commissioned ten more family portraits and visited the artist in his studio most Sundays for the rest of his life. An authority on Rembrandt, to whose great, unsparing portraits his own was often compared, Asher embraced Sargent's rendering

in full, claiming at once a place in the history of art, an alignment with patrician British culture, and his specific ethnic identity, as if saying, proudly, "This is who I am."

Like his Jewish friends, Sargent would never be fully "one of us" in England, although aristocrats lined up to pose for him and the nation claimed his work for its premier national collections. To Americans he seemed British, to Britons, American. Henry James once said he aspired to write in such a way that it would be impossible for a stranger to tell whether he was an American writing about England or an Englishman writing about America—and that he was proud of the ambiguity. Sargent, who had told Whistler, "I keep my [American] twang," had a similarly mid-Atlantic identity.

He never married, and there is no evidence of his having sexual relationships with either women or men. Like James, he appears to have been primarily attracted to men—not that such inclinations would have been a bar to social acceptance in England. Yet homosexual acts, defined as "gross indecency" under English law in 1885, were punishable by two years in prison with or without hard labor. When they led to public scandal, as they did for Oscar Wilde in 1895, the doors to many closets shut tight.

Sargent moved in a range of social circles, and a number of his friends, acquaintances, and sitters were quietly or overtly homosexual.* His many paintings and drawings of male nudes were rarely seen during his lifetime. The most spectacular is *Nude Study of Thomas E. McKeller,* an oil portrait of a young Black man who worked as an elevator operator at Boston's Hotel Vendôme, where Sargent stayed for most of 1916–1918. McKeller became one of his

* Among them Wilde, James, Philip Sassoon, W. Graham Robertson, Robert Ross, Montesquiou, Edmond de Polignac, Léon Delafosse, Percy Grainger. Also Vernon Lee, Clementina Anstruther-Thomson, Mabel Batten, Radclyffe Hall, Ethel Smyth.

principal models, posing for nearly all the classical male figures and some of the females in the murals he was painting for the Boston Public Library.

In the portrait, McKeller half kneels on a cushioned bench, legs apart, genitals conspicuous, head tilted back. His hands grip the edge of the bench, arching his muscular torso and neck. Sargent kept the painting in his Boston studio. It changed hands several times after his death, held briefly by the artist William ("Billy") James, Jr., a son of the philosopher and psychologist. Charles Merrill Mount published a small black-and-white photograph of it in his 1955 biography *John Singer Sargent*. The Boston Museum of Fine Arts acquired the painting in 1986 through the efforts of Trevor Fairbrother. Since then it has been on view at the MFA, occasionally loaned to other institutions, and was the subject of a 2020 exhibition at the Isabella Stewart Gardner Museum called *Boston's Apollo*.

The female body has always been essential to art, yet Sargent left no trove of female nudes, and nothing like the full-frontal audacity of *Thomas McKeller*. In Cairo in 1891 he painted a nude Egyptian girl viewed from behind, her muscular legs taut, upper body twisted to partial profile as she braids her long hair. A French critic pronounced her limbs marvels of "sinewy slenderness. A study by a master, a study by a prince of form and modelling." Sargent showed the picture widely and ultimately gave it to his American friend Charles Deering.

The nature of his sexuality has been a subject of speculation for more than a century. After Sargent died, the art critic Clive Bell reported that the hostess of a London lunch party proposed that the artist had had no sex life. To which the French painter Jacques-Émile Blanche—married, closeted, a fount of envy and unreliable gossip—responded that Sargent's sexual activity had been "notorious in Paris, and in Venice positively scandalous. He was a frenzied bugger."

Bernard Berenson mused about Sargent years later: "As a man he was good company, although not overexpressive. A musician, a great and selective reader, an appreciator, a loyal friend. Was he a lover of women?"

In one version of a story regarding Sargent's friendship with the Wertheimers, someone asks Flora if she worries about her daughters spending so much time with him. She replies, "Of course not: he's only interested in Venetian gondoliers." If that was indeed the family's tolerant attitude—whether or not the story is true—it would have enhanced the ease Sargent found in their company. Reticent and shy even among friends, he was markedly disinclined to portray or reveal himself. He once wrote to Vernon Lee, "O for Henry James' faculty of saying something so cautiously that you only know what he meant the next day."

James and Sargent both drew indelible portraits of women in the years around the turn of the twentieth century. A James acquaintance noted that the novelist "seemed to look at women rather as women looked at them. Women look at women as persons; men look at them as women. The quality of sex in women, which is their first and chief attraction to most men, was not their chief attraction to James." Nor was it to Sargent.

The artist's frequent visits to Connaught Place had partly to do with his love of good food, which the Wertheimers' cooks provided in abundance. He also spent weekends with the family in the country near the village of Bisham, in Berkshire on the Thames. The large house on the property, called Temple, had been built in the late eighteenth century by a Welsh copper baron, from whose grandson Asher began renting it in 1897.

Sargent accepted a weekend invitation from Ena in 1899 "with pleasure," saying, "I will come by some late afternoon train and

will bring a lot of music with which to make night hideous." He declined another with decorous self-mockery, explaining to Flora that although it had come "in Miss Ena's best handwriting," he had sworn to spend "no more week ends this season in lovely country houses":

> By the time Saturday comes the only thing I feel inclined for is a quiet evening of God and man in an empty house. In my present state of mind induced by too much portrait painting I feel as much inclined to visit a West Indian island during an eruption as to accept invitations for Saturday till Monday, and I am not a desirable guest. I wish I was in a fitter condition for enjoying your kind hospitality and the joie de vivre of your young folk.

Always generous to other artists, he introduced several to his own patrons, and felt free enough with the Wertheimers to propose weekend guests. One spring he sent Asher a note about Léon Delafosse, a young French pianist and composer who was in London to perform—"a very clever little man and a first rate musician, who I foresee will commit suicide on Whitsunday unless he can spend it in the country. Might he have the pleasure of spending the day of Sunday at your place, coming back in the evening? It would be doing him a kindness and I should be grateful to you." Sargent himself would be joining the family that Friday, and concluded his note to Asher: "if you are as usual hospitably inclined, I can give him your message—with instructions how to get there." He had painted a half-length portrait of the delicately beautiful Delafosse, who shared his enthusiasm for the music of Gabriel Fauré and knew both Proust and Montesquiou in Paris.

Sargent also brought into the Wertheimer circle an Italian painter he met in Paris named Antonio Mancini. A photograph from the summer of 1901 shows the two artists paused during a

game of croquet on the lawn at Temple with Asher and Edward Wertheimer. Mancini, who spoke little English, was emotionally volatile, chronically insolvent, and periodically hospitalized with mental breakdowns. He described himself as *un povero matto*— a poor madman—and as "knocked about by the twists and turns in my brain." Sargent painted a blurry watercolor of Mancini resting his head against Ena's shoulder, inscribed "Souvenir of Temple, JSS," and also a quick bust-length oil sketch on which its subject wrote in Italian: "Mancini reverently thanks Mr. Sargent who is so good to the bad painter Manciney [*sic*] London."

That summer Mancini did a painting of Flora at Temple "among multitudes of Israelites," he told a friend, as well as a portrait of the youngest Wertheimer daughter, Ruby, and a pastel of Ena. He used a *graticola* or perspective grid, often leaving crisscross patterns in his thick impasto, and mixed glass shards or foil into the paint for luminescence. Other Sargent friends who bought or commissioned Mancini's work included Ralph Curtis, Isabella Stewart Gardner, Mrs. Leopold Hirsch, Mary (Mrs. Charles) Hunter, and Sir Hugh Lane.

Sargent sent Mancini's portrait of Mary Hunter to Asher "to be framed and shown to people" in Bond Street, and Mancini submitted it, along with his paintings of Charles Hunter, Flora Wertheimer, and a young boy, to the Royal Academy for its 1902 summer exhibition. He gave his address as 33 Tite Street—Sargent's studio. The academy accepted the Mary Hunter portrait but turned the others down, which sent Mancini into a rage. Sargent gave him the name of an agent to pick up the paintings—"Show him my business card"—and tried to talk him out of reworking the excluded pictures: "Remember that this affair means nothing," he went on in French. "The Hunters and Mr. Wertheimer are too intelligent to imagine that their paintings are dishonored by such a rejection. By revising the portraits, you would seem to be justifying that stupid decision. It would be better to laugh!"

Incapable of laughing at rejection, Mancini thought his strongest supporter, whose eight submissions for 1902 *were* accepted, ought to have protected him. Sargent eventually drew back from this difficult friendship but continued to help Mancini professionally and with more practical matters. He wrote to Ena one evening:

> You will be seeing Mancini before Monday, I suppose—Do bring up the subject of evening clothes. This dinner of Monday with the Italian ambassador is a very formal affair—& I was told that [Mancini] has lost his dress clothes. He *must*, at Covent Garden or elsewhere, fit himself out or he will be wondered at by his compatriots. Ask Downes [Asher's butler] to lend him his third best.

Another artist was less kind. William Rothenstein regaled a dinner party in 1902 with "amusing and malicious gossip," according to the evening's host:

> It seems Sargent . . . recommends to his sitters the abominable work of an Italian named Mancini, who plasters his paint on by the inch and has the taste of a *commis-voyageur* [traveling salesman]. Sargent gave this protagonist in paint a sketch by himself . . . Mancini gave it to a really great artist, Wertheimer's French cook; the cook in turn gave it to young Wertheimer, who gave it to his father, who in turn gave it back to Sargent.

Mancini's sense of grievance cannot have been assuaged by Sargent's showing at the academy that year, which included *The Duchess of Portland, Lord Ribblesdale, The Misses Hunter* (Mary Hunter's daughters), *The Ladies Alexandra, Mary and Theo Acheson*—and *Alfred Wertheimer*. It was, observes the art historian Elizabeth Prettejohn, the artist's "most spectacular collection

of aristocrats at a single exhibition. From this date, his reputation as the painter *par excellence* of the British aristocracy was unassailable, for better or worse."

Rodin, on seeing *The Misses Hunter* at the academy, pronounced Sargent "the van Dyck of our time."

‿

Not all the artists Sargent introduced to the Wertheimers were in need of rescue. He sent Ena to call on Rodin in Paris. And one night he brought Monet to dinner.

Between 1899 and 1901, Monet was working on a series of paintings of the Houses of Parliament from a single vantage point across the Thames. He stayed at the Savoy Hotel and dined regularly with Sargent at the Café Royal. The two went to London galleries and exhibitions; one of them, organized by Durand-Ruel, included nine Monets. Sargent's friend Wilfrid de Glehn recalled a day he and Monet spent at the Tite Street studio, their host providing lunch and dinner. Later, de Glehn told Sargent of his surprise that the French artist had barely looked at a couple of the Wertheimer portraits. Sargent replied, "But he hates this sort of painting."

He took Monet to watch Queen Victoria's funeral procession from a private house facing Buckingham Palace on February 2, 1901. Thrilled by the spectacle, Monet reported in French to his wife, Alice: "There were a hundred people in the house . . . with superb weather, a light fog in half-sun, and in the background, St. James's Park. What a crowd! I wish I could have made a sketch of it." One of the people he met was "a great American writer, living entirely in England, speaking French admirably, who was completely charming to me, explaining everything, pointing out all the important people of the Court, etc. (his name is Henry James). Sargent says he is the greatest writer in English."

Entranced with London's fog-diffused light and hectic activity,

especially after dark, Monet wanted to find a space from which to paint these "marvelous night effects." He turned for help to Sargent, who turned to Asher. Monet told his wife that he and Sargent were about to dine at the Wertheimer house, and "I'm certain of having a splendid place within a week."

The dinner took place on Sunday, February 24. Monet described the evening:

> The house is indeed quite extraordinary, a palace with some very beautiful things and a quite distinctive society, nothing but Jews [*rien que des Juifs*], or almost, an infernal din and very relaxed manners despite a high degree of elegance, ten children, five daughters, three of them married and several quite beautiful; dinner lavish and quite good. The sons took electrical photographs, and I had to pose with Sargent and another painter and then by myself. I should be getting proofs with a special apparatus for looking at them, because they are very different from other photographs, in a way that is at times terrifying. As Sargent and I were leaving, they sat down to play games. It's a really extravagant, crazy place; the father and mother are good people.*

Sargent and Asher arranged for Monet to work in a room at the New Lyric Club in Coventry Street, with a window looking out on Leicester Square. He found the club "very noisy, as its name suggests," the room too small ("the size of a hand") and dirty, but its "superb" vantage point made up for the drawbacks. From this

* There were six daughters, and only Betty was married in 1901. Ruby, the youngest, may not have been present. Regarding the photographs: Sargent and his friends took hundreds of pictures with stereoscopes, which made two images of an object from slightly different angles, reproducing binocular vision and requiring a special apparatus for viewing; there was no electricity involved.

improvised atelier, working only on nights when there was fog—
during the days he continued his work on the Thames series—
Monet painted three sketches (*pochades*) of Leicester Square at
night (now privately owned, one on long-term loan to the Granet
Museum in Aix-en-Provence).

ᖆ

Frank Rutter, appointed art critic for *The Sunday Times* in 1903,
met Asher a few years earlier while he was working as a journalist
for British and American publications. His American editor asked
him to ingratiate himself with the "Big Men" in Bond Street in
order to ferret out news about upcoming art sales, negotiations,
and prices. At his first interview with Asher, Rutter recalled, the
dealer said "with perfect courtesy that he had nothing to tell me
for publication, but that if I was really interested in art, he would
be pleased to show me a few things, only I must promise not to
write about them." Recognizing the need for confidentiality in the
art market, Rutter promised. He went on:

> When Mr. Wertheimer found out that I could be trusted
> not to blab, he expanded and became much more commu-
> nicative, showing me a number of precious things which
> otherwise I should have had no chance of seeing. What I
> admired so much about Asher Wertheimer was that he was
> never a worshipper of mere names, it was "quality" in the
> painting that he sought, whoever it was by, and he was as
> keenly appreciative of good work by an almost unknown
> painter as he could be severely critical of an inferior work
> by a famous master.

Not surprisingly, Rutter lost his job as London correspondent
for the American paper. When he told Asher this news, the dealer

"twinkled," sat his young friend down, gave him "one of his fa-
mous cigars," and said, "Never mind, Mr. Rutter: you'll always be
a bad journalist. You're too scrupulous. You'd much better stick to
criticism."

As one of the "New Art Critics" interested in Impressionism,
Rutter was appalled at Britain's "antediluvian hostility" to the
movement he regarded as the most important in contemporary
painting. When Durand-Ruel opened a new exhibition of Impres-
sionists in London in 1905, Rutter organized a "French Impression-
ist Fund" to buy paintings for the National Gallery. He posted a
subscription notice in *The Sunday Times*. Sargent and Asher Wert-
heimer were among the first subscribers, for ten guineas each.

The appeal raised £160. Rutter arranged to buy Monet's
Vétheuil: Sunshine and Snow (later called *Lavacourt under Snow*)
from Durand-Ruel at that price. A member of the Impressionist
Fund's executive committee stopped the sale, however, claiming
that the National Gallery did not accept work by living artists—the
widely held misconception that surfaced again regarding Asher's
gift of Sargent portraits. The names Manet, Pissarro, and Sisley
came up next—"all safely dead," recalled Rutter, yet not "dead long
enough for England": National Gallery trustees found these artists
too "advanced." The fund finally settled on *The Entrance to Trou-
ville Harbour,* by Eugène Boudin. Rutter protested that Boudin was
not an Impressionist, but bought the picture anyway and presented
it to the gallery in 1906.

He later left a vivid tribute to his early tutor in the art world.
"What Asher Wertheimer was, anybody may see by looking at
Sargent's masterpiece in the National Gallery," Rutter wrote.

> Cigar in right hand, left thumb in trouser-pocket, an enig-
> matic smile on his lips, an inscrutable twinkle in his eye,
> there he stands for all time with his poodle by his side; the
> great Jew, the generous Jew, proud of his race, proud of his

family, confident of his taste, satisfied with his judgment, but so full of learning that he can still be amused at the notion that anyone could suppose he had arrived at a finality of knowledge on any subject. He is a great expert, but he is a good fellow, human, kindly and humorous.

Nest of Vipers

A collection of paintings Asher Wertheimer bought in 1898—the year his and Flora's Sargent portraits first appeared at the Royal Academy—proved to be his greatest acquisition.

The eighty-three Dutch and Flemish paintings had belonged to a family named Hope, wealthy Scottish bankers and traders who were living in Amsterdam when the Dutch Republic was the financial and cultural capital of Europe. The most powerful merchant bank in the Netherlands, Hope & Co. helped finance the Dutch East India Company and the Seven Years' War, and worked closely with Barings Bank in London. The two firms funded America's purchase of the Louisiana Territory from France in 1803.

Generations of Hopes collected an extraordinary range of fine and decorative arts. The family moved from Amsterdam to England ahead of Napoleon's armies at the end of the eighteenth century and continued to collect, often buying from aristocrats who had not managed to ride out the recent hurricanes of political upheaval.

Thomas Hope, a grandson of the bank's founder, was an architect, artist, writer, collector, and imaginative patron. He designed his houses in London and Surrey for the display of art, and took

the unusual step of admitting visitors in 1804. There was as yet no formal exhibition space in Britain; the first public facility for viewing art, the Dulwich Picture Gallery, opened in South London in 1817, followed by the National Gallery in Trafalgar Square twenty years later.

After Thomas Hope died, in 1831, the family collections remained essentially intact for six decades. Then one of his great-grandsons, who had inherited a life interest in the art, decided to sell. Henry Francis Hope Pelham-Clinton-Hope, known as Lord Francis, had run up huge debts. He lent the eighty-three Dutch and Flemish paintings, considered the most important of the Hope holdings, to London's South Kensington Museum (now the Victoria and Albert) in 1891, presumably aiming to attract buyers. The museum exhibited the pictures and published a catalogue that year.

If the loan was a promotional tactic, it worked. Asher Wertheimer offered £80,000 (about $400,000) for the paintings in 1893. Lord Francis did not own them outright, however, only for his lifetime. To sell, he needed permission from the Court of Chancery, which has authority over civil disputes concerning property, land, bankruptcy, taxes, and wills, and which refused to approve this sale.

Five years later, Lord Francis had gone bankrupt and the court relented. This time, Asher offered £110,000 (about $550,000). Another "gentleman" offered £111,000. The presiding justice, saying he did not think the Chancery Court ought to be turned into an auction room, announced that he would hold the £111,000 bid open for twenty-four hours and then accept the highest offer over that amount. The next day, July 26, 1898, Asher bid and paid £121,550 for the eighty-three paintings, which included works by Rembrandt, Vermeer, Van Dyck, and Rubens, among many others.

The price, about $600,000 in 1898, would be almost $22 million in today's dollars. Some of these paintings, now in public and private collections on both sides of the Atlantic, might sell for more

than $22 million individually today.* Asher published a new catalogue with sepia-tone photographs, descriptions reprinted from the 1891 volume, and a brief history of the collection that concludes with his own purchase. He gave copies to collectors, dealers, and friends.†

And from the outset there was trouble. In the seventeen years since Samson's triumph at the Hamilton Palace sale, an exuberant art market had intensified competition among dealers and opened up new fields of expertise. Scholars had begun to catalogue works by major painters and to formulate standards for authentication. The opinion of an expert could increase or reduce the commercial value of a painting, and an authority working with a dealer might not be above "inflating" attributions.

Another contender for the Hope pictures had been the firm P. & D. Colnaghi, a distinguished seller of fine prints now aggressively seeking access to the Old Master trade, although its efforts with Lord Francis Hope had failed. Once Asher succeeded, he gave Colnaghi a share of his deal, probably to help place such a large number of works. There appears to have been no agreement in advance as to the mechanics of this arrangement, including how the paintings were to be apportioned and sold, where they would be physically held, or how profits would be divided. Colnaghi put up about a fourth of the purchase price and immediately began offering the best pictures to its own clients.

Two of the principal actors in this drama were the Colnaghi

* The following pictures are not from the Hope collection: A Rembrandt (Portrait of a Man with Arms Akimbo) sold for more than $33 million in 2009. Vermeer's exceedingly rare paintings hardly ever come on the market—by most counts only about thirty-six survive; his Young Woman Seated at a Virginal sold in 2004 for $30 million. A large Rubens (Massacre of the Innocents) went for $75 million in 2002.
† In 1901 Lord Francis sold the famed Hope Diamond for £120,000—about what Asher had paid for eighty-three paintings. The largest known deep-blue diamond in the world, it is now at the Smithsonian Museum of Natural History in Washington, DC. Estimates of its current value range from $200 to $350 million.

partner Otto Gutekunst and the American "expertiser" (his own term) Bernard Berenson.

Berenson, born Bernhard Valvrojenski in a Lithuanian shtetl, had emigrated to Boston with his family at age ten in 1875. His father changed the family surname. An excellent student, the young man spent a year at Boston University, then transferred to Harvard, where he studied art history. When Harvard rejected him for a traveling fellowship, he secured the backing of wealthy Bostonians and went to Europe on his own. His chief patron was Sargent's friend Isabella Stewart Gardner.

Otto Gutekunst, the son of a Stuttgart auctioneer (the name means "good art"), divided paintings into two categories—"angel food and *big*, BIG, *BIG* game." The Hope collection brought *BIG* game into his sights, and he did not intend to waste the opportunity. But he had a problem. Mrs. Gardner had worked with Colnaghi in the past and refused to have anything more to do with the firm, citing its high prices and failure to follow her shipping instructions. "She hates us," Gutekunst told Berenson. "I hate Colnaghi," she confirmed.

The combination of Berenson's intelligence, discerning eye, and above all access to Mrs. Gardner's bank accounts made him a valuable asset for Colnaghi, and Gutekunst took the younger man under his wing. BB, as he was called, specialized in art of the Italian Renaissance. Gutekunst assured him, "For Dutch you can at any time take my word, old boy"—and he whispered: "*Neither you nor we have ever had such a windfall as Mrs. G. before, nor shall we ever in our lives have another.*"

Three days after Asher acquired the Hope paintings in 1898, Gutekunst told Berenson to offer Mrs. Gardner the "gems" of the collection—two Rembrandts and a ter Borch—for £30,000 ($150,000). The Rembrandts were *A Lady and Gentleman in Black* and *Christ in the Storm on the Sea of Galilee*—for £13,000

and £6,000, respectively—and ter Borch's *The Music Lesson* for £11,000. Since Gutekunst had to deal with this coveted client indirectly, he scripted the proceedings for his confederate: "and then when you get photos write [to her] again & say, 'look what a brick I am!'"

He urged BB to act quickly, claiming, "We have already sold £50,000 worth of the Hope lot"—which was not true—and that two other people wanted the Rembrandts, "but I will . . . make it clear to [Wertheimer] that they are under offer till we write and tell him it's off."

Hold on: Wertheimer had purchased these paintings; it was his deal.

Berenson improved on Gutekunst's scheme. Although he had only just been asked to help sell Hope pictures, he told Mrs. Gardner he had been working night and day for months to be able to offer her the collection's "jewels." He brazenly crowed, "At last I have triumphed," and proposed that she buy "two of the finest Rembrandts and perhaps the very best ter Borch in the world." To force her hand, he went on, "As there are at least six buyers waiting for these same pictures, you can imagine my difficulties, and my rejoicing." (Gutekunst had just told him there were two other buyers, and even those may have been fictional.)

When BB sent Mrs. Gardner photographs and detailed descriptions of the paintings, he quoted the prices Gutekunst had named (a total of £30,000) and asked her to telegraph her decision. She hesitated. He told her the "owners" of the pictures (would that be Asher?) were now demanding an additional £3,000, but that he had fought to keep the offer at £30,000 for her. And he added more self-aggrandizing lies: "I had better remind you that . . . I had the greatest difficulty in getting those three particular pictures . . . to offer you. It took all my persuasions, all my threats, and all my influence. You see when a collection of that sort has been rifled by

a person with such authority as I happen to have, the other pictures sink lamentably in value."

G~

While Gutekunst worked through Berenson on "Mrs. G.," another Colnaghi partner was offering more of "the finest and most important" Hope paintings to a leading authority on art in Berlin. Dr. Wilhelm Bode was in the process of assembling major national collections for Germany—he was director of Berlin's Gemäldegalerie (Picture Gallery) and founded the Kaiser Friedrich Museum there in 1904. He worked closely with collectors and dealers, all of whom relied on him for invaluable authentication. Dealers, especially eager to please him since he could send clients and artworks their way, offered him first choice of treasures at reduced prices. He published an eight-volume *Complete Work of Rembrandt* with C. Hofstede de Groot between 1897 and 1906.

The Wertheimers had worked with Dr. Bode since the 1880s. Asher wrote to him from Dresden in 1890 to say that he was bringing his family to Berlin expressly to look at art, and requested help getting to see "the famous Watteaus" in the Charlottenburg Palace, "which I believe are otherwise inaccessible." Also, he wanted to offer Bode first refusal on a "very fine Rembrandt" his firm had recently acquired. Bode did not buy the 1632 painting (*Man in a Turban*, which the Wertheimers sold to William K. Vanderbilt in New York), but his Rembrandt catalogue describes it as "one of the most magnificent" of its series. The artist had depicted figures in Orientalizing costumes throughout the 1630s and early 1640s.

Asher could have dealt directly with Bode for the Hope pictures had the Colnaghi partners not kept cutting him out. When Bode told Colnaghi's William McKay which three Hope paintings he wanted for his gallery—including Vermeer's *The Glass of Wine*—McKay replied that he had "fought Wertheimer to retain" these

works and "had much difficulty in restraining him." Offering Bode a fourth Hope picture as well, at a reduced price—Adriaen van de Velde's *The Farm*—McKay asked for a firm commitment immediately, since the transaction "would appear doubtful to Wertheimer." He concluded, "In any case you are secure through us."

The transaction did appear doubtful to Wertheimer, who had offered the van de Velde to one of his own clients at the full price and was sure it would be accepted. Out of town that August, Asher wired McKay to hold off. McKay replied, "In spite of your telegram I have sold the van de Velde for £4000 to Berlin."

"Wertheimer is mightily angry at our action with regard to this picture," reported another Colnaghi partner to Bode, "and I am sorry to say will hold us to his own price . . . He has begged us not to deal with any more pictures until his return early in September."

The difficulty with the collection was that it had, in addition to masterpieces, many less important pictures that would be difficult to place. To Asher, McKay justified his defiance because Bode could help find buyers for "the minor stars." A fair point, yet it did not justify elbowing Wertheimer aside. McKay was ingratiating his own firm with the master in Berlin at Asher's expense, telling Bode, *"In any case you are secure through us."*

Asher was not the only party injured by Colnaghi's bare-knuckle tactics. Britain was another. After selling a Rembrandt from the Ashburnham collection to Berlin in 1894 (*The Mennonite Preacher Anslo and His Wife*), McKay told Bode, "I suppose we shall annoy our National Gallery." Still, he wanted it widely known that Colnaghi had handled the sale: "from a business point of view this would benefit us greatly."

Even the genteel, widely respected Thomas Agnew & Sons, Bond Street's preeminent dealer in fine art, was not above pressing Bode for favorable attributions. In 1901, Lockett Agnew wrote to him about a painting he had acquired as a Rembrandt—*A Mathematician and a Scholar*—for nearly ten thousand pounds. It had

recently been cleaned, and Lockett thought it now "very fine," although he knew Bode had questions. He pressed: to "throw a doubt (which your great knowledge and position would accentuate) upon the picture would be a very serious matter for me." Was it not "on its merits worthy to be inserted in your book [*Complete Work*] as a Rembrandt?" And, "although you have a doubt, may I not ask you to waive this doubt?"

Bode neither waived his doubt nor included the painting in his catalogue. Now considered "school of" Rembrandt, it has been at Chequers in Aylesbury, the country residence of Britain's prime ministers, since 1917.

⁓

While McKay was cultivating Dr. Bode, the negotiations with Mrs. Gardner in Boston were blowing up. Her husband, John L. ("Jack") Gardner, thought Berenson was not only shamelessly flattering Isabella but also boosting attributions, prices, and his own importance, all of which was true. Still, Jack Gardner agreed to lend his wife the money to buy the Hope pictures, and she cabled Berenson that she would take all three.

The next day, however, she wrote to Berenson ("My dear friend") of "a terrible row about you" in Boston. People were saying "vile things" to her husband, she went on: "*They* say (there seem to be many) that you have been dishonest in your money dealings." Jack Gardner agreed, and predicted, regarding the Hope paintings, "Now we shall see if he is honest."

Her letter sent Berenson into a panic. He told Gutekunst it made "everything look as black as death." Quoting the "Now we shall see if he is honest" line, Berenson wrote, "What this can mean I cannot tell." He wondered whether Asher Wertheimer had offered the same three pictures to Mrs. Gardner or someone else for less than the Colnaghi price of thirty thousand pounds.

This news alarmed Gutekunst as well. "After a wretched day & sleepless night," he reported, he asked Wertheimer whether he had indeed offered the three paintings to others and on what terms, and learned that Asher had shown them to the American collector George Gould, had "casually" mentioned a price for one of the Rembrandts, and knew that Mrs. Gardner wanted them. Gutekunst, still playing puppeteer, urged Berenson: "Now you must take a stand against your friends [the Gardners], show the Innocent Aggrieved and Insulted, and absolutely repudiate their . . . insinuations." Mr. Gardner was an "odious beast . . . On no account of course could she [Mrs. Gardner] be let out of this purchase, you must naturally make that clear." And "We carefully concocted with Wertheimer, that the conspiracy came from quite a different quarter than you guessed."

What conspiracy? The accurate information that Berenson was overcharging? The concocted story blamed the reputable Agnew firm for sowing doubts about Colnaghi's integrity: "Everybody has been trying to gain Mrs. G's custom," Gutekunst went on— "Agnews harder than anyone else . . . by throwing us & you over with her; displacing us."

It seems surprising that Asher would go along with this conspiracy tale—if in fact he did. So much of what Gutekunst and Berenson say here is not true that it is difficult to tell what is. Also surprising is Asher's failure to have established clear terms from the outset as to the allotment and sale of the pictures. It may not have occurred to him that the Colnaghi partners might hijack his deal, and by the time they did it was too late. Possibly he was simply naïve, playing by gentlemanly rules in a newly cutthroat market.

Gutekunst had been boasting for weeks about buyers clamoring for the Rembrandts on offer to Mrs. Gardner, but he now wailed to a partner that if she rejected the paintings, they would "be left in our hands!!!"

Jack Gardner, despite his doubts, wired forty thousand pounds

to Berenson's bankers in early October: thirty thousand for the three Hope pictures plus ten thousand for a Cellini bust. A few days later, Isabella sent an additional two thousand pounds—Berenson's 5 percent commission on forty thousand pounds.

Colnaghi, informing Asher of this sale to "our client," did not name the actual figure the Gardners paid for the three Hope paintings—thirty thousand pounds—but twenty-five thousand pounds. The five-thousand-pound difference went to Berenson: slightly more than 16 percent of the sale, in addition to his two-thousand-pound commission. Presumably, Mrs. Gardner did not know that her "dear friend" was taking a substantial cut of her purchase price in addition to his commission—nor that he was in league with Colnaghi, a firm she detested. He may have wanted her to think he was charging her less than others would (the standard dealer's fee at the time was 10 percent), but he more than made up the difference with his profit share.

She repeatedly asked Berenson for a catalogue of the Hope paintings, a request he repeatedly sidestepped, saying he did not know if one existed. In fact, Colnaghi's McKay had sent him a copy annotated with prices, warning, "be very careful not to let it out of your hands." Since the catalogue's introduction named the buyer (Asher) and the price he paid (£121,550), Berenson probably feared the Gardners would do the math: he was charging them £30,000 for three paintings—25 percent of the total cost for less than 4 percent of the deal.

Mrs. G. kept insisting. "I am sure there is a Hope Catalogue," she wrote in early November: "I must have it." She alarmed Berenson further when she added, "I have a letter today of introduction to the Younger Wertheimer who arrives from London with a large assortment of the Hope pictures for sale!" The Younger Wertheimer was Edward, Asher's son and deputy, presumably traveling with copies of the catalogue. The letter of introduction came from

Sargent. It was here that he suggested Mrs. Gardner might find "some new toys" among the Hope offerings. He probably did not know she had just acquired three.

Gutekunst, evidently worried that his lies and manipulations might come to light, told Berenson at the end of October 1898, "Burn or return to me all the letters written by me since the commencement of the H[ope] affair." With the sale to Mrs. G. concluded, he added a cheery sign-off: "And now my dear boy, I don't see how you need fear the bully Mr. G. any longer."

The bully Mr. G. died six weeks later. Berenson continued to shower Isabella with flattery and proffers of art, and she continued to work with him as she created her Boston museum. The two Hope Rembrandts were among the works stolen from the Gardner in 1990 and never recovered. *The Music Lesson*, which Berenson had touted as "perhaps the very best ter Borch in the world," is now credited to the artist's workshop.

Colnaghi's machinations effectively sold the "gems" of the Hope pictures out from under Asher's clients, among them two Jewish financiers who had made fortunes in South Africa: Alfred Beit and Ludwig Neumann.

Beit, who came from a mercantile family in Homburg, had worked closely with Cecil Rhodes and become one of the wealthiest Jews in England. He began collecting art in the 1890s, often with Dr. Bode's help. Regarding the Hope pictures, he complained to Bode that "Wertheimer is asking horrendous prices"—ten thousand pounds for Rembrandt's *Lady and Gentleman in Black*. "I offered him £9000," Beit continued. "Would you go higher?" Berenson was just then selling this painting to Mrs. Gardner for thirteen thousand pounds. In the end, Beit bought five Hope paintings from Asher.

Ludwig Neumann and his brother Sigismund, originally from
Fürth, were former "Randlords," now international bankers in Lon-
don. Ludwig had been the "gentleman" underbidder for the Hope
collection in Chancery Court in July 1898. He and Asher were rep-
resented by the same lawyers in those proceedings and may have
been working together. In spite of Colnaghi's cherry-picking, Neu-
mann ultimately acquired several Hope paintings.

A few years later, he and his brother arranged for their twenty-
three-year-old nephew/apprentice to consult with Asher. They
wanted to send the young man to South Africa. He wanted to open
an art gallery in Paris. The nephew later recalled that Asher had
given him "a little test" that did not go well. Still, he went on,
the "very big art dealer . . . must have been a kind man," since his
Neumann uncles gave him one thousand pounds for a Paris gallery
on condition that he come back to work with them after a year if it
failed. Opened in 1907 on the rue Vignon, it did not fail. Daniel-
Henry Kahnweiler became one of the most important art dealers of
the twentieth century, an early champion and financial supporter
of Picasso, Braque, Léger, Gris, and other Cubists. Picasso famously
asked, "What would have become of us if Kahnweiler hadn't had a
business sense?"

One of the great regrets of Asher's life, according to his well-
informed obituary in *The Times*, was having sold the "pearl" of the
Hope collection—Vermeer's *Glass of Wine*—to Berlin for too low a
price. In fact, he hadn't; Colnaghi had.

The Colnaghi partners commandeered the Hope sale so thor-
oughly that Asher's name has been obscured in accounts of it for
more than a hundred years. The entire purchase is generally cred-
ited to Colnaghi, occasionally to Bode. In correspondence with cli-
ents at the time, the Colnaghi principals describe Wertheimer as

"our partner" in the business, yet in no financial or moral sense was this a partnership.

Trust is as rare and valuable a commodity in the high-stakes, high-risk world of art dealing as it is in finance, the source of many collectors' wealth. Over several decades, the Wertheimers earned the confidence of Rothschilds, members of the British royal family, fellow dealers, sellers and buyers of art in Britain, America, Russia, and on the Continent. By contrast, Colnaghi routinely betrayed the trust of clients and colleagues in the 1890s, forfeiting direct access to a number of first-class collections.

Berenson turned down a partnership offer from Colnaghi in 1902. Ten years later he entered into a secret contract with Duveen that provided, among other things, a financial incentive to "upgrade" attributions. Colnaghi gained greater access to American buyers through an affiliation with Knoedler in New York, and in the twentieth century the firm attained the prominent position in the art market it had been seeking for years.

Since the Wertheimer firm's records have been lost, there is no account of these events from Asher's perspective. He appears only in his catalogue of the Hope collection, in contemporary newspaper accounts, in the letters of Colnaghi partners ("I fought Wertheimer to retain" pictures for Bode; a transaction "would appear doubtful to Wertheimer"; "Wertheimer is mightily angry at our action"). Seen indirectly through these lenses, Asher appears to have been more scrupulous than this rival firm, less aggressive and self-promoting—and unprepared for the brutal tactics of the modern competitive marketplace.

He had not previously included Colnaghi in major acquisitions, such as paintings he bought in 1895 from the estate of the former owner of *The Times*, John Walter, which Colnaghi had also tried and failed to secure. Nor did he bring this rival into his significant deals after the Hope sale—for pictures owned by the Russian duke Nicolas de Leuchtenberg; the Cheremeteff collection of old Sèvres

porcelain; or paintings belonging to Francis Baring, 5th Baron Ashburton.

Asher continued to work with Dr. Bode in Berlin. His son Edward told this German colleague in 1902, "We want to do business with Agnew's, not with Colnaghi."

"Wicked Uncle Charlie"

Another dealer Asher did not want to do business with was his brother, Charles. The two had been estranged for years, most visibly after their father died in 1892, when Asher took over the Bond Street gallery and Charles set up as a dealer on his own. Accounts in the popular press rarely referred to them together.

In the early 1880s, when Asher and Flora moved to Connaught Place, Charles and his mistress, Sarah Hammond, settled nearby at 21 Norfolk Street. Norfolk Street ran parallel to Park Lane along the eastern edge of Hyde Park, below Marble Arch.

Park Lane's residents, like those in Connaught Place, were a mix of titled aristocrats and newly wealthy business figures, many of them Jewish: the financier Sir Ernest Cassel, "Randlords" who had earned fortunes in South Africa—Alfred Beit, Joseph Robinson, Barney Barnato. After Barnato died in 1897, Sir Edward and Lady Sassoon bought his mansion at 25 Park Lane, which had a four-story marble staircase, a conservatory, a winter garden, and a ballroom.*

* Ostentatious remodeling of elegant old houses by the nouveau riche in these years prompted *The Architectural Review* to warn that "frippery and extravagance" were threatening to turn Park Lane into another Fifth Avenue. Norfolk Street was later renamed Dunraven Street and Charles's former house was officially listed as both 21 Dunraven Street and 132 Park Lane.

Charles Wertheimer made alterations to his house, which was also his gallery, and filled it with treasures of fine and decorative art, especially eighteenth-century French furniture and English portraits. He arranged everything to look as if it had always been there—a fine piece of salesmanship, noted one critic, for however much Charles loved the "choice works of art which passed through his hands," he would, "if pressed, sell the Sèvres porcelain and Georgian silver from his dining table, or the Persian carpet from under his feet."

Joseph Duveen, who greatly admired Charles, took a house of his own in Norfolk Street and made the "staging" of luxurious interiors a feature of his galleries in London and New York. He described Charles selling a Gainsborough portrait to Pierpont Morgan over dinner one night: when Morgan asked the price of the picture, his host protested, "Mr. Morgan, this is my private residence and not a shop."

Morgan: "Don't be silly, Charlie, I like it. I'll give you £60,000 for it." It was probably *Mrs. William Tennant*, which Morgan bought from Charles in 1902 for £30,000.

Unlike his father and brother, Charles did not have a royal warrant as a dealer in fine art, although he handled works of great consequence and had illustrious clients. In place of the monarch's coat of arms on his stationery he used a monogram of his initials, CJW. At times, he worked with the esteemed Paris dealer Charles Sedelmeyer. On his own, he caused various kinds of trouble.

In 1892, he sold a Frans Hals, *The Carousing Couple*, to the London dealer Lawrie & Co., for forty-five hundred pounds. Mr. Lawrie, examining the canvas closely, found a mysterious monogram of the initials *JL*. Not Hals. He sued Wertheimer and won a reduction in price though not a full refund. Since the picture had been credited to Hals for more than two centuries, it may

be less surprising that Charles did not look carefully at the signature than that Lawrie did. Still, Lawrie did. The distinctive monogram was identified in 1893 as belonging to Judith Leyster, a rare female painter of the Dutch Golden Age. That she was skilled enough to have most of her work attributed to Hals did not then figure in assessments of her work, although she has since been recognized and honored. The Louvre acquired the painting as by Leyster in 1914.

Making a gift to England that was also a tribute to his own heritage, Charles in 1898 presented the House of Commons with a marble bust of Oliver Cromwell, "in recognition of the Protector's kindness to the Jewish race." Charles identified the sculptor as Bernini, although that attribution has not held up.

As he gave to the nation with one figurative hand, Charles was trying with the other to thwart a sale to the National Gallery. Two large Rembrandt portraits of a prominent wealthy couple from Dordrecht—Jacob Trip and his wife, Margaretha de Geer—belonged by inheritance to Jane Anne, Lady de Saumarez. Her husband, the 4th Baron de Saumarez, told the gallery's director, Sir Edward Poynter, of Charles's interest as the details of the sale were being worked out in July 1898, and asked: "Is there any objection . . . to my writing to Wertheimer to inform him that the pictures have been sold to the Gallery?"

Four months later, de Saumarez wrote to the gallery again: "My solicitor feels some uneasiness as to possible complications if Mr. Charles Wertheimer should persist in attempting to interfere." He enclosed copies of correspondence between his own and Wertheimer's attorneys.

Charles's solicitors said their client was prepared to make a substantial offer after being allowed to inspect the paintings. Solicitors for de Saumarez replied that their clients were committed to the National Gallery and "do not see their way to affording facilities to

third parties for their inspection with the view of the latter making offers."

The sale of these Rembrandts, like that of the Hope collection, had to be approved by the Chancery Court. Charles's lawyers argued: "We should have thought it the duty of those protecting the estate to obtain the best price possible for the heirlooms," and since their client was likely to bid more than the gallery, "we cannot suppose that permission will be refused to him to view the pictures before making his formal offer."

Permission was refused.

As the Chancery Court weighed approval of the sale, a solicitor from the firm Dawes and Sons, which represented both Asher Wertheimer and the National Gallery trustee Alfred de Rothschild, attended the proceedings. Mr. Dawes reported to the gallery's director that although de Saumarez was committed to selling the pictures as agreed, others intent on acquiring them—he did not name Charles Wertheimer—were likely to argue in court that the current offer of £12,500 was too low. Dawes thought, correctly, that the judge did not have the power to insist on sale to the highest bidder, but suggested the gallery increase its offer nonetheless. In the end, Alfred de Rothschild and another trustee contributed funds for the purchase, and the gallery acquired the Rembrandts for £15,050.

Asher may have brought the efficacious Mr. Dawes into the picture, aiming to check his brother's aggression and protect the Wertheimer name. Or it may have been Alfred de Rothschild, eager to secure the paintings for the nation, or the gallery itself, since Dawes reported to its director. The resolution, whatever its dynamics, appears to have benefited everyone except Charles.

Asher came into a different kind of conflict with Charles in a sensational affair that wound up in court. One of the impoverished

European aristocrats who had gone hunting for an American heiress in the 1890s was Count Paul Ernest Boniface de Castellane. The son of a marquis who traced his ancestry back to eleventh-century France, "Boni," as he was known, tried his luck with Pierpont Morgan's daughter Anne, who was not interested. Then, in 1895, he married Anna Gould, a daughter of Jay Gould, the railroad baron who had recently died and left her eighteen million dollars in trust. The wedding took place at the Fifth Avenue house of Anna's brother George, to whom Asher later showed some of the Hope paintings.

Boni, with his wife's money, built an enormous pink-marble mansion on the avenue Foch in Paris called the Palais Rose, modeled on the Grand Trianon at Versailles. Between 1895 and 1898, the couple bought nearly four hundred thousand dollars' worth of paintings, furniture, and decorative arts from Asher and never paid for any of it. Four hundred thousand dollars in 1898 would be more than fourteen million dollars now.

Asher had met the newlyweds through a Paris dealer, and on their first visit to his gallery they bought six items for £20,800, agreeing in writing to pay at a later date. They went on to acquire a great deal more on these terms. He had trusted them with a long-running credit, he later said, because he knew the "glorious tradition of the Castellane family"—and was also aware of the ample Gould millions. The count, pressed for payment, sometimes said his brother-in-law George would cover it. At other times he promised to return artworks to Asher. He never did.

In 1900, Asher sued the Castellanes in New York. While Anna was drawing nine hundred thousand dollars a year from her trust fund (about thirty-two million dollars today), the couple had run up nearly four million dollars in debt, half of it to art dealers. Asher's attorneys won an injunction to set aside some of Anna's income until the rights of her creditors had been adjudicated. Her family in New York tried to prove that neither they nor she were responsible

for her husband's debts, although she had chosen and signed for many of the purchases.

The Castellanes countersued in Paris, claiming that Asher had defrauded them with fakes and charged outrageous prices. Asher's French lawyer described his client as astounded that the count, "after the most friendly relations, social and business, which had existed between them, should now accuse him of deceitful and usurious manoeuvres"—and said that Wertheimer's honesty had never before been questioned.

Asher himself, in an affidavit for the New York case, testified that everything he sold the Castellanes was genuine, the prices not exorbitant, the couple's promises to pay given voluntarily and willingly through lawyers for both sides. Describing his repeated attempts to recover works the couple had not paid for, he said he had especially wanted to retrieve Gainsborough's portrait of Nancy Parsons. Boni claimed the picture was in his wife's bedroom, but it turned out to have been sold, along with several other works that Asher wanted back. They had gone, Asher told the court, "either to my brother, Charles Wertheimer, who has no connection with me in business, or to some other dealer," and when Castellane "made the above representation and promise to me, the pictures had already been disposed of. As a fact, they have disposed of most of the articles purchased from me, very few of which are now in their possession."

Gainsborough's *Nancy Parsons* was indeed now in Charles Wertheimer's possession, along with a number of other Asher-to-Castellane items, including Romney's portrait *Mrs. Morton Pitt and Her Daughter*, which had come from Samson's estate. One of the finest objects was a Pierre Gouthière masterpiece: an eighteenth-century blue turquin marble console table with neoclassical gilt-bronze mounts, commissioned by the Duchesse de Mazarin. Samson, whose own console table in the style of Gouthière had

won a prize in 1862, might have been pleased that Asher had acquired the genuine article; less pleased, but probably not surprised, at the conflict between his sons.

Asher's New York attorney Samuel Untermyer delivered a scathing summary:

> A more aggravated case of fraud on a colossal scale has never been exposed. It shows the [Castellane] defendants to be scamps as thorough as ever lived. With a princely fortune as an annual income, these defendants have . . . descended to methods in dealing with their creditors that would arouse the contempt of the ordinary thief. For years they use the goods; then they resell part of them at a profit, all this time promising to pay and indulging in profuse expressions of gratitude for the indulgence shown, and when finally sued, they say they were cheated.

The courts arranged a settlement in 1902: Asher would be repaid in full by the Jay Gould estate in monthly installments over four years, plus 4 percent interest. His claim would take precedence over those of other creditors since the debt to him was the largest by far. And "the Countess" would insure her life for the full amount of Asher's claim, the policy made out to him in case she died before the final payment. Untermyer announced that the settlement acknowledged "the fairness of the transactions between Mr. Wertheimer and Count Boni, and the genuineness of the articles bought."

Could Charles not have known that the notable paintings and furniture for which he was paying large sums did not in fact belong to Castellane but to Asher? At least one of the pictures had been in their father's estate. The art market depends on discretion as well as trust. The critic Frank Rutter reported Asher being willing to

show him "precious things" only once he knew that Rutter would not "blab" about them in print. Still, dealers tend to be aware of what their colleagues (not to mention their brothers) acquire at public auctions and estate sales, and often to whom they sell—especially such major works as the Gouthière table and celebrated English portraits. If, to give Charles the benefit of the doubt, he was not aware of the Castellane fraud when he made these purchases, he certainly knew once Asher's high-profile lawsuit began.

While the suit was underway, Charles sold the Gouthière table to Pierpont Morgan. Duveen eventually bought it from Morgan's estate and sold it on to the Frick, where it remains a highlight of the collection.

Early one morning in 1907, a burglar broke into Charles's Norfolk Street house and made off with a cache of pictures cut from their frames, including a Reynolds and the Gainsborough *Nancy Parsons* that Asher had particularly wanted back.

The critic Roger Fry, lamenting this "deplorable loss" in *The Burlington Magazine*, took an optimistic line: "The theft of masterpieces of painting is fortunately as rare as it is foolish. Every picture is unique, and its identity is easier to establish than that of a living person." With this consoling "white elephant" theory, Fry expected the Wertheimer theft would come to be "regarded as one of those unfortunate lapses from common-sense which are likely to become rarer with the spread of education among the criminal classes." Not rare enough to prevent future thefts of famous masterpieces, including the heist at the Isabella Stewart Gardner Museum in 1990. Fry did not specify who, exactly, would be educating the criminal classes.

The paintings from "the great Park Lane robbery" were never recovered, although three men were charged and convicted. Years later, the principal thief told an Australian journalist that he had destroyed them.

Asher eventually received full payment from the Gould-Castellanes and affirmation of his good name, but the protracted lawsuit and its attendant publicity had been a nightmare. The experience, following on the difficulties he had with the Hope sale, may have led him to take a new approach to the art market. For major acquisitions in the early twentieth century, he often preferred to operate at a level above the competitive fray, financing deals rather than actively participating in them.*

Both Wertheimer brothers lived extremely well. Charles, known for serving fine wines and food in Norfolk Street, dressed smartly, traveled widely, employed a riding master, and owned prizewinning horses.

A decade before Sargent began painting his portraits of Asher's family, Charles had commissioned two of his own by the Pre-Raphaelite John Everett Millais, to whom Sargent had turned for advice in the mid-1880s. Millais painted Charles in 1888 and Sarah Hammond, as *Mrs. Charles Wertheimer*, in 1891. The actual Mrs. Charles, formerly Frieda Flachfeld, was still living with her father-in-law, Samson, in New Bond Street. "Sarah Wertheimer" is listed in the 1891 census as Charles's wife, although they never married.

* Anna Gould sued Boni de Castellane for divorce in 1906, on grounds of infidelity. He had spent ten million dollars of her inheritance. Two years later she married one of his cousins, the Marquis de Talleyrand Périgord, Duc de Sagan. Boni tried to get an annulment from the Vatican in order to marry again within the church. On April 13, 1925, two decades after the divorce, *Time* magazine reported drily: "Probably not since Henry VIII tried in vain to get an annulment of his marriage with Catherine of Aragon has a matrimonial case been so long in the courts of the Roman Catholic Church as that on which nine Cardinals have just handed down a final decision." The cardinals declared the Castellane-Gould marriage valid, which took Boni out of the running for a new heiress.

Her portrait has been exhibited, reproduced, and sold several times as *Mrs. Charles Wertheimer.*

Charles collected Millais's work, and in 1883 had architectural plans drawn up for a room dedicated to the artist at 21 Norfolk Street. He eventually sold several of the paintings, including the highly popular *Cherry Ripe* and *Christmas Eve,* to his Park Lane neighbor Sir Joseph Robinson, for twenty thousand guineas.

Millais died in 1896. His portraits of Charles and Sarah were part of a retrospective at the Royal Academy two years later, a few months before Sargent's Asher and Flora first appeared there. Not surprisingly, the Wertheimer brothers in middle age looked very much alike: full lower lips, large noses, receding hairlines; and both sported thick mustaches and neatly trimmed beards. In Millais's three-quarter-length *Charles,* now at the Musée d'Orsay in Paris, the sitter wears a cutaway jacket and wire-rimmed glasses, hands behind his back, a hint of a smile on his face. Yet compared to Sargent's *Asher,* with its Old Masterly play of light and shade, the rich, dark space around the figure, the subtle verticals of the Japanese screen behind him, and the vital presence of the dog, the picture of Charles is unremarkable.

Millais's Sarah, plump and buxom, looks fussily overdressed in lace-trimmed red velvet, emeralds, and fawn-colored gloves, with a pouty, dissatisfied expression. Sargent's 1898 *Flora,* elegant and poised in white, belongs to a different universe—as, apparently, did the two women.

Charles lived with Sarah for nearly thirty years. Then, in 1899, the couple separated. Charles arranged a generous financial settlement and set Sarah up in a posh Knightsbridge flat. For most of the rest of her life, she lived with her niece, Alice Warren, in the Knightsbridge apartment and at a country house in Berkshire. Alice, born in 1883, had been baptized at Charles's Norfolk Street house ten years later as the only child of Maria Hammond Warren—probably Sarah's sister—and her husband, Alfred. The

use of 21 Norfolk Street and the ten-year delay in baptism raise the possibility that Alice was Sarah's child, with Maria providing cover. When Sarah died in 1940 as "Mrs. Hammond," a widow, she named Alice her executor and left the Millais portrait to her.

Possibly Charles did not marry Sarah because she wasn't Jewish, and/or because Frieda wouldn't grant him a divorce. Three months after Frieda died, in 1904, he married Elizabeth Jessica Trautz, the daughter of a diamond setter. His liaison with Jessie, as she was called, may have led to his separation from Sarah. Charles Hercules Read, the keeper of British and Medieval Antiquities at the British Museum, attended the couple's register-office wedding.

By the time of Charles's second marriage, most of Sargent's Wertheimer portraits had been widely exhibited and acclaimed, and Charles commissioned a series of his own from the young Irish painter William Orpen. At the time, Orpen was sharing a teaching studio in Chelsea with a fellow recent graduate of the Slade School of Fine Art, Augustus John. Charles's selection of the relatively unknown Orpen was audacious. Joseph Duveen pronounced it "rash."

In 1904, Orpen did portraits of Charles, his new wife, his solicitor, and his riding master. This bust-length Charles, in a white cravat and fur-trimmed coat, regarding us sidelong through his pince-nez, is more penetrating and evocative than the Millais. Four years later, Orpen painted his principal patron again, twice. One of the 1908 portraits served as highly effective promotion for both men. Not long after thieves had stolen pictures by Gainsborough and Reynolds from Charles in "the Great Park Lane Robbery," Orpen portrayed him at home with another Gainsborough (*Miss Elizabeth Linley*) and a Lawrence (*Miss Julia Peel*), surrounded by fine French furniture. A King Charles spaniel sprawls across Miss Peel's lap. Wertheimer's nearly identical spaniel lies at his feet. Charles arranged to have this portrait interior submitted to the Royal

Academy, where it was accepted and shown, effectively launching Orpen's career. The artist was elected an associate of the academy in 1910 and a full member in 1919.

Whether or not Charles intended his Orpens to compete with Asher's Sargents—and it is hard to imagine he did not—the younger artist measured himself against the elder, who had promoted his early work. Orpen drew a witty private sketch called "Orpen Pleading with Sargent" in a letter to his mistress, Evelyn St. George: he shows himself, a diminutive Irishman barely five feet tall, holding out his hands in supplication toward the commanding American who towers over him like a giant, one hand in a trouser pocket, legs spread wide.

Another measure of comparison was price: Orpen charged Charles one hundred pounds for his portrait—one tenth of Sargent's rate—and even less for the one of his wife, Jessie.

The second 1908 Orpen painting shows Charles in the same clothes and much the same pose, only in closer focus and looking off to his right, his left hand on a table. Larger than the one exhibited at the Royal Academy, it was acquired at auction in 1990 by Ronnie Wood of the Rolling Stones, a collector of Orpen and himself a painter, for a fraction of what it turned out to be worth.

Asher tried at least once to help Charles sell a painting, but only as a favor to Wilhelm Bode in Berlin, specifying again that he and his brother did not work together. He knew Dr. Bode wanted a "representative" work by Joshua Reynolds for his Kaiser Friedrich Museum, which opened in 1904, and told him that January about a "magnificent" Reynolds portrait, *John Manners, Marquess of Granby*, which belonged to his brother. Charles was willing to let Bode have it for twelve thousand pounds, Asher wrote—"guided

by the consideration that it is going to your Museum"; the price to a private buyer would be higher. Asking his correspondent to keep the price and his letter confidential, Asher said in closing: "I beg of you to understand that it will not be a matter of business, either directly or indirectly, to me, if you buy this picture, but if I can be of any help in negotiating or otherwise of use, it will afford me great pleasure."

Bode did not buy the painting. Duveen Brothers, who probably acquired it from Charles's estate, sold it in 1927 to John Ringling, of the Ringling Brothers and Barnum & Bailey Circus, for $22,500 (about £4,500). It is now at the Ringling Museum of Art in Sarasota, Florida.

"Wicked Uncle Charlie" was family shorthand for a difficult man—brilliant, extravagant (though he could afford to be), erratic in personal relations, frequently lacking a moral compass. Charles died in April 1911, at the age of sixty-nine, after an operation for cancer of the tongue. The mourners who attended his funeral included George Lewis, who had represented the Wertheimer brothers after the 1870 bar fight, the dealers Durlacher and Duveen, Charles's private secretary, his art custodian, and a son-in-law. Asher, who was in the South of France, sent an assistant.

The *Times* obituary described Charles's transactions in the art market as "always on the heroic scale." The net value of his estate was £761,000 (then about $3.8 million). He left Sarah Hammond her portrait by Millais and all the furnishings in her Knightsbridge flat, and his will reconfirmed the terms of two indentures he had settled on her when they separated. He gave his own Millais portrait to Jessie, along with an annuity of six thousand pounds a year for as long as she remained his widow, the amount to be reduced if she remarried. Jessie left Millais's portrait of Charles to the Musée d'Orsay in Paris in 1914; the museum acquired its

pendant, now correctly identified as *Portrait of Sarah Hammond*, in 2023.

Charles had set up trust funds for his daughters and grandchildren, and left cash gifts to servants, friends, and charities. His bequests to Jewish charities were considerably larger than those of his father or brother—£250,000 to the Jewish Board of Guardians, £100,000 to the London Jewish Hospital. He was buried at the Willesden Jewish Cemetery in northwest London, as were his first wife, Frieda, and all four of their children.

In his will, Charles recommended that his executors—one of whom was the British Museum's Hercules Read—sell his collections through Christie's. Duveen Brothers bought most of the paintings and furniture privately before the auction took place, however. Christie's sold the objects of decorative art in 1912, mostly to other dealers.

"Art Prices Slump at Wertheimer Sale," reported *The New York Times* that May. Among the pieces showing sharp declines in value were a commode and table Charles had bought for £44,000 that sold in 1912 for 780 guineas. To great fanfare Charles had acquired a rock-crystal drinking vessel in the shape of a monster, ostensibly made in Augsburg in the sixteenth century, for £15,600 in 1905; after his death it was judged a "made-up piece" and went for £3,800. And he had paid £4,000 for a gold pendant falcon with bejeweled wings, also as sixteenth-century German, which experts in 1912 held to be Spanish; it sold for £800—to Asher.

The Duveen firm acquired much of its inventory from other dealers, the Wertheimers "above all." Joseph Duveen, assiduously cultivating the California railroad magnate Henry Huntington and his wife, Arabella, sold them some of Charles's eighteenth-century French furniture and English portraits. Among the prizes were three full-length Gainsboroughs for $775,000 and Romney's *Beauty and the Arts,* a painting of the sisters Lady Caroline and Lady Elisabeth Spencer, for $250,000.

In a wild flourish, Duveen told Huntington: "in my opinion you have the greatest eye for an English picture I have ever known in anyone. The only man of the past generation who could in any way equal it was Charles Wertheimer . . . and, although I should not perhaps admit it—Myself!!"

SUCCESSION

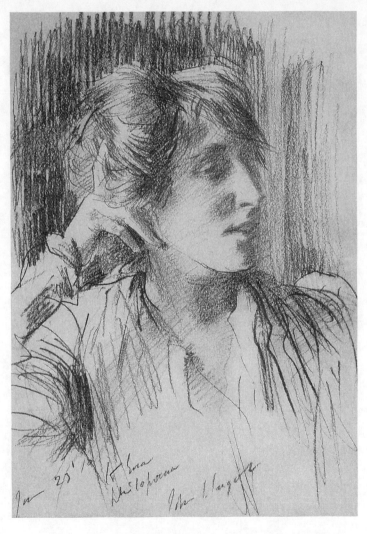

Ena Wertheimer Mathias, pencil sketch. Inscribed "Jan 25 '10
to Ena philoprocree John S. Sargent." (Private collection)

Sons

Sargent painted the Wertheimers in roughly declining order of age, beginning with Asher and Flora in 1897–98. Next he did the older "children," all in their twenties, then the younger six in two groups of three. Patron and artist saw one another regularly throughout the decade-long process, and Asher probably weighed in on sequence and groupings. It seems likely that he left aesthetic decisions to the expert.

Whereas Asher and Charles had attended London's egalitarian University College School, all four of Asher's sons, in the arc of upward mobility, went to elite educational institutions—Harrow, then Cambridge and Oxford. Being Jewish at a British boarding school (called public, although they are private) generally entailed torment. Harrow, founded in 1572 under Queen Elizabeth I and second only to Eton in prestige, admitted "professing" Jews for the first time in the late 1870s, after its leaders concluded that "a school for the rich could not ignore a possibly lucrative market." The first Jewish students boarded with individual masters; in 1881, the school opened a "Jewish house" for eight or nine boys, possibly to facilitate observance of dietary laws. Other Harrovians called them "Junipers." Charles Rothschild, a Harrow student at the same

time as some of the Wertheimers, told a friend when he left: "If I ever have a son he will be instructed in boxing and jiu-jitsu before he enters school, as Jew hunts such as I experienced are a very one-sided amusement." Having a German-sounding name such as Rothschild or Wertheimer enlarged the targets on these boys' backs.

About seventy students lived in each of Harrow's primary residential houses, each with its own customs, sports teams, tutors, and masters. There were less prestigious "small houses" for students waiting for space in the main residences. Asher's three eldest sons lived in small houses for their entire time at Harrow. The youngest, Ferdinand, was in a "big" house called the Grove from 1901 to 1904.

Alfred, the second Wertheimer son, attended Harrow from 1890 to 1893, and entered Trinity College, Cambridge, in 1894, but did not take a degree. Instead, he went to work as a chemist at a research lab in Stratford, East London, and published a few papers and letters in scientific journals.

He wanted to be an actor. And Asher wouldn't hear of it. They fought, bitterly. Alfred moved out of his father's house to live at the Oxford and Cambridge Musical Club in Leicester Square. Sargent, close to both men, tried to mediate. He was teaching at the Royal Academy and working on his portrait of Alfred when he wrote to him at the end of November 1901:

> My dear Wertheimer,
>
> I have been hoping you would come and see me, especially since your father, who paid me his Sunday morning visit, talked about his feeling with regard to your mutual disagreement.
>
> I shall be lunching tomorrow, Thursday, at Monico's [Café Monico in Shaftesbury Avenue] after my R. A. schools and if you would lunch with me there I would tell

you my impression. I shall lunch there at any rate so you needn't let me know, and if you get there before me, begin lunch.

I daresay I may have nothing to add to what you know already, for your father told me that he had written you exactly what he explained to me were his views. I can only add that he seemed to me so absolutely to hate the idea of your going on the stage, that I believe he is really quite resolved to give you a nominal allowance and a nominal legacy in his will, if you take a decisive step in that direction. Forgive me once more for meddling in your affairs—it is really not as a busybody nor as an agent of your father's, but because I should be very sorry to see you embark on a life of risks and worries.

I write this time in case you think your father is not in earnest. He really is, I believe.

Two months later, in January 1902, Alfred went to South Africa with his friend Harry Freeman Cohen, a wealthy British financier and founder of the *Rand Daily Mail*. He was back in England by the summer when his portrait made its debut at the Royal Academy.

Alfred bore a stronger resemblance to his mother than his father. He stands, in Sargent's rendering, with one hand on a stack of books, light glinting off chemical flasks on a wall behind him. His striking looks and impeccable clothes seem more suited to the stage than a lab.

Among the other Sargents in the 1902 exhibition was *The Duchess of Portland*, which the critic Charles Lewis Hind dismissed as "but one sumptuous portrait among many. It will pass like the rest." Of a different order, Hind went on, was "the portrait of the Jewish youth [which] remains in the memory, and will remain a thing of beauty. Not that the sitter is beautiful"—actually, he was—"but because the quiet dignity of the figure, so exquisitely

drawn, is so modest in its appeal, so suggestive of controlled and organized power in the painter, without hint of cleverness or bravado."

Boston's *Sunday Herald* reported that all London was flocking to see Alfred's portrait, and that its subject had become a celebrity:

> It is the sensation of the year at Burlington House. The im-
> maculate young Jew is probably the best dressed sport in
> England. He is pictured in an ordinary sacque suit, black,
> perfect in fit, a buff waistcoat and a riding stock, not a
> wrinkle anywhere. Since the picture Mr. Wertheimer has
> been pointed out whenever he appears in Bond street, the
> Arcade, in Prince's or the Royal, as the original of, perhaps,
> Sargent's greatest portrait.

Relations between "the immaculate young Jew" and his father had not improved. Sargent continued to try to help. Another crisis arose, its facts not clear. Alfred had borrowed money from Asher and lent it to someone; it was gone; Asher was furious; the contentious matter of "the stage" remained.

Would Asher have objected so fiercely if Alfred had wanted to be a painter rather than an actor? Was a life in the theater simply beyond the aspirational pale?

"My dear Wertheimer," Sargent wrote to Alfred again:

> Your news of an hour ago took my breath away and I
> have ruminated it all the way home; and I cannot refrain
> from writing you that I think you are taking a very crit-
> ical step and one which may make your brouille [quarrel]
> with your father much worse, for the simple reason that it
> makes a public éclat of what is really a private matter easily
> patched up.

He had a wry observation—and a generous idea:

> Let me propose to you, if I may do so with safety to my
> life, for you have a celebrated temper, and no doubt wear a
> revolver somewhere behind, that I should be the man you
> lent the money to, return it to you tomorrow, and you take
> it back to your father and the incident is closed.
>
> There would be the advantage of ending a false situation,
> and of not touching the stage with a pair of tongs.

Whether or not Alfred took Sargent up on this suggestion, he returned to South Africa shortly after his portrait caused a "sensation" in London. On September 18, 1902, he died at Long's Hotel in Johannesburg. He had been addicted to morphine and taken an overdose. His heart stopped. He was twenty-six.

An inquest in Johannesburg took testimony from Alexander Rennie, the local pharmacist from whose shop a hotel porter had recently picked up a package for Mr. Wertheimer. Mr. Rennie said he had not known what was in the parcel, which had been left with him, and denied selling morphine to Wertheimer, though he *had* known of the young man's addiction and tried to help him break the habit. The coroner concluded that Rennie was not responsible for Alfred's death.

A register from the Jewish Burial Society in Johannesburg identifies Alfred as "Friend of H. Freeman Cohen." The body was sent to London, its entrails buried in Johannesburg's Braamfontein Cemetery. The monument on Alfred's grave at Willesden bears a broken column, signifying a life cut short. The burial certificate gives the causes of death as "Morphine poisoning," "Syncope" (loss of consciousness, followed in this case by cardiac arrest), and, in parentheses, "Suicide."

Harry Freeman Cohen killed himself in Johannesburg fifteen

months later, at age forty-nine, leaving a wife and four children. It is impossible to know whether there was any connection between these untimely self-inflicted deaths.

Alfred's painful story may figure in W. Somerset Maugham's 1931 short story "The Alien Corn," about a family of wealthy British Jews. Maugham knew Alfred's sister Ena, and could have learned of these events from her. His title refers to Keats's "Ode to a Nightingale" and the biblical story of Ruth, widowed in a foreign land: "sick for home / She stood in tears amid the alien corn."

Most members of the fictional Jewish family in Maugham's story have erased their origins and changed the name Bleikogel to the delectably denatured Bland—all except the cultured, rich, socially brilliant Ferdy Rabenstein, now in his seventies. Maugham's narrator describes him:

> It was not hard to believe that in youth he was as beautiful as people said. He had still his fine Semitic profile and the lustrous black eyes that had caused havoc in so many a Gentile breast . . . He wore his clothes very well, and in evening dress, even now, he was one of the handsomest men I had ever seen . . . Perhaps he was rather flashy, but you felt it was so much in character that it would have ill become him to be anything else.
>
> "After all, I am an Oriental," he said. "I can carry a certain barbaric magnificence."

Ferdy's sister had married Alphonse Bleikogel, "who ended life as Sir Alfred Bland, first Baronet, and Adolph, their only son, in due course became Sir Adolphus Bland, second Baronet." Sir Adolphus and his wife, Miriam (now Muriel), live on a vast manicured

estate in Sussex. Their eldest son, George, is slated to inherit the family fortune, go into politics, and be the perfect English gentleman. Yet George has no interest in money or politics. Sent down from Oxford with huge debts in spite of a princely allowance, he wants only to become a professional pianist—no more acceptable to his father than Alfred Wertheimer's desire to be an actor was to Asher.

During the family battle over his future, George learns for the first time that he is Jewish. His grandmother—Ferdy's sister—persuades the young man's parents to let him study piano in Germany for two years, then come back to perform before a disinterested expert. If, in the expert's opinion, he shows real talent, they will not only not stand in his way but offer him every advantage and encouragement. If he is found to have no true gift or prospect of success, he will give up music and comply with his father's wishes.

George agrees. In Munich he lives like a bohemian, takes piano lessons twice a week, practices ten hours a day, spends all his free time with Jews. After two years he returns to England as promised. Ferdy Rabenstein brings the concert pianist Lea Makart, "acknowledged to be the greatest woman pianist in Europe," to hear him. George plays Chopin. When he finishes, he turns to face Makart without speaking.

"What is it you want me to tell you?" she asked.

They looked into one another's eyes.

"I want you to tell me whether I have any chance of becoming in time a pianist in the first rank."

"Not in a thousand years."

In the silence that follows, her eyes fill with tears. She offers to introduce George to Paderewski for another opinion. He smiles, says that will not be necessary.

He walks out onto the terrace, where his father joins him. Sir Adolphus has triumphed but cannot bear the anguish of the son he

adores with "such an unEnglish love." Unlike Asher Wertheimer, he relents, offering to send the young man back to Munich for another year—or around the world.

"Thanks awfully, Daddy, we'll talk about it. I'm just going for a stroll now." George kisses his father on the lips, then makes his way to the gun room and shoots himself through the heart.

Two months after Alfred's death, Sargent was working on a portrait of Edward, the eldest Wertheimer son, now Asher's business partner. "Today is a fine day for Eddie & I will expect him at 2:30," the artist wrote to Flora. Edward was about to be married, and Sargent went on: "But is tomorrow the wedding day? I am quite muddled about that—and I am not sure that my sentiments about functions and ceremonies won't keep me away."

Edward at twenty-nine looked very much like his father, down to an early receding hairline. In Sargent's painting, he rests one arm on a cabinet beside a small cast of Bernini's *Apollo and Daphne* from the Borghese Gallery in Rome—an "attribute" representing the art trade.

He had attended Harrow from 1886 to 1890, then gone up to Trinity College, Cambridge. Life was no easier for Jews in the elite universities than it was at public schools. Oxford had begun admitting non-Anglicans in 1871, but had at most a dozen Jewish students by the 1890s. Cambridge accepted a few more. Edward earned a B.A. and an M.A. in medieval and modern languages, leaving with proficiency in German and French.

Once he began working with his father, he put his German to use in stilted, reverent letters to Wilhelm Bode in Berlin. In 1901, he suggested that he might be able to secure an extraordinary prize—Velázquez's *Toilet of Venus*. The painting had belonged for most of the nineteenth century to the Morritt family at Rokeby Park, in

the north of England, and was known as the *Rokeby Venus*. One of the Morritts had just died; Edward had his eye on the heir.

The *Venus* is Velázquez's only surviving female nude and one of his most celebrated paintings. The goddess of love reclines on a bed with her back to the viewer, her voluptuous curves and luminescent skin set off by richly colored fabrics. Her son Cupid holds a mirror to reflect her face, which was not the feature of most interest to her new owner. After J. B. S. Morritt acquired the painting for five hundred pounds in 1809, he told his friend Sir Walter Scott that he had rearranged all his artworks to make room for

> my fine picture of Venus's backside which I have at length exalted over my chimney-piece in the library. It is an admirable light for the painting and shows it to perfection, whilst raising the said backside to a considerable height, the ladies may avert their downcast eyes without difficulty and connoisseurs steal a glance without drawing the said posterior into the company.

A skeptical Asher told one of Bode's colleagues in May 1901 that Edward had not seen the painting in three and a half years, "and since then we have had no relationship with the family, as from everything we have heard, they are not going to sell the picture."

Still, Edward continued to pursue what he called the "Velázquezichen Venus." At the end of November 1901, he told Bode: "I would be very happy to do my best to acquire it for you—at cost. For the many things you have done for us, we are not ungrateful. I hope it will eventually be possible to accomplish this."

A few days later, Asher forwarded to Bode a letter from a Morritt family lawyer saying the picture was "certainly not for sale, nor would Mr. Morritt part with it."

Yet in 1905, Morritt did part with it. After securing permission from the Chancery Court, he sold the painting to the Agnew

firm for £30,500. It aroused intense international interest. Britain, increasingly concerned about losing art to foreign buyers, had created a National Art Collections Fund to compete for major works. The fund raised £45,000 to acquire the Velázquez, which it presented to the National Gallery at the beginning of 1906.

Punch published a cartoon that January showing Velázquez and Sargent strolling past the National Gallery arm in arm, each carrying a painting tagged "Purchased for the Nation"—Velázquez *The Toilet of Venus*, Sargent *Ellen Terry as Lady Macbeth*, which Sir Joseph Joel Duveen had just given to the Tate. The caption: "Desirable Aliens."

Sargent had mentioned "Eddie's" upcoming wedding in the autumn of 1902. Edward married May George Levy at London's Central Synagogue on November 18. On their honeymoon in Paris he fell ill, reportedly after eating a bad oyster. Sargent wrote to Asher on Christmas Eve: "I am so glad to know that the last accounts of Edward are very good, and I hope you are out of all anxiety. I have been very sorry for you during all these weeks of trouble, but I hope they are ending in a complete recovery and that Edward will soon enjoy his usual health, and you your usual spirits." In closing, "Please give kind messages from me to Edward and his wife."

Edward had contracted typhoid, which can be transmitted by raw shellfish. He died at the Élysées Palace Hotel in Paris on January 2, 1903. Sargent wrote to Flora the next day: "The news which just reached me of poor Eddie's death is dreadful and I cannot find words to express to you and Mr. Wertheimer how deeply sorry I am for you both and for your children. Please accept my very real sympathy."

Dr. Bode wrote from Berlin to inquire about the young man's health. Asher responded on black-bordered stationery: "I am heartbroken to say that the poor boy succumbed to his illness and it is indeed a great grief and trouble to us all. I hope you will allow me to add that the poor fellow always had the highest esteem and

regard for you, and invariably spoke with gratitude of your great kindness and consideration towards him."

Edward and Alfred died four months apart. Both graves at Willesden, side by side a few rows from their parents, bear the broken column that indicates a life cut short. Sargent's portrait of Edward remains, appropriately, unfinished.

Charles Wertheimer's sons, John and Isador, went to University College School and the University of London rather than Harrow and Oxford or Cambridge. The younger of the two, Isador Emmanuel, worked briefly at S. Wertheimer and Sons in the 1880s. He was a troubled character, like his father only more extreme. After Isador ran up large gambling debts in his twenties, Charles sent him abroad with an allowance of five pounds a day on condition he stay away for a year. He lasted four months, then returned to England, forfeiting his allowance.

In 1890, at twenty-seven, Isador was named corespondent in a sensational divorce case. William, Viscount Dunlo, the eldest son of the 4th Earl of Clancarty, had married a young music-hall performer named Belle Bilton in 1889. His outraged father dispatched William to Australia, threatened to disinherit him, and instituted divorce proceedings on his behalf, which required proof of adultery. Private detectives hired to follow Isador and Belle testified at trial that they had observed the pair kissing, traveling together on the Continent, staying at his house at Maidenhead and hers in London. He gave her jewelry and horses. On the witness stand, he swore to the innocence of their attachment and said he longed to marry her, although she had refused. He knew her former life had not been unimpeachable, he said, but "nothing gave me as much pleasure as to be in her society—nothing in the world." If her marriage to Dunlo were dissolved, he hoped he might realize "the great desire"

of his life, but had come to court as a "man of honour" to tell the truth and ask for justice, since Belle had been "deeply, unjustifiably, and ruthlessly wronged."

The jury deliberated for fifteen minutes and dismissed the charges. The 4th Earl of Clancarty died a few months later. Belle's husband became the 5th Earl and she his countess; they had five children.

Six months after the Dunlo verdict, Isador appeared in court again, on charges of failing to support an illegitimate child. His accuser was Mabel Harrison, an actress who said he had sent her ten pounds to pay for "an illegal operation." He admitted having had "immoral intimacy" with her but insisted he always paid for it, and that her accusation amounted to blackmail. The presiding magistrate said he didn't believe either party but judged Isador to be the father and ordered him to pay six shillings a week until the child was sixteen, along with twenty guineas for Harrison's expenses.

Later that year Isador declared bankruptcy and moved to France. He was mentioned in a fraud case regarding the promoters of a Transvaal gold mining company. News accounts of his troubles invariably mentioned the Dunlo divorce case.

Then, in 1892, he married a woman named Maud Mary Hammack in the Anglican parish church of St. Marylebone. And six months after his wedding, staying with his mother, Isador died. Death notices said he had "taken a chill" while riding in Hyde Park's fashionable Rotten Row and contracted typhoid fever. Taking a chill does not cause typhoid, which is a bacterial infection, although many at the time thought it could.

Charles's elder son, John, became a barrister. He published a handbook called *The Law Relating to Clubs* (members' clubs, proprietary clubs, workingmen's clubs), which is still available, sometimes referred to as *Wertheimer's Law Relating to Clubs*. John died in 1888, at the age of twenty-seven. He, too, was staying with his

Samson Wertheimer
(1658–1724), court factor
in Vienna. (Early-nineteenth-
century copy of a ca. 1700 original.
Private collection)

Asher Wertheimer.
Photograph by
Lizzie Coswell Smith,
The Gainsborough Studio.
Gelatin silver print.
(Collection of the late David and
Katherine Mathias)

Mrs. Asher Wertheimer.
(Collection of the late David and
Katherine Mathias)

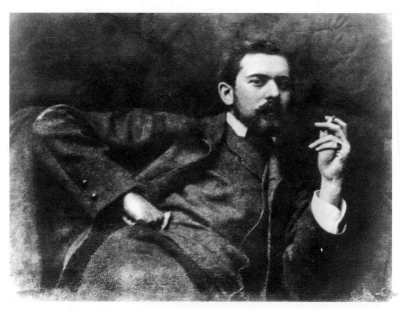

Sargent in Paris, c. 1884. (Private collection)

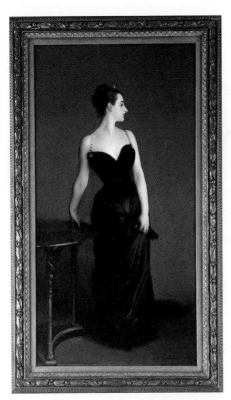

LEFT: *Madame X* (Madame
Pierre Gautreau), 1883–1884.
Oil on canvas. (The Metropolitan
Museum of Art. Arthur Hoppock
Hearn Fund, 1916 [16.53])

BELOW: Sargent with the
Madame X portrait in his
Paris studio, 41 Boulevard
Berthier, c. 1884. (Private
collection)

Ena Wertheimer.
Photograph by
G. C. Beresford. Gelatin
silver print. (Collection of the
late David and Katherine Mathias)

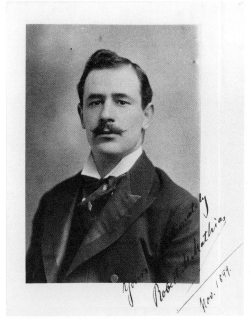

Robert Mathias,
November 1899.
(Collection of the late
David and Katherine Mathias)

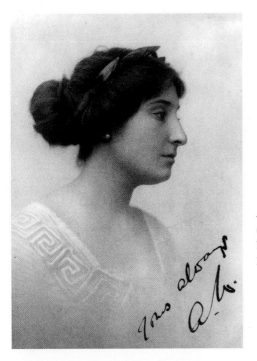

Almina Wertheimer.
(Collection of the late
David and Katherine
Mathias)

Ferdinand (left) and Conway
Wertheimer. Gelatin silver
print. (Collection of the late
David and Katherine Mathias)

Asher Wertheimer.
Photograph by T. H. Voight,
Bad Homburg. Inscribed to
Ferdinand, *"29.8.04 From Father to
dear old Bobbie."* (Collection of the late
David and Katherine Mathias)

Reverse image of
Asher Wertheimer
by T. H. Voight. (Collection of the late
David and Katherine Mathias)

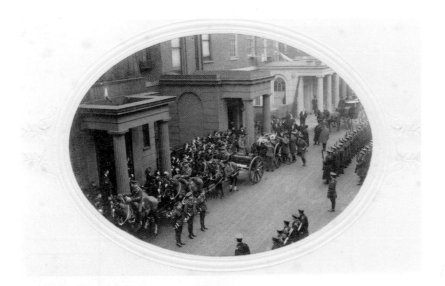

ABOVE: Funeral cortege for Euston Salaman, husband of Betty Wertheimer, in front of the couple's house at 6 Connaught Place, 1917. Asher and Flora's house, 8 Connaught Place, is to the right in the photograph. (Collection of the late David and Katherine Mathias)

LEFT: Ena Wertheimer Mathias standing in doorway, her daughter Diana holding a dog, Siegfried Sassoon sitting on step, 1926. (Photograph by Ottoline Morrell. National Portrait Gallery, NPG Ax142520)

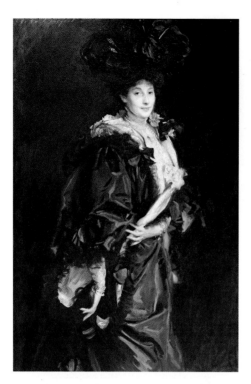

Lady Sassoon
(née Aline de Rothschild), 1907.
Oil on canvas. (Private Collection.
Bridgeman Images)

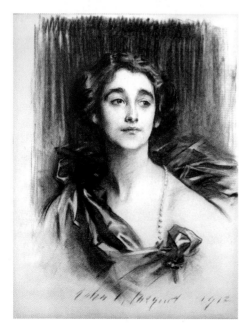

Sibyl Sassoon, 1912.
Charcoal portrait. (Private Collection.
Bridgeman Images)

mother at the time. The cause of death listed on his burial certificate: also typhoid.

John's twin sister, Julia, reconnected the family to Fürth by marrying a man named Moritz Dünkelsbühler, who worked in the metals business there. The wedding took place at London's Central Synagogue. The couple settled in Nuremberg, six miles from Fürth, and had five children, some of whom changed their surname to Duncan—as, eventually, did Julia. One of the Duncans claimed to descend from an affair that Julia had had with Rupprecht, Crown Prince of Bavaria, the last heir apparent to the Bavarian throne.

Henrietta, the younger daughter of Charles and Frieda, married a stock dealer from Australia named Morris Davis, also at the Central Synagogue. After Samson Wertheimer died, Frieda lived with the Davises until her own death in 1904. The inscription on her tombstone reads: "Never forgotten by her sorrowing daughters."

Charles, with no surviving male heir, suggested in his will that the sons of his daughters, and the sons of those sons, take the name Wertheimer. None did. And since neither of Asher's remaining sons, Conway and Ferdinand, had children, the surname in this branch of the family did not continue beyond the second generation born in England.

Samson had been a king of the London art trade, Asher a prince regent, Charles a prince of darkness. Only Edward among Samson's grandsons might have carried their enterprise forward in the twentieth century. His early death accounts in part for the Wertheimer firms being less well-known than those of several of their professional peers.

Typhoid fever was epidemic in England when John and Isador died in their twenties, five years apart—but did it serve as a screen for suicide? Both men were staying with their mother when they died, John at Samson's house in New Bond Street, Isador at his sister Henrietta's in Great Cumberland Place. Although typhoid is

highly contagious, no one else in those households appears to have died.

Suicide rarely has a single cause and is difficult to fathom in any case, especially in retrospect and without firsthand evidence. Sargent's compassionate letters to Alfred offer glimpses of the younger man's struggles with his father, but they are tantalizing fragments of a story that is impossible to piece together now. This family may have been particularly vulnerable to emotional instability. The death of a son before the age of thirty is heartbreaking, the loss of two in quick succession, devastating. That four of Samson Wertheimer's six grandsons died young—from typhoid, drug addiction, perhaps more than one suicide—seems a scourge.

Daughters

"What do you think of it?" Sargent asked an American visitor to his studio in 1901, indicating his portrait-in-progress of the two eldest Wertheimer daughters. His questions made his own answer clear: "Isn't it stunning of the taller girl? Don't you think she is hand-some?" A few minutes later, "Isn't Miss Wertheimer beautiful?"

Six feet tall, with luxuriant dark hair and a *Rokeby Venus* figure, Ena was twenty-three when Sargent, forty-one, entered the Wertheimer family circle. They remained such close friends that her husband later wondered whether they had been lovers.

The décor at 8 Connaught Place perfectly frames *Ena and Betty, Daughters of Asher and Mrs. Wertheimer*. A Louis Seize com-mode and the edges of large paintings are dimly visible behind the figures, with the gleaming Chinese vase to Ena's left. In several other portraits of sisters—*The Misses Vickers, The Wyndham Sisters, The Misses Hunter*—Sargent seated three young women in a decorous middle distance. His two Wertheimers stand close to the picture plane, as if announcing, "Here we are!"

The art critic Roger Fry, usually scathing about Sargent, de-clared this painting "in its way a masterpiece" ("in its way" quali-fying the praise), and went on: "The poses of the figures are full of

spontaneity and verve, and the contrast between the leaning figure of the younger girl and the almost exaggerated robustness of her sister is entirely felicitous . . . Mr. Sargent has recorded it as no one else could have done."

The cleaning and close examination of the picture in 1998 found tiny amounts of all its pigments in the incandescent white of Ena's gown. The lacy strap sliding off her right shoulder summons the ghost of *Madame X,* as do traces of one of Betty's straps, also originally off the shoulder, then scraped away and repainted in the vertical position. In *Madame X,* Sargent captured the icy artifice of a "professional beauty," with her powdered pallor, theatrical sexuality, and air of arriviste hauteur. He offers a very different drama in the art dealer's daughters, a painting suffused with exhilaration and affection: these young women are warm, natural, radiantly alive.

Just as *Asher Wertheimer* occasioned references to golden shekels and crucifixion, *Ena and Betty* lent itself to the image of the beautiful, sexual Jewess—*la belle Juive.* Even praise for the painting defined the sisters, with their physical intimacy and bare skin, as "other." Sargent's friend and first biographer, Evan Charteris, called the pair "splendid types of their race." The critic and artist D. S. MacColl said the figure of Ena had "a vitality hardly matched since Rubens, the race, the social type, the person."

Sargent painted Ena again in 1904, but first he did a second portrait of her mother. Edward and Alfred Wertheimer had recently died, and this *Mrs. Asher Wertheimer* offers a stark contrast to the earlier one. In both paintings Flora looks highly refined, attended by luxe objects from her husband's and Sargent's collections. In the brightly lit 1898 image she stands, wearing white, her countenance attentive and direct. Six years later Sargent portrays her in black,

seated in near darkness, with graying hair and quieter jewels—
majestic, grave, apart.

The Royal Academy showed the second *Mrs. Asher Wertheimer*
in the summer of 1904. To Ena, Sargent wrote, "Tell your mother
that her portrait is the favorite among my things at the RA & looks
very well." *The Academy*, a weekly review of literature and art,
called it "surely one of the finest things in modern portraiture." In
its depth and tone, the second Flora proved a better match for *Asher
Wertheimer* than its predecessor had. Asher hung it facing his own
portrait in the Connaught Place dining room and included it in his
gift to the British national collection.

Ena began sitting for her new portrait that spring, only "sit-
ting" is the wrong word. It seems that she swept into the studio one
day with her scarf and coat flying behind, and Sargent decided to
paint her that way, "in full sail"—*a vele gonfie.*

He was also working at the time on his picture of the Marlbor-
ough family, initially at Blenheim, their Oxfordshire estate, then
in his studio. The duke left his ceremonial Order of the Garter robe
and plumed hat in Tite Street between sittings. These—or impro-
vised copies—proved perfect props for an artfully transgressive
collaboration between Sargent and Ena that transforms her into a
dashing cavalier.

Members of the Most Noble Order of the Garter, the oldest and
most senior order of knighthood in the British system of honors, are
chosen by the sovereign. Aside from royalty, only twenty-four indi-
viduals hold it at a time. Edward VII appointed his wife, Queen Al-
exandra, the second woman ever to become a "Lady of the Garter."

Ena, who had worn a revealing white gown in Sargent's 1901
portrait of her and Betty, appears three years later fully swathed
in masculine black (Garter robes are actually deep blue velvet). Her
face, as she looks back over her shoulder, again appears lit from
within, and she makes the hat with its fancy ostrich feathers look
feminine and stylish. For a touch of color Sargent added a man's

ceremonial vest, its gold braid visible by her chin. Even Ena's black glove and the white ruffles at her wrist and throat echo male courtly attire. Barely visible beside her is a broomstick Sargent asked her to hold to puff out the cloak, simulating the volume and motion of her initial entrance "in full sail." Several viewers saw it as a sword.

When the portrait was shown at the Royal Academy in 1905, the caption on the inevitable *Punch* cartoon read: "Call yourself a soldier! Look at *me!*" The critic for *The Graphic* pronounced the painting "a triumph . . . one of the most subtle and brilliant things Mr. Sargent has ever achieved."

The artist sent Ena a review of the exhibition stamped with the word DAMN in black ink—a device he used not infrequently. The paragraph he damned criticizes his handling of perspective and his "roystering braggadocio," yet the review offers "a word of unreserved praise for our best portraitist. 'A Vele Gonfie' is delicious . . . The arch beauty of the face is haunting." In a note Sargent sent to Ena with the review, he wrote, "The last phrase of this is a gem": it was, "The natural man would dearly like to take that exquisite little countenance between his palms and kiss it, and so I think, too, would the natural woman." Exquisite little countenance? Ena was six feet tall, the painting only slightly smaller. Insouciant crossdressing and ambidextrous sexuality heighten the figure's allure.

According to Evan Charteris, Sargent did not read newspapers and was indifferent to world events. Yet he had shown two portraits of Jews, *Asher Wertheimer* and *Mrs. Carl Meyer and Her Children*, at the 1900 Paris Exposition during France's infamous Dreyfus affair. He may have seized another highly charged moment in 1904–05 to portray Ena—not royal, noble, Anglican, or male—as a knight of the Garter in full regalia, potent symbols of the uppermost British honor.

Tens of thousands of Jews fleeing poverty and religious persecution in eastern Europe had come to Britain in the 1880s and '90s, which led to a sharp rise in opposition to immigration. Early

in the new century, British nationalists railed against becoming the "dumping ground" for Europe's "dregs"; newspaper editorials warned against foreigners bringing in dirt, disease, and crime; a priest in Limerick led a boycott of Jewish traders; violent mobs attacked Jews in Wales. The British government in 1903 proposed new restrictions on "undesirable" immigrants, and debates about a proposed Aliens Act took place in Parliament and the press throughout 1904. The act, passed in 1905, aimed to control the influx, despite opposition from Liberal politicians and Jewish leaders. While the law did not name specific groups, its intent was clear: the only "aliens" entering Britain in large numbers at the time were eastern European Jews.

Asher Wertheimer and other acculturated British Jews provided financial support to the newcomers as well as to their coreligionists in Russia after thousands were killed in pogroms. Still, the immigrant population embarrassed the Anglo-Jewish elite.

It was in this context that Sargent knighted Ena, and the *Punch* cartoon depicted him and Velázquez delivering their paintings to the National Gallery as "Desirable Aliens."

A Vele Gonfie was one of three Sargent portraits in the 1905 Royal Academy exhibition that underscored the dramatically shifting currents in British society at the turn of the century, with much of the old order in decline and new energies on the ascent. The other two were *The Marlborough Family* and *The Countess of Warwick and Her Son*.

Like many of the aristocrats described by one journalist as "Splendid Paupers" during Britain's long agricultural depression, the 8th Duke of Marlborough—Winston Churchill's great-grandfather—had begun selling land and heirlooms from his Oxfordshire property in the 1870s. It was his son, the 9th Duke,

who married Consuelo Vanderbilt and commissioned Sargent's portrait of his family. The artist posed the couple with their two young sons and Blenheim spaniels in the soaring Great Hall of Blenheim Palace. Consuelo, taller than her husband, stands on a higher step to account for the difference. The beautifully composed portrait is ceremonial and stately, the duke in his Garter robe, the faces as expressionless as the architectural stone except for the faintly smiling younger son and one eager dog. This marriage of British title and American wealth had been a fiasco from the outset, although Consuelo's fortune did save the palace. The couple separated in 1906 and eventually divorced.

The third emblematic Sargent portrait in the 1905 exhibition was of Daisy Greville, Countess of Warwick—a glamorous beauty who had inherited one fortune and married another, although both were on the wane. Born Frances Evelyn Maynard, she was descended from viscounts on her father's side and, on her mother's, from mistresses to kings. Daisy specialized in spending money and in the high Edwardian sport of adultery. Her husband, Francis Greville, Lord Brooke, became the 5th Earl of Warwick in 1893. Their only child, born in 1882, would be the 6th. A year after the arrival of his heir, Lord Brooke had a "natural" son with a household servant.

And Daisy had a passionate affair with a close friend of the Prince of Wales, Lord Charles Beresford, a navy admiral and MP who fathered at least one of her children. (He famously declined an invitation from the prince by wire: "Can't possibly. Lie follows by post.") When Daisy learned that Beresford's wife was pregnant, she sent him an outraged letter. Lady Charles opened it and threatened to have her husband's mistress banished from the London season. Daisy appealed to the prince, who tried unsuccessfully to negotiate with the Beresfords, then took her up himself, calling her "my own darling Daisy wife." She retained that

position for most of the 1890s—it was she who later explained that his Marlborough House set objected to the inclusion of Jews because they had brains and understood finance. The prince took up with a new mistress, Alice Keppel, in 1898, and became King Edward VII in 1901. Daisy fell in love with Joseph Laycock, a wealthy brigadier general and Olympic sailor, with whom she had two more children.

After a left-wing journalist criticized the lavish ball she threw to celebrate her husband's accession to the earldom, Daisy converted to socialism, supporting efforts to help poor women and children, founding schools, backing liberal political candidates, even running for office—and prompting jibes about the socialite socialist and the "Red Countess."

Sargent painted her in his studio with one of her sons—not the next Earl of Warwick, now twenty, but seven-year-old Maynard, the boy she had with Laycock. Alluding to portraits by Romney and Van Dyck in Warwick Castle, he set his subjects in an idealized sylvan landscape—Daisy statuesque in a low-cut oyster-colored gown and elaborately draped cloak, Maynard perched on a pedestal in a ruffled white shirt and black tights. The child hated the sittings and later said he'd been strapped to the pillar for hours. Sargent's antagonist Roger Fry found the painting "unpleasant," its color "clayey." A critic for *The Art Journal* noted "the superb make-believe of imperious disdain expressed in the tense profile and pose of the Countess."

The combination of the agricultural depression, the 1894 imposition of estate taxes, Daisy's extravagance (some of it philanthropic), and her husband's ill-advised speculations landed the Grevilles in serious debt. And like many of their peers, they began selling pieces of their heritage—among them Rembrandt's *Portrait of Floris Sloop* (to Charles Wertheimer) and the Romney and Van Dyck from Warwick Castle. After Edward VII died in 1910, Daisy

threatened to publish his letters to her, hoping for a large settlement from his son. A court stopped her.

All the markers of aristocratic privilege—Marlborough's palace, ancestral portraits, chivalric robes, Blenheim dogs; Daisy's beauty, royal license, more portraits, "imperious disdain"—could not keep these lives from losing altitude. At the same time, Consuelo and her "new" American fortune were about to leave the Marlborough fold. And the American Sargent was conspiring with the Anglo-Jewish Ena to play around with emblems of patrician entitlement. Ena in full sail looks as vibrant and sparkling as Marlborough and Daisy appear flat and stale.

Ena wanted to be a painter. She studied with Julius Rolshoven, an American friend of Sargent's who taught in Venice, Paris, and London. And in 1902 she enrolled at the Slade School of Fine Art, where William Orpen and Augustus John had recently trained. She left three years later with a certificate in painting. The Slade had begun admitting women as soon as it opened in 1871, and most of its students at the turn of the twentieth century were female. The graduating class of 1905, photographed on a lawn in front of the school, is a sea of white dresses and picture hats. The artists Dora Carrington, Gwen John, and Vanessa Stephen went to the Slade; Stephen was there in Ena's first year, although she was also studying with Sargent at the Royal Academy School. Even for women who did not become professionals, art school provided an opportunity to learn from experts; for many, it was a beguiling interlude before marriage. Walter Sickert, an instructor at the Slade, told Ena after looking at her drawings, "Miss, you had much better go home and learn how to wash and iron, you might be quite good at that."

Although Ena got married shortly after leaving art school,

washing and ironing were not in her remit. First, however, she went to France, where she secured permission to sketch at Versailles and tried, with an introduction from Sargent, to see Rodin; the sculptor wrote on his business card, in French, "Madame: I am very unhappy not to be able to accept your kind invitation but I am tired and somewhat ill."

The Court Circular announced Ena's engagement in July 1905. Her fiancé, Robert Moritz Mathias, came from Cologne, in North Rhine-Westphalia. He proposed "for the nth time" at a musical party given by one of his relatives, reported their eldest daughter, and Ena was so moved by the evening's lieder that she accepted.

Mathias had come to London to work for his mother's brother, Ludwig Mond, a highly successful German-born industrial chemist, philanthropist, and art collector. Among Mond's major discoveries were a compound used to produce pure nickel and an extraction process that made Brunner Mond Ltd. the largest alkali-manufacturing firm in the world. In 1926, it merged with other leading chemical companies, including Nobel Enterprises, into the giant Imperial Chemical Industries.

Robert Mathias served as secretary and then managing director of the Mond Nickel Company. He had "a delightful sense of the ridiculous and an imperfect mastery of the English language," wrote a Mond biographer, providing "a gay contrast to the serious company" in his uncle's household.

Somewhat like the Rothschilds, although less prominently and on a much smaller scale, Ludwig Mond built a dynasty based on family, business, and art. He appointed his sons, Robert and Alfred, to key positions in his enterprises, and brought in the sons of his sisters—Robert Mathias and Emile Schweich (who changed his name to Schweich-Mond)—as well. Also like the Rothschilds, the Monds tended to marry within a fairly small circle.

Ludwig himself married one of his cousins. Their elder son,

Robert, married Edith Helen Levis, the sister of Adèle, Mrs. Carl Meyer. The Monds' second son, Alfred, married Violet Goetze, whose sister Angela married Alfred's cousin Emile Schweich-Mond. And Emile's sister married his wife's brother, the artist Sigismund Goetze. Another Goetze brother, Leopold, was a print-maker who did mezzotints of several Sargent portraits, including those of Asher, Flora, and Ena. Moving outside the tribe, Robert Mathias's sister, Maria Theresa, married Rudolph Said-Ruete, a grandson of the sultan of Muscat, Oman, and Zanzibar.

The Monds lived in an imposing London mansion called the Poplars on Avenue Road near Regent's Park, with large gardens and a conservatory, and had an estate in Kent called Combe Bank. Ludwig's wife, Frida, never entirely adjusted to life in England. To mitigate her loneliness, Mond brought a close friend from Cologne, Henriette Hertz, to live with them. Hertz introduced the couple to the art historian Jean Paul Richter, who encouraged Ludwig to collect and became his principal adviser. One of Ena's daughters re-called being mystified, on childhood visits to the Poplars, by a large painting of Christ on the Cross that had the sun and moon in the sky at the same time. It was an early Raphael.*

Ena and Robert Mathias were married on October 25, 1905. Among Asher's wedding gifts to his eldest daughter were her por-trait by Sargent, *A Vele Gonfie,* and a generous financial settlement. Sargent gave her a picture by his friend Robert Brough, a young Scottish artist who had recently died. He sent it early since he was about to go away: "Please accept it with my blessings," he wrote. "I shan't be back in time for the auspicious wedding, and this place may be burgled and burnt."

* The Monds and Henriette Hertz spent part of each year at the sixteenth-century Palazzo Zuccari in Rome, which Ludwig bought in Hertz's name in 1904. Assisted by Richter and others, Henriette turned it into a research library specializing in Italian art, the Bibliotheca Hertziana, which she later gave with an endowment to the Kaiser Wilhelm Institute in Berlin. Now run by the Max Planck Institute for Art History, it remains a vital center for art historical study in Rome.

The auspicious wedding took place at the West London Synagogue in Upper Berkeley Street. In a formal bridal photograph, Ena looks resplendent in silk and lace, holding an armful of white lilacs, surrounded by children and bridesmaids with sheaves of lily of the valley. A diaphanous veil settles in soft folds at her feet. The Mond greenhouses may have supplied these spring flowers in October. The children probably came from the Mond contingent as well, since there were no Wertheimer grandchildren yet.*

The newlyweds spent their honeymoon at the Grand Hotel in Paris. Things did not go well at first, according to their daughter Diana, who heard this story from Robert when she was about to get married. After dinner, Ena refused to let her husband into the bedroom. He spent their wedding night alone in the suite's sitting room. Evidently she later relented. They had five children in seven years. Sargent made up the word *philoprocree* probably to mean "lover of procreation" when he inscribed his 1910 pencil sketch of her "to Ena philoprocree."

Mr. and Mrs. Robert Mathias lived at 15 Montagu Square, a five-story terraced town house between Hyde Park and Regent's Park, not far from her parents. Ena converted a room above the garage into her painting studio. The marriage did not significantly alter her friendship with Sargent, who now addressed her by mail as "Dear Mrs. Mathias," where he had previously written, "Dear Miss Wertheimer," "Dear Miss Ena," and "My dear Ena." He called regularly at Montagu Square, asked her to lend *A Vele Gonfie* to various exhibitions, and enlisted her help in supporting other artists. The organizers of a London conference on the French painter Auguste Bréal wanted "a few distinguished and illustrious names

* Consecrated in 1842, the West London Synagogue of British Jews had been founded by prominent families who broke away from London's two major Orthodox congregations, Bevis Marks (Sephardi) and the Great Synagogue (Ashkenazi), to establish a somewhat less conservative house of worship in the fashionable West End. It moved to Upper Berkeley Street in 1870.

for a list of patronesses to bring good luck," Sargent told her: "Will you give yours? Of course *cela n'engage de rien.* [It won't commit you to anything.] Please say yes."

It was with regard to a dinner invitation from one of the Monds that Sargent told Ena he could not attend since he had plans with Rodin that evening, but he promised her he would try to stop by after dinner, "& if I do I shall crawl in on all fours straight to you."

He occasionally joined her for outings with her children, and when she proposed bringing the eldest, John, to his studio, replied, "I will be delighted to see you and the Greek God (so shy and struggling although possessed of magnificent aplomb) on Sunday morning."

A note declining an invitation was a gift in itself:

> How can one explain to you, and remain your friend and sincere well wisher, that lunching out is one of the things one dreads the most in a life beset with nightmares? Especially at a season when there are only about four hours of daylight. If I were blind or paralyzed you would see me dropping in daily and enchanting you with my cheerful presence—that time may shortly come—but for the moment I can still sit up and tint my little pictures, singing merrily the while.
>
> Won't you come here on Sunday morning & see a few Carrara watercolours? . . . I hope your father may pay us one of his Sunday visits.

Commissioned to "do" Robert Mathias a few years later, Sargent told Ena, "I am watching my chance to give your husband a sitting." It was on this occasion that he sighed, "Why won't some of my sitters' portraits get finished?" His sister Violet Ormond now had children, and Sargent whispered his strategy for thinning out

the crowd: "I have tried giving my nephews' mumps to some of them."

In the reception of Sargent's 1901 *Ena and Betty*, Ena drew the most attention, as she did in life. The younger sister in the portrait could be a rosebud beside a peony in full bloom. Yet the bud had been married for two years. Betty's husband, Euston Abraham Salaman, came from another large, wealthy clan. One of fifteen siblings, he had been named for Euston Square in central London, where his parents were living when he was born. His brother Redcliffe, later a distinguished scientist, arrived when the family resided in Redcliffe Gardens, Kensington. Their father, Myer Salaman, had attended University College School at about the time that Asher and Charles Wertheimer did.

Euston took over as head of the family's ostrich feather business after his father died in 1896. I. Salaman & Co., founded by his grandfather, had once been the largest importer and wholesaler of ostrich plumes in the world. It had an active office in New York, where Euston and Betty spent a good deal of time during the first years of their marriage. In London they eventually settled at 6 Connaught Place, next door to her parents.

A year after Sargent painted Ena and Betty, another artist did a portrait of Betty alone. Giovanni Boldini, an Italian who had taken over the lease on Sargent's studio in Paris, spent most of 1902 in London; Sargent and Ena helped him find a studio. Known as "The Master of Swish" for his sinuous brushstrokes, Boldini was, according to one irreverent account, "a society portraitist as artificial as any who ever stretched a lady's fingers to tickle her vanity." He painted several of Sargent's subjects, as well as Whistler, Montesquiou, Degas, and supposedly Sargent himself, twice, although neither of those portraits looks like Sargent.

Boldini's Betty is swishy indeed. She holds a fan in one hand, as in Sargent's double portrait, but that is the extent of the similarity. Where Sargent's Betty is a secret in dark red velvet, Boldini's is a vamp in gauzy pink and white, her waist cinched tight, left breast almost entirely exposed, right hand reaching up to her shoulder as if she might slip the bodice entirely off. This outré image may have been the Salamans' answer to Sargent's comparative restraint—and perhaps to his fondness for Ena.

Asher now spent winters in Cannes on the French Riviera with Flora and their younger children. He had always been drawn to bodies of water: to Ramsgate on the English Channel, where he rescued a drowning woman in 1869; to Plymouth, the port city on England's southwest coast where he and Flora spent their honeymoon; Temple, the country house he rented for several years, was on the Thames. From Cannes in February 1913, Betty sent her mother-in-law a photograph of her parents strolling with Ena on the promenade—Asher in a three-piece suit, Flora in black, Ena, as tall as her father, in white. Asher turned sixty that year; both he and Flora carry walking sticks.

Ena and Betty remained close throughout their lives, speaking by phone nearly every day. And in 1908, as Sargent was swearing off what he now called "paughtraits," Ena and her husband commissioned one of Betty that set off quite a kerfuffle.

Unlike all the other Wertheimer pictures, this one is oval in shape. Ena drafted a letter of effusive thanks to Sargent "for the wonderful 'Pawtrait' . . . truly I am struck dumb with delight and speechless." She had found a frame "quite deep enough for your canvas—it is creaking in its excitement & eagerly awaiting the 'Pretty Creature' it is to encircle!"

Her letter survives only in two extensively revised, incomplete

drafts, and what actually happened here is not clear. Sargent's
Wertheimer portraits were Asher's province. Ena was afraid her
father would want to add "this MASTERPIECE to his 'Mess'" (the
Connaught Place dining room): "Rob & I are really in a very awk-
ward dilemma being left to settle with Father. Of course now I am
married it is not the same."

Another portrait further complicated things. Sargent was
also working that spring on his painting of the fifth Wertheimer
daughter, Almina (called Alna), and had decided to reduce its size.
"Otherwise," he told Ena, "I will never pull through." He folded
several inches of canvas over the edges of a stretcher smaller than
the one he had started with, and advised Asher that he would re-
turn half the payment.

The Mathiases wanted to pay for the picture of Betty, Ena
continued:

> Robert would feel it a salve for his conscience if you will
> accept the enclosed cheque (£500) for the present at any
> rate. I don't like to ask you. I know we can't call it quits on
> that. The picture is priceless. But will you accept it? You
> mentioned something to us at your house about half [the
> cost of] Alna's—but I have no idea what Alna's was, as you
> well know. I hope I have not done nor said anything wrong.
> If so please let me cover my faux pas with our thanks &
> unbounded gratitude.

She was worried about offending both Sargent and her father: "I
cannot write & explain [to Asher] about Alna's picture—I dare
not!"

Thanking her for the letter and check, Sargent graciously
claimed, "if there is anything wrong it is on my side." He had not
expected payment for Betty's portrait, he said, thinking it cov-
ered by Asher's advance for Almina's—evidently assuming that a

thousand pounds for a large portrait would cover two smaller ones at five hundred pounds each. He sent the Mathias check on to Asher and told Ena he would have the oval canvas stretched "as soon as it is dry enough and then we must see how it looks in its frame."

As Ena expected, Asher did not like this arrangement. From the French Riviera he sent a wire to her and Robert: "Think it best & right that you should settle with Sargent independently of me all well best love Wertheimer."

He did not blame Ena and Robert for this tangle, saying, "Sargent would have done just as well not to interfere—although I am sure he meant it kindly." Actually, Sargent hadn't interfered. Insofar as we can tell from limited evidence, he forwarded the Mathias check in order to clear his debt to Asher, effectively taking no payment for Betty's portrait.

Turning to happier subjects, Asher reported to Ena on the fine weather, golf links, and family outings in Cannes, and added: "I need hardly say that Mother & I will be more than delighted if you or Betty or both of you will pay us a visit & we shall do our best to give you an enjoyable time." If their husbands would accompany them, "it would enhance our pleasure." As exacting about cuisine as he was about financial arrangements with Sargent and the careers of his sons, Asher had found the fare at their hotel "rather indifferent," but discovered a "great resource" in the club (probably a golf club), where he had just had "a most sumptuous meal. Quite worthy of [the] Ritz!!"

His invitation to Ena came with a condition: she must see her doctor and get his "*full* permission" to travel. She was pregnant again.

Ena's excitement over "this MASTERPIECE" notwithstanding, the oval portrait of Betty in a low-cut scarlet gown, seated outdoors against a cloudy sky, is more faux eighteenth century than genuine early twentieth. Seeing it in 1921, the *Times* critic said that despite Sargent's attempt to revive the Rococo, "One feels that

neither he nor his sitter believes in the world of Louis Quinze; it is like fancy dress worn with constraint."

Asher did claim the picture for Connaught Place, but hung it in an upstairs boudoir rather than the dining room, and did not include it in his gift to the National Gallery. It went to Betty after her parents died. She loaned it to a Sargent retrospective at the Royal Academy in 1926. And then she sold it.

She had a copy made by Reginald Eves, a Sargent protégé who "replicated" about a dozen of the older artist's portraits, with his consent. It was not uncommon for sitters to commission copies to give to friends or hang in place of paintings they had sold. And a dealer might supply a copy to forestall awkward questions about a suddenly empty space on a wall. Three Eves copies of *Sir George Lewis* had "something wrong" about the heads; Sargent repainted them himself.

The New York collector John Gellatly bought the oval *Betty* for 6,250 guineas ($30,000) in 1928, and gave it to the Smithsonian American Art Museum in Washington the following year. A memorandum in the museum's curatorial files quotes an agent for the picture saying that Betty sold it to pay her gambling debts. Robert Mathias, noting that both Betty and Ena were wildly extravagant, said nothing about gambling.

On a photograph of the painting, Betty wrote:

> This portrait of me (Betty Wertheimer) was painted specially by Sargent for my father Asher Wertheimer, and the artist always considered it one of his finest examples in Portraiture. It was painted about the year 1908 and hung for many years in my father's dining-room, which was often spoken of as the Sargents Mess.

The only accurate fact here is the date. Was Betty angling for a high sale price? Gellatly compounded the distortions, claiming that Sargent had been in love with her, "that if he married any one it

would be Betty," and "that he never accepted a guinea in payment
for this portrait either from Betty or her father, as it was a labor of
love and devotion." He may have been quoting the sitter—and also
attempting to enhance the significance of his gift.

<center>⌒</center>

Betty's husband, Euston Salaman, volunteered for war service in
1914 and spent a year with the British ambulance corps in Flanders.
Then, in November 1915, he received a commission as second lieu-
tenant in the Royal Field Artillery, Territorial Force. Three months
later he died of typhoid fever. Though not killed in action, he re-
ceived a farewell military salute. One hundred uniformed soldiers,
a Royal Field Artillery band, and horse-drawn carriages escorted
his casket from Connaught Place to the Willesden cemetery in Feb-
ruary 1916. He and Betty had been married for seventeen years.
They had no children.

A year later, Betty married Major Arthur Ricketts, a surgeon.
She wrote a play with one of her friends called *A House of Cards*
under the pseudonym "Laurence Euston," using her first husband's
first name as a surname. The play, about a woman who cheats at
poker to support her husband's diplomatic career, was produced in
1926 and ran for thirty-six performances to mostly negative re-
views. One said that "as the inexorable law of London society . . .
is that you may break all the ten commandments provided you do
not cheat at cards, she kills herself, thus ending at the same time a
hectic career and an unsatisfactory play."

As Mrs. Arthur Ricketts, Betty spent most of her time at Mill-
water Cottage, near the village of Ripley in Surrey. Her husband
visited on weekends, but the couple eventually separated, and by
1932 Ricketts had deleted her from his entry in *Who's Who*. Until
her death in 1953, Betty lived in Surrey with an Austrian woman
named Angela Thumer.

Oriental Accents

Sargent posed a trio of the younger Wertheimer children, Essie, Ruby, and Ferdinand, informally at home in 1902. Barely visible behind them, a terrestrial globe suggests a schoolroom, although the scene's deep shadows and saturated colors give it an exotic, sensual mood.

Thirteen-year-old Ruby, the youngest member of the family, steals the show. Innocently alluring in a red dress and gossamer pinafore, she tilts her pretty head to one side and leans on a large Oriental ottoman. There are bows everywhere—in her hair, on the ottoman, around the neck of her small dog, even on Asher's black poodle, next to her on the carpet and nearly her size. The skirted ottoman anchors the scene. Ruby's pinafore, done in a few deft strokes, trails down her back and slips off one shoulder.

Inviting Elizabeth Lewis to his studio that spring, Sargent promised to show her Antonio Mancini's recent portrait of "the invalid Wertheimer child which is very fine." He meant Ruby, who had diabetes as an adult and health problems all her life.

The only Wertheimer daughter not to marry, Ruby had a good singing voice and performed at benefits, private concerts, and, after 1914, for the war effort in England and France. Asher and Flora left

legacies to all her siblings, but their wills do not mention Ruby. They had probably made provision for her early on.

Ferdinand Wertheimer was a lot of name to carry around. Asher and Flora's youngest son, a godson of Ferdinand de Rothschild, was called Bob. He was fourteen and a student at Harrow when Sargent painted this trio. Sitting opposite Ruby on the floor and, like her, leaning on the ottoman, he looks precocious and alert. He wears the classic British schoolboy outfit—a waist-length Eton jacket (they were known as "bum freezers"), a white shirt with a broad, stiff collar, and a black necktie. His right hand lightly supports his head, the left rests backward on his calf. After Harrow, Bob went to Balliol College, Oxford, and took first-class honors in modern history in 1911.

That September, Asher asked a favor of Wilhelm Bode in Berlin. Ferdinand/Bob was interested in fifteenth-century Italian history, "especially in its artistic aspect," Asher wrote, and was thinking of writing a thesis on Leonardo at the court of his patron Ludovico Sforza, for a further degree. The young man's tutor at Balliol had advised him to consult Dr. Bode, and Asher hoped this eminent friend might be willing. Bode replied at once, and Bob made plans to visit him. The exchange of letters ends there, unfortunately. Whether or not Bob embarked on the Leonardo project, he enlisted in the Royal Army Medical Corps when war broke out in 1914, and later transferred to the Royal Field Artillery, rising to the rank of lieutenant. He served in India, Mesopotamia, and France for the next four years.

At the height of the war, the British royal family changed its name from the Germanic Saxe-Coburg-Gotha to Windsor. And in 1916, the two surviving Wertheimer brothers, Conway and Ferdinand, legally changed theirs to Conway Joseph Conway and

Ferdinand Joseph Conway (the anodyne "Joseph" being Flora's maiden name)—to avoid any identification with the enemy, and no doubt also to avoid sounding Jewish. There is no record of Asher's response to the erasure of his surname.

Hundreds of British Jews anglicized their names in these years. William Rothenstein's brothers Albert and Charles became Rutherstons. Schlosses turned into Castles, Auerbachs into Arbours; Waldsteins became Walstons. Famous German-born Jews including Sir Ernest Cassell, Sir Carl Meyer, and Sir Felix Semon published "loyalty letters" in *The Times* declaring their allegiance to Britain.

After the war, Ferdinand Wertheimer/Bob Conway became a painter, a pianist, and a writer. A literary friend to whom he sent some of his short stories wrote a kind but honest response, singling out the overuse of a character named "Peter Schlemiel" and warning, "you ought to beware of him." Bob hosted private concerts at his house, once featuring the young Spanish pianist José Iturbi. He gave motorcars to his nieces and nephews for their eighteenth birthdays.

In the 1930s, he began living with a sculptor named George Edgar Campbell. The couple spent part of each year in the South of France. Bob gave the architect Denys Lasdun his first private commission in 1937, to design a modernist town house at 32 Newton Road in Paddington. Just twenty-three and strongly influenced by Le Corbusier, Lasdun built a four-story structure with a steel and concrete frame, a glass-brick wall by the front door, thirty feet of plate glass windows spanning the living room, and a large studio on the top floor that had north light and a terrace. Bob collected antique furniture and modern art: early photographs of the house show a Modigliani on a wall.

He and George moved in the 1940s to Camberley in Surrey, about twenty miles from Bob's sister Betty. The artist and cartoonist Ronald Searle bought the Newton Road house, and later said it

had been built for "two bachelor artists, unknown artistically, but extremely wealthy." He found paintings by Lucian Freud left behind in the cellar.

Bob died at Camberley in 1950. Having joined the Anglican Church, he was buried in the cemetery of St. Peter's Churchyard in Frimley. He left half of his estate to George Campbell, the other half to the bishop of Bath and Wells. His tombstone bears a Canterbury cross and two Jewish stars.

The light in Sargent's 1902 trio portrait falls on Ruby, Ferdinand, and the ottoman. Essie, behind them on a sofa in the shadows, age twenty-two, looks sullen and bored. She holds another small dog in her lap. Ruffles at the neck, wrists, and hem of her dress echo the ottoman's gathered skirt, and a loose vermilion sofa cover accentuates her pallor.

She married Eustace Henry Wilding, a stockbroker and the son of an Anglican vicar, "by special license" at a register office in Paddington Road in 1905. A special license allowed a couple to marry outside the Church of England, in any location at any time, without posting public "banns" or notices of the upcoming wedding. It required permission from the archbishop of Canterbury, and was often sought when the parties were in a hurry (if the bride was pregnant, for instance), or came from different religions, as Essie and Wilding did. The couple lived at Wexham Place, a large "gentleman's residence" on heavily wooded grounds in Stoke Poges, a village in Buckinghamshire. They had three children, all baptized in the Church of England. Essie died in 1933.

When London's New Gallery showed *Essie, Ruby and Ferdinand, Children of Asher Wertheimer*, in 1902, a writer for *The Spectator* pronounced Sargent "a great painter not merely because of his enormous technical power, but because he can penetrate

below the surface and reach the heart of his subject." The heart of
the subject, to this critic, was its artifice and "Oriental" tone: "the
air we feel smells of scent and burnt pastilles . . . the moral atmo-
sphere of an opulent and exotic society has been seized and put
before us."

Another critic went further: the artist had adopted "a more dec-
orative scheme, a more luscious chord of color than usual," and the
three figures, "variously and gaudily dressed . . . lie about among
cushions like odalisques in a harem, and are sprinkled over with
dogs." Asher hung the painting over the mantelpiece in the Con-
naught Place dining room.

Sargent's second Wertheimer trio, *Hylda, Almina and Conway*
(1905), appears to be set outdoors but was probably done in the
studio with props, as were the oval *Betty* and *The Countess of War-
wick*. And here again, the artist seems less than engaged.

The most appealing of the figures is Hylda, seated in the fore-
ground with a terrier under one arm, looking lost in thought. With
her pink-tinted spectacles, downward glance, frizzy hair, and white
lace bonnet and blouse, she offers a sharp contrast to the impassive
siblings standing behind her. Although this trio, like the first, is
identified as *Children of Asher Wertheimer*, Almina was nineteen,
Conway twenty-four, Hylda, looking much younger than the oth-
ers, twenty-six.

Sargent had painted Hylda alone in 1901, the year he did *Ena
and Betty*, but everything about this single portrait is awkward.
Standing beside an eighteenth-century table in a pale mauve eve-
ning gown, Hylda cocks her head to the right with her body angling
left. No doubt Sargent suggested this pose, but it feels unnatural.
Spiky chrysanthemums in a fish-shaped silver vase on the table
seem to tug at her dress, and her spectacles make her look vaguely

ill. "I had great difficulty persuading [Sargent] to paint me wearing my pince-nez," she later recalled: "He tried hard to induce me to take them off, but I should have felt uncomfortable without them." Even with them she appears uncomfortable. *Hylda*, the largest of the Wertheimer portraits, was not exhibited during Sargent's lifetime; nor was the trio of *Hylda, Almina and Conway*.

Hylda married Henry Wilson Young, an electrical engineer and contractor, also "by special license," at the Paddington Road Register Office. The couple lived on Russell Square in Bloomsbury and had one son.

Conway, who stands behind Hylda holding another dog, has a stockier build than his brothers. He followed Edward and Alfred from Harrow to Trinity College, Cambridge, then transferred to Balliol, where he took B.A. and M.A. degrees. He studied and practiced law, and stood for Parliament in 1910 and 1916, losing both times.

He married Joan Cecily Young, a New Zealander, in 1917. The couple moved next door to Asher and Flora at 6 Connaught Place, where Betty and Euston Salaman had lived. The deaths of his brothers Alfred and Edward had left Conway the senior Wertheimer son, and he took charge of the art gallery's papers after Asher died in 1918. He was appointed king's counsel, a high professional distinction, in 1927, and queen's counsel in 1953. He and Joan bought a house called Turville Court at Henley-on-Thames in Buckinghamshire, where Conway died in 1953. They had no children. The Wertheimer archive disappeared, apparently discarded by Joan.

In this 1905 group portrait, Almina is dressed for riding in a dark fitted jacket, white stock tie, and red hat, holding gloves and a crop in one hand. She had attended the Roedean boarding school in East Brighton, Sussex, between 1900 and 1902. Founded in 1885 to pre-

pare girls for the newly opened women's colleges at Cambridge, this Church of England school had a selective admissions process that required a letter of reference. Almina's came from Alfred de Rothschild.

She may have been named after his "natural" daughter, Almina Wombwell. Alfred de Rothschild, who never married, was widely known to have had a child with his French mistress, Marie Boyer Wombwell. Called Mina, Mrs. Wombwell had been estranged from her British husband for years when the baby was born. The child's unusual first name was said to combine *Alfred* and *Mina*. Dickens might have made up her surname.

Almina Wombwell married George Edward Stanhope Moly-neux Herbert, 5th Earl of Carnarvon, at St. Margaret's Church, Westminster, in June 1895. Carnarvon, like many of his peers, had inherited a large estate and incurred mountains of debt. He needed an heiress. Alfred de Rothschild had quietly let it be known that he would settle a fortune on his "goddaughter" when she married, and he did: he gave her five hundred thousand pounds outright plus an annual income of twelve thousand pounds. He also paid off her husband's debts.

Among the couple's thousand wedding guests were H.R.H. the Prince of Wales and a roster of Britain's hereditary aristocracy, as well as diplomats, art collectors, musicians, and members of the more recently wealthy international elite—Rothschilds, Sassoons, Ephrussis, Montefiores. Also "Mrs. and Miss A. Wertheimer"— Flora and Almina. Asher's gift to the couple was a travel bag with gold fittings and a monogram and coronet of diamonds.

As Countess of Carnarvon, Almina restored and modernized Highclere Castle, her husband's property on five thousand acres of land in Hampshire—now renowned as the location for *Downton Abbey* (also for the orgy scene in Stanley Kubrick's *Eyes Wide Shut* and parts of the comedy series *Jeeves and Wooster*). The fortune that supports the fictional Downton Abbey, up to a point, comes

from Lord Grantham's American wife, Cora Levinson, who, like the source of the wealth that sustained the real Highclere Castle, is Jewish. Almina's Rothschild funds also enabled Lord Carnarvon to underwrite the archaeologist Howard Carter's discovery of Tutankhamun's tomb in Egypt's Valley of the Kings. Alfred de Rothschild never formally acknowledged Almina as his daughter, yet when he died, in 1918, he left her half of his estate.

Alfred's Almina was ten years older than Asher's Almina. At Roedean, Almina Wertheimer played soccer, studied piano, joined the drama club, and attended a Sunday evening lecture on Giotto by Roger Fry. She did not go on to a Cambridge college.

Sargent, having portrayed her with Hylda and Conway in the 1905 trio, painted her on her own three years later. This is the picture he reduced in size, telling Ena he would "never pull through" if he didn't and returning half of the thousand pounds Asher had paid for it—although his refund got bollixed up with the Mathias payment for the oval of Betty.

As he did with Ena for *A Vele Gonfie*, Sargent enlisted Almina, then twenty-two, in a costume-drama lark, this one pure Oriental fantasy—a sharp contrast to her appearance as buttoned-up equestrienne in the 1905 group. A rage for *turquerie* had swept the courts of western Europe beginning in the sixteenth century, as trade, travel, and international diplomacy introduced Ottoman culture to the Occidental imagination.

The vogue for all things Turkish peaked in the eighteenth century.* Enacting what Edward Said, the Palestinian American literary scholar and political activist, has called "the European idea of the Orient," Madame de Pompadour, the favorite mistress of Louis

* Not even the 1683 Siege of Vienna—when Ottoman Turks attacked the Habsburg capital and its Emperor, Leopold I—managed to dim the Western romance with the "exotic" East. Poland led the forces that defeated the attackers, which marked the beginning of the end of the powerful Ottoman Empire. Just then, in 1683, the early Samson Wertheimer arrived in Vienna to work with Samuel Oppenheimer as Leopold's court factor.

XV, turned the bedchamber of her château at Bellevue into a *chambre à la turque* modeled on images of the seraglio. She collected Turkish pipes, smoked Turkish tobacco, commissioned portraits of herself in Turkish costume. The Habsburg Empress Maria Theresa, a granddaughter of Leopold I, posed in Oriental dress for portraits by, among others, Jean-Étienne Liotard (called *le peintre turque* for his extensive use of this trope), and held gala celebrations with Oriental themes at the Viennese court. The figure in Rembrandt's 1632 *Man in a Turban*—previously titled *The Noble Slav* and *Man in Oriental Costume*, purchased by Samson Wertheimer, sold to the Vanderbilts, and now at the Metropolitan Museum of Art—was most likely a Dutchman dressed as a Persian or Ottoman prince.

Upholstered ottomans like the one in *Essie, Ruby and Ferdinand* became essential features of European interior décor. The first English-language edition of *The Thousand and One Nights*, a compendium of medieval Arabic tales with later French admixtures, appeared in the early 1700s. Sargent read the stories all his life, often in French, and especially loved *Dalziels' Illustrated Arabian Nights' Entertainments*, published in 1865 with images by, among others, John Everett Millais and John Tenniel.

His portrait of Almina Wertheimer draws on this historical fantasy and alludes to at least one specific painting—Ingres's 1842 *Odalisque with Slave*, in which a nude concubine reclines in a Turkish seraglio with a slave playing a lute near her feet. Sargent cast Almina as the slave, in a man's full-length Turkish coat (one of his favorite studio props) over a white gown. Suggestions of colonnades and a pool fill the background shadows. Like the Ingres figure, Almina holds a long-necked stringed instrument (an Indian sarod, also a studio prop), folds one leg under the other "Eastern style," and wears a choker and turban. And like the Western figures in eighteenth-century Orientalist paintings, she is clearly playacting. She doesn't even pretend to strum the sarod. Her accessories are lavish—gold coins dangle from the choker; there are

pearls and an egret feather on her large silk turban. Though the colors here are somewhat subdued, slices of ripe melon in a silver shell at Almina's feet enhance the sensual theme.*

Rather than minimize the Anglo-Saxon identification of Jews with Eastern exoticism in his Wertheimer series, Sargent accentuated it. Asher stands before a Japanese screen. Ena in the double portrait with Betty rests one hand on a Chinese jar. The shadowy "schoolroom" in *Essie, Ruby and Ferdinand* could be an opium den in Tangier. On a table in the second Flora portrait, a small Chinese porcelain lion supports a crystal vase.

With Almina, the artist turned that identification into a double or even a triple play: an "Oriental" Jewess posing as a harem slave in Oriental costume—and also as an eighteenth-century European aristocrat dressing up as Oriental. In his Wertheimer portraits, Sargent took striking liberties with social types, strictures, the history of art.

This painting, the last in the family series, is in effect its finale. Asher hung it in the Connaught Place morning room, adjacent to the dining room, where eight of the others were on view, and included it in his gift to the nation.

Almina married Antonio Pandelli Fachiri, an American from a family of Greek merchants and bankers, in 1915. He worked at the London Aerodrome in Hendon for Claude Grahame-White, an early British aircraft manufacturer. The couple lived in England and Switzerland, and traveled frequently to the United States. They had no children. Almina died of pleurisy and pneumonia in 1928. She was buried in the Greek Orthodox Cemetery in West Norwood, London.

* On Sargent's relation to Ingres, the biographer and art critic Mark Stevens has suggested (in conversation) that the American found his admired predecessor's magnificent neoclassicism tight and controlled. "Sargent's brush lived to play," notes Stevens, "and one of his particular joys was loosening that classical stitch. He lets air into the Ingres room."

Only three of Asher and Flora's ten children married Jews—Betty (Euston Salaman), Edward (May Levy), and Ena (Robert Mathias). And only three—Ena, Hylda, and Essie—had children, none of whom married Jews. Like many other acculturated Anglo-Jewish families, this one was gradually blending into upper-middle-class British society.

Sargent told a friend in 1904 that he was "sick of portrait painting" and had gone to Italy "to escape the cursed business." Accordingly, he rarely portrayed a sitter more than once. Yet in the early years of the twentieth century he did at least two images in oil or charcoal of a few close friends, among them Sybil and Philip Sassoon, Henry James, and five of the Wertheimer women—Flora, Ena, Betty, Hylda, and Almina.

DEPARTURES

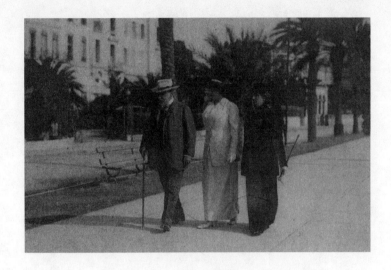

Asher, Ena, and Flora Wertheimer at Cannes, 1913.
(Collection of the late David and Katherine Mathias)

Asher: Art Wealth

A great public uproar in England over the impending sale of a Holbein painting to the American collector Henry Clay Frick in 1909 prompted Henry James to write a play called *The Outcry*. It was on schedule for production when the death of King Edward VII closed London's theaters, and James turned it into a short novel. In his high-toned comedy, the Holbein—*Christina of Denmark, Duchess of Milan*—becomes a fictional portrait by Joshua Reynolds, *The Duchess of Waterbridge*.

A character in the novel describes rich Americans as "such a conquering horde as invaded the old civilisation, only armed now with huge cheque-books instead of with spears and battle axes." The fictional owner of the Reynolds *Duchess* is the autocratic, impoverished Lord Theign of Dedborough. Although he needs huge checks, he disdainfully—and in tortured syntax—tells an American who is "after" his Reynolds that it is "a golden apple of one of those great family trees of which respectable people don't lop off the branches whose venerable shade, in this garish and denuded age, they so much enjoy."

The fictional American, whose compatriots were scooping up

Britain's ancestral portraits, reasonably asks, "Then if they don't sell their ancestors where in the world are all the ancestors bought?"

When Theign's intelligent daughter, Lady Grace, urges him not to sell the Reynolds, saying she has set her heart on saving the picture for England, he explodes: "And pray who in the world's 'England' . . . unless *I* am?"

A young art scholar tells Lady Grace that the current "trafficking" in art "deprives me of my rest, and, as a lover of our vast and beneficent art-wealth, poisons my waking hours . . . Precious things are going out of our distracted country at a quicker rate than the very quickest—a century and more ago—of their ever coming in."

Grace points out that England's precious things don't really belong to England: "I suppose our art-wealth came in—save for those awkward Elgin Marbles!—mainly by purchase too, didn't it? We ourselves largely took it away from somewhere else, didn't we? We didn't *grow* it all."

Much of England's "art wealth" had indeed come from somewhere else: British collectors had been acquiring precious things from all over the world for more than a century. And in the late-Victorian era, the direction of the flow had in fact markedly changed.

The "trafficking" lamented by Henry James's young pair—between old families lopping branches off their heritage and newcomers armed with huge checkbooks—was largely brokered by dealers acting as intermediaries. Samson Wertheimer had managed the transfer of eighteenth-century French furniture from the dukes of Hamilton to Rothschilds and Vanderbilts. Many of the Dutch and Flemish paintings Asher acquired from the Hope family went to Americans, Randlords (Alfred Beit and Ludwig Neumann), and Dr. Bode's museums in Berlin.

The rising concern about England's art drain that had helped secure the *Rokeby Venus* for the National Gallery in 1905 came into play here as well. The Holbein portrait, commissioned by Henry VIII in his search for a fourth wife, was owned in 1909 by the Duke

of Norfolk. Colnaghi and Knoedler were about to ship it to Frick in New York when the National Art Collections Fund raised £72,000 ($360,000) to acquire it for the National Gallery. Holbein, a German who spent years in England as artist to the Tudor court, might have joined Velázquez and Sargent in *Punch*'s cartoon of "Desirable Aliens."

As art collectors, the Rothschilds—patrons of the Wertheimer firms for six decades—succeeded both to the old-line British aristocracy and to more recently wealthy banking families such as the Hopes and Barings.

The Austrian Ferdinand de Rothschild moved to England after his mother died, in 1859. Like Samson Wertheimer, he spoke English with a German accent. He fell in love with his British cousin Evelina, a daughter of his mother's brother Lionel, and married her in 1865. The couple bought a house at 143 Piccadilly, in a stretch of mansions facing Green Park known as "Rothschild Row." Evelina's grandfather Nathan Mayer Rothschild had acquired number 107 in 1825. Her parents lived at 148.

There were so few Jews of wealth and stature comparable to the Rothschilds' that many members of the family, including the parents of both Ferdinand and Evelina, married relatives. Like Europe's ruling dynasties and eighteenth-century court Jews, they practiced "tactical endogamy," which protected their fortunes and status but probably not their gene pool. Evelina's sister Leonora married a French cousin, Alphonse, whose parents were also both Rothschilds. Her brother Nathaniel—the first Lord Rothschild—married a daughter of his mother's brother and his father's sister. In England, four of Nathan Mayer's seven children married Rothschilds. In the European capitals, eight of Mayer Amschel's grandchildren did the same. And that is by no means a full count.

Evelina died in childbirth eighteen months after her wedding. The baby was stillborn. A devastated Ferdinand never remarried. He founded the Evelina Hospital for Sick Children in her memory and devoted the rest of his life to his country house and collecting art.

Inheriting a fortune after his father died in 1874, he bought the estate of Waddesdon and Winchendon from the 8th Duke of Marlborough—twenty-seven hundred acres of farmland in Buckinghamshire's Vale of Aylesbury. Over the following decade he acquired additional acreage, transformed the property into a vast park, and hired a French architect to build a château modeled on those of Touraine in central France, only with running water, electricity, and central heating. He began inviting guests to Waddesdon Manor in 1883. The Prince of Wales was a frequent visitor. Queen Victoria came for lunch in 1890 but declined to use a small passenger lift built expressly for her, evidently not trusting the newfangled device. Henry James told a friend after spending several days at Waddesdon, "the gilded bondage of that gorgeous place will last me for a long time."

Although Ferdinand referred to art dealers as *"la bande noire,"* he needed their help in his grand acquisition campaign. His collections reflected the family taste for Dutch masters, British portraits, and the kinds of gorgeously wrought gold and silver "wonder cabinet" objects—cups, vases, tankards, small figures, portrait miniatures—favored by Habsburg rulers and earlier banking families such as the Medicis and Fuggers. Yet the distinctive feature of the sumptuous Waddesdon interiors was what their owner called "the graceful composition of the French eighteenth century."

Samson Wertheimer had supplied Ferdinand with eighteenth-century French furniture by Riesener and Boulle from Hamilton Palace just as the Waddesdon construction neared completion. Also a beautifully crafted pendulum clock from the 1740s in a case of fine woods, ivory, and mother-of-pearl, with ormolu sculptural

figures and mounts, and "Wertheimer 1889" inscribed on its pendulum bob. The art historian Geoffrey de Bellaigue, writing in a Waddesdon catalogue, notes Samson's work as an artisan in bronze and observes, "The provision of a new pendulum would clearly have presented no problems to Samson Wertheimer." The provision of paintings presented no problems, either: among those Samson acquired for Ferdinand were three by Sir Joshua Reynolds.

Asher's purchases for Ferdinand included a portrait bust of Madame de Pompadour, gold snuffboxes, and two pairs of small paintings by Francesco Guardi. The Wertheimers also worked with Ferdinand's unmarried sister, "Miss Alice," who bought the house next to his in Piccadilly and had a suite of rooms at Waddesdon as well as a manor house of her own nearby.

Ferdinand died in 1898. The Prince of Wales and a representative of the queen attended his funeral at London's Central Synagogue, as did Rothschild relatives, the future prime minister H. H. Asquith, Sir George Lewis, Asher Wertheimer, and Jewish schoolchildren, among many others.

A Waddesdon bequest Ferdinand left to the British Museum remains intact: three hundred "wonder cabinet" objects made of precious metals and jewels. Waddesdon itself, and the rest of Ferdinand's collections, went to "Miss Alice," who bequeathed them with her own to their French cousin James. Like Ferdinand and Alice, James had no children. He left the estate to the National Trust in 1957. Thirty years later his widow designated Jacob, 4th Lord Rothschild, as her heir. He restored and managed Waddesdon, one of the National Trust's most popular sites, until his death in 2024.

The gallery founded by Samson Wertheimer at 154 New Bond Street remained there for half a century. Then, in 1903, Asher moved to new quarters nearby. He had taken over the lease of a

larger gallery, 158 New Bond Street, after the death of its owner, Flora's brother Edward Joseph. The move required a change of one number on Asher's stationery. He hired French artisans to line the walls with new wood paneling and build a Louis XIV–style staircase connecting all three floors. His eldest son, Edward, was to have joined him there. The renovations were nearly complete when Edward died, in January 1903.

That March, Asher ran notices in London newspapers announcing his move, and held a viewing for the press two days before the opening. *The Times* saluted his "splendid new galleries," *The Queen* pronounced them "sumptuous and beautiful," *The Connoisseur* compared them to the Wallace Collection on nearby Manchester Square. The works on view at 158 New Bond Street were signature Wertheimer: Riesener, Boulle, Caffieri, Berthoud; Regency chairs, Sèvres and Oriental porcelain, clocks, tapestries, Italian bronzes; paintings by Watteau, Gainsborough, Henry Raeburn, Jean-Baptiste Pater, and Ferdinand Bol.

When some of Edward Joseph's collections were sold at Christie's in December 1903, *The Daily Telegraph* reported that the sale was "nobly supported" by "that trio of giants at auction, Mr. Charles Wertheimer, Mr. Charles Davis, and Mr. Asher Wertheimer."

Asher was said to have regretted letting the "pearl" of the Hope collection—Vermeer's *Glass of Wine*—go to Dr. Bode in Berlin, via Colnaghi, for £8,000 (about $40,000 then, roughly $1.5 million today). He acquired another Vermeer, *Mistress and Maid*, with the London dealer Arthur J. Sulley a few years later. The Dutch Baroque artist, little known following his death in 1675, had been "rediscovered" in the 1860s, and by the 1890s his rare, luminous paintings were in high demand. Otto Gutekunst at Colnaghi told a colleague in 1906: "Sulley sold his Vermeer, wh. belonged to him with Wertheimer, to a friend of ours in Berlin £16,000 (through Bode)!!" The buyer was James Simon, a German entrepreneur and

collector who, in the chaos after World War I, sold the painting to Henry Clay Frick for £60,000.

Sargent once told his friend Vernon Lee, now a writer about art: "Some day you must assert that the only *painters* were Velázquez, Frans Hals, Rembrandt, and Van der Meer of Delft [Vermeer], a tremendous man."

Nearly a decade after Asher purchased the Hope family's Dutch and Flemish Old Master paintings, he acquired another major collection from Francis Denzil Edward Baring, 5th Baron Ashburton. The Barings Bank had so dominated late-eighteenth-century international finance that the duc de Richelieu allegedly announced in 1818, "There are six great powers in Europe: England, France, Prussia, Austria, Russia, and Baring Brothers." Power in the banking world shifted markedly during Queen Victoria's reign, however. Barings, faced with intense competition from rivals such as the Rothschilds and Morgans, and having taken on excessive risk in Argentina, nearly failed in 1890 and had to be rescued by the Bank of England. Members of the Baring family, like many others with noble titles and declining incomes, began selling art.

In acquiring the Ashburton collection in 1907, Asher worked in concert with Alfred de Rothschild, Ferdinand's cousin and brother-in-law. The sale marked yet another symbolic changing of the guard: one of the Barings, preeminent bankers of one era, ceding "art wealth" through a Wertheimer to a Rothschild, preeminent bankers of the next.

Alfred, like Ferdinand, had built a "French château" in Buckinghamshire. His Halton House opened to guests in 1884. The first name in the visitor's book that January was Albert Edward, Prince of Wales. Asher Wertheimer visited Halton with his son Edward, with Ferdinand de Rothschild, with Flora's cousin Charles Davis—Alfred's primary dealer—and on his own.

Benjamin Disraeli once declared the traditional English country-

house weekend a "monotony of organized platitude." Weekends at Halton were not boring. Guests included prominent musicians and political leaders, international bankers, society beauties, opera stars—and the host's mistress, Marie Wombwell; Alfred introduced their daughter, Almina, to Lord Carnarvon at Halton. Paintings and tapestries lined Halton's walls, French furniture filled its rooms, peacocks roamed the lawns. Mouton Rothschild wines accompanied dinners prepared by master chefs. Entertainments included a private orchestra, a circus, and a mesmerizer of chickens. Alfred sent guests home with boxes of cigars and hampers of freshly picked flowers and fruit.

A grandiose new château with recently acquired art was a far cry from the classic English estate steeped in centuries of history, and it made an easy target for disdain—as did its owner's un-English love of luxury and spectacle. Sir Algernon West, private secretary to Prime Minister William Gladstone, called Halton "an exaggerated nightmare of gorgeousness and senseless and ill-applied magnificence." Eustace Balfour, an architect and a relative of prime ministers, said he had "seldom seen anything more terribly vulgar . . . Oh, but the hideousness of everything, the showiness! the sense of lavish wealth thrust up your nose!"

Unlike Ferdinand, who lived primarily at Waddesdon, Alfred was more town than country, using Halton primarily on weekends. He worked as a partner at N. M. Rothschild & Sons, became the first Jewish director of the Bank of England, and was a founding trustee of the Wallace Collection.

He joined efforts to stanch the British art drain, pressing the government to acquire paintings from Blenheim Palace and supporting the creation of the National Art Collections Fund. His contribution of ten thousand pounds toward the National Gallery's purchase of paintings from the Earl of Radnor in 1890, most notably Holbein's *The Ambassadors*, earned him a place on the board.

For the gallery, as for his own collections, Alfred had no interest in "moderns"—Manet, Renoir, the Impressionists. He hated Sargent's portrait of his cousin Lady Sassoon, calling it "a caricature."

And in 1907 he advanced nearly £146,000 for Asher Wertheimer's purchase of sixty-three paintings from the Ashburton collection. Alfred's loan earned him right of first refusal to works by, among others, Rembrandt, Velázquez, Van Dyck, Rubens, Caravaggio, and Bronzino.

The purchase was concluded in late August. Asher took three fourths of the total and paid in full for his share in early October. An envelope in The Rothschild Archive bearing Alfred's monogram provides the details:

AW	£109,312.10.6
CD	£36,437.10
	£145,750

"AW" was Asher. "CD" was Flora's cousin Charles Davis, who paid for his quarter share with a loan, cosigned by Alfred, from the Alliance Assurance Company. The AAC had been founded by Nathan Rothschild and Moses Montefiore in 1824 as an alternative to Lloyd's of London. Its chairman in 1907 was Alfred de Rothschild's brother Nathaniel.

This time, to avoid the tangles he had gotten into with Colnaghi over the Hope paintings, Asher formed a syndicate with colleagues he trusted: the esteemed Agnew firm; Arthur Sulley, with whom he had just owned and sold a Vermeer; and Charles Davis, who had compiled a catalogue of Alfred de Rothschild's collections, negotiated the sale of Raphael's *Ansidei Madonna* to the National Gallery, and been appointed "art expert" to Edward VII.

Asher allotted thirds of his own three-quarters stake to Agnew

and Sulley, which meant that each syndicate partner, including
Davis, had a quarter share in the investment and profits. On August
23, 1907, Agnew agents delivered Rothschild's check to Ashbur-
ton's solicitor and removed the pictures from their owner's Hamp-
shire estate. Most accounts of the sale have attributed it to Agnew's
ever since.

Why would Asher allow someone else to take credit for a deal
he had secured? Perhaps to have a Gentile name out front. And
perhaps to accord with professional changes he was making early
in the new century. Continually rising prices for art and a mea-
sure of irrational exuberance had intensified market strife, and
experiences such as Colnaghi's hostile takeover of the Hope pic-
tures and Boni de Castellane's huge unpaid bill (with an assist from
Charles Wertheimer) may have convinced Asher to rise above the
fray. His court factor ancestor in Vienna had served as financier to
immensely powerful Habsburg rulers. Two hundred years later in
London, Asher began to serve as informal financier to extremely
profitable art markets. He was now in a position to advance sums—
"sometimes to a considerable extent," he said later—to dealers and
collectors for transactions in which he had minimal or no direct
interest, although he continued to buy and sell art on his own.

In the 1907 Ashburton purchase, Arthur Sulley took thirty-
three of the paintings to sell, Agnew eleven, Charles Davis ten. Al-
fred de Rothschild bought seven outright and more through Davis
and Sulley. Asher Wertheimer took only two—Adriaen van Ostade's
Two Men and One Woman and *The Seven Works of Mercy* by
David Teniers the Younger—acting more as collector than dealer.
Both paintings were in his house when he died.

Alfred de Rothschild had run up a significant tab with Asher.
In 1914, he settled "all my indebtedness" to Wertheimer—£153,750
(principal plus interest): about $770,000 then, roughly $23 million
in early-twenty-first-century dollars.

Why had a Rothschild incurred such a large debt to a Wertheimer? Perhaps Alfred's capital was tied up in the bank, his houses, collections, gifts to his daughter and others. His £146,000 cash advance for the Ashburton paintings in 1907 may have been, like Charles Davis's share, a loan from the Alliance Assurance Company, headed by Alfred's brother.

Asher evidently had an abundance of cash on hand. He paid on his own for the entire Hope collection and three quarters of the cost of Ashburton's. And Alfred Rothschild reimbursed him for nearly £154,000. It was a long way back to Asher's father hesitating for two years before submitting a bill to Alfred's uncle Anthony for £27 in 1860.

When Lord Theign's daughter Lady Grace, in Henry James's *Outcry*, notes that England has taken its "art-wealth" from other places, she adds: "We didn't *grow* it all." England did, in a sense, grow Sargent's Wertheimer portraits—twelve London-born subjects by a long-resident artist whom Britain claimed as her own. In response to Asher's pledge to leave nine of the paintings to the National Gallery, the Tate's director had said that acts of such "munificence" with regard to art in England were rare. As indeed they were.

Ferdinand de Rothschild observed in a memoir that "most fine works of art drift slowly but surely into museums and public galleries." Yet there were sharp distinctions within the drift. Members of the old-line British aristocracy tended to keep art in their houses and families and, when in financial straits, to sell rather than give it to the nation. The National Gallery bought thirteen paintings from the 12th Duke of Hamilton in 1882 and acquired Raphael's *Ansidei Madonna* and Van Dyck's *Charles I on Horseback* from the 8th Duke of Marlborough in 1885 and 1895. The sale of the

two de Saumarez Rembrandts went ahead despite Charles Wertheimer's attempt to interfere. The Wallace Collection, assembled by Marquesses of Hertford, did not go to the nation as a gift from the 4th Marquess but from the French widow of his illegitimate son, Sir Richard Wallace.

For the most part, gifts of art came from people with more recently acquired wealth. Henry Tate, who made millions in sugar refining, had given his nineteenth-century British paintings with an eighty-thousand-pound endowment to create a National Gallery of British Art, the Tate. Samuel Courtauld, whose family fortune derived from rayon, founded the Institute of Art that bears his name, gave it his extensive collection of Impressionist and Post-Impressionist paintings, and set up a purchase fund at the Tate. Major gifts from the Duveen family of art dealers went to, among others, the National Gallery, the British Museum, and the Tate. In the north of England, business figures who established municipal museums for their collections included the brewers Alexander Laing in Newcastle and Frederick Mappin in Sheffield, the household-products manufacturer Thomas Ferens in Hull, William Henry Wills (tobacco and snuff) in Bristol, and William Lever (soap) in Liverpool.

Ludwig Mond, the industrial chemist and uncle of Robert Mathias, contributed to the purchase price of the Velázquez *Rokeby Venus* and left most of his Old Master collection to the National Gallery, although the complexity and imprecision of his will led to a struggle. In the end, forty-three paintings, including Raphael's *Crucified Christ with the Virgin Mary, Saints and Angels* (showing the sun and moon in the sky at the same time) went to the gallery, and the donor's younger son, by then Sir Alfred Mond, 1st Baron Melchett, paid half the cost of a new room for their display. Contrary to Mond's wishes, the collection did not remain substantially united or on view, although a Mond Room still exists.

The English Rothschilds, like the older landed gentry, tended

to leave art to relatives rather than donate it to the nation.* Ferdinand, from the Austrian branch of the family, left his collections to his sister Alice, with the exception of the "wonder cabinet" bequest to the British Museum. Sixty years later it was their French cousin James who gave Waddesdon and its contents to the National Trust.

And while Alfred de Rothschild supported efforts to keep important works of art in England, his only bequest to the National Gallery was his favorite Reynolds portrait, *Lady Bampfylde*. He died in 1918, leaving Halton to a nephew who auctioned off the collections and sold the property to the Royal Air Force. The London house went to Alfred's daughter, Almina, who sold most of the furniture and art over the next few years.

Some of Sargent's subjects were selling their portraits as well, occasionally with his help. The Earl and Countess of Warwick, having sold paintings by Rembrandt, Van Dyck, and Romney, turned next to the Sargent portrait of Daisy, *The Countess of Warwick and Her Son*.

In July 1913, the artist told his friend Frederick Pratt, a trustee of the Worcester Art Museum in Massachusetts, that this "somewhat theatrical" painting might be available, and "I don't suppose such an important portrait of mine is likely to come on the market soon." He found out from Daisy that she had just sold the picture to Asher Wertheimer for three thousand pounds. Pratt immediately wrote to Asher, who told him the picture was now with Knoedler & Co. in London. "I have acquainted them of your communication," wrote Wertheimer, "and have no doubt they will be very pleased to show the picture to you." That fall, Worcester bought the painting

* Exceptions included Lionel Walter Rothschild, who opened his natural history collections to the public at Tring Park (Hertfordshire) in 1892 and left them to the British Museum; and Constance Rothschild Flower, Lady Battersea, who was a patron of modern art and a donor to museums. The French Rothschilds, in contrast— particularly Alphonse—were generous donors of art to public institutions and builders of municipal museums.

from Knoedler—or Knoedler and Wertheimer together—for five thousand pounds (about twenty-five thousand dollars).*

<center>〜</center>

As fine art migrates through private collections, designations of ownership change, and past possessors appear mainly in provenance notes. After Pierpont Morgan died, a number of works he had owned were acquired by Frick and his museum, among them the blue marble Gouthière table, Rembrandt's *Nicolaes Ruts*, Fragonard's *Progress of Love* series, Renaissance bronzes, and fine clocks. The Duke of Norfolk's Holbein nearly became a Frick Holbein.

A gift or sale to a public museum, however, brings the genealogy of names to a full stop. Into the indefinite future a Raphael at the National Gallery is known as the *Mond Crucifixion*, a Velázquez as the *Rokeby Venus*; medieval and Renaissance treasures at the British Museum as the Waddesdon Bequest; a medieval carved ivory box at the Met as the Morgan Casket.

The Wertheimer Sargents—or the Sargent Wertheimers—are in a somewhat different league, since artist and donor were contemporaries, both alive when the pledge was made, and the paintings never belonged to anyone else.

There may be as many motivations for giving art to museums as there are donors. Asher's included patriotism and gratitude to a country that had provided his family with a wealth of opportunities. The gift was also a public assertion of privilege, taste, and rarefied knowledge—a transformation of profit earned through

* In November, Sargent learned that Daisy's sale of the portrait had infuriated some of her creditors and seemed likely to lead to lawsuits. He told Pratt he had known nothing of this complication when he recommended the painting to Worcester and was "very much perturbed" by the information, hoping the museum would not find itself in legal difficulties. He had recently been assured that the museum's ownership could not be challenged and that the dispute was between Lady Warwick and her creditors. The painting remains in Worcester.

trade into a place in the history of art and in England's national col-
lections. It positioned Asher's large Jewish family in the company
of countesses and kings. And it paid eloquent tribute to the artist.
"Knowing that contemporary art would be called upon to supply a
successor to Reynolds, Gainsborough, and Romney," observed *The
Daily Telegraph*, "Mr. Wertheimer saw to it that his famous series
of family portraits by Mr. Sargent would eventually be the prop-
erty of the nation."

Moreover, Asher made the pledge in 1916, when England and
Europe were convulsed by war. His sons Conway and Bob changed
their surname that year, as did other English Jews of German de-
scent. Asher invested large sums of money in British war bonds,
according to his obituary in *The Times*, and "always had the most
undisguised hatred and contempt, professional and personal," for
Germany and the Germans. Which might have come as a sur-
prise to Dr. Bode in Berlin, with whom Asher worked amicably for
decades. Still, for someone named Wertheimer, the political and
moral significance of investing in war bonds and being known for
antipathy to Germany was great.

Asher's bequest to the National Gallery consisted of the eight
portraits he had hung in the Connaught Place dining room: his
own; the second (1904) Flora; the double of Ena and Betty; singles
of Hylda, Alfred, and Edward; and the two groups of three—Essie,
Ruby, and Ferdinand, and Hylda, Almina, and Conway. Plus the
"Oriental" Almina from the morning room.

The Times assessed the gift as having "almost incalculable
value" for the national collections. It had tangible value as well.
Since the financial records of neither artist nor patron survive,
there is no account of the original transactions. Sargent had begun
charging one thousand guineas for a portrait in the 1890s, which
suggests that Asher paid slightly more than one thousand pounds
each for twelve paintings between 1897 and 1908. In the contre-
temps over the oval *Betty*, five hundred pounds appeared to be half

of what Asher had advanced for *Almina*. The cost for the series, then, came to about twelve thousand pounds (sixty thousand dollars). In terms of monetary value over time, sixty thousand dollars in 1900 would be worth roughly two million today. Yet strictly monetary calculations based on inflation rates for an economist's "ordinary basket of goods" do not account for the steep appreciation in the value of art. Several Sargent paintings have sold for more than two million dollars each in the early twenty-first century (see chapter 15).

Asher's health began to decline early in 1918. He was seventy-four, and spent that summer with Flora at Cravenhurst, a Victorian manor in the seaside resort of Eastbourne, on the English Channel. He died there on August 9, 1918.

The funeral took place at the Willesden Jewish Cemetery on August 12, conducted by the Reverend Emanuel Spero, rabbi of the Central Synagogue. Among the mourners were Asher's son Conway, his five sons-in-law, and the two sons-in-law of his brother, Charles. Sargent was at the western front in France, working as an official war artist, and Ferdinand Wertheimer/Bob Conway was overseas with the Royal Field Artillery; the war did not end until November. Also absent that day were Asher's wife and daughters; Jewish women in England did not then attend graveside funerals. Representatives from the dealers Agnew, Sulley, Hodgkins, and Davis attended, as did the Venerable E. E. Holmes, Anglican archdeacon of London, and "Mr. W. Roberts," most likely William, the art critic who wrote Asher's obituary in *The Times*. Asher's gallery manager and personal secretary were there as well, along with other men who worked for him in Bond Street and Connaught Place.

His estate was ultimately valued at more than £1.5 million—
about $7 million in 1918 dollars, about $140 million today. Sam-
son, arriving in England in 1839 with virtually nothing except his
intelligence and skill, had done extraordinarily well, leaving nearly
£400,000 in 1892. Asher, inheriting the intelligence, skill, and half
of his father's estate, had done even better.

His will appointed Flora, Conway, and Dr. Sidney Philip Phil-
lips, a family friend, as the estate's executors and trustees. Asher
had owned the freehold on his property in Connaught Place. He left
Flora the house, premises, and stabling as well as his horses, motor-
cars, carriages, wines, watches, jewels, ornaments, tableware, fur-
niture, pictures (separate from those at the gallery), an annuity of
ten thousand pounds a year—and a life interest in the Sargent por-
traits. To his children he gave substantial cash legacies and shares in
his investments, real estate holdings, trusts, and other properties.

With regard to his work as an art market financier, he urged his
trustees to be generous: "Inasmuch as I am from time to time en-
gaged in business transactions which involve my financing (some-
times to a considerable extent) other persons or firms and it may
happen that at the time of my death I may be engaged in one or
more of such business transactions," his executors could defer call-
ing in those loans for up to five years. Asher expressly did not want
his borrowers to be "inconvenienced" by requests for repayment
without adequate notice.

He also asked for leniency regarding his real estate holdings,
instructing the trustees to deal with tenants as they knew he would
have done, prizing flexibility over restrictive leases or immediate
profits.

Authorizing the trustees to "wind up" his business and all its
concerns within five years, he granted them full powers and dis-
cretion to sell his stock of art. He left six thousand pounds each to
his gallery manager and personal secretary, provided they stay on

for a year without additional pay to work with his executors, and gave smaller amounts to other gallery employees and members of his household staff, specifically naming his butler, cook, masseur, chauffeur, and groom.

Asher left twenty thousand pounds to hospitals, most of them charities for children of the poor—one thousand pounds to the Evelina Hospital for Sick Children, founded by Ferdinand de Rothschild in memory of his wife. He gave one thousand pounds to the Jewish Board of Guardians and five hundred pounds to the Jews Deaf and Dumb Hospital in Wandsworth—far less than his brother had left to Jewish institutions. Asher's obituary in *The Jewish Chronicle* noted, "Except from time to time giving donations to Jewish charities, etc., Mr. Wertheimer took no part in Communal affairs." It was on the day of his funeral that *The Daily Telegraph* described the three Wertheimer men as having been "thoroughly Anglicized in thought and action."

Christie's auctioned the "remaining stock" from Asher's gallery at 158 New Bond Street in June 1920. Noting that prices at dealers' sales usually reflected depreciation, *The Daily Telegraph* recalled the sharp declines in value of items sold from Charles Wertheimer's estate, and reported no such "mistakes" among Asher's holdings. The sale took three days and yielded about fifty thousand pounds.

The house at Connaught Place remained intact during Flora's lifetime. In addition to the eight Sargent portraits in the dining room, the artist's first (1898) painting of Flora was in the adjacent morning room with the "Oriental" Almina; the oval of Betty was upstairs. Mancini's portraits of Flora and Ruby, and watercolors Sargent had inscribed to various family members, were in the breakfast room. The master bedroom had drawings of Asher's parents (now lost) and an engraving by Leopold Goetze after Sargent's portrait of Ena, *A Vele Gonfie*. Two more Goetze prints, of the Asher and Flora paintings, were in a maid's room. And throughout

the house were miscellaneous works by Flemish, Dutch, French, and English painters, typical of the era's taste.

Flora died on December 5, 1922. Four days later, C. H. Collins Baker, the keeper at the National Gallery, asked Asher's solicitor how quickly the Sargent portraits could be delivered, saying his trustees felt "that considerable prominence should be given as soon as possible to the munificent addition to this collection made by the public-spirited generosity of the Wertheimer family."

To Conway, who was managing the transfer, Collins Baker conveyed the trustees' sympathy over Flora's death and their sense of great debt not only to Asher but to his heirs for generously carrying out his intentions. When Conway delivered the portraits to the gallery at the end of 1922, he reminded the keeper of his father's clear but nonbinding wish that they be kept there together on view. Collins Baker, having told Asher he thought he could "guarantee" just that, now repeated the assurance. The paintings went up in early January.

The Wertheimer siblings chose what they wanted from Connaught Place: Sargent's inscribed watercolors; his first portrait of Flora and the oval of Betty; Mancini's paintings of Flora and Ruby; quantities of fine furniture and decorative art. The remaining "Contents of the Mansion" were sold at auction by Christie's and by Phillips, Son & Neale. What received the most attention in the press was a silver toilet service formerly owned by Tsar Alexander I, which Asher had brought out of Russia and kept for his family's use.

At the end of the remaining-stock sale from Asher's gallery in 1920, *The Daily Telegraph* recalled Samson's in 1892 and reflected: "One watching that sale twenty-eight years ago could not contemplate that the name of Wertheimer would disappear from art sales' annals."

The Wertheimer name did disappear from art sales after 1918, having lasted for only two generations. Yet Asher's gift to the

National Gallery carried his own name into the future. "Seldom is a national collection lucky enough to get so important a group of portraits," said an article in *The Saturday Review* shortly after Asher died. When posterity reached "a final estimate of Mr. Sargent's varied and unequal portraiture," suggested the writer, it might conclude that his genius was "most inspired" by this family. And that "the generous patriotism of Mr. Wertheimer will at least have this reward: while Sargent's fame endures the name of Wertheimer will inextricably be bound up with it."

Ena in Full Sail: *A Vele Gonfie*

Although no grandson of Samson Wertheimer maintained the family presence in the art trade, a granddaughter did. Seven years after Asher died, Ena opened a gallery at 52 Brook Street, opposite Claridge's Hotel in Mayfair. Rather than follow family precedent with Old Masters, British portraits, and the arts of ancien régime France, she located herself firmly in the twentieth century, aiming to promote the work of young artists. The only other female art dealer in the family had been her great-grandmother Hannah Falcke, who ran a curiosity shop in Oxford Street after being widowed in 1841.

Sargent, finishing work on *Ena and Betty* in his studio in 1901, had indicated the "taller girl" and asked a visitor, "Isn't Miss Wertheimer beautiful?" More than two decades later, now a mother of five, Ena was still handsome. She moved in heady social circles and drew on them extensively in her new venture. Her Claridge Gallery launched in July 1925 with a loan exhibition of works by Sargent, who had recently died. The critic for *The Times* said the gallery "sets itself a very high standard" with this inaugural display, noting its plan to support new artists, its apt tribute to a painter known for his generosity to younger colleagues, and its donation of proceeds from catalogue sales to the National Art Collections Fund.

On loan were seventeen watercolors, three drawings, and one oil painting. An unsigned foreword to the exhibition's small catalogue, possibly written by Ena, asks whether "the real John Sargent" was "the rather unapproachable *chef d'école* in his great studio or the happy wanderer in his gondola moored off the Salute, painting furiously between sun and water." In the present show, "we shall only find . . . the great man at play" and will be "free to enjoy ourselves with something of the pleasure that was his as he worked."

Ten of the watercolors had been at Connaught Place and now belonged to Ena's siblings. The 1910 pencil sketch of her was there, but not her 1904 portrait, *A Vele Gonfie*. The single oil painting was *The Sitwell Family*, which had been compared unfavorably to *Ena and Betty* at the Royal Academy in 1901. Seeing it at the Claridge Gallery twenty-four years later, the *Times* critic said it represented "celebrities in the age of innocence."

Edith, Osbert, and Sacheverell Sitwell had indeed become avant-garde literary celebrities. Ena attended the first performance of *Façade*, Edith's recitation of her experimental poems set to music by the young composer William Walton, at the Sitwell house in Chelsea in January 1922. Two weeks later the second staging took place in Ena's drawing room at Montagu Square. Edith, whom Sargent had captured on the verge of adolescence in the Sitwell family portrait, had grown into what her biographer Victoria Glendinning calls her "stark Plantagenet" looks. Cecil Beaton said she resembled "a tall, graceful scarecrow with the hands of a medieval saint." In *Façade*, standing behind a sheet painted as a face and holding a megaphone through the cut-out mouth, she trumpeted each poem. "The audience was stunned," she proudly told a friend after the performance in Montagu Square.

A singular presence in the audience at Ena's that night in 1922 was unlikely to have been fazed. Sergei Diaghilev stood at the forefront of modernism, integrating the performing and visual arts. He had studied art in St. Petersburg and founded the revolution-

ary Ballets Russes in Paris in 1909. As his company toured foreign capitals, the cultural impresario turned first to Russian artists to design costumes and sets, then to Picasso, Braque, Cocteau, Matisse, Rouault, and others.

Not Sargent, who was far from that modernist cutting edge, although Diaghilev had admired his paintings at the Royal Academy. The American aficionado of music and dance attended Ballets Russes performances and might have liked, as an expert on *The 1001 Nights*, to work on the company's 1910 *Scheherazade*, starring the spectacular young Vaslav Nijinsky. His 1911 drawing of Nijinsky captures the dancer's exuberant, androgynous appeal. The ballerina Tamara Karsavina claimed that Sargent sketched her every year until the war.

Diaghilev took several of his leading male performers as lovers—Nijinsky, Léonide Massine, Anton Dolin, Serge Lifar. With a streak of white in his thick black hair, the maestro was tyrannical, charming, imperially extravagant, and perpetually short of funds. He surrounded himself with wealthy women, who adored him.

Ena met him through Walter Archibald Propert, a retired physician and the author of two lavishly illustrated books on the Ballets Russes. Archie Propert became Ena's *cavaliere servente*—the social companion of a married woman. According to a mutual friend, the pair had been "the earliest and most enthusiastic devotees of the Russian Ballet in all its aspects, terpsichorean, musical, and decorative." In the first copy of his *Russian Ballet in Western Europe 1909–1920*, Propert wrote: "No. 1 and rightly reserved for Ena Mathias without whose persistent encouragement the book would never have been written." He inscribed the second volume, *1921–1929*, to "EM—The constant friend and unhesitating critic of Diaghilev and of the author." To the Mathias children, Propert was "Uncle Archie." The youngest, David Frederick Archibald Mathias, was called Archie until he went away to school.

When the Ballets Russes performed in London, Ena attended rehearsals and first nights, opened her house to Diaghilev, and invited members of the troupe to post-performance dinners at Montagu Square. Her husband complained about how much they ate.

One Sunday she wrote to Diaghilev in perfect French:

> Cher Maître,
>
> After the ballet tomorrow night, I invite you to dine with us—with all your friends—M. Dolin, etc. etc. I will be at the performance with many admirers and very much hope that you will give us the pleasure of bringing you back here.
>
> Bien des amitiés,
>
> Ena Mathias

She added, "Madame Eva Gauthier—M. Gershwin—will be here. You *must* come."

That would be the Canadian mezzo-soprano Eva Gauthier and the American composer and pianist George Gershwin. Gauthier, who had given up opera and developed a large contemporary repertoire, came to be called the "High Priestess of Modern Song." Stravinsky chose her to premiere his vocal pieces. Sargent sketched her in charcoal, emphasizing her bare neck and lush eyebrows. In 1923 she shocked critics and delighted a New York audience by concluding a recital with jazzy songs by the young Gershwin, who was at the piano. She performed with him in London in May 1925, which is probably when Ena invited Diaghilev to join them for dinner.

Another night, after the impresario told Ena he was going to have to cancel the premiere of a new ballet for lack of funds, she took off her pearl necklace and handed it to him. Robert Mathias retrieved it the next day.

Ena appointed Archie Propert co-director of her Claridge Gallery. As secretary they hired the young Alan Searle, then a lover of

Lytton Strachey (who called him "my Bronzino Boy") and later of Somerset Maugham. Not surprisingly, Ena and Propert showed many works created for the Ballets Russes. A week after its Sargent loan exhibition closed in 1925, the gallery presented stage designs for the ballet *Les Matelots* and masks for *Zéphire et Flore*, followed by portrait heads of dancers by one of Diaghilev's principal scene painters, Elizabeth Polunin. In 1926, it showed paintings and designs for Stravinsky's *Les Noces* by the "Cubo-Futurist" Natalia Goncharova, a leading avant-garde Russian artist whom Diaghilev had brought to Paris. *The Times* apparently hadn't caught up with Cubism; its critic praised one of Goncharova's paintings but was "not quite clear what the artist gains by superimposing different aspects of things in the same picture, *à la* Braque."

Also à la Picasso, who dined at the Wertheimer house in 1919. He had left wartime Paris for Rome with Jean Cocteau early in 1917 to collaborate on the Ballets Russes' *Parade*, and married one of the dancers, Olga Khokhlova. Diaghilev brought him to London in 1919 to design costumes and sets for the Spanish-themed *Le Tricorne* (*The Three-Cornered Hat*), arranging for him to share a studio with Elizabeth and Vladimir Polunin, to their delight.

And London's cultural vanguard fought over the privilege of entertaining the great man. The art critic Clive Bell appointed himself Picasso's cicerone and organized dinners with the likes of Roger Fry and John Maynard Keynes—pointedly excluding another ardent Picasso admirer, Lady Ottoline Morrell.

Born Ottoline Violet Anne Cavendish Bentinck, the half sister of the Duke of Portland, she was what the French call jolie laide, homely in an attractive way: six feet tall, with copper-colored hair, a long, square jaw, and a prominent nose. She dramatized her extraordinary appearance with huge hats and flamboyant clothes. Virginia Woolf described her as "a Spanish galleon, hung with golden coins and lovely silken sails." Members of the Bloomsbury group attended her famous parties but thought her ridiculous, which may in part

explain Clive Bell's cruelty. Married to the Liberal politician Philip Morrell, "Ott" had good taste in lovers (Augustus John, Bertrand Russell, Roger Fry, Henry Lamb)—and in art, despite being a cultural trophy hunter.

Ena and Ottoline were close friends, joining forces to promote young artists and raise money for cultural events, and looking out for each other's grown children. Ena held the wedding reception for Ottoline's daughter, Julian, in Montagu Square. She addressed letters to "Dearest Ottoline," said, "I admire you above all women!," and reported with delight when her brother Bob bought "a really good" painting by one of Ottoline's favorite artists, Mark Gertler.

Ottoline gave Ena a portrait of herself posing nude outdoors like a wood nymph, by Henry Lamb. She took thousands of photographs of her friends, among them T. S. Eliot. She labeled a photo of Gertler and the poet Siegfried Sassoon "The Two Jews." She might have called another—of Ena standing in a rustic doorway, laughing, cigarette in hand, with Siegfried S. seated on a step at her feet and her daughter Diana in the foreground holding a dog— "The Three Jews."

Before the war, Ottoline had visited Picasso in his Paris studio with Gertrude Stein. In 1919, she set her heart on giving a dinner for him in London and entertaining him for a weekend at Garsington, her manor house near Oxford. Clive Bell scotched the weekend plan. It was probably Ottoline who arranged for the dinner in Connaught Place, since she and her husband were selling their London residence. She described the evening briefly to Mark Gertler: "The Party was rather horrible in the old Wertheimer House which you know surrounded by Sargents—I am fond of Ena Mathias—but the others are awful." Still, she exulted: "Picasso sat next me—& I loved him so full of humour & quickness." An entry for "Mathias, 15 Montagu Place, W1" appears in Picasso's London address book, though there is no evidence that he followed up with Ena.

"What, one wonders," mused the Picasso biographer John

Richardson, did the artist "make of the twelve full-length Sargent portraits of the family members that covered the Wertheimers' walls?" (Only eight were in the dining room.) How, one could also wonder, might Sargent have answered the question? Perhaps the way he responded to Wilfrid de Glehn's protest about Monet having barely looked at some of the same pictures at Tite Street in 1901—"But he hates this sort of painting." Picasso, whose own portraits often refer to earlier masters—Velázquez, Rembrandt, Goya, Ingres—may not have hated the work of another artist who was also, though in far less radical ways, making portraits new. The Spaniard's 1906 portrait of the formidable Gertrude Stein, influenced by ancient Iberian sculpture, led some of her friends to object that she didn't look like his image—to which Picasso is said to have responded, accurately, "She will."

The Ballets Russes had a glorious run from 1909 until Diaghilev died, in 1929. The Claridge Gallery held a memorial tribute to him in March 1930, with costumes, drawings, posters, books, designs (including one of Picasso's for *Le Tricorne*), and Stravinsky's original score for *Les Noces*. The dancer Tamara Karsavina, presiding over the opening in a black mink coat, brought the crowd to tears with her account of Diaghilev's last days.

The gallery was not Ena's first commercial venture. In January 1923, just as her father's gift of Sargent portraits went on display at the National Gallery, she opened a dress shop in George Street. ART DEALER'S DAUGHTER IN A SHOP, announced a headline in *The Evening Telegraph*, then, NEW VENTURE ACCORDING TO HER BELIEFS. "I think everyone should work who can," she told an interviewer. The shop, specializing in French dresses for girls, was called Poulain (meaning "foal"). Ena outlined her intentions to the reporter: "Don't imagine I intend it to be a small thing because I am beginning with a

comparatively small and select stock. I shall be going often to Paris to bring home the prettiest children's and debutantes' frocks I can find there." The journalist thought the shop's offerings reflected the taste of a person brought up around art—and that its yellow, saffron, and orange décor set off Mrs. Mathias's "own dark beauty."

Ena hired Russian émigrées and a "professional manageress" to run Poulain, which soon moved to larger quarters at 52 Brook Street. When an examination of the books found the business to be deeply in the red (among other things, the manageress had been helping herself to cash), the shop closed. Robert Mathias said Ena might as well have given each dress away with a ten-pound note pinned inside. The space was reconfigured as the Claridge Gallery, which provided its owner with greater cultural and social sustenance.

Boundaries between the gallery and Ena's personal life were indistinct. The young Catalan artist Pedro Pruna stayed with her in Montagu Square while his stage designs were shown in Brook Street, and used her studio above the garage. Glyn Philpot, a painter and sculptor, did a portrait of her son David. The landscape painter Harold Squire marbleized walls, pillars, and furniture in the Mathias drawing room, to Robert's dismay. Ena showed work by Malcolm Milne, who lived with her friend and business partner, Archie Propert.

She honored her pledge to promote young artists, giving several their first solo shows. For an exhibition called *Under 30*, she stretched the category to include the rising stars Ben and Winifred Nicholson, both then thirty-five. And she presented established artists as well. Those from France included André Lhote, Fernand Léger, Raoul Dufy, Max Jacob, Jean Hugo, and Henri Gaudier-Brzeska (who had been killed in the Great War). Modern British artists appeared singly and in groups. Reviewing an exhibition of flower paintings at the end of 1926, *The Times* praised pictures by Duncan Grant, Mark Gertler, D. S. MacColl, and Harold Squire—but not "the cunningly designed 'Wild Flowers,' by Mr. Roger Fry," in

which "we are made aware of his defective sense of values." A later show of landscapes included several of those painters and "Miss Vanessa Bell"—Virginia Woolf's sister, Duncan Grant's lover, Clive Bell's wife. Both Vanessa and Grant contributed to an exhibition of French and English decorative art in 1928, as did the Diaghilev patron Misia Sert and the sculptors John Skeaping and Barbara Hepworth.

The Sitwells made several appearances at the Claridge Gallery, in person and in art, beginning with Sargent's family portrait in 1925. Other artists captivated by Edith's "stark Plantagenet" looks included the photographers Cecil Beaton and Horst P. Horst and the Russian painter Pavel Tchelitchew, who did six major portraits of her.

Edith recalled meeting this young Russian between acts at the ballet in Paris: "I noticed a tall, desperately thin, desperately anxious-looking young man circling round me, staring at me as if he had seen a ghost." Gertrude Stein introduced them three days later. Edith was forty, Tchelitchew twenty-nine. Though openly homosexual, he became the most important man in her life. She loved him for the next thirty years, writes Glendinning, with "some happiness and a great deal of unhappiness."

Ena showed Tchelitchew's work, including a portrait of Edith, at her gallery in 1928. Diaghilev attended the private preview. Edith said that this portrait—a spooky, hollow-eyed image done in gouache with sand—made her look as if she'd been "buried under the earth for a million years." She did not object.

The Claridge Gallery closed at the end of 1931, probably in financial arrears. Ena frequently purchased works that failed to sell, which cannot have been good for her bottom line. And the Great Depression was forcing the Mathias household to economize.

One of the gallery's last exhibitions featured a portrait of Somerset Maugham by his friend Philip Steegman. The two men posed beside the picture for a photograph at the opening. Maugham had

just published the collection of stories that includes "The Alien Corn," perhaps based in part on the life of Ena's brother Alfred.

$$\backsim$$

In the tempestuous Mathias marriage, Ena was as extravagant, strong-willed, and impulsive as her husband was cautious and restrained. Francis Toye, a music critic who worked for Robert Mathias at Mond Nickel in the early 1920s, left a vivid sketch of the couple. Citing Ena's involvement with Edith Sitwell's *Façade*, Toye described her as "a kind of high priestess of modern art." He went on:

> Since she and Robert agreed on nothing in this world or, I should imagine, the next, he progressively reacted to the extremes of philistinism. The more high-falutin her enthusiasm, the more materialistic, the more prosaic he became; the more money she spent, the more close-fisted he tended to be. His English was often defective, deteriorating in proportion to the degree of his excitement—and, like all Jews, he could get very excited—so that once the sight of an army of charwomen imported to clear up after some party provoked him to exclaim: 'Ena! Ena! What make these women on the stairs?'

The German verb *machen* means both to make and to do.

Toye, also acquainted with the Monds, reflected further on the "Jewish citadel into which I had penetrated":

> Like all Jewish families connected by blood or marriage, they lived in each other's pockets, forming . . . a nebula of heterogeneous, shifting acquaintances, Jew and Gentile, a distinct little world of their own. They were rich, but they

were not "big Jews" like the Rothschilds and the Monte-
fiores, nor were they so thoroughly Anglicized, though
nothing would have annoyed the majority of them more
than to be told so.

If the Mathiases were not "big Jews," as Toye memorably phrased
it, they lived very well. Ena gave lavish dinners, teas, and musical en-
tertainments with the help of a large household staff. Toye thought
her indispensable butler might have been the model for P. G. Wode-
house's Jeeves. When the children were young, the family spent
summers by the sea in the British Isles. In winter, Ena and Robert
traveled to the Continent, North Africa, the Middle East, leaving
their offspring with nannies and French governesses. They even-
tually bought a manor house in the West Sussex village of Bury,
where they had gardens, orchards, horses, dogs, lawn tennis, streams
of guests. Among the regulars were Ottoline and Philip Morrell. The
Mathias daughters learned not to accept Sunday rides back to town
with Philip, who invariably tried to get them to stop at a hotel.

What did Robert Mathias make of his wife's close friendships
with homosexual men? She was hardly unique in that regard, es-
pecially in the world of the arts. If Mathias had been paying atten-
tion, he might not have been concerned about her intimacy with
figures such as Diaghilev, Archie Propert, and Alan Searle, who
were exclusively interested in men. Evidence of hazard, however,
was near at hand: Edith Sitwell was in love with Tchelitchew, Dora
Carrington with Lytton Strachey. The dancer Lydia Lopokova mar-
ried John Maynard Keynes, who had previously been involved with
men. Vanessa Bell, married to Clive, lived and had a child with
Duncan Grant, all of whose other lovers were male. Nijinsky was
bisexual, as was Somerset Maugham.

After Ena died, her husband found a packet of letters to her
from Sargent. Unable to decipher Sargent's handwriting, he gave
them to their daughter Diana, saying, "I would like you to read

these and see if you think your mother had an affair with Sargent."
Diana could not read the letters, either, nor could her aunt Betty.
Asked about the possible affair, Betty told Diana—in the second
version of this Wertheimer family story—"Darling, don't be silly.
Sargent was only interested in Venetian gondoliers." (In the first
version, Flora gives the same answer to a question about her daugh-
ters spending so much time with the artist.) The repeated anecdote
suggests the Wertheimers knew of their friend's inclinations and
were not troubled by them.*

Most of the strife in the Mathias marriage seems to have had
less to do with Ena's male friends than with her extravagance.
Robert objected to how much the Ballets Russes dancers ate, Ena's
impetuous gift of the pearl necklace to Diaghilev, the hemorrhag-
ing red ink of the dress shop. The couple fought. Ena threatened
to move out, and often ran away to her sister Betty, where Robert
knew to phone her. She told Diana, "Darling, however annoyed I
get with your father, remember he has a heart of gold."

He needed it. The children made fun of his German accent. Ena
painted a mural based on Uccello's *Battle of San Romano* in the
National Gallery, with her children as mounted warriors and her
husband on the ground being trampled by a horse. The marriage
probably suffered its worst strain in 1925, the year Sargent died
and the Claridge Gallery opened.

A Vele Gonfie, Ena's portrait in the black cloak and plumed hat,
did not appear in the gallery's inaugural exhibition because it was
in New York—for sale.

Sargent had helped the Worcester Art Museum acquire *The
Countess of Warwick and Her Son* after Daisy sold it to Asher
Wertheimer in 1913. Ten years later, Emily Sargent wrote to her

* Diana apparently kept the Sargent letters Robert Mathias found after Ena died.
One of her granddaughters sold them, and they are now in my possession, identified
in source notes as "Collection of the author." For the story of their acquisition, see
the introduction.

brother's good friend Charles Deering, heir to the International Harvester fortune and a leading Chicago collector: "John dined with me last night, & said to tell you that the only thing of his which may still be available . . . is a beautiful portrait of Mrs. Hugh Hammersley, who died some years ago." This was the painting of a banker's wife in rose-colored velvet, perched "like some alert springing flower" on the edge of a sofa, that had helped launch Sargent's career in England. In 1923, Deering bought the picture from Mr. Hammersley, who had suffered large financial losses. Sargent told Deering of his pleasure at this outcome, adding, "I hope you will like her and her really charming Louis XV frame."

He knew of Ena's intentions regarding her own portrait. After she expressed concern about the painting of her brother Edward, probably when her father pledged it to the nation as part of his gift, Sargent wrote: "I don't share your indignation about Eddie's unfinished portrait. Anybody can see that it is unfinished. To settle your scruples I should suggest that you give 'A Vele Gonfie' in exchange for it, which I know you are trying to get rid of."

Get rid of is harsh. In view of his long friendship with Ena, his two portraits of her, their collaborative adventure in creating this painting, and its presentation as a wedding gift from her father, Sargent may have seen her wish to sell it as a betrayal, unlike the sales of the Warwick and Hammersley pictures. Presumably he did not really think she would swap it for the unfinished *Edward* rather than try to realize its value in cash.

Her husband also knew she wanted to sell the picture. In June 1925, two months after Sargent died, Mathias told the man who was acting as her agent that since it had been a wedding gift to them both, his wife could not dispose of it without his consent, "and I have no desire to sell." She sold it anyway, to the Grand Central Art Galleries in New York, for £6,500 (about $30,000). When Mathias found out a month later he was livid. He engaged lawyers, threatened injunctions and liens. Ena, through her own

lawyers, insisted the portrait had been given to her alone. Robert could not prove that it had not. She eventually agreed to transfer the £6,500 into an investment account in both their names, but only put in half that amount. The couple probably spent £6,500 on lawyers.

Sargent did not live to witness this drama, although he might have been pleased that the man who bought *A Vele Gonfie* from the Grand Central Art Galleries was Charles Deering. He probably did know that Ena had sold another of his paintings, since by the time he died it belonged to Viscount Lascelles, 6th Earl of Harewood, and his wife, Princess Mary, the daughter of George V. It was *Hall of the Grand Council, Doge's Palace, Venice* (1898), depicting the interior of the monumental Palazzo Ducale, its ceilings and walls painted by Tintoretto and Veronese. Whether Ena had purchased the painting or received it as a gift from Sargent is not clear; Richard Ormond and Elaine Kilmurray find the latter more likely.

That she would "get rid of" paintings resonant with personal value, by the artist to whom she had been exceptionally close for years, seems shocking. Since *A Vele Gonfie* sold just as the Claridge Gallery opened, she may have intended its proceeds to support her shows of new art. Still, she had a significant inheritance, a wealthy husband, a life of immense privilege. To put the question of these sales another way, how could she?

She hired Reginald Eves to copy *A Vele Gonfie*, just as Betty did for her oval portrait three years later. Perhaps Ena meant simply to fill the space left by the original at Montagu Square; possibly she also meant to deceive her husband. If the latter, the deception did not work for long.

⌒

With most of their children grown by the 1930s and the world in economic crisis, Ena and Robert Mathias moved out of their large

house in Montagu Square to a town house at 8 Lee's Place, Grosvenor Square.

In mid-February 1936, Ena visited her son David, now a student at Oxford. They saw a production of *Richard II* with one of his friends in the cast. "A stupendous achievement for so young a man," she wrote to David from their house in Bury. She was getting ready for a trip to Spain: "Very cold here but some sun. The garden just waking up—showing little poking signs of spring. It will be perfect just after Easter when we get back—expect you will be here then."

Two days later she had an attack of acute abdominal pain. The doctor in Bury thought it "a colic." London doctors diagnosed cancer and sent her for surgery. Ena died on March 25, 1936. She was sixty-one.

The obituary in *The Times*, subtitled "A VELE GONFIE" and written by "a correspondent" who clearly knew Ena, recalled her "artistic temperament," generosity, candor, and "innocence of mind." The writer praised Sargent's 1904 portrait as a "true and beautiful reading of character," and concluded: "'A vele gonfie'—that was Ena's way of life. She was never one to shorten sail, and when the storm struck her she sank swiftly, but with all her colours flying."

Beneath that tribute was another, signed by Lady Ottoline Morrell:

> To the world in general Ena will always be known as the most beautiful of the Wertheimer sisters whose portraits, painted by Sargent, are in the Tate Gallery; but to those who knew her well she will survive as a figure of extraordinary grace and distinction. She was the bravest, most generous, most lovable of women; full of the joy of life and the appreciation of art and beauty. Her kindness was inexhaustible; her vitality apparently unquenchable. She had, more than any one I have known, the precious gift of

youth. At her charming house in London, and at her lovely
little manor under the Sussex Downs, it was her delight to
entertain her friends. To them the news of her sudden and
premature death will bring a sense of irreparable loss.

Ena had been "drifting toward Anglicanism," reports one of
her descendants, and the family held a small service at the church
next to their house in Bury. Her body was cremated at Hoop Lane,
Golders Green, in Northwest London, and her ashes interred
nearby in the Jewish cemetery affiliated with the West London
Synagogue.

In April, Robert Mathias took his family to Greece. Before
leaving he wrote to Gisela Richter, a curator at New York's Met-
ropolitan Museum of Art and the daughter of Jean Paul Richter,
the art historian who had been advising Ludwig Mond. Mathias
wanted Miss Richter's help in locating *A Vele Gonfie*. She wrote to
the director of the Chicago Art Institute and learned that the paint-
ing now belonged to the Charles Deering estate (Deering had died
in 1927), that it was at the Art Institute, and that correspondence
about it should be addressed to Chauncey McCormick in Chicago.

Mathias did not know that McCormick was Deering's son-in-
law and a manager of the estate. Worried that the picture might not
be genuine and that the owners would take advantage of his per-
sonal interest, Mathias sent inquiries through his secretary. Miss
Richter assured him that it must be the real thing since it had gone
straight from Deering's collection to the Art Institute, and that if
the heirs knew the reason for his interest they would probably al-
low him to buy it back. He took her sound advice. After hearing
from the institute's director that the painting was indeed the origi-
nal and in excellent condition, he bought it from the Deering estate
for thirty thousand dollars, about what Ena had sold it for in 1925.
A Vele Gonfie sailed back to England on the S.S. *Queen Mary* in
October 1936.

Mathias also tried to repurchase the other Sargent painting Ena had sold, the interior of the Doge's Palace in Venice. He wrote to the buyers twice—first to the Earl of Harewood, in 1937, then to Harewood's widow, the Princess Royal, in 1954. Both politely declined to sell. A lady-in-waiting to Princess Mary replied: "Her Royal Highness is very much interested to know that the painting" was formerly in your possession, "and bids me say that she is particularly fond of this picture."

Ruby: "Enemy Alien"

Ena died nearly a century after Samson Wertheimer arrived in England. He may not have told his London family much about his life in Fürth or the harsh restrictions that led half of Bavaria's young Jews to leave at about the time he did. Immigrants often choose not to look back. What did his grandchildren know about virulent anti-Semitism, sometimes called history's oldest hatred? Raised as wealthy English Jews, they moved fairly freely in British society, though encountering occasional hostility and exclusion. Many of them read widely; most traveled. Did they assume that what had happened to Jews elsewhere could not happen to them?

Two of Samson's grandchildren left England to live abroad. Charles's elder daughter, Julia, reversed Samson's exodus by moving to Nuremberg with her Fürth-born husband, Moritz Dünkelsbühler, in 1878. She had grown up in her grandfather's house. He may have tried to warn her. She may have thought the world had changed. Julia had five children in Bavaria, changed the name Dünkelsbühler to Duncan, and died in London in 1930. Eight years later, fifteen-year-old Henry Kissinger and his family left Fürth to escape the Nazis. Not enough had changed.

The youngest Wertheimer grandchild, Ruby, went to Italy in

1925. She is the appealing thirteen-year-old leaning on an ottoman in Sargent's 1902 group portrait. Antonio Mancini also painted her in 1902, in the picture Sargent described as of "the invalid Wertheimer child." Mancini's Ruby looks older than Sargent's, but both artists took liberties with age. Using his signature thick impasto, the Italian portrayed her in a low-cut gown, seated beside a table, index finger at her cheek. She has curly dark hair, full lips, a pensive expression.*

Ruby had diabetes as an adult and perhaps as a child. Insulin did not become commercially available until 1923, by which time she was thirty-four. Before then, diabetic children might survive on extremely low-calorie, low-carbohydrate diets, but Ruby does not look emaciated in either portrait. She may have had a different illness as a child, or more than one. Her family would have secured first-class medical care. There was an "invalid chair" in the basement of the house at Connaught Place.

Clearly Ruby was not incapacitated. After singing at a benefit for Guy's Hospital in 1909, she was called back for two encores; the hospital's *Gazette* praised her "well-trained voice and good enunciation"—and noted the presence of Asher Wertheimer in the audience. During the First World War, Ruby performed in concerts to raise money for English, French, and Italian soldiers. France later honored her as "one of the great friends of our country" for her "works of military philanthropy."

After her parents died, Ruby moved to 1 Upper George Street, not far from Ena's family in Montagu Square. She kept that address into the mid-1930s but moved to Italy in 1925 with her maid, Louise Bligh, returning to England only for brief visits. She lived at Milan's luxurious Hotel Excelsior Gallia once it was built in 1932.

* Cinzia Virno's fine catalogue raisonné of Mancini's work (2019) identifies this portrait as *Betty Wertheimer*, but there is no indication that Mancini ever painted Betty. His portraits of Flora and "Miss Ruby" hung in the breakfast room at Connaught Place.

Ruby's story is shrouded in mystery. By the late 1930s, she was involved in an unlikely romance with an Italian named Paolo Mari. Thirteen years younger than Ruby, he had joined the National Fascist Party on January 1, 1921, virtually at its inception, and was a decorated *squadrista*—a member of the violent paramilitary action squads called Blackshirts that attacked and threatened the party's enemies.

Italian Jews had coexisted with the Mussolini forces for years, and some joined the Fascist Party. Everything changed in 1938, when the government passed a series of decrees "for the defense of the Italian race" similar to Germany's Nuremberg laws. Italy's racial laws excluded Jews from schools, politics, finance, the military, property ownership, marriage with non-Jews, and most forms of employment. Foreign Jews who had arrived after 1919, as Ruby had, were ordered to leave the country by March 1939. Those who did not would be expelled. About nine thousand left; four thousand remained.

Ruby did not leave. Perhaps she stayed to be with Paolo Mari and thought he would protect her. She may never have had a lover before, although what *lover* means under these circumstances is not clear. In 1939, Ruby turned fifty, Mari, thirty-seven. She was Jewish, British, wealthy, ill. He, born in Gorla Minore near Milan in 1902, was committed to a brutally anti-Semitic regime.

In one reading of this story, the two are, however incongruously, in love, and Mari is using his Fascist Party credentials to help her. In another, he is after her money, preying on her loneliness and naïveté. Her long-term residence at a first-class hotel plainly signaled affluence. He may also have been keeping her in his sights for the Fascists.

The romantic version of the narrative seems plausible when, on December 9, 1939, Mari asks for an appointment with the chief of police at the Ministry of Internal Affairs in Rome, the department responsible for national security and public safety. His petition, like

other documents in Ruby's file at Rome's Central State Archive, bears the calendar date followed by the age of the Fascist regime: "9.12.1939, Year 18." Mari identifies himself as a "Squadrista," his profession as "Administrator," his Milan address as Piazza Duca d'Aosta 9—the Hotel Excelsior Gallia, where Ruby lives, although he does not name it. He may have worked there. It is unlikely that they were living together. A ministry official writes on the petition that it concerns "Wertheimer Ruby, [daughter] of the deceased Asher and Joseph, Flora . . . English subject, Jew." And: "She is Mari's *amante* (mistress), will ask for a postponement at police headquarters in Milan"—probably postponement of her expulsion under the racial laws.

The official asks someone to get in touch with the party regarding the *squadrista*'s interest in this case.

All the Italian documents give Ruby's birth date as March 8, 1890, although she was born in April 1889. Perhaps she was trying to shave a year off the age difference between herself and Mari; her passport would have had the correct date.

Italy formally joined the Axis powers—Germany and Japan—in 1939, and declared war on Britain and France on June 10, 1940. Mussolini's government began rounding up anti-Fascists, "ethnic undesirables" (including Gypsies and Slavs), and "enemy aliens" (particularly foreign Jews), and sending them to detention camps. Being British may have put Ruby in as much danger as being Jewish.

In July 1940, the Ministry of Internal Affairs ordered her to leave Milan without her possessions by August 10, to be interned in the southern province of Avellino.

Two days before that deadline, she wrote to the ministry in Italian, describing herself in the third person: "She is gravely ill with a serious case of diabetes," with complications including infected boils, diabetic neuritis, and "notable" loss of vision (often caused by diabetes). An accompanying note from her doctor in Milan uses exactly the same words, adding that Signora Wertheimer needs

continued therapy and "assiduous care." For these reasons, Ruby asks the ministry to revoke the order against her or else to grant her an exit visa for neutral Switzerland.

She had gone to Switzerland briefly in 1937, and been detained and searched on her return, suspected of smuggling in cash. The opposite scenario also seems possible—that she had taken items of value there for safekeeping. She had a Swiss entrance visa, and submits with her 1940 letter to the ministry a note from the Swiss consul general saying the visa will soon expire but she may stay indefinitely if the Italians allow her to leave.

Her urgent plea, which sounds like a hostage video and may reflect Paolo Mari's coaching, goes on to say that "she has always been an excellent guest, that she loves Italy more than her country of origin, that she admires Il Duce and his Institutions," lives off her own income, has never in fifteen years of residence acted against the regime or "occasioned reproach for her conduct." And finally: "The applicant feels that she would not be able to survive in the place which will be assigned to her . . . Confident that this appeal will be benevolently received, she expresses her utmost respect."

None of it worked. On August 12, she was interned in the village of Ospedaletto d'Alpinolo, in Avellino, about forty miles inland from Naples.

Fascist Italy had two kinds of detention for its real and perceived enemies. The oxymoronic "free internment" (*internamento libero*)—enforced stays in small townships such as this one, usually in remote locations, mostly for women and children. Internees could move about freely but were under surveillance and required to check in daily with the local police. The harsher option was confinement in a "concentration" or "internment" camp—the adjectives were used interchangeably.

The day after Ruby arrived at Ospedaletto she sent two requests to the Ministry of Internal Affairs. In one, she asks if she might

be allowed to live with Paolo Mari, her "future husband" (she uses the old-fashioned word *consorte*), and points to his credentials as an original member of the *Fascio di combattimento* (fighting league) of Legnano. Giving the same Milan address for them both, she evidently hopes their intimacy will help her, although marriage between Jews and "Italians of the Aryan race" was forbidden. In the second letter, she asks to live with her "companion and nurse," Louise Bligh, a widow, who has been in her service for fifteen years and whose continued care is "absolutely indispensable."

Mari went to Rome to make another appeal on August 14. This time, he identifies his profession as "Writer" and meets with the commander in charge of interning foreign Jews. His new request: Ruby wants—inexplicably—to be transferred to Vinchiaturo, a "concentration" camp for foreign women. And this time, Mari's effort succeeds. Handwritten notes on his petition, mostly illegible, say in part, "to Vinchiaturo right away . . . the Jewess . . . in the interest of a lover of a squadrista."

Was it really her idea to go from "free internment" in a rural village to a concentration camp? She later said she hadn't realized the camp would be so much worse—that she had wanted to move because the house in Ospedaletto did not have running water, "which is absolutely necessary" for her health. Diabetes causes dehydration, thirst, a frequent need to urinate. Had Mari recommended Vinchiaturo? This appeal is his last appearance in the invaluable but woefully incomplete Ruby file. He may have been trying to help her, although this transfer and his exit from the record lend credence to the harsher reading of the story: he has done his part—secured her trust, effected her move to a camp, vanished. Searches in various Italian archives turn up no further trace of him.

The Italians' conflation of the words *concentration* and *internment* muddies the waters. Most of these camps were less brutal than those of the Nazis, though that's an atrociously low bar. Italy did

not subject detainees to systematic torture, forced labor, or medical experiments, and did not murder them. Still, there were many incidents of violence, and internees suffered acutely from isolation, illness, cold, starvation, and primitive living conditions, often without sanitation or fresh water.

Shortly after Mari's intervention, state police agents took Ruby north to the Vinchiaturo camp, in the Campobasso province. Louise Bligh followed. There, along with other political prisoners, they shared crowded quarters with prostitutes and criminals.

Ruby immediately wrote to the ministry about the wretched state of her health. And five days after arriving at Vinchiaturo, she and Louise were transferred to yet another camp, Pollenza, in the Macerata province. This one, a villa on a country estate surrounded by a park, held about one hundred women, mostly "enemy aliens," who were allowed to walk in the park and attend Mass. It even had an infirmary. As internment camps go, this was the Ritz.

Still, Ruby wanted out. She wrote yet again to the ministry on September 10, 1940. Although Pollenza is "an excellent location," she says, the "desperate" state of her health renders her unable to bear "the inevitable hardships of a concentration camp." Appealing to the "enlightened generosity of the Italian government," she asks to live in a town with her "nurse," Louise Bligh. She will pay for the accommodations her condition requires, "being of means."

Another mystery. On August 12, when Ruby arrived for her first internment in the village of Ospedaletto d'Alpinolo, the local prefect reported to the authorities in Rome that she had been "stripped of means" and would be assigned a daily stipend of 6.50 lire plus .50 lira for monthly lodging, in accordance with ministry regulations. Yet two months later, when she transfers to the camp in Pollenza, she says she has the means to live with her nurse in a town. And local officials report that she has an income of ten thousand lire a month—equivalent to about five hundred dollars then,

worth roughly nine thousand dollars today. In 1942, Italians earning over sixteen hundred lire a month were considered wealthy.

Ruby may have managed to safeguard some of her assets, possibly in Switzerland, and Louise Bligh may have been smuggling money in. Did Ruby's family in England know where she was? Only three of her siblings were still alive in 1940—Betty, Conway, and Bob—and with Italy and England at war, communication between the countries was difficult, if not impossible.

At least part of Ruby's income came via the American government. The United States did not enter the war until December 1941. Its embassy in Rome, which had a Department of British Interests, quietly channeled funds to some interned British subjects—possibly, in Ruby's case, money supplied by her family or a London banker, if they did know of her detention. In the autumn of 1940, the U.S. embassy contacted the Italian Ministry of Foreign Affairs about "Interned British Subjects," requesting special attention to "instances of illness and advanced age," and providing a list of particularly important cases. Ruby was #2: "She suffers from chronic diabetes and is in poor condition. For her health she would like to go to a place where she can receive medical care."

The Ministry of Internal Affairs authorized a medical exam, at Ruby's expense, referring to Signora Wertheimer as the "Englishwoman interned at Pollenza." The physician who conducted the exam confirmed that she was not fit to withstand camp conditions. His report, forwarded to Rome, describes in grisly detail her "severe diabetes causing notable decline, asthenia, sharp decrease in vision . . . loss of feeling in her right big toe," and abscesses and boils on various parts of her body. Plus an infestation of bedbugs.

Ruby's first two transfers—Ospedaletto to Vinchiaturo, then Vinchiaturo to Pollenza—took place almost immediately upon request. Getting released from Pollenza took nearly three months. Still, it seems remarkable that she had any agency here at all—that

she made so many appeals, that she secured a Swiss visa, that her maid was allowed to live with her in the camps, that the Americans weighed in, and that some of her efforts succeeded.

She had grown up in privilege, as had, to take a few well-known examples, the Ephrussis in Paris and Vienna, the Camondos in Paris, Giorgio Bassani's fictional Finzi-Continis in Ferrara. They regarded themselves as British, French, Austrian, Italian—and also Jewish. Others, fatally, defined them only as Jews. Like many people caught up in these events, Ruby probably expected the world to operate as it had before the war, and could not imagine the horrors in store until they materialized. Still, she fared far better than most, shielded to an extent by Paolo Mari, then by Louise Bligh, her own wealth, her confident petitions, and U.S. government intervention.

In early November 1940, she received permission and the requisite papers to live at her own expense in the town of San Severino Marche with Louise Bligh. She hired a car to drive them the twenty-five kilometers from Pollenza to San Severino. Documents in a Macerata archive fill in further details. When the two women arrived, an official recorded their physical appearance: Ruby was five feet, two inches tall, with chestnut hair, "bright" eyes, "natural" coloring, "regular" forehead, mouth, nose, and body type. Her profession: *"benestante"* (wealthy). Most of the details for Louise are the same, except her hair is streaked with gray, she wears glasses, and her profession is *"cameriera"* (chambermaid).

They took a first-floor apartment at 113 Via Eustachio. In effect, Ruby was back where she had started four months earlier, under surveillance in "free internment." Her health did not improve. She spent two months in bed, and had to be hospitalized in February 1941. She told authorities in Rome that her stipend from the American government did not cover her medical treatments, and asked for the daily allowance provided to civil internees. Virtually all the

detainees who started out with "means" eventually asked for the subsidy. Ruby's request was denied.

She died in the apartment at San Severino Marche on December 3, 1941, at age fifty-two, of diabetic gangrene and cardiac insufficiency.

Wertheimer descendants were told that her death had been caused by her inability to get insulin in the camps, yet nowhere in the letters from her and her doctors does the word *insulin* or even *medicine* appear.* Ruby could not have survived into her fifties without some kind of medication. Louise Bligh may have kept a supply, which would help explain her indispensability and designation as "nurse."

The day after Ruby died, local officials took inventory of her belongings, with the help of Louise and a neighbor. There were two trunks, containing furs, capes, shawls, dresses, nightgowns, hats, leather bags, shoes, boots, linens—and twenty-seven gold-plated bracelets and chains. Ruby had been ordered to leave Milan in 1940 without her possessions. How she had managed to retain these items through various internments is one more mystery. Perhaps Louise had hidden them. And Ruby may have left her real jewelry in London, or taken it to Switzerland, or given it to Paolo Mari. Macerata officials entrusted all the property to Louise, who would be held responsible if anything went missing.

The final document in Ruby's Central State Archive file classifies her as *"Inglese"* and records the numbers assigned to her case by the Ministry of Internal Affairs. Someone drew a cross on the page, presumably to indicate death.

The authorities in Macerata sent copies of the death certificate

* Scientists discovered in 1918 that adult-onset diabetes (type 2) responded to a blood-sugar-lowering agent found in plants, and a synthetic version called metformin came into use in the 1920s. The hormone insulin, isolated by Canadian researchers in 1921, also proved highly effective, and the substance extracted from animals soon became widely available; its discoverers won the Nobel Prize in Medicine in 1923.

to the ministry in Rome, the Swiss legation, the prefect of Milan, and the Department of British Interests at the American embassy in Rome. The Swiss asked for additional documents to send to British authorities.

Louise Bligh paid for the funeral in San Severino Marche, and in May 1942 asked Ruby's brothers to reimburse her for expenses. She also wrote to her former employer's financial manager in London about the possessions in her custody. She remained in San Severino until her own death in 1955.

On December 7, 1941, four days after Ruby died, the Japanese bombed Pearl Harbor. The United States declared war on the Axis powers on December 11. Mussolini was deposed, and Italy surrendered to the Allies, in 1943, at which point Germany occupied the country's northern and central regions. Aided by Italian authorities, the Nazis conducted massive sweeps of native and foreign Jews, and deported most of them to German extermination camps. Ruby's gruesome death at least spared her the gas chamber.

FLUX

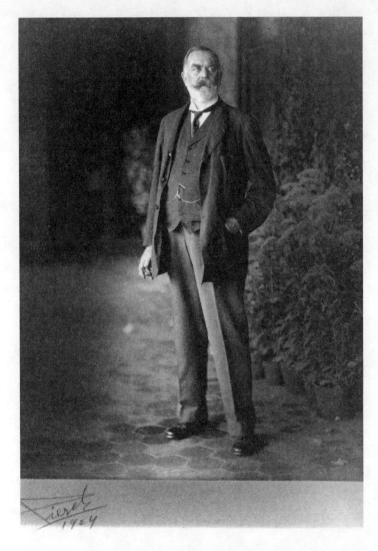

John Singer Sargent, 1924.
(Photograph by H. H. Pierce. Private collection.)

"An Age on Edge"

When Sargent finished the Wertheimer series, in 1908, he had been eager for some time to escape the confines of the studio, the relentless pressure of sittings, the demands and vanities of imperious clients. His immense success as the painter of choice for British and American elites had become a trap. He had said in 1904 that he was "sick of portrait painting" and longing to quit the "cursed business." Three years later he announced, "No more paughtraits . . . I abhor and abjure them and hope never to do another, especially of the Upper Classes."

Released from the silken shackles of commissions, he worked as indefatigably as ever, on watercolors, figure studies, landscapes, and murals for the Boston Public Library. He had always safeguarded time to paint outdoors in natural light, and now traveled more than ever, to the Alps, the South of France, the Levant, Spain, Italy, and Greece. The paintings he did on these trips have an exuberant sense of freedom.

One of his traveling companions, the American art dealer and critic Martin Birnbaum, described Sargent starting work every day after an early breakfast, stopping only for lunch, and reading before dinner to relax. For the watercolors he used an ordinary folding

box of discs, leaving dabs of paint on the tin cover and keeping a clean space the size of a soup spoon in the center. "I find 'box colour' very useful," he told Birnbaum, "and I use a great many different brushes, keeping my fist full when I work."

The artist's manservant, Nicola d'Inverno, scouted locations. Sargent would sit at his easel under large green-and-white umbrellas that sometimes blew over in the wind and left him looking, wrote Birnbaum, like "a newly hatched chicken surrounded by broken eggshells."

Watercolor requires quick execution and minimal revision, which perfectly suited Sargent's skills. Using broad, fluid washes, precise underdrawing, bare white paper, wax-resist texture, he caught the crimson heart of a pomegranate, shadows of leaves on a Corfu wall, dazzling effects of sunlight on water and stone. These immensely popular paintings brought out the familiar charge of superficiality. "Visual sensations so vivid as these shut back, by their very acuteness, the deeper springs of emotion," wrote a British critic in 1908: "One is impressed, astounded, but one carries little away." An American critic had no such reservations: seeing eighty-three of the watercolors at the Knoedler Gallery in New York in 1909, Royal Cortissoz wrote, "Only a man of genius could have done this work."

The watercolors were not for sale. Sargent said that only a museum or collector wanting to buy a "whole lot *en bloc*" might tempt him, since the pictures only amounted to anything when seen together. In the autumn of 1909, the Brooklyn Museum acquired all eighty-three of the paintings shown at Knoedler for twenty thousand dollars. The Museum of Fine Arts in Boston had wanted them as well but its offer arrived too late. The MFA scheduled a second American exhibition for 1912 and bought that whole lot ahead of time.

Since demand for Sargent portraits did not let up after the artist declared, "No more," he substituted charcoal sketches, which he

called mugs. He could do one in two to three hours, and produced an average of thirty-three a year between 1907 and 1925, including the drawings of Nijinsky, Karsavina, and Eva Gauthier. Again, demand grew oppressive. Calling down a *murrain* (plague) upon the charcoals, Sargent told a friend, "I have become prohibitive—they are now 40 guineas a mug." That price increase had no greater deterrent effect than had raising the cost of his oil portraits in the 1890s.

He occasionally broke his no-more-portraits rule for prominent public figures and close friends. Having done the official White House portrait of Theodore Roosevelt in 1903, he was in Washington working on another, of Woodrow Wilson, when he wrote to Isabella Stewart Gardner in 1918, joking yet again about "something not quite right about the mouth":

> It takes a man a long time to look like his portrait, as Whistler used to say—but [Wilson] is doing his best, and has been very obliging about finding time for sittings. He is interesting to do, very agreeable to be with, and the conditions are perfect as he allows no interruptions and does not hold levees as Roosevelt used to do—and his wife approves and does not even think there is 'just a little something not quite right about the mouth.'

Had Picasso heard Whistler's remark when he told the friends of Gertrude Stein who complained that she didn't look like her portrait, "She will"?

To honor Henry James's seventieth birthday in 1913, a group of his English friends raised funds to commission a formal Sargent portrait. The artist, also a James friend of long standing, refused payment. He warned the novelist, who reported the conversation to a nephew, that after giving up portraiture he had "quite lost his nerve," and reserved the right to destroy the picture if he didn't

like it. He hadn't liked his 1912 drawing of James, saying, "It has neither his grim expression nor his amused one"—but hadn't destroyed it.

James had turned down a request from William Rothenstein to write an essay on Sargent in 1897: "I have written so much and so hyperbolically and so often about that great man that I scarce feel I have another word to say in public." He nonetheless had a great many words to say in private about sitting for his 1913 portrait. He so enjoyed the process, he told a friend in his circuitous late style, that he was sorry when it ended—"in spite of the repeated big holes it made in my precious mornings"—

> J.S.S. being so genial and delightful a *nature de grand maître* to have to do with, and his beautiful high cool studio, opening upon a balcony that overhangs a charming Chelsea green garden, adding a charm to everything. He liked always a friend or two to be in to break the spell of a settled gloom in my countenance by their prattle.

Sargent's James, seated against a dark background, his great domed head drawn slightly back, seems to look inward and outward at once, as if illustrating his famous advice to be one of the people "on whom nothing is lost." He declared the picture "Sargent at his very best and poor old H.J. not at his worst; in short a living breathing likeness and a masterpiece of painting." He went expansively on: "I am really quite ashamed to admire it so much and so loudly— . . . as if I were calling attention to my own fine points. I don't, alas, exhibit a 'point' in it, but am all large and luscious rotundity—by which you may see how true a thing it is."

During a private viewing in the Tite Street studio, James stationed himself beside the picture and reported to Edmund Gosse that "the translation . . . visibly left the original nowhere."

A militant suffragette attacked the portrait with a meat cleaver at

the Royal Academy in May 1914. Another had slashed Velázquez's *Toilet of Venus* at the National Gallery in March. Feminist hostility to the languorous nude Venus made somewhat more sense than to the staid American writer. The aim, each time, was to demand women's rights by destroying valuable property. Both paintings were restored. James bequeathed his to the National Portrait Gallery in London.

Sargent also made exceptions to the portrait ban for his friends Philip and Sybil Sassoon. Their father, Sir Edward Albert Sassoon, 2nd Baronet, descended from wealthy Baghdadi Jews—treasurers to pashas, then merchant traders who multiplied the family fortune in India, China, and Shanghai. It was Sargent's 1907 portrait of Sir Edward's wife, a French Rothschild, that prompted the remark about his preferring to paint "Jewesses . . . as they have more life and movement than our English women." And also the line he deployed for the rest of his life—"a portrait is a painting with a little something wrong about the mouth."

Philip and Sybil spent much of their early lives in Paris. Sibyl recalled playing piano duets and taking drives in the Bois de Boulogne with Sargent. He sketched and painted her several times, saying she was the most beautiful woman he had ever drawn. His 1912 charcoal portrait emphasizes her long neck, wide-set eyes, and arching brows, one shoulder bared by luxuriant folds of a satin opera cloak. He did her portrait in oil as a wedding gift when she married George Cholmondeley, Earl of Rocksavage, in 1913. For another painting, commissioned by her brother in 1922, she wore a Spanish court dress reminiscent of Velázquez, designed by Worth at Sargent's request. Philip pronounced the portrait a masterpiece: "Her face is like a camellia with an electric light behind it."

Sybil became Marchioness of Cholmondeley in 1923, when her

husband (called Rock) succeeded to his title as 5th Marquess. She restored Houghton Hall, the Palladian house on his family's Norfolk estate, much as Almina Carnarvon restored Highclere Castle.

From the citadel of Anglo-Jewry, Sibyl reflected on her marriage to an Anglican: "it never *gêned* [troubled] me because ... the Rothschilds never wished us or anybody else to have Jews in the house. The only Jews that were ever there were Rothschilds." Talk of her marrying a Rothschild came to nothing. She reflected, "We used to go once or twice a year to the synagogue, very rarely."

While the generic identification of Jews as "Oriental" cast them as Eastern, alien, other, not Anglo-Saxon, not "us"—the Sassoons actually *were* "Oriental," their family having been in Mesopotamia since the sixth century B.C. Sybil and Philip inherited the paternal complexion. Sargent once exclaimed with delight, "Sybil is *lovely*; some days she is *positively green!*"

At Eton and Oxford, Philip's French accent, Jewish lineage, olive skin, and ostentatious displays of wealth marked him out. In one notorious incident at Oxford, Julian Grenfell, later a soldier and poet who was killed in the Great War, chased him around a college quad with a bullwhip, shouting his name in its French pronunciation: "Phee-leep, Phee-leep! I see you!" Others repeated the taunt for years.

Lady Sassoon died in 1909, Sir Edward in 1912. Philip succeeded to his father's title and was elected to his seat in Parliament. He inherited a fortune, a country estate in North London, and the town house at 25 Park Lane, which he completely remodeled, devoting an entire room to paintings by Sargent and installing the portraits of his mother and sister (the "Velázquez" Sybil) over the staircase. He did not meet his cousin Siegfried until after the First World War.

Baronet, politician, aviator, sybarite, collector and patron of art, Philip was such an elusive character that one acquaintance compared him to a fragrance. He kept his sexual life private. By all accounts it revolved around men.

Sargent was in the Dolomites, "painting hard," when Britain and France declared war on Germany and Austria in August 1914. He could not get back to England until November, and spent that Christmas in Tite Street with Henry James. The novelist, horrified by the war, renounced his U.S. citizenship and became a British subject to protest his native country's neutrality in 1915. Sargent did not. He returned a Prussian Order of Merit award and did paintings to benefit the British Red Cross, yet remained for the most part disengaged from world affairs.

Early in 1916 he went to the United States and stayed for two years, working on the Boston Public Library murals, traveling in the West, visiting Charles Deering in Miami. He painted a portrait of this old friend in dappled Florida sunlight, and a watercolor of Deering's half brother, James, who was building an Italianate villa called Vizcaya nearby. Sargent also did watercolor studies of the villa, its gardens, its Black construction workers taking a nude swim at the beach. Shortly after the United States finally entered the war, in April 1917, he wrote to Sybil, Countess of Rocksavage, that he was feeling "out of all that matters—I am fiddling and doing watercolors while Rome is burning."

In England the following spring, the British Ministry of Information commissioned him to paint a "big" picture honoring Anglo-American military cooperation. At sixty-two, in July 1918, he traveled as an official war artist to the western front. The officer in charge of him was Major Philip Sassoon, private secretary to the commander in chief of the British forces in France, Sir Douglas Haig. Sassoon left an indelible account of his friend's arrival for war work "in the most faultless khaki, Sam Brown belt under his armpits, puttees, etc. & Saratoga trunk upon trunk filled with trousseau." Field Marshal Haig said the corpulent artist "doesn't look as if he took much exercise. He'll burst one of these days."

Sargent did not find a suitably epic British-American subject. He painted vivid scenes of destruction—the ruins of the Arras

Cathedral, wrecked tanks, a bombed sugar refinery, a crashed plane—and of military life: soldiers sleeping, bathing, stealing apples, confined to hospital beds. Then, in August, after the Germans attacked British troops with mustard gas, which burns eyes, skin, and lungs, he began sketching the consequences. In his monumental war painting, *Gassed*—twenty feet wide and nearly eight feet high—blinded soldiers with bandaged eyes are led single file to medical tents as if in a classical frieze, each holding onto the shoulder of the man in front. One leans over to vomit. More blindfolded Tommies lie on the ground around them. In a semblance of normal life, a few men play football (soccer) in the distance. A pale sun is setting in mustard-yellow light.

The reception of the painting was mixed. Winston Churchill, seeing it at the Royal Academy in 1919, praised the "brilliant genius and painful significance" of the "tragic canvas." Eighty years later, an American historian called it "the most haunting image of this war." Others faulted it for aestheticizing the conflict—the men too good-looking, the football game too carefree, the entire tableau too artful and clean.

Another Sargent image provoked a different kind of controversy across the Atlantic in 1919. From Boston that fall, the artist wrote to his friend Evan Charteris, "I am in hot water here with the Jews."

He had been working on mural decorations for the Boston Public Library for nearly three decades. The subject he had chosen— the history of religion—was an unlikely one for a secular artist and an American civic space. The building was hailed as "a palace for the people" when it opened in 1895. Sargent's ambitious narrative cycle, called in the end *The Triumph of Religion*, begins with pagan gods, moves through Old and New Testament scenes, and ends with allegorical figures representing Church and Synagogue

in a section called "The Medieval Contrast." It was the synagogue image, unveiled in the fall of 1919, that landed him in hot water. Church is represented as a beautiful young woman with symbols of the Eucharist and Gospels, gazing directly at viewers over the fallen body of Christ. The figure for Synagogue is a blindfolded crone, slumped to one side amid ruins, her crown falling off, a broken scepter and tablets of the law in her muscular, masculine arms.

The portrayal of Judaism in decrepit defeat offended Christians as well as Jews, provoking national debate and calls for the panel to be taken down. An aggrieved Sargent told Charteris, "A prominent member of the Jewish colony is coming to bully me about it and ask me to explain myself." His explanation: the images derived from iconography in medieval cathedrals—Notre Dame, Strasbourg, Reims.

Carved in stone on the façades of these cathedrals is the triumphalist agenda of the twelfth-century Catholic Church: Christianity vanquishing Judaism. In a niche on the front façade of Notre Dame, a victorious crowned "Ecclesia" stands upright with chalice and cross, looking to the future. Beside her, "Synagoga," blindfolded by a snake, head bent in humiliation, her crown on the ground, holds a broken lance in one hand and holy tablets slipping from the other. The blindfold represents Jews' refusal to see the light of Christ. Sargent depicted not the triumph of Religion so much as the triumph of Christianity. No reference to Islam, although he had traveled extensively in Muslim lands.

As pressure for removal of the image intensified, some of the artist's friends tried to organize a counterprotest. "Fortunately," Sargent reported to Charteris, "the Library Trustees do not object, and propose to allow this painful work to stay." Painful for both the public and the artist. The Massachusetts legislature, which did object, passed a bill to remove the panel in 1922 but repealed it two years later. In 1924, someone splashed black ink on the image, which was quickly cleaned. Sargent had planned to install a panel

of the Sermon on the Mount in between Church and Synagogue, but never returned to the project.

His use of a derogatory Catholic icon for "Synagogue" is especially remarkable since, not to coin a phrase, some of his closest friends were Jewish. The pain and anger it caused took him by surprise. Had its presence in sacred art-historical spaces blinded him to its current impact? Had he intended it to represent only the past ("The Medieval Contrast")? Up to this point he had seemed in effect philo-Semitic. While most of the Wertheimers, Sassoons, Rothschilds, Lewises, and Meyers were not religious, they identified with Judaism, which is a culture as well as a religion, and had clearly not been destroyed by Christianity. There is no record of what any of them thought about the Boston fracas. Asher had died before it began.

Sargent's letters rarely mention Jews, although he spent a great deal of time among them. One of the few references he did make appears in a 1923 note to Isabella Stewart Gardner about a British Foreign Service officer she had recently met, Ronald Storrs, the military governor of Jerusalem. Sargent described him as "a capable and energetic fellow—more popular with the Arabs in Jerusalem than with the Jews. He thinks, as Max Beerbohm does:

> It's odd
> that God
> should choose
> the Jews."

It wasn't Beerbohm who coined that famous epigram; the lines are attributed to the British journalist and occasional poet William Norman Ewer, and the original is:

> How odd of God
> to choose the Jews.

"How odd of God to . . ." is a more bemused reflection than "It's odd that God should . . . ," which seems declarative and perhaps somewhat put out. Either way, Sargent's atypical comment isn't his own but a (mis)quote from a clever friend.

He did murals for two other Boston institutions in the early 1920s: a tribute to Harvard men who had died in the Great War for the college's Widener Library, and a series of allegorical images from classical mythology for the Museum of Fine Arts. All three architectural projects addressed large public themes in the tradition of the Italian Renaissance. The installation of the first Public Library panels led to predictions that the space would become the American Sistine Chapel.

According to some of Sargent's friends, he thought these decorations would be his most significant legacy. Major European academies in the seventeenth century had ranked history painting— narrative scenes addressing lofty subjects from classical antiquity, religion, mythology—far above portraiture, which was thought merely to "copy" natural reality. Sir Joshua Reynolds, a founder of the Royal Academy and one of the foremost portrait artists in eighteenth-century England, had believed in the primacy of history painting.

In turning from portraiture to public art, Sargent sacrificed his greatest strengths. He responded most powerfully and imaginatively to living figures—to gesture, expression, the eloquent ways in which people inhabit their bodies, clothing, surroundings. While he met the formal challenges of mural work with artistry and technical skill, the themed narratives pale beside his portraits. One critic writing about the murals missed the "real thrill" elicited by *Madame X*, with its "design, nerve, heart."

Loss of sight, for an artist, is a kind of death, and a theme of blindness runs through these years. Blinded soldiers in *Gassed*. Blindfolded Judaism in medieval iconography. Sargent's failures to take in the enormity of the war until it was nearly over, and

to foresee the impact of his Synagogue image—as he had earlier failed to anticipate the response to *Madame X*. Also, his embrace of the outmoded history-painting genre just as modern art was moving in revolutionary new directions.

<center>⌒</center>

While he did not ignore negative responses to his work, Sargent tended to shrug them off, at times deploying his useful DAMN stamp. Still, in the early years of the new century the chorus of criticism intensified. He had essentially stopped painting portraits, yet his detractors continued to condemn them as shallow, flashy, too popular—and too profitable.

The harshest censure came from Roger Fry. He had complained in 1900 of being "deafened by the fizz and crackle of Mr. Sargent's brushwork," had called the artist "simply a précis writer of appearances," and dismissed the portrait of Ena, *A Vele Gonfie*, as an example of the "blandness of his commonplaces and the apparent sincerity of his love of the banal." Fry had admired a few early Sargents, but noted after the artist died, "I seem to have been all my life pursuing him with disobliging remarks."

The two had a public dispute in 1910 over an exhibition Fry organized at London's Grafton Galleries, *Manet and the Post-Impressionists*. An ardent advocate of the French avant-garde, Fry asked Sargent to lend his name in support of the show, an invitation the painter declined. Nonetheless, in a letter to *The Nation* magazine, Fry listed him as among the champions of the group, which included Cézanne, Van Gogh, Seurat, Gauguin, Picasso, and Matisse. Sargent responded with a letter of his own saying, among other things, that he had turned down the request because he did not know the work of most of the artists, nor did he think Fry's term "Post-Impressionist" applied to Manet or Cézanne.

The British press and public hated the exhibition. Lytton Strachey

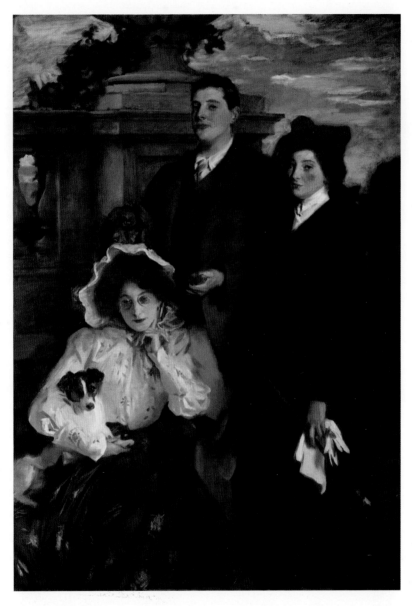

Hylda, Almina and Conway, Children of Asher Wertheimer, 1905.
Oil on canvas. (Tate. Presented by the widow and family of Asher Wertheimer
in accordance with his wishes, 1922. Photograph: Tate)

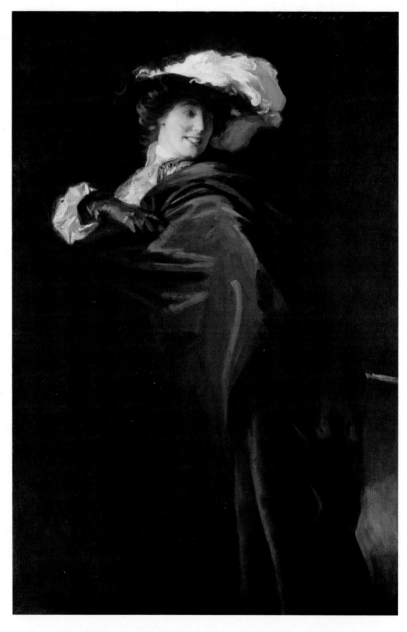

A Vele Gonfie: Portrait of Ena Wertheimer, 1905.
Oil on canvas. (Tate. Bequeathed by Robert M. Mathias, 1996. Photograph: Tate)

Almina, Daughter of Asher Wertheimer, 1908.
Oil on canvas. (Tate. Presented by the widow and family of Asher Wertheimer
in accordance with his wishes, 1922. Photograph: Tate)

Betty Wertheimer, 1908.
Oil on canvas. (Smithsonian American Art Museum. Gift of John Gellatly, 1929.6.107)

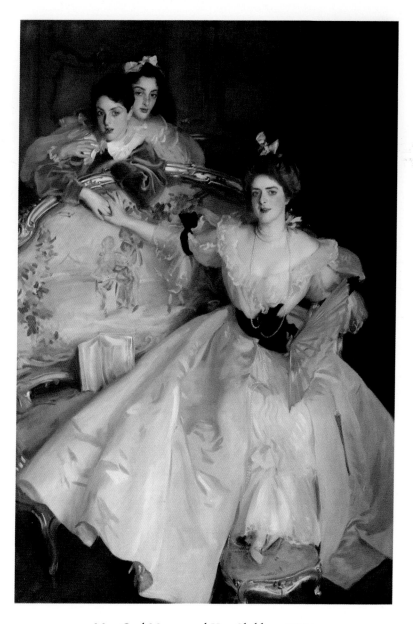

Mrs. Carl Meyer and Her Children, 1896.
Oil on canvas. (Tate. Bequeathed by Adèle, Lady Meyer. Accessioned 2009.
Photograph: Tate)

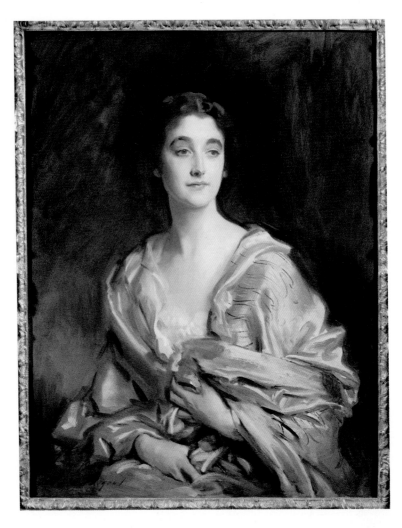

Sibyl Sassoon, 1913.
Oil on canvas. (Private Collection. Bridgeman Images)

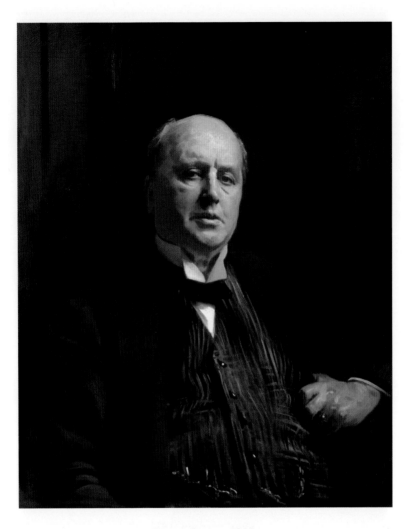

Henry James, 1913.
Oil on canvas. (Bequeathed by Henry James, 1916. National Portrait Gallery,
London, NPG 1767)

Sir Philip Sassoon, 1923.
Oil on canvas. (Tate. Bequeathed by Sir Philip Sassoon, Bt, 1939. Photograph: Tate)

proposed in dark jest that Fry be burned as a heretic in the academy courtyard. Yet *Manet and the Post-Impressionists* represented a pivotal moment in the advent of modernism, leading to Virginia Woolf's oracular pronouncement, "On or about December 1910 human character changed."

The episode redounds to no one's credit: Sargent, and much of British critical opinion, for dismissing the shock of the new; Fry for publicly claiming an endorsement he did not have. That he wanted the backing of an artist he so resoundingly disparaged is surprising. The intensity of his focus on Sargent went far beyond the professional.

Walter Sickert, in his 1910 essay "Sargentolatry," denounced British critics for their worship of a false god, yet acknowledged the character of his quarry: "If sense and modesty could disarm criticism, [Sargent] would be immune. But alas! nothing disarms me." Sickert blamed the world's "unbroken adulation" for forcing him "to write grudgingly of a man whose great and rare qualities I cordially envy."

Fry offered no comparable concessions. He, too, aspired to be an artist, telling a friend, "I loathe art criticism more and more, and long to create." Yet his paintings met with scant appreciation.* He wanted tangible rewards as well. Struggling to support his family,

* In November 1921, Fry's friend and former lover Vanessa Bell wrote to her husband, Clive, from St. Tropez, where she and an entourage that included Fry had gone to paint:

> Roger left for Paris today. You will soon no doubt have to see his works unless he leaves them all in Paris. I hope you will be as appreciative as you can, as he is really in rather a bitter state about the lack of appreciation he gets in England, most of which I gather he puts down to you and me. We have had one or two rather painful moments when I have been simply driven into a corner about his painting. Do what I will, he sees I don't like it, and now that he's such a success, a *sociétaire* of the autumn salon and all the rest of it, he seems only to resent more the fact that I can't show any pleasure in his works. When one is actually here in the midst of the country he paints it's even more difficult I think than in England to like what he does. He does manage to reduce it all to such a dead drab affair . . . I begin to think that finally there'll be nothing for it but to tell him the truth. Prevarication is becoming too painful and unsuccessful. But I managed to avoid it this time.

his travels, and the fine arts journal he cofounded, *The Burlington Magazine*, he went to New York—where the money was—in 1905. He found the American millionaires alternately enthralling and contemptible. Up for a job at the Metropolitan Museum, he overestimated his value and asked for a much larger salary than had been offered, which ended the negotiations. In 1906, he accepted a lesser position at the Met, for even less money, and was let go in 1909.

He seized on the exhibition of Sargent's Wertheimer portraits at the National Gallery in January 1923 as the occasion for a new diatribe. Recalling the acclaim that had greeted these paintings as they appeared (though it had not been universal) and the "acid and disobliging phrases with which . . . I denounced them," Fry pretends to wonder whether honesty might now compel him to admit a mistake, and is relieved to find that it does not. Instead, seeing the portraits "enshrined in the National Gallery" confirms his view that Sargent is not a "pure" artist but a "practitioner in paint," whose work amounts to "art applied to social requirements and social ambitions." He was probably not amused by *Punch*'s "Young Master" cartoon just then, with Rembrandt, Velázquez, Van Dyck, et al. saying to Sargent on the National Gallery steps, "WELL DONE. YOU'RE THE FIRST MASTER TO BREAK THE RULE AND GET IN HERE ALIVE."

Fry's condescension toward Sargent is matched by his disdain for new wealth. He confers on Asher a sardonic "Sir":

> I see now that this marvellous series of portraits represents a social transaction quite analogous to the transactions between a man and his lawyer. A rich man has need of a lawyer's professional skill to enable him to secure the transmission of his wealth to posterity, and a rich man, if he have the intelligence of Sir Asher Wertheimer and the luck to meet a Sargent, can, by the latter's professional skill, transmit his fame to posterity.

Throwing over as irrelevant the "purely aesthetic point of view," Fry "rejoices" in Sargent's ability to record the "life of a successful businessman at the close of the 19th century":

> It was a new thing in the history of civilization that such a man should venture to have himself and the members of his numerous family portrayed on the scale and with the circumstances of a royal or ducal family, and I see that Mr. Sargent has quite peculiar and unique gifts for doing what both his patron and posterity required of him . . . No man who was mainly an artist could have, so to speak, "delivered the goods."

It was hardly a new thing in the history of civilization for a successful businessman to have himself portrayed in noble style at scale. The Medicis, depicted by leading artists of the Italian Renaissance, had earned their fortunes in banking and trade. Likenesses of the banker and arts patron Bindo Altoviti were recorded by Raphael, Benvenuto Cellini, and Francesco Salviati in a 1545 painting on marble that portrays the sitter in a sumptuous velvet coat lined with fur. Two centuries later, Dutch masters presented wealthy burghers in starched white ruffs and also costly furs. Perhaps by "such a man," Fry meant a Jewish one.

In the end, Fry assigns the core of his Sargent problem to others—"a painful feeling of injustice which rankles unnecessarily in the hearts of many artists" that one of their number should reap abundant material rewards while they care only for truth and beauty:

> It ought to be as clearly understood in art as it is in science that those who profess the applied branches of these studies have a right to ten times the salary and far higher honours than those who are obsessed by the love of truth and

beauty. The latter must accept the fact that those who are as pre-eminent in applied art as Mr. Sargent, may gain, besides present wealth and fame, almost as much posthumous glory as the true Parnassians.

The object of all this scorn would have no such posthumous glory if Roger Fry had anything to say about it, which he relentlessly did. He expanded and reprinted his Wertheimer essay in 1926, after Sargent died, cheerfully adding: "I am sure that he was no less distinguished and genuine as a man than, in my opinion, he was striking and undistinguished as an illustrator and non-existent as an artist." A parting shot: "Wonderful indeed, but most wonderful that this wonderful performance should ever have been confused with that of an artist."

The case against portrait painters who "deliver the goods" for patrons got an unexpected boost in 2022 when a critic for *The New Yorker* described Hans Holbein as a "hired-gun celebrant of whoever employed him, most decisively Henry [VIII]," and asked, "Could Holbein have been a greater artist if he'd been granted imaginative license?" The proposition that patronage rules out imaginative freedom would have astonished most of history's great artists.

Sargent had taken Philip Sassoon to watch the hanging of his Wertheimer portraits at the National Gallery in early January 1923, remarking as they left, "I feel quite puffed up."

Later that year, he painted a half-length portrait of Philip, one of his last. Posed like the fashionable aesthete he was, in a tailored black jacket over a white shirt and subtly patterned waistcoat, with a white cravat looped twice around his neck and tucked into the

waistcoat, Philip stands with one hand on a hip, the long fall of white against black accentuating his height. Like his sister, Sybil, he is a beauty. Unlike her, he looks wary, solemn. Seeing the painting at the Royal Academy in 1924, the *Times'* critic said, "Above all, it is the quiet vitality of the interpretation, as from inside, which impresses the observer and makes everything else in the room look a little fussy."

Somerset Maugham may have had this portrait in mind a few years later when he imagined the character of Ferdy Rabenstein in "The Alien Corn." With his fine Semitic profile, lustrous black eyes, and "flashy" style, Ferdy says, "After all, I am an Oriental . . . I can carry a certain barbaric magnificence."

Philip lent twenty-seven paintings, including this one, to a Sargent retrospective at the Royal Academy early in 1926. E. M. Forster wrote an odd, antic essay about the exhibition called "Me, Them, and You." Beneath his own ill-fitting suit, runs Forster's conceit, is "Me . . . a human being . . . not exposed much to the public gaze." And yet,

> Me was what mattered, for it was Me that was going to see Them. Them what? Them persons what governs us, the dukes and duchesses and archbishops and generals and captains of industry. They have had their likenesses done by this famous painter (artists are useful sometimes), and, for the sum of one and six, they were willing to be inspected.

Mocking the entire enterprise—artist, sitters, governing class— the novelist mounts a soapbox. He first encounters "a respectable family servant" to whom he comments on the weather, but "realizes" his mistake on receiving no reply: he has addressed the portrait of Lord Curzon. "I ought to have looked only at the clothes, which were blue and blazing . . . They cost a hundred pounds perhaps. How

cheap did my own costume seem now?" And "how impossible it was to imagine that Lord Curzon continues beneath his clothes, that he, too . . . was a Me."

Forster moves on to the next room, where his attention is drawn by "a young Oriental, subtle and charming and not quite sure of his ground. I complimented him in flowery words." Again, he is talking to a portrait, not a person, and goes on:

> He winced, he disclaimed all knowledge of the East. I had been speaking to Sir Philip Sassoon. Here again I ought to have looked first at the clothes. They were slightly horsey and wholly English, and they put mine to shame. Why had he come from Tabriz, or wherever it was, and put them on? Why take the long journey from Samarcand for the purpose of denouncing our Socialists? Why not remain where he felt himself Me? But he resented my analysis and I left him.

Less interested in art than in attitude, Forster hadn't really looked at the clothes. He could have had much more fun than he did with Curzon's blue velvet Garter robe—identical to the one worn by the Duke of Marlborough (and possibly Ena) in their 1904 portraits—which he simply calls blazing and costly. And though Philip's silk cravat could be a riding stock, his elegant black-and-white day wear seems more stylish than "horsey." But that wasn't the point. Sniping at upper-class power and "Oriental" exoticism was. A great deal could be and has been said against the arrogant Curzon and the orchidaceous Sassoon. But were only Forster and his friends entitled to a sense of true British identity, of being "Me"?

Forster had been over this ground before, in fiction. The Schlegel sisters in *Howards End* (1910) embody the Bloomsbury

values of moral imagination and personal connection. "There are two kinds of people," says Helen Schlegel: "our kind, who live straight from the middle of their heads, and the other kind"— powerful men who "can't say 'I' . . . because their heads have no middle." She is trying to convert a bank clerk to her views, and explains to him that no powerful man could say, "I want," because that must lead to the question, "'Who am I,' and so to Pity and to Justice. He only says 'want.' Want Europe, if he's Napoleon; 'want wives,' if he's Bluebeard; 'want Botticelli,' if he's Pierpont Morgan. Never the 'I'; and if you could pierce through him, you'd find panic and emptiness in the middle." What mattered was "our kind," and it was impossible to imagine that a Lord Curzon or a Philip Sassoon, under his expensive clothes, was one of "Us."

Virginia Woolf took a swipe of her own at Philip Sassoon after meeting him in 1929. With an acidly inaccurate reference to immigrant-crowded East End slums, she described him to her sister as "an underbred Whitechapel Jew." She had to know that Philip was if anything overbred, a hothouse plant unlikely ever to have set an elegantly shod foot in the East End unless perhaps for a charitable cause.

⁓

"Ours is, above all, a restless, nervous age," wrote Max Beerbohm in 1903—"an age on edge . . . [Its] supreme interpreter is, of course, Mr. Sargent."

It was indeed an age on edge, precariously balanced between centuries, between tradition and modernity, between a past dominated by Europe and an indistinct American future, between long-standing social hierarchies and disruptive forces of new power and wealth. And Sargent *was* its supreme interpreter. Having always

lived between continents and cultures, he had an imaginative free-
dom not widely shared by class-conscious Britons or upwardly mo-
bile Americans.

Early on, even as he studied the great artists of the past, Sargent
was trying out new approaches in his paintings of Carolus-Duran,
Dr. Pozzi, the Boit and Pailleron children, "Madame X." Later, as
the chosen painter of the international elite—whom he often ren-
dered in unconventional ways—he depicted new kinds of sitters as
well.

Like Henry James, he was captivated by the possibilities open-
ing up to modern young women. James, in a preface to *The Por-
trait of a Lady*, wrote that he had started the novel with only
the idea of "a certain young woman affronting her destiny"—an
American, a "mere slim shade of an intelligent but presumptu-
ous girl"—and had asked himself at the outset, "Well, what will
she *do*?"

Unlike James, Sargent did not explain his thinking. He simply
painted sensual, witty, eloquent portraits that, among other things,
prompt us to wonder what his fresh young women might do. Among
them: Ena, Betty, and Almina Wertheimer and Sybil Sassoon in
England, and a striking array of Americans—"mere slim shades of
intelligent but presumptuous girls"—the adolescents Alice Vander-
bilt Shepard, Elsie Palmer, Beatrice Townsend. Also thirty-year-
old Edith Minturn Stokes, self-assured in a starched white skirt,
tailored jacket, and bow tie, holding a boater hat at her hip. When
the painting was shown at the Society of American Artists in 1898,
one critic pronounced it "more than an individual portrait—it is
'The American Girl' herself."*

* Sargent had planned for Edith to rest one hand on the head of a large Great Dane,
but he could not find a dog in time for the sittings. Instead, her husband filled in as a
shadowy figure standing slightly behind her. Though the portrait is called *Mr. and
Mrs. I. N. Phelps Stokes*, it is all about Edith. It was Mr. Stokes who thought Asher

Sargent portrayed a number of his audacious young women in male attire: Ena as a dashing cavalier in *A Vele Gonfie*; her sister Almina as an "Oriental" harem slave in a man's Turkish coat; the androgynous Vernon Lee in a boyish Gladstone collar; Lee's lover Clementina Anstruther-Thomson in walking clothes and a shepherd's hat, striking a masculine pose with her hands on the lapels of her cape. And he frequently captured effeminate beauty in men—Léon Delafosse, W. Graham Robertson, Albert de Belleroche, Alfred Wertheimer, Philip Sassoon.

Sexual ambiguity in art was hardly a new thing, dating back to classical antiquity, to Shakespeare's cross-dressers, to paintings by Michelangelo, Bronzino, Caravaggio, and many others. It was, however, a striking new thing for the most prominent chronicler of high society to do more than seventy pictures of Jews, often in postures and styles that allude to the Old Masters.

The paintings Sargent chose to show at the Paris Exposition in 1900, two of Jews and one of a leading American feminist, could read as a quiet salute to social change. His *Asher Wertheimer* and *Mrs. Carl Meyer and Her Children* drew large crowds in the midst of France's fraught Dreyfus Affair. M. Carey Thomas, the president of Bryn Mawr College and the first woman to earn a Ph.D. from the University of Zurich (in linguistics), was a tireless promoter of women's education and voting rights, and openly lesbian. Sargent portrayed her as he did the Harvard presidents Charles W. Eliot and A. Lawrence Lowell, in academic robes.

The art historian Elizabeth Prettejohn challenges critics who nod to Sargent's technical skill while dismissing his work as shallow and tainted by commerce. She argues that his portrayal of "the precarious glamour of an upper class in rapid transition" is "more

Wertheimer, in Sargent's portrait, looked as if he were "pleasantly engaged in counting golden shekels."

'modern' than many kinds of class representation conventionally considered avant-garde." What distinguishes his portraits from the work of other artists and periods is

> the powerful projection of the sitter's presence, not in the timeless realm of traditional portraiture, but in the modern here and now; the dramatization of social flux as opposed to the petrification of social status; the projection of the social self; the crystallisation of the present moment in the psychological stream of consciousness; the play between surface artifice and realist illusion.

Prettejohn's prime example:

> *Ena and Betty, Daughters of Asher and Mrs. Wertheimer,* can sustain all of these interpretations. From close range the play of gigantic brushstrokes flattens into pure painterliness, yet from a distance the "speaking likenesses" start from the picture space. The glittering highlights on the white dress, the gleaming vase and the summarily foreshortened fan are readable in turn as symbols of the Wertheimers' Jewish opulence or abstract patches of luscious pigment . . . What makes this portrait a representation is precisely what makes it a work of art.

In April 1925, Sargent was preparing to travel to Boston to supervise the final installation of his murals in the Museum of Fine Arts. He had dinner on April 14 with his sisters, Emily and Violet, at Emily's flat in Carlyle Mansions, a fifteen-minute walk from Tite Street. The party included his artist friends Henry Tonks, Lawrence ("Peter") Harrison, and Philip Wilson Steer, and the Barnard

sisters, whom he had painted as children lighting paper lanterns in *Carnation, Lily, Lily, Rose*. When the party broke up, he went home. He died in bed that night, age sixty-nine. His housekeeper found him in the morning with his glasses pushed up onto his forehead and an open volume of Voltaire's *Dictionnaire Philosophique* beside him.

Legacies

Sargent was buried at Brookwood Cemetery in Surrey, and there was a memorial service at Westminster Abbey on April 24. Several months later, the Boston Museum of Fine Arts and New York's Metropolitan Museum of Art mounted commemorative exhibitions. The Royal Academy's retrospective, open from January to March 1926, included more than six hundred works.

The largest lenders to the academy tribute in London were the artist's sisters, followed by Philip Sassoon and the Imperial War Museum. *Lady Agnew* was there, on loan from the National Library of Scotland, and *Henry James* from the National Portrait Gallery. Tate loans included *Carnation, Lily, Lily, Rose* and a study in oil of Madame Gautreau. From the Wertheimer family: watercolors, the pencil drawing of Ena, the 1908 oval portrait of Betty, and the 1913 Robert Mathias.

"The Academy exhibition is the most crowded resort in London," reported *The Westminster Gazette*, the galleries "so tightly filled with people that it was about impossible" to see the paintings. The paper offered an assessment and a forecast: "Pictures so popular can never hope to satisfy our contemporary highbrows; but no doubt future highbrows will rediscover the genius of Sargent."

The nine Wertheimer portraits Asher had given to the National Gallery were not in the academy retrospective. They had been on view in Trafalgar Square for more than a year when Asher's son and executor, Conway, learned from news reports in April 1924 that they would soon be moved to the Tate. Joseph Duveen had pledged five thousand pounds to build a Sargent gallery in the Tate's Turner Wing.

Conway wrote at once to the gallery's keeper, C. H. Collins Baker, reminding him of Asher's strong wish that the paintings be shown together in Trafalgar Square, and of the keeper's repeated assurances that the trustees would honor his wish. Conway said he hoped the trustees would not now reverse their decision, and that the creation of new space in Millbank would inspire others to make significant gifts of Sargent's work to the Tate.

Collins Baker temporized at first, telling Conway that his letter had come up late in a board meeting and that the trustees, who "did not readily apprehend your point," had postponed discussion of it. Then he came down hard: "You certainly cannot be under the impression that the present arrangement" of the portraits would be permanent, he wrote, since the gallery had never promised to keep them on view. In fact, he himself had told Asher he thought he could "guarantee" compliance with his wishes and made a similar pledge to Conway when the gallery took possession of the "magnificent bequest" in 1922.

To Conway in 1924, Collins Baker said the trustees had agreed to display the portraits "as a special exception" to honor Asher's generosity and respect his wishes, but "I may say, in confidence, that this very exceptional procedure has given rise to a considerable amount of antagonistic feeling and criticism in certain artistic quarters." A number of Sargent paintings would indeed go to the Tate, the keeper went on, although the artist would continue to be represented in Trafalgar Square, and "everyone assumes that some at least of the series we are discussing"—the Wertheimer portraits—would stay as well.

His reproach concludes:

> I am sure the last thing you would like would be that the
> Trustees here should get it into their heads that your fa-
> ther's family were raising unreasonable issues. I therefore
> write to you thus privately, before our next Board meeting,
> to suggest that if you still wish to raise the question, after
> reviewing the circumstances, you might see your way to
> raise it in a rather different form.

Conway proposed meeting in person, to no avail. All nine Wert-
heimer portraits went to the Tate. Ludwig Mond's collection of Old
Master paintings temporarily replaced them in the National Gal-
lery's Room 26.

Officials at public museums, invariably short of funds, maintain
a careful balance between honoring donors' wishes and preserv-
ing space for the future. Recent major gifts with naming rights in
New York have raised the intriguing question, "How long is perpe-
tuity?" London's National Gallery had indeed never committed to
keeping the Wertheimer portraits on permanent view, regardless
of private assurances, and Asher had not made it a binding con-
dition. No museum would be likely to keep such a large gift on
display forever. Still, C. H. Collins Baker's dealings with Conway
seem gratuitously harsh. He would not have been likely to take this
condescending tone with a son of the patrician Lord Ribblesdale.

King George V officially opened the Sargent Gallery in the Tate's
Turner Wing, along with three Duveen-funded rooms for modern
foreign art, in June 1926. Duveen had not stinted on architecture
or décor. The galleries for foreign art had green marble doorways,
gilt ceilings, parquet floors with marble borders, a new ventilation

system; the Sargent room had crimson silk walls, a high coved ceiling, and vertical lights.

French Impressionist and Post-Impressionist paintings had been purchased largely through a fifty-thousand-pound fund set up by Samuel Courtauld. As if to confirm Britain's lack of interest in modern foreign art, and also its "Sargentolatry," the *Times* account of the opening awarded "the final word . . . to the splendid effect of the Sargent Room—much more solid and not less brilliant than that of the [recently closed] Academy memorial exhibition." On view were the Tate's own Sargents: again, *Carnation, Lily, Lily, Rose* and the oil study of Madame Gautreau (given by Joseph Duveen); *Ellen Terry as Lady Macbeth, The Misses Hunter* (donated by Mary Hunter in memory of the artist), watercolors, landscapes, and the nine Wertheimer portraits. Also the National Gallery's *Lord Ribblesdale*. Loans from private owners included *Philip Sassoon, Lady Sassoon, The Misses Vickers*, and *Mrs. Carl Meyer and Her Children*—all of which, confessed the writer for *The Times*, "we still covet."

At the opening ceremony, the chairman of the National Gallery Board of Trustees, Lord D'Abernon, somewhat surprisingly acknowledged England's lost cultural ground: with its new space for modern foreign art, he said, the Tate now compared "not unfavorably with standards created on the other side of the Atlantic." And he echoed many others in claiming for Britain an artist who, like the new standards for museums, had come from across the Atlantic: "To the British side," Duveen had "supplied a gallery for the works of the late Mr. John Sargent, among them being the remarkable group of family portraits bequeathed by Mr. Asher Wertheimer."

The king thanked the donors—many of whom (or their descendants) were present—then announced, "I have much pleasure in declaring the Sargent Gallery and the Modern Foreign Gallery open for the benefit and enjoyment of the public." No one seemed concerned about the Wertheimer portraits hanging near the "brilliant

examples of the art of Turner" rather than in a "special chamber of horrors," as one MP had proposed in 1923.

⟡

By the 1920s, Sargent's reputation was in decline, and it plummeted after his death. Modern art and its champions had been shifting away from realistic representation for years. "Critics have not yet decided whether Sargent is an immortal artist or only a super-clever illustrator," said *The Westminster Gazette* in 1926. Even the unsigned foreword to the catalogue of Ena's 1925 Claridge Gallery Sargent exhibition said the future would decide whether this "con-fessed worshipper of Ingres" had been "the last upholder of a great tradition, or the belated follower of an out-worn fashion."

The Edwardian era ended decisively with the First World War. In its aftermath, and during the Depression and Second World War, portraits of the glamorous international elite lost all appeal. There was no Sargent exhibition on either side of the Atlantic for three decades following the memorial tributes of 1925–26.

A few museums and galleries, mostly American, began to show the artist's work again in the 1950s and '60s. Frederick A. Sweet, a curator at the Chicago Art Institute, organized a *Sargent, Whistler and Mary Cassatt* exhibition for the Institute and the Metropolitan Museum in 1954. He wrote to Ena at the beginning of 1953, un-aware that she had died, asking to see *A Vele Gonfie*. Her husband offered to show him the painting, but it did not appear in the exhi-bition; the 1904 *Mrs. Asher Wertheimer* did.

Sweet put *Madame X* on the cover of his Sargent-Whistler-Cassatt catalogue. While all three expatriate artists had fallen from grace in the early twentieth century, he noted, Sargent, having enjoyed the greatest popularity, had sunk "nearest to oblivion." The public (not to mention the critics) remained "apathetic" about its former favorite, and Sweet urged viewers to look beyond the

"surface glitter" of the paintings to what was "vital and substantial underneath." Sargent here "emerges as the dark horse," he concluded: "Misjudged for years he now appears as an artist of truly great stature."

Not yet. In some quarters not ever.

The Mathiases received another request to lend *A Vele Gonfie* from the Corcoran Gallery of Art in Washington, DC, in 1963. Planning a large exhibition on *The Private World of John Singer Sargent*, the gallery aimed to "re-establish him as an artist of great and diverse talent," wrote its director, Hermann Warner Williams, Jr. *The Private World* would focus on the painter's family and friends rather than on "the fashionable portraiture which Sargent himself finally rejected toward the end of his career"—and the painting of Ena would be "vital" to its success. In an introduction to the exhibition catalogue, Williams articulated the mid-century art world's attitude toward the "fashionable" portraits: "We no longer so greatly admire the technical virtuosity, nor the illusion of worldly elegance, nor even the very act of portraiture itself. The mainstreams of modern art flow elsewhere in our own times."

By "fashionable," Williams appears to have meant aristocratic, since he wanted to include *A Vele Gonfie*—an act of portraiture rich in technical virtuosity and worldly elegance. Robert Mathias had died in 1961, leaving a life interest in the painting and the 1913 portrait of himself to his adult children in order of seniority. He had told Sir John Rothenstein, the director of the Tate, that after the death of his and Ena's last child, the paintings would go to the Tate to "complete the Wertheimer collection." A family struggle over Mathias's bequest complicated matters for the Corcoran. The eldest son, John, died in April 1963, and the eldest daughter, Diana, now the Baroness de Bosmelet, was next in line for the two portraits. She wanted to take *A Vele Gonfie* to her château in Normandy and bequeath it to her children. The estate's lawyers ultimately refused, arguing that the dilapidated condition of the

château was unsafe, that taking the painting out of England would affect its tax status and cause insurance problems, and that Mathias had specifically set out the line of succession. But in the mid-1960s the struggle was on.

The writer Charles Merrill Mount had befriended Diana while he was working on his biography of Sargent in the 1950s. He wrote to her from Washington in 1963 praising the Corcoran's progress on the *Private World* exhibition and the "splendid" work of its curator, Donelson Hoopes: "There are to be very few portraits as you know but Mr. Hoopes absolutely has his heart set on the one of your mother." Clearly speaking for the gallery, whom he copied on his letter, Mount asked Diana to let "us" know if she would consent to lend the picture, and enclosed forms for her to sign. He offered sympathy—"I quite realize your feelings" about the painting—and a sweetener: "the fact of its being . . . fêted in this way I think will ease the eventual problem of passing its possession to yours in Paris."*

Diana and the trustees of her father's estate did lend *A Vele Gonfie* to the *Private World* exhibition, which opened in the nation's capital in April 1964, then traveled to the Cleveland Museum of Art, the Worcester Art Museum, and the Munson-Williams-Proctor Arts Institute in Utica, New York.

No one had much interest in the 1913 portrait of Robert Mathias. His older children renounced their claims to it. David, the youngest, hung it at his house in Kent. In 1996, after David died, it went with *A Vele Gonfie* to the Tate.

In the early 1960s, the Tate altered its Sargent gallery, adding paintings by other artists—Whistler, G. F. Watts, Alfred Stevens—and moving most of the Wertheimer portraits into a storage basement. Humphrey Brooke, secretary of the Royal Acad-

* Mount, born Sherman Merrill Suchow, was arrested by the FBI at a Boston bookshop in 1987 for stealing documents from the National Archives and the Library of Congress. Convicted in 1989, he was sentenced to eight years in prison.

emy and a former deputy keeper at the Tate, sent furious letters to the press, calling the change a "monstrous violation" of Duveen's gift. He told the now-senior Mathias son, Anthony, that he aimed to "compel" the Tate to keep the Wertheimer pictures on view "in accordance with Duveen's gift and your grandfather's wish," and urged Mathias to send his own objections to *The Times.* Anthony complied: his grandparents would have been unlikely to leave the paintings to the nation had they known that all but two of them would be permanently stored "out of view of the public," he wrote, and repeated Brooke's charge about the Duveen gift.

Norman Reid, the director of the Tate, told Anthony that Duveen's trustees had given him permission to show Sargent contemporaries in the gallery. Also that Asher's gift had not required the permanent exhibition of the portraits (which was true), that not all the pictures were of the same quality (also true), and that the two "finest" remained on view. The two—*Asher Wertheimer* and *Ena and Betty*—have indeed been the ones most frequently borrowed and shown by other museums. Occasional loans aside, most of the paintings have been in storage, with exceptions in 1999 and 2021, ever since.

A range of twentieth-century artists helped portraiture emerge from the purgatory to which modernism, formalism, and abstraction had consigned it. Picasso and some of the Expressionists had maintained links with the figurative tradition. Later artists with extremely diverse techniques and sensibilities who have rendered the figure include Alex Katz, Jacob Lawrence, Fairfield Porter, Alice Neel, Lucian Freud, Francis Bacon, David Hockney, Diane Arbus, Andy Warhol, Chuck Close, Cindy Sherman, and Kehinde Wiley.

In 1997, seventy years after *The Westminster Gazette* said of

Sargent's work that "pictures so popular can never hope to satisfy our contemporary highbrows," the headline of an article by the critic Hilton Kramer announced, "It's Time to Forgive Sargent for Making It Big in the 1880s."

The person most responsible for the rebirth of interest in Sargent is his great-nephew Richard Ormond. In 1964, Ormond organized the first exhibition of the artist's work in England since 1926, at the Birmingham Museum and Art Gallery. Six years later, he published the first of his many fine books on the painter: *John Singer Sargent: Paintings, Drawings, Watercolors*. With James Lomax in 1979, Ormond co-curated another landmark exhibition, *John Singer Sargent and the Edwardian Age*, which, unlike its predecessors in the 1950s and '60s, did not shy away from portraits of the patrician elite. It included *Lady Agnew, The Earl of Dalhousie, The Duchess of Portland*, and *The Acheson Sisters*, as well as *Venetian Bead Stringers, A Javanese Dancer, Ena and Betty Wertheimer*, and *Henry James*.

Ormond and Elaine Kilmurray, now his full-time collaborator, curated a major Sargent retrospective in 1998. Shown at the Tate, the National Gallery of Art in Washington, DC, and the Boston Museum of Fine Arts, it drew large crowds and resonant acclaim. And working with the leading Sargent art dealers, Warren Adelson and Elizabeth Oustinoff of New York's Adelson Galleries, they created the grand catalogue raisonné *John Singer Sargent: The Complete Paintings*—nine volumes, coauthored by Ormond and Kilmurray, handsomely published by Yale University Press between 1998 and 2017. An edition of the artist's charcoal drawings is forthcoming, and Ormond and Adelson have established a Sargent archive at the Boston Museum of Fine Arts.

Other excellent scholars and writers had begun looking closely at Sargent as well (see the Select Bibliography on page 285). And his Wertheimer portraits began to emerge from storage. The British art historian Kathleen Adler presented a paper on these paintings at a conference in 1994 and published a groundbreaking essay about

them two years later. Responding to her work, the curator Norman Kleeblatt at New York's Jewish Museum organized an exhibition with Adler as consulting curator. They brought all twelve portraits together for the first time. Neither Asher nor Sargent had ever seen them on display in one space. *John Singer Sargent: Portraits of the Wertheimer Family* opened in New York in 1999, nearly a century after the artist began working on the commission. From there it traveled to New Orleans, Richmond, Virginia, and Seattle.

Twenty years later, in 2021, Tate Britain mounted its Wertheimer portraits in a "Spotlight" display. Spotlights are not formal exhibitions but presentations of artists and themes from the gallery's collections. "This is the first time the Wertheimer portraits are being shown as a standalone group at Tate," announced the promotional materials. Nearly seventy Wertheimer descendants, ranging in age from one hundred to in utero, had a private tour of the room in April 2022. Tate curators gave another private tour that month to Charles, then Prince of Wales, and Camilla, Duchess of Cornwall.

The dramatic vicissitudes of Sargent's standing, in the far-from-consonant views of critics, scholars, and the public, highlight the instability in cultural assessments of art over time. Museums in the early twenty-first century cannot seem to show enough of the artist's now immensely popular work. Recent exhibitions have included *Sargent and Italy; Sargent & Sorolla; Sargent and the Sea; John Singer Sargent and Chicago's Gilded Age; Sargent and Spain.* Also *John Singer Sargent: The Sensualist; John Singer Sargent Watercolors; Sargent: Portraits of Artists and Friends; John Singer Sargent: Portraits in Charcoal.* And *Sargent Abroad; Sargent's Venice; Lady Agnew of Lochnaw; Sargent, Whistler, and Venetian Glass; Boston's Apollo*—as well as the two shows of the Wertheimer portraits. *Fashioned by Sargent,* at the Boston Museum

of Fine Arts and Tate Britain in 2023–24, included three Wertheimer portraits: *Ena and Betty*, *Almina*, and *A Vele Gonfie*. An exhibition on *Sargent and Paris* will be at the Metropolitan Museum of Art and the Musée d'Orsay in 2025.

A different measure of an artist's perceived value comes from the commercial marketplace. Prices realized by sitters who sold their Sargent portraits in the early twentieth century included $25,000 for *The Countess of Warwick and Her Son*, and about $30,000 each for *A Vele Gonfie* and the oval *Betty Wertheimer*. Given the long-term depreciation in the value of the dollar, those figures would now be roughly $500,000 to $700,000.

And not surprisingly, they pale next to sums paid for Sargent paintings a century later. The 1885 *Robert Louis Stevenson and His Wife*—less a conventional portrait than an inspired riff on the long-limbed writer fidgeting in mid-stride with his wife barely visible on a sofa behind him—sold in 2004 for $8,800,000. The buyer was the Las Vegas casino owner and art collector Steve Wynn, who later sold it to Alice Walton, the Walmart heiress, for even more. It is now at Crystal Bridges, her museum of American art in Bentonville, Arkansas.

Some of the narrative figure studies Sargent did on his travels as he freed himself from portraiture, posing his companions outdoors in brilliant Alpine light and inviting viewers into quiet sensual idylls, have set the highest market values for his work.

Paul Allen, the co-founder of Microsoft, bought *The Chess Game* (1907) from the Harvard Club of New York in 2000 for $12.5 million. The painting, of two players in flowing robes and harem pants reclining by a stream, was not in the record-breaking 2022 auction of art from Allen's estate. Sargent titled another 1907 painting of casually lounging chess players *Dolce Far Niente* ("It's sweet to do nothing")—a phrase that could describe the whole Alpine series.

Since art tends to migrate toward recently acquired wealth, it

is no more surprising that Sargent paintings traveled in the early twenty-first century to Seattle, Las Vegas, and the Ozarks than that Old Master works, grand-manner British portraits, and fine French furniture relocated in the late nineteenth to Buckinghamshire, Berlin, Philadelphia, and New York.

Another *dolce far niente* scene of elegant languor, the 1905 *Group with Parasols (Siesta)*, went to a different private collector, for $23,528,000, in 2004. The painting portrays four of Sargent's friends resting in a meadow, their bodies so closely intertwined that it takes a minute to sort them out. One reviewer said the suggestive tangle showed "a magnificent disregard of conventional proprieties." At the left, Lillian Mellor and Dorothy ("Dos") Palmer, in long white skirts, doze under parasols. Next to them the brothers Leonard ("Ginx") and Lawrence ("Peter") Harrison stretch out, angular knees akimbo, Ginx with his head in Lillian's lap. That physical intimacy seems a knowing decoy, since Peter, whose wife was also on the trip, had been having an affair with Dos, the daughter of an American railroad baron, for years.

Cashmere (1908), a shadowy sequence of seven young women draped in luxuriant shawls, sold at auction in 1996 for $11.1 million. The figures forming a processional line might be the seven graces, vestal virgins, one girl coming of age, or simply studies in beauty and poise. The models for all seven were the artist's nieces, Reine and Rose-Marie Ormond—in just one shawl.

Sargent told a cascade of stories with this sheet-sized Kashmiri scarf, usually enlisting Rose-Marie as model.* No other accessory appears as often or as variously in his work. Its paisley pattern, muted colors (creamy white, gray blue, mauve), soft fall of folds

* Rose-Marie, the younger daughter of Sargent's sister Violet, married Robert André-Michel, a French art historian, in 1913. He was killed in the war a year later. She died attending a concert in a Paris church in March 1918, when Germans bombed the building. On receiving the news, Sargent wrote to Violet from Boston: "I can't tell you how sorry I am for you, and you all, and how I feel the loss of the most charming girl who ever lived."

and curves, at once veil and reveal the female form. The deep privacy in these images is as seductive as it is enigmatic.

In *Nonchaloir (Repose)*, Rose-Marie, sheathed in the shawl, leans back against a sofa, her eyes closed, dark hair loose. Penguin Modern Classics reproduced the image on the cover of *The Golden Bowl*, Henry James's late novel about love, sex, adultery, knowledge, and art.

And Rose-Marie is both of the *Two Girls in White Dresses* reclining in an Alpine meadow in voluminous skirts, gloves, bonnets, the shawl. One of the figures, seen in profile in the middle distance, is reading. The other, in the foreground, faces viewers over billows of skirt, with the softly draped shawl a triangle pointing north between her legs. A British critic, quoting the poet Robert Herrick, pronounced the scene a "liquefaction of clothes."*

Nearly a century later, *The New Yorker*'s Adam Gopnik described the girl in the foreground as "a delicious little scallop in a big striated shell . . . so dressed up she's nearly naked." And Michael Kimmelman in *The New York Times* wrote of this picture, "Maybe Sargent never experienced sex, but he certainly knew how to paint it."

The Wertheimers, despite their prominence in the art trade over more than half a century, their financial success, and their intersections with brilliant social and cultural worlds, have been almost entirely forgotten. Only Asher's name endures, and it proved, as *The Saturday Review* had predicted, inextricably bound up with Sargent's reputation. The twelve family portraits met with praise

* "Whenas in silks my Julia goes / Then, then (methinks) how sweetly flows / That liquefaction of her clothes."

and venom when they first appeared between 1898 and 1908, and again in the 1920s; then most of them were stored out of sight for decades. They reemerged at the end of the twentieth century during the Sargent restoration, alongside widespread interest in pluralism, ethnic identity, women, sexuality, gender, Jewish experience, art dealing, and portraiture itself. What made these paintings controversial in the past is, in addition to their aesthetic merits, what gives them fresh force and consequence now.

Sargent has always resisted classification and occupied contested ground. And though he has been emphatically forgiven for making it big in the 1880s, there may be changes still to come. The financier and collector J. Pierpont Morgan, asked to predict what the stock market would do, is said to have offered a forecast that applies as well to markets and tastes in art: "It will fluctuate."

The imperious Lord Theign in Henry James's novel *The Outcry*, enraged at the decline of his family fortune, at Americans armed with "huge cheque-books" looking to buy old art, and at the idea that his inherited pictures truly belong not to him but to England, harrumphs: "And pray who in the world's 'England' . . . unless *I* am?"

The question "Who *is* England?" runs through channels of turbulent history between the 1880s and the 1920s. Was it the old aristocracy, many of its members in financial and political decline but still assuming sovereign privilege? Newly wealthy plutocrats acquiring Oxbridge educations, seats in Parliament, grand houses, land, titles, and art? Writers and intellectuals who claimed the moral high ground? The people who did the country's physical labor—farmers, bricklayers, factory workers, coal miners? The young men who went off to fight, and often died, for Britain in the Great War?

The cosmopolitan Sargent, an astute witness to this drama, portrayed its cast of characters with broader sympathies than many

of the actors had. Being American may have sharpened his eye for the conflict, although what interested him was not abstract history but character, self-presentation, visual style. Illuminating the stage, he captured fading grandeur and fresh energies, the colors and shadows, the dazzle and the unease of a world in radical flux.

Supplement A: Sargent's Jewish Sitters

OIL PAINTINGS

Isidor George Henschel, 1889
Lady Lewis (Elizabeth Eberstadt), 1892
Sir George Lewis, 1896
Mrs. Carl Meyer (Adèle Levis) and her children, 1897
The Right Hon. Arthur Cohen, 1897
Asher Wertheimer, 1897–98
Mrs. Asher Wertheimer (Flora Joseph), 1898
Mrs. Ernest Franklin (Henrietta Montagu), 1898
Lady Faudel-Phillips (Helen Levy), 1898
Mrs. Edward L. Goetz (Angelina Levy), 1901
Ena and Betty Wertheimer, 1901
Hylda Wertheimer, 1901
Alfred Wertheimer, ca. 1902
Essie, Ruby, and Ferdinand Wertheimer, 1902
Mrs. Leopold Hirsch (Frances Mathilde Seligmann), 1902
Edward Wertheimer, 1902
Mrs. Asher Wertheimer (Flora Joseph), 1904
Joseph Joachim, 1904
Ena Wertheimer, 1904
Hylda, Almina, and Conway Wertheimer, 1905

Mrs. Ernest G. Raphael (Flora Cecelia Sassoon), 1905

Mrs. Adolph Hirsch (Georgette Seligmann), 1905

Joseph Pulitzer, 1905

Franz Moses Philippson, 1906

Katherine Elizabeth Lewis, 1906

Mrs. Louis Edward Raphael (Henriette Goldschmidt), ca. 1906

Mrs. William George Raphael (Margherita Goldsmid), 1906

Mrs. George Mosenthal (Marguerite Biedermann), 1906

Lady Sassoon (Aline de Rothschild), 1907

Betty Wertheimer, 1908

Almina Wertheimer, 1908

Robert Mathias, c. 1913

Sybil Sassoon, 1913

Countess of Rocksavage (Sybil Sassoon), 1922

Sir Philip Sassoon, 1923

WATERCOLORS

Ena Wertheimer and Antonio Mancini at Temple, 1904

Betty Wertheimer Salaman, 1910 (?)

PORTRAIT DRAWINGS, IN CHARCOAL UNLESS
OTHERWISE INDICATED

William Rothenstein, 1897 (lithograph)

Dr. Charles Fleischer, 1903

Mrs. Theodore Birnbaum/Burney (Gertrude Rachel Lewis), 1907

Mrs. George James Graham Lewis (Marie Anna Hirsch), 1907

Lady Elsie Meyer, 1908

Mrs. Paul von Fleischl (Cécile Levis), 1909

Sir Edgar Speyer, 1st Baronet, 1909

Mrs. Karl Derenburg (Ilona Eibenschütz), 1909

Ena Wertheimer Mathias, 1910 (pencil)

Honorable Mrs. Charles Rothschild (Rózsika von Wertheimstein), 1910

Mrs. Gilbert Russell (Maud Nelke), 1911

Sybil Sassoon, 1911, 1912, 1920 (Countess of Rocksavage from 1913 to
 1923)

Sir Philip Sassoon, 1912, 1921

Mary Lady Delamere (Honorable Mary Ashley), 1912

Countess Mountbatten (Honorable Edwina Ashley), 1912

Countess Anton Apponyi (Kate Nelke), 1912

Lady Lewis (Elizabeth Eberstadt), 1912

Katherine Elizabeth Lewis, 1912

Mrs. Alfred Fowler (Eva Neumann), 1912

Baroness Leopold de Rothschild (Marie Perugia), c. 1913

Mrs. Philip Schweich-Mond (Elizabeth Derenburg), 1913

Mrs. C. F. Rubinoff (Rosie Derenburg), 1913

Sir George James Ernest Lewis, 3rd Baronet, 1914

Lady Michaelis (Lilian Elizabeth Michaelis), 1914

Sir Max Michaelis, 1915

Émile Verhaeren, 1915

Jascha Heifetz, 1918 (pencil)

Julie Helen Heynemann, 1919

Dame Myra Hess, 1920

Martin Birnbaum, 1922

David Gubbay, 1925

Lady Aline Cholmondeley, 1925

George Henry Hugh Cholmondeley, Earl of Rocksavage, 1925

Rufus Daniel Isaacs, 1st Marquess of Reading [no date]

Supplement B: Locations of Wertheimer Images

AUSTRIAN JEWISH MUSEUM, EISENSTADT
Copy of a lost original portrait of the court factor Samson Wertheimer
(1658–1724)

BEECROFT ART GALLERY, SOUTHEND-ON-SEA, ESSEX, ENGLAND
William Orpen, *Charles Wertheimer* (oil on canvas)

BRITISH MUSEUM, LONDON
Four mezzotints by Leopold Goetze after Sargent:
> Two of *Asher Wertheimer*
> *Mrs. Wertheimer* (Flora)
> *A Vele Gonfie* (Ena Wertheimer)

HARVARD ART MUSEUMS (FOGG), CAMBRIDGE, MA
Sketchbook containing Sargent's preparatory drawings for his portraits of
Asher and the 1898 Flora Wertheimer

HIRSHHORN MUSEUM AND SCULPTURE GARDEN,
WASHINGTON, DC
Sargent, *Betty Wertheimer Salaman (Mrs. Arthur Ricketts)* (watercolor)

JEWISH MUSEUM, VIENNA
Copy of a lost original portrait of the early Samson Wertheimer
(1658–1724)

MUSÉE D'ORSAY, PARIS

John Everett Millais, *Charles Wertheimer*

John Everett Millais, *Sarah Hammond* (originally described as
Mrs. Charles Wertheimer)

NATIONAL GALLERY OF IRELAND, DUBLIN

William Orpen, *Portrait Sketch of Charles Wertheimer*

NEW ORLEANS MUSEUM OF ART

Sargent, *Mrs. Asher Wertheimer* (1898)

PRIVATE COLLECTION, ISRAEL

Copy of a lost original portrait of the early Samson Wertheimer
(1658–1724)

SMITHSONIAN AMERICAN ART MUSEUM, WASHINGTON, DC

Sargent, *Betty Wertheimer* (1908)

TATE BRITAIN

Ten Sargent Wertheimer portraits and one of Ena's husband, Robert M.
Mathias

James Havard Thomas, *Mrs. Asher Wertheimer* (sculpture bust commis-
sioned by Asher Wertheimer)

Drawings by James Havard Thomas

> *Mrs. Asher Wertheimer*
>
> *Alna Wertheimer* (Almina)
>
> *A Wertheimer Daughter, Full Face* (probably Ruby)
>
> *A Wertheimer Daughter, Profile* (probably Ruby)

VICTORIA & ALBERT MUSEUM, LONDON

William Orpen, *Portrait of Miss Wertheimer* (drawing, probably of Flora,
Mrs. Asher Wertheimer)

Notes

INTRODUCTION

xvi *"I have forgotten"* and *"What a tiresome thing"*: JSS to Elizabeth Lewis, Oxford, Bodleian, Dep. c. 836, #204 and #206.

xvi *"some new toys"*: JSS to Isabella Stewart Gardner, Oct. 27, [1898], Isabella Stewart Gardner Museum, #40.

xvii *"haunting . . . an act"*: Richard Holmes, *Footsteps: Adventures of a Romantic Biographer* (New York: Penguin Books, 1985), p. 66.

xvii *"I mark my beginning"*: Holmes, *Footsteps*, p. 135.

xxi *"& if I do"*: Sargent to Ena #26 [1913], Collection of the author.

xxi *"Sargent is"*: Richard Ormond speaking at the Brooklyn Museum in connection with the exhibition *John Singer Sargent Watercolors*, April 2013.

I. WERTHEIMER'S GIFT

3 *"chronic Wertheimerism"*: Evan Charteris, *John Sargent* (New York: Charles Scribner's Sons, 1927), p. 164.

4 *"These are more than a group"*: *The Times*, Jan. 6, 1923.

4 *"and the visitors comprised"*: *The Times*, Jan. 9, 1923.

5 *"a masterpiece"*: *The Athenaeum*, June 11, 1898, p. 762; in RO-EK, vol. II, *Portraits of the 1890s* (New Haven: Yale University Press, 2002), p. 13.

6 *"instinct with life"*: *The Times*, May 4, 1901, p. 13; cited in RO-EK, vol. III, *The Later Portraits* (New Haven: Yale University Press, 2003), p. 55.

6 *"exuberant physical force"*: *Saturday Review of Politics, Literature, Science, and Art*, Sept. 14, 1918.

6 *"Gargantuan"*: William Rothenstein, *Men and Memories: Recollections of William Rothenstein, 1872–1900* (New York: Coward-McCann, 1931), vol. II, p. 244.

6 *"greatly satisfied"*: *Pall Mall Gazette*, Jan. 6, 1923.

7 *"As to the question"*: JSS to James McNeill Whistler, n.d., in Glasgow University Library Whistler Papers, quoted by Stanley Olson, *John Singer Sargent: His Portrait* (New York: St. Martin's Griffin, 2001), p. 24.

8 *"in the case of an offer"*: C. H. Collins Baker to AW, June 28, 1916, NGA.

8 *"good humoredly explains"*: Charles Aitken, "Mr. Asher Wertheimer's Benefaction," *Burlington Magazine for Connoisseurs* 29, no. 161 (Aug. 1916), pp. 216–20.

8 *"I regret to say"*: AW to Lord D'Abernon, Nov. 11, 1916, NGA.

9 *"use and enjoyment"*: Will of Asher Wertheimer, Feb. 8, 1918.

10 *"whether, since the time of Rembrandt"*: Frank Rutter, *Arts Gazette*, Jan. 13, 1923.

10 *"will justly stand"*: *Saturday Review*, Sept. 14, 1918.

10 *"pleasantly engaged"*: I. N. Phelps Stokes, quoted in RO-EK, vol. II, p. 133.

10 *"I am English-born"*: George Eliot, *Daniel Deronda* (1876; repr. New York: Penguin Books, 1995), p. 193.

10 *"is a peculiar sensation"*: W. E. B. Du Bois, *The Souls of Black Folk: Essays and Sketches* (1903; repr. New York: New American Library, 1969), p. 45.

11 *"to keep all these eleven"* and the following quotes from the House of Commons debate: Hansard Parliamentary Debates, House of Commons, 1803–2005: March 8, 1923, vol. 161, c726. Parts reported in *The Times*, Mar. 9, 1923.

11 *"the only pictures"*: *The Times*, Apr. 16, 1925, p. 13.
13 *"tell the Trustees"*: Frances Spalding, *The Tate: A History* (London: Tate Gallery, 1999), p. 41.
13 *"extremely unflattering"*: *Time*, Apr. 14, 1923.
14 *"long overdue"*: *The Times*, July 23, 1918.

2. SARGENT'S PAINTBRUSH

15 *"at home everywhere"*: Stanley Olson, *John Singer Sargent: His Portrait* (New York: St. Martin's Griffin, 2001), p. 84.
15 *"no superfluity of means"*: Charles Merrill Mount, *John Singer Sargent: A Biography* (New York: W. W. Norton, 1955), p. 21.
16 *"a good deal deformed"*: Olson, *John Singer Sargent*, p. 7.
16–17 *"elevated topics"* and *"dark, damp little churches"*: Richard Ormond, "John Singer Sargent and Vernon Lee," *Colby Quarterly* 9, no. 3 (Sept. 1970), pp. 156–57.
17 *"many-windowed"* and *"kept a white-capped* chef": Evan Charteris, *John Sargent* (New York: Charles Scribner's Sons, 1927), p. 243.
17 *Beerbohm said that walking*: in Martin Birnbaum, *John Singer Sargent* (New York: William E. Rudge's Sons, 1941), p. 6.
17 *"I am sorry to leave"*: Sargent to Vernon Lee, Sept. 4, 1874, in RO-EK, vol. I, *The Early Portraits* (New Haven and London: Published for the Paul Mellon Centre for Studies in British Art by Yale University Press, 1998), p. xvii, n. 12.
18 *"Caro il mio ben"*: Charteris, *John Sargent*, p. 22.
19 *"If it were not"*: Charteris, *John Sargent*, p. 47.
19 *"he works like a dog"*: Ormond, "John Singer Sargent and Vernon Lee," p. 162.
19 *"a major means"*: Kenneth Clark, *An Introduction to Rembrandt* (London: J. Murray, 1978), p. 11.
19 *"sensory revelation"*: Bernard Berenson, *Sunset and Twilight* (1963), and *"dragging the truth"*: *Magazine of Art* 18 (1895), p. 282. Both in Trevor Fairbrother, *John Singer Sargent: The Sensualist* (Seattle Art Museum/ New Haven: Yale University Press, 2000), p. 18.
20 *"of something large and dignified"*: William Rothenstein, *Men and Memories: Recollections of William Rothenstein, 1872–1900* (New York: Coward-McCann, 1931), vol. I, pp. 190–92.
20 *"I think of his huge frame"*: Quoted by Sarah Churchwell, "How John Singer Sargent Made a Scene," *The Guardian*, Jan. 30, 2015.
20 *"When he painted the size"*: Rothenstein, *Men and Memories*, vol. I, pp. 190–92.
21 *"We all want"*: Michael Kimmelman, "Sargent's Dazzling Sensuality," *New York Times*, Feb. 19, 1999.
21 *"always predicated"*: Michael Fried, *Absorption and Theatricality: Painting and Beholder in the Age of Diderot* (Berkeley: University of California Press, 1980), p. 109.
23 *"with spirit, 'have you seen'"*: Richard Ormond with Elaine Kilmurray, *Sargent: Portraits of Artists and Friends* exhibition catalogue (London: National Portrait Gallery Publications, 2015), p. 25.

23 *"The symphony of reds"*: Ormond with Kilmurray, *Sargent: Portraits of Artists and Friends*, p. 55.

23 *"You once said"*: JSS to HJ, June 29, 1885, Houghton Library, Richard Ormond typescript.

24 *"spent two days"*: Leon Edel, *Henry James: The Middle Years (1882–1895)* (Philadelphia: J. B. Lippincott, 1962), p. 13.

25 *"creating disjunctions"*: Erica Hirshler, *Sargent's Daughters: The Biography of a Painting* (Boston: MFA Publications, 2009), p. 92.

25–26 *"that peacock woman"* and *"lavender"* through *"laziness"*: Charteris, *John Sargent*, pp. 250 and 59.

26 *"You will see"*: Julian Barnes, *The Man in the Red Coat* (New York: Alfred A. Knopf, 2020), p. 112.

26 *"decomposed"*: Ralph Curtis, in Charteris, *John Sargent*, p. 61.

27 *"My daughter is lost"*: Charteris, *John Sargent*, p. 61.

27 *"I suppose it is"*: JSS to Edward Robinson, Jan. 8, 1916, in Charteris, *John Sargent*, p. 65.

28 *"Is it really you"*: Monet told this story in French to Sargent's biographer Evan Charteris: "Est ce vraiment vous-vous-Claude Monet?" Charteris, *John Sargent*, 1927, p. 130.

28 *"the whole"* and *"took up his place"*: Gosse in RO-EK, vol. V, *Figures and Landscapes, 1883–1899* (New Haven and London: Published for the Paul Mellon Centre for Studies in British Art by Yale University Press, 2010), pp. 52, 128–29.

29 *"the first instance"*: John Ruskin, *Pre-Raphaelitism* (1851; repr. London: Dent, 1906), p. 220.

29 *"Then I can't paint"*: Elaine Kilmurray, "Sargent, Monet . . . and Manet," in *Sargent and Impressionism* (New York: Adelson Galleries, 2010), p. 3.

30 *"slightly 'uncanny' spectacle"* and *"In Mr. Sargent's case"*: Henry James, "John. S. Sargent," *Harper's New Monthly Magazine*, October 1887, pp. 683–91.

30 *"labored over his work"*: Marc Simpson with Richard Ormond and H. Barbara Weinberg, *Uncanny Spectacle: The Public Career of the Young John Singer Sargent* (New Haven: Yale University Press, 1997), p. 31.

31 *"the fine balance"*: Jacqueline Ridge and Joyce Townsend, "John Singer Sargent's Later Portraits: The Artist's Technique and Materials," *Apollo* 148, no. 439 (1998), pp. 23–30.

31 *"Very few writers"*: Charteris, *John Sargent*, p. 110.

31 *"Something's gone wrong"*: P. G. Wodehouse, "The Artistic Career of Corky" (1916), in *Carry On, Jeeves* (1925; repr. Penguin, 1957), p. 46.

32 *"like a lemon"*: Lucia Fairchild diary, Archives of American Art, quoted in Ormond with Kilmurray, *Sargent: Portraits of Artists and Friends*, p. 180.

32 *"My going to America"*: Sargent to Marquand, Princeton University Library; quoted in RO-EK, vol. I, p. 199.

33 *"vaguely"*: Sargent to Ralph Curtis, in Charteris, *John Sargent*, p. 141.

33 *"The world calls him"*: Charteris, *John Sargent*, p. 117.

34 *"As to Mr. Sargent"*: Clementina Anstruther-Thomson to Vernon Lee, Sun-
 day [1893], Vernon Lee Collection at Colby College, Special Collections.

36 *"resented the introduction"* and *"society's prejudice"*: Frances Greville,
 Countess of Warwick, *Afterthoughts* (London: Cassell, 1931), p. 40.

37 *"It is another link"*: William Harcourt to Joseph Chamberlain, Dec. 2, 1998,
 in Richard W. Davis, "'We Are All Americans Now!' Anglo-American
 Marriages in the Later Nineteenth Century," *Proceedings of the American
 Philosophical Society* 135, no. 2 (June 1991), pp. 140–41.

37 *"too dignified to have"*: J. P. Morgan, Jr., to A. Lawrence Lowell, Feb. 13,
 1912, Morgan Library & Museum.

3. MERCHANTS OF ART

39 *"one of the kings"*: Nicholas Penny, *Catalogue of European Sculpture in
 the Ashmolean Museum, 1540 to the Present Day*, vol. II (Oxford: Claren-
 don Press, 1992), p. xxi.

40 *"a Jewess"*: Mark Westgarth, "The Emergence of the Antique and Curi-
 osity Dealer in Britain 1815–c. 1850: The Commodification of Historical
 Objects," vol. II (Ph.D. diss., University of Southampton, Sept. 2006), p. 61.
 This thesis was published, with significant revisions and additions, by
 Routledge in 2020. The four quotes cited here do not appear in the finished
 book. See https://eprints.soton.ac.uk/466210/.

41 *"two* real *pictures"*: John Coleman Isaac to Sarah Davies Isaac, May 22,
 1835, in Westgarth, "Emergence," Appendix I, p. 71.

41 *"a great many Jews"* and *"dreadful"*: in Westgarth, "Emergence," pp. 69
 and 71.

42 *His trade card*: © Bodleian Library, John Johnson Collection, reproduced in
 Mark Westgarth, "A Biographical Dictionary of Nineteenth Century An-
 tique and Curiosity Dealers," *Journal of the Regional Furniture Society* 23
 (2009), p. 49.

44 *"tactical endogamy"*: Joshua Teplitsky, *Prince of the Press: How One Col-
 lector Built History's Most Enduring and Remarkable Jewish Library*
 (New Haven: Yale University Press, 2019), p. 43.

46 *"For the Fine Arts"*: *The Picture of London for 1802, being a correct
 guide . . .* (London, 1802), p. 211; cited in David Watkin, *Thomas Hope:
 Regency Designer* (New Haven: Yale University Press, 2008), p. 193.

46 *"the furniture of the great"*: David Jones quoting Loudon in the preface to
 Westgarth, "Biographical Dictionary."

47 *"Messrs. Wertheimer"*: *Morning Post*, Jan. 26, 1858.

48 *"Mr. Wertheimer requests"*: Samson Wertheimer to Anthony de Roth-
 schild, RAL, XII/41/1/588/1+2.

48 Samson Wertheimer sales to Lionel de Rothschild: RAL, XII/41/7A/294,
 XII/41/7B/486, XII/41/7B/556.

49 *"Mr. Wertheimer of New Bond Street"*: *The Art Journal, Illustrated Cat-
 alogue of the International Exhibition 1862* (London: J. S. Virtue). Hathi-
 Trust, from the Library of Princeton University.

49 *"without exception"*: *Morning Post*, June 19, 1862.

50 *"brilliant evidence"* etc.: *Sunday Times*, July 25, 1875.

52 "Gallant Rescue": Jewish Record, no. 73, Oct. 22, 1869.

52 "an agreeable circumstance": Jewish Chronicle, Oct. 29, 1869.

52 "no gentlemen" and "loaded with": South London Chronicle, May 7, 1870.

53 "the best in London": Quoted in RO-EK, vol. II, Portraits of the 1890s (New Haven: Yale University Press, 2002), p. 120.

55 "I am greatly astonished": Goncourt quoted in Charlotte Vignon, Duveen Brothers and the Market for Decorative Arts, 1880–1940 (New York: Frick Collection in Association with D Giles Limited, 2019), p. 27.

4. S. WERTHEIMER AND SONS

58 "thoroughly Anglicized": Daily Telegraph, Aug. 12, 1918.

58 "The vast majority": Eugene C. Black, The Social Politics of Anglo-Jewry, 1880–1920 (Oxford: Basil Blackwell, 1988), p. 391.

59 "The mania for old art": Ferdinand de Rothschild memoir, 1897, reproduced with an introduction by Michael Hall as "Bric-à-Brac: A Rothschild's Memoir of Collecting," Apollo (July–Aug. 2007), p. 65.

60 "the most important art sale": H. C. Mariller, Christie's 1766 to 1925 (London and New York: Constable & Co./Houghton Mifflin, 1926), p. 55.

60 "the very highest chic": The Times, June 17 and 21, 1882.

61 "Mr. S. Wertheimer": The Times, June 21, 1887.

62 "I wish the Vanderbilts": Edith Wharton to Ogden Codman, May 2, 1897, in Pauline Metcalf, Ogden Codman and the Decoration of Houses (Boston: Boston Athenaeum, 1988), p. 149.

62 "Such a price": Quoted in Country Life, Dec. 28, 2016.

63 "of the first grade" and ff.: Memoir of Alva Murray (Smith) Vanderbilt Belmont, as dictated to Mrs. Belmont's secretary Matilda Young, Matilda Young Papers, cited by courtesy of the William R. Perkins Library, Duke University, Durham, NC.

64 "with great public spirit" and "As a rare": O. M. Dalton, The Royal Cup in the British Museum (London: British Museum, 1924), pp. 6, 11.

65 Mayfair real estate: The Standard, Apr. 20, 1892, p. 8, classified ad.

65 "Messrs. Wertheimer": The Times, Mar. 16, 1892.

65 The yield from the sale: Daily Telegraph, June 19, 1920.

66 "It is to an English": David Kaufmann, George Eliot and Judaism: An Attempt to Appreciate "Daniel Deronda" (London: William Blackwood and Sons, 1878), p. 20.

5. ARTIST AND PATRON

72 "What only this monish": Punch, May 7, 1898.

72 "To-day comes a savant": C. Brinton, "Sargent and His Art," Munsey's Magazine XXXVI, no. 111 (Dec. 1906).

72–73 "pleasantly engaged" and "Sargent has just completed": in RO-EK, vol. II, Portraits of the 1890s (New Haven: Yale University Press, 2002), p. 133.

73 "to be painting for his pleasure": Robert Ross, "The Wertheimer Sargents," Art Journal, Jan. 1911.

73 *"I loved Henschel"*: Richard Ormond with Elaine Kilmurray, *Sargent: Portraits of Artists and Friends* (London: National Portrait Gallery Publications, 2015), p. 129.

74 *"wide and accurate acquaintance"*: Edmund Yates, ed., *Celebrities at Home* (London, 1878), pp. 265–71.

74 *"Good books, good plays"*: *The Times*, Dec. 14, 1931.

75 *"Otherwise I fear"*: JSS to Elizabeth Lewis, June 23, 1909, Bodleian, #132.

75 *"Hold up, mother"*: *Punch*, May 8, 1897, reproduced in RO-EK, vol. II, p. 109.

75 *"Never was construction"* and *"knock-down insolence"*: in RO-EK, vol. II, p. 109.

76 *"shy olive faces," "even Mr. Sargent's,"* and *"$10,000"*: in RO-EK, vol. II, p. 109.

76 *"full"* of commissions: JSS to Elizabeth Lewis, Bodleian, #164, July 25 [n.d].

76 Max Beerbohm cartoon: in RO-EK, vol. III, *The Later Portraits* (New Haven: Yale University Press, 2003), p. 214.

77 *"a brilliant, superficial likeness"*: W. Graham Robertson, *Life Was Worth Living: The Reminiscences of W. Graham Robertson* (New York: Harper and Brothers, 1931), p. 234.

78 *"The number of pictures"*: JSS to AW, Jan. 13, 1900, Papers of Bridget Chetwynd. Private collection, England.

78 *"He paints nothing"*: Wilfrid Scawen Blunt quoting Francis Meynell, *My Diaries* (1921; repr. New York: Octagon Books, 1980), vol. II, p. 171.

78n *"The unexpected near future"*: Mary Blume, "Expo 1900: The American School in Paris," *New York Times*, Mar. 31, 2001.

79 *"a timid aspirant"*: Robertson, *Life Was Worth Living*, p. 233.

79 *"dreadful"*: Frederick A. Sweet, *Sargent, Whistler and Mary Cassatt* (Chicago: Art Institute of Chicago, 1954), p. 7.

80 *"white with fury"*: Victoria Glendinning, *Edith Sitwell: A Unicorn Among Lions* (Oxford: Oxford University Press, 1981), p. 22.

80 *"It seems . . . there is a little something wrong"*: in RO-EK, vol. III, pp. 185–86.

80 *"When you came yesterday"*: JSS to Elizabeth Lewis, Bodleian, #220.

80 *"Anybody may have"*: in Ormond with Kilmurray, *Sargent: Portraits of Artists and Friends*, p. 108.

80 *"talking the whole time"*: in Ormond with Kilmurray, *Sargent: Portraits of Artists and Friends*, p. 57.

81 *"hedge his attraction"*: Trevor Fairbrother, *John Singer Sargent: The Sensualist* (Seattle Art Museum/New Haven: Yale University Press, 2000), p. 83.

81 *"testify to deep trust"*: Fairbrother, "The Complications of Being Sargent," in Norman L. Kleeblatt, ed., *John Singer Sargent: Portraits of the Wertheimer Family* (New York: Jewish Museum, 1999), p. 41.

81 *"an Englishman"*: Peter Stansky, *Sassoon: The Worlds of Philip and Sybil* (New Haven: Yale University Press, 2003), p. 2.

83 *"sinewy slenderness"*: Camille Mauclair, in *L'Art et les Artistes* 4 (Dec. 1906), p. 378, cited in RO-EK, vol. V, *Figures and Landscapes, 1883–1899* (New Haven and London: Published for the Paul Mellon Centre for Studies in British Art by Yale University Press, 1998), p. 231.

83 *"notorious in Paris"*: Clive Bell to Mary Hutchinson, July 31, 1927, quoted in Fairbrother, "The Complications of Being Sargent," p. 39.

84 *"As a man"*: Bernard Berenson, *Sunset and Twilight: From the Diaries of 1947–1958* (New York: Harcourt Brace & World, 1963), p. 480.

84 *"O for Henry James' faculty"*: JSS to Vernon Lee, 1884, Vernon Lee Collection at Colby College, Special Collections.

84 *"seemed to look at women"*: Ehrman Syme Nadal, Second Secretary of the American Legation in London, quoted in Leon Edel, *Henry James: The Conquest of London, 1870–1881* (Philadelphia: J. B. Lippincott, 1962), p. 359.

84 *"with pleasure"*: Collection of the author, #34.

85 *"in Miss Ena's best handwriting"*: Collection of the author, #24.

85 *"a very clever little man"*: Collection of the author, #6.

86 *"knocked about"*: Ulrich W. Hiesinger, *Antonio Mancini: Nineteenth-Century Italian Master* (New Haven and London: Philadelphia Museum of Art in association with Yale University Press, 2008), p. 40.

86 *"Mancini reverently thanks"*: RO-EK, vol. II, p. 139.

86 *"among multitudes of Israelites"*: Antonio Mancini to Marchese Capranica del Grillo, in Dario Cecchi, *Antonio Mancini* (Turin: Unione, 1966), p. 183, note 3.

86 *"to be framed"*: JSS to Elizabeth Lewis, Bodleian, #170, [1902?].

86 *"Show him my business card"*: JSS to Antonio Mancini, Tuesday, May 1902; Archivio Capranica del Grillo, Rome, no. 29.

87 *"You will be seeing"*: Collection of the author, #5.

87 *"amusing and malicious gossip"*: Cecil Lewis, ed., *Self-Portrait: Letters and Journals of Charles Ricketts, R. A.*, collected and compiled by T. Sturge Moore (London: Peter Davies, 1939), Mar. 6, 1902, p. 74.

87 *"most spectacular collection"*: Elizabeth Prettejohn, *Interpreting Sargent* (London: Tate Gallery Publications, 1998), p. 36.

88 *"the van Dyck"*: RO-EK, vol. III, *The Later Portraits*, 2003, p. xii.

88 *"But he hates"*: Martin Birnbaum, *John Singer Sargent, A Conversation Piece* (New York: William E. Rudge's Sons, 1941), p. 41.

88 *"There were a hundred people"*: Claude Monet to Alice Hoschedé Monet, Feb. 2, 1901, in Daniel Wildenstein, ed., *Claude Monet: Biographie et Catalogue Raisonné*, vol. IV (Lausanne: Bibliothèque des Arts, 1985), #1592, p. 351. Translation by Jean Strouse.

89 *"marvelous night effects"*: Claude Monet to Alice Monet, Feb. 17, 1901, in Wildenstein, *Claude Monet: Biographie et Catalogue Raisonné*, vol. IV, #1606a, p. 353. Translation by Arthur Goldhammer as a generous favor to the author.

89 *"I'm certain"*: Claude Monet to Alice Monet, Feb. 22, 1901, in Wildenstein, *Claude Monet: Biographie et Catalogue Raisonné*, vol. IV, #1608c, p. 354.

89 *"The house is indeed"*: Claude Monet to Alice Monet, Feb. 25, 1901, in Daniel Wildenstein, ed., *Claude Monet: Biographie et Catalogue Raisonné*, vol. V (Lausanne: Wildenstein Institute, 1991), #2999 (1609a), p. 211. Translation by Arthur Goldhammer.

89 *"very noisy"*: Claude Monet to Alice Monet, Feb. 26, 1901, in Wildenstein, *Claude Monet: Biographie et Catalogue Raisonné*, vol. IV, #1610, p. 354. Translation by Jean Strouse.

90 *"with perfect courtesy"* and ff.: Frank Rutter, "Wertheimer and Sargent," *Arts Gazette*, Jan. 13, 1923.

91 *"antediluvian hostility"*: Frank Rutter, *Since I Was Twenty-Five* (Boston: Houghton Mifflin, 1927), p. 155.

91 *"all safely dead"*: Frank Rutter, *Art in My Time* (London: Rich & Cowan, 1933), pp. 114–19.

91 *"What Asher Wertheimer was"*: Rutter, *Since I Was Twenty-Five*, pp. 169–70.

91 *"Cigar in right hand"*: Rutter, "Wertheimer and Sargent," *Arts Gazette*, Jan. 13, 1923.

6. NEST OF VIPERS

94 *"gentleman"* and ff.: *Pall Mall Gazette*, July 16, 1898, and *The Times*, July 16 and 27, 1898.

96 *"angel food"*: Donald Garstang, *Art-Commerce-Scholarship: A Window onto the Art World—Colnaghi 1760 to 1984* (London: Colnaghi, 1984), p. 22.

96 *"She hates us"*: OG to BB, Oct. 14, 1898, in Colnaghi.

96 *"I hate Colnaghi"*: ISG to BB, Nov. 7, [1898], in Rollin van N. Hadley, ed., *The Letters of Bernard Berenson and Isabella Stewart Gardner, 1887–1924* (Boston: Northeastern University Press, 1987), p. 158.

96 *"For Dutch"*: in Garstang, *Art-Commerce-Scholarship*, p. 22.

96 *"Neither you nor we"*: in Nicholas H. J. Hall, ed., *Colnaghi in America* (New York: Colnaghi, 1992).

96 *"gems"* and ff.: OG to BB, July 29, 1898, Ref. no. 1/4/3, Colnaghi.

97 *"jewels"* and ff.: BB to ISG, July 31, 1898, in Hadley, ed., *Letters of Bernard Berenson and Isabella Stewart Gardner*, p. 146.

97 *"owners"*: BB to ISG, Sept. 29, 1898, in Hadley, ed., *Letters of Bernard Berenson and Isabella Stewart Gardner*, p. 155.

97 *"I had better"*: Fragment, n.d., BB to ISG, in Hadley, ed., *Letters of Bernard Berenson and Isabella Stewart Gardner*, p. 156.

98 *"the finest and most important"*: William McKay to WB, August 10, 1898, Colnaghi.

98 *"the famous Watteaus"*: AW to WB, Sept. 5, 1890, ZA.

98 *"fought Wertheimer"*: William McKay to WB, Aug. 10, 1898, Colnaghi.

99 *"In spite of your telegram"*: William McKay to AW, Aug. 16, 1898, Colnaghi.

99 *"Wertheimer is mightily angry"*: Edmond Deprez to WB, Aug. 20, 1898, ZA: NL Bode 1443.

99 *"the minor stars"*: William McKay to AW, Aug. 16, 1898, Colnaghi.

99 *"I suppose we shall"*: William McKay to WB, July 14, 1894, Colnaghi letterbooks, Colnaghi.

100 *"very fine"*: Lockett Agnew to WB, October 8, 1901, ZA: IV-NL Bode 6148.

100 *"My dear friend"*: ISG to BB, Sept. 25, 1898, in Hadley, ed., *Letters of Bernard Berenson and Isabella Stewart Gardner,* p. 154.

100 *"everything look as black"*: BB to P. and D. Colnaghi, Oct. 1898, enclosed with other letters, Colnaghi.

101 *"After a wretched day"*: OG to BB, Oct. 14, 1898, Colnaghi.

101 *"be left in our hands"*: OG to Deprez, Oct. 30, 1898, p. 140, Colnaghi.

102 *"our client"* and prices: PDC to AW, Sept. 29, 1898, and ref. no. Col. 2/5/1, Private Ledgers, pp. 94 and 54, Colnaghi.

102 *"be very careful"*: McKay to BB, Oct. 27, 1898, Colnaghi.

102 *"I am sure"*: ISG to BB, Nov. 7, [1898], in Hadley, ed., *Letters of Bernard Berenson and Isabella Stewart Gardner,* p. 159.

103 *"some new toys"*: JSS to ISG, Oct. 27, [1898], ISG Museum.

103 *"Burn or return"*: OG to BB, Oct. 31, 1898, Colnaghi.

103 *"Wertheimer is asking"*: AB to WB, October 1, 1898, ZA.

104 *"a little test"*: Daniel-Henry Kahnweiler with Francis Crémieux, *My Galleries and Painters* (New York: Viking Press, 1971), pp. 27–30.

104 *"What would have become of us"*: John Richardson, *A Life of Picasso,* vol. II (New York: Random House, 1996), p. 36.

104 *"pearl"* of the Hope collection: *The Times,* August 12, 1918.

106 *"We want to do business"*: Edward Wertheimer to WB, Feb. 26, 1902, ZA (in German).

7. "WICKED UNCLE CHARLIE"

107n *"frippery and extravagance"*: *Architectural Review,* vol. IX, Jan.–June 1901, pp. 42–43, quoted in *Survey of London,* vol. 40, "The Grosvenor Estate in Mayfair, Part 2."

108 *"choice works of art"* and ff.: P. G. Konody and William Dark, *Sir William Orpen: Artist and Man* (London: Seeley, Service, 1932), p. 203.

108 *"Mr. Morgan"*: Edward Fowles, *Memories of Duveen Brothers* (New York: Times Books, 1976), p. 66.

109 *"in recognition"*: *The Times,* July 9, 1898.

109 *"Is there any objection"*: Baron de Saumarez to Edward Poynter, July 29, 1898, NGA, folder NG7/228.

109 *"My solicitor feels"*: Baron de Saumarez to Mr. Turner, Dec. 5, 1898, NGA, folder 7/228.

109 *"do not see"*: Dec. 1, 1898, Patterson, Snow & Co., solicitors for de Saumarez, to Bircham & Co., solicitors for Charles Wertheimer. NGA, folder 7/228.

110 *"We should have thought it"*: Bircham to Patterson, Dec. 2, 1898, NGA, folder 7/228.

111 *"glorious tradition"*: *New York Times,* Dec. 21, 1900.

112 *"after the most friendly relations"*: *New York Times,* Dec. 21, 1900.

112 *"either to my brother"*: *New York Times,* Jan. 11, 1901.

113 *"A more aggravated case"*: *New York Times*, Feb. 9, 1901.

113 *"the fairness of the transactions"*: *New York Times*, Oct 1, 1902.

114 *"The theft of masterpieces"*: Roger Fry, *Burlington Magazine* 10, no. 48 (Mar. 1907), pp. 375–79.

114 *Years later, the principal thief*: Leonard Matters, "The Great Park Lane Robbery," *McClure's* 55, 1923.

117 *"rash"*: Bruce Arnold, *Orpen: Mirror to an Age* (London: Jonathan Cape, 1981), p. 22.

118 *"Orpen Pleading with Sargent"*: in an illustrated letter to Mrs. St. George, June 25, 1907; Sotheby's, private sale, May 26, 2007.

118 *acquired at auction in 1990*: Gertrude P. Nutting, *Irish Arts Review Yearbook* (1990), pp. 244–47.

118 *"magnificent"*: AW to WB, Jan. 19, 1904, ZA.

119 *"always on the heroic scale"*: *The Times*, Apr. 26, 1911.

120 *"Art Prices Slump"* and figures: *New York Times*, May 9, 1912; *Jewish Chronicle*, May 10, 1912; *Daily Telegraph*, June 17, 1920.

120 *"above all"*: Charlotte Vignon, *Duveen Brothers and the Market for Decorative Arts, 1880–1940* (New York: Frick Collection, 2019), p. 175.

121 *"in my opinion"*: Shelley M. Bennett, *The Art of Wealth: The Huntingtons in the Gilded Age* (San Marino, CA: Huntington Library Press, 2013), p. 277 and n. 68.

8. SONS

125 *"a school for the rich"* and *"Junipers"*: Christopher Tyerman, *A History of Harrow School* (Oxford: Oxford University Press, 2004), pp. 321–22.

126 *"If I ever have a son"*: Charles Richmond and Paul Smith, eds., *The Self-Fashioning of Disraeli, 1818–1851* (Cambridge: Cambridge University Press, 1998), p. 18.

126 *"My dear Wertheimer"*: JSS to Alfred Wertheimer, Nov. 28, 1901, Papers of Bridget Chetwynd.

127 *"but one sumptuous"*: Charles Lewis Hind, *Academy and Literature*, May 10, 1902.

128 *"It is the sensation"*: *Boston Sunday Herald*, June 1, 1902.

128 *"My dear Wertheimer"*: JSS to Alfred Wertheimer, Thursday night, [1902?], Collection of the author, #18.

129 *An inquest in Johannesburg*: *Chemist and Druggist* 61, no. 17 (Nov. 8, 1902), p. 772.

130 *"It was not hard to believe"*: W. Somerset Maugham, "The Alien Corn" (1931), in *First Person Singular, Six Stories Written in the First Person Singular, W. Somerset Maugham* (Garden City, NY: Doubleday, Doran, 1931), p. 191.

130 *"who ended life"*: Maugham, *First Person Singular*, p. 201.

131 *"acknowledged"*: Maugham, *First Person Singular*, p. 238.

131 *"What is it"*: Maugham, *First Person Singular*, p. 241.

132 *"such an unEnglish love"*: Maugham, *First Person Singular*, p. 210.

132 *"Thanks awfully"*: Maugham, *First Person Singular*, p. 245.

132 *"Today is a fine day"*: JSS to Flora Wertheimer, Sunday, n.d. [Nov. 16, 1902], Collection of the author, #29.

133 *"my fine picture"*: Quoted in Dawson W. Carr, *Velázquez* (London: National Gallery, 2006), p. 99.

133 *"and since then"*: AW to Max J. Friedlander, May 21, 1901, ZA.

133 *"Velázquezichen Venus"* and *"I would be very happy"*: Edward Wertheimer to WB, Nov. 27, 1901, ZA.

133 *"certainly not for sale"*: AW to WB, Dec. 3, 1901, ZA.

134 *"Desirable Aliens"*: Bernard Partridge, *Punch*, Jan. 31, 1906, p. 75; in RO-EK, vol. III, *The Later Portraits* (New Haven: Yale University Press, 2003), p. 2.

134 *"I am so glad to know"*: JSS to AW, Dec. 24, 1902, Collection of the author, #36.

134 *"The news which just reached me"*: JSS to Flora Wertheimer, Jan. 3, 1903, Collection of the author, #1.

134 *"I am heartbroken"*: AW to WB, Jan. 23, 1903, ZA.

135 *"nothing gave me as much pleasure"* and other Isador Wertheimer quotes: *South Australian Register*, Sept. 6, 1890; *The Times*, July 24–31, 1890.

136 *"an illegal operation"*: *The Times*, Jan. 29, 1891; *Dundee Weekly News*, Jan. 31, 1891.

9. DAUGHTERS

139 *"What do you think"*: William C. Loring, Jr., and William Cushing Lawrence, "An American Art Student in London," *Archives of American Art Journal* 24, no. 3 (1981), pp. 17–21.

139 *"in its way a masterpiece"*: Evan Charteris, *John Sargent* (New York: Charles Scribner's Sons, 1927), p. 165.

140 *"splendid types of their race"* and *"a vitality hardly matched"*: Quoted in RO-EK, vol. III, *The Later Portraits* (New Haven: Yale University Press, 2003), p. 55.

141 *"Tell your mother"*: JSS to EW, Apr. 22, 1904, Collection of the author, #14.

141 *"surely one of the finest"*: Quoted in RO-EK, vol. III, p. 124.

142 *"Call yourself a soldier"*: *Punch*, May 10, 1905.

142 *"a triumph"*: Quoted in RO-EK, vol. III, p. 142.

142 DAMN and *"The last phrase"*: Mar. 5, 1905, Tate Archive, TGA A.24465.

143 *"Splendid Paupers"*: W. T. Stead, *The Splendid Paupers: A Tale of the Coming Plutocracy: Being the Christmas Number of* The Review of Reviews (London: Review of Reviews, 1894).

144 *"Can't possibly"*: in Andrew E. Adam, *Beechwoods & Bayonets. The Book of Halton* (London: Barracuda Books, 1983), p. 51.

145 *"unpleasant"*: Roger Fry, *The Athenaeum*, May 6, 1905.

145 *"the superb make-believe"*: in RO-EK, vol. III, p. 140.

146 *"Miss, you had much better"*: Quoted in Diana de Bosmelet, unpublished memoir, courtesy of Yolanda Chetwynd, p. 25.

147 *"Madame: I am very unhappy"*: Auguste Rodin to Ena. This note was in the collection of Sargent letters and notes I transcribed for the dealer GH

(see the introduction); it had been removed by the time I acquired the letters at auction.

147 *"for the nth time"*: Diana de Bosmelet, unpublished memoir.

147 *"a delightful sense"*: J. M. Cohen, *The Life of Ludwig Mond* (London: Methuen, 1956), p. 192.

148 *"Please accept it"*: JSS to Ena, July 28, [1905], Collection of the author, #8.

149 *"a few distinguished"*: Feb. 9, #23; *"& if I do"*: #26; *"I will be"*: #25; *"How can one"*: #27; *"I am watching"*: #26. All JSS to Ena, Collection of the author.

151 *"I have tried giving"*: JSS to Ena #26, Collection of the author.

151 *"a society portraitist"*: *Time*, Apr. 3, 1933.

152 *"for the wonderful 'Pawtrait'"*: Ena to JSS, Mar. 4, [1908]. Papers of Julian Mathias.

153 *"Otherwise . . . I will never pull through"*: JSS to Ena, Mar. 6 [1908], copy of this letter by someone in the Mathias household. Papers of Julian Mathias.

153 *"Robert would feel it"*: Ena to JSS, Mar. 4, [1908]. Papers of Julian Mathias.

153 *"if there is anything wrong"*: JSS to Ena, Mar. 6, [1908]. Papers of Julian Mathias.

154 *"Think it best & right"*: AW cable to Mathias, Mar. 5, 1908. Papers of Julian Mathias.

154 *"Sargent would have done"*: AW from Cannes, to Ena, Mar. 9, 1908. Papers of Julian Mathias.

154 *"One feels that"*: *The Times*, Jan. 12, 1921.

155 *"This portrait of me"* and *"that if he married"*: Smithsonian Archives, American Paintings, curatorial files for Gellatly Collection.

156 *"as the inexorable"*: *The Scotsman*, Nov. 19, 1926.

10. ORIENTAL ACCENTS

157 *"the invalid Wertheimer child"*: JSS to Elizabeth Lewis, Bodleian, #170.

158 *"especially in its artistic aspect"*: AW to WB, Sept. 1 and 8, 1911, ZA.

159 *"loyalty letters"*: Todd M. Endelman, *The Jews of Britain: 1656 to 2000* (Berkeley: University of California Press, 2002), pp. 184–85.

159 *"Peter Schlemiel"*: Letter to Ferdinand Wertheimer in the papers of the late David and Katherine Mathias.

160 *"two bachelor artists"*: Valerie Grove, *So Much to Tell* (London: Viking, 2010), p. 92.

160 *"a great painter"*: *Spectator*, May 10, 1902, in RO-EK, vol. III, *The Later Portraits* (New Haven: Yale University Press, 2003), p. 67.

161 *"a more decorative"*: "The Royal Academy and the New Gallery," *The Pilot* 5 (May 10, 1902), in Trevor Fairbrother, *John Singer Sargent: The Sensualist* (Seattle Art Museum/New Haven: Yale University Press, 2000), p. 123.

162 *"I had great difficulty"*: RO-EK, vol. III, p. 55.

163 *Among the couple's thousand wedding guests*: *Berkshire Chronicle*, June 29, 1895, p. 2.

167 *"sick of portrait painting"*: JSS to Edward Speyer, in RO-EK, vol. III, p. 135.

II. ASHER: ART WEALTH

171–72 The following quotes are from Henry James, *The Outcry* (New York: New York Review of Books Classics, 2002): *"such a conquering"*: p. 99; *"a golden apple"*: pp. 55–56; *"And pray"*: p. 129; *"deprives"* and *"I suppose"*: pp. 34–35.

174 *"the gilded bondage"*: HJ to Grace Norton, Aug. 23, 1885, in Leon Edel, ed., *The Letters of Henry James*, vol. III: 1883–1895 (Cambridge, MA: Harvard University Press, 1981), p. 98.

175 *"The provision"*: Geoffrey de Bellaigue, The James A. Rothschild Collection at Waddesdon Manor, *Furniture Clocks and Gilt Bronzes* (London: National Trust, 1974), vol. 1, #8.

176 *"splendid new galleries"*: The Times, Mar. 6, 1903, p. 1; *"sumptuous and"*: The Queen, Mar. 7, 1903; The Connoisseur 5, no. 20, April 1903.

176 *"nobly supported"*: Daily Telegraph, Dec. 11, 1903.

176 *"Sulley sold his Vermeer"*: OG to Charles Carstairs, Feb. [14], 1906, ref. no. Col 1–4–8, pp. 63–64, Colnaghi.

177 *"Some day you must assert"*: in RO-EK, vol. IV, *Figures and Landscapes, 1874–1882* (New Haven and London: Published for the Paul Mellon Centre for Studies in British Art by Yale University Press, 2006), p. 22.

178 *"monotony of"*: in Andrew E. Adam, *Beechwoods & Bayonets: The Book of Halton* (London: Barracuda Books, 1983), p. 51.

178 *"an exaggerated nightmare"* and *"seldom seen anything"*: Cecil Roth, *The Magnificent Rothschilds: The Rise and Colorful Reign of the World's Most Fabulous Financial Family* (New York: Pyramid Books, 1962), pp. 149–50.

179 *An envelope in The Rothschild Archive*: RAL, 000/174B, #35–39.

180 *"sometimes to a considerable extent"*: Will of Asher Wertheimer, dated Feb. 8, 1918.

180 *thirty-three of the paintings*: Agnew's stock books, with records of the 1907 Ashburton purchase, are held at NGA, ref. no. NGA27/1/1/10, pp. 121–24.

180 *"all my indebtedness"*: RAL, 000/174B, #55.

181 *"most fine works of art"*: Michael Hall, ed., "Bric-à-Brac: A Rothschild's Memoir of Collecting," *Apollo* (July–Aug. 2007), p. 68.

183 *"somewhat theatrical"*: in Frederick Pratt to Philip T. Gentner, July 20, 1913; *"I don't suppose"*: JSS to Pratt, July 9, 1913; *"I have acquainted them"*: AW to Pratt, July 17, 1913; bought the painting: Pratt note on letter from Knoedler, July 22, 1913. All Worcester Art Museum Archives.

184n *"very much perturbed"*: JSS to Pratt, Jan. 15, 1914. Worcester Art Museum Archives.

185 *"Knowing that contemporary art"*: Daily Telegraph, June 19, 1920.

185 *"always had the most"*: The Times, Aug. 12, 1918.

185 *"almost incalculable value"*: The Times, Jan. 6, 1923.

187 *"Inasmuch as I am"*: Will of Asher Wertheimer, dated Feb. 8, 1918.

188 *"Except from time to time"*: Jewish Chronicle, Aug. 16, 1918; *"thoroughly Anglicized"*: Daily Telegraph, Aug. 12, 1918.

188 *"mistakes"*: Daily Telegraph, June 17, 1920.

189 *"that considerable prominence"*: Collins Baker to Messrs Dawes & Sons, Dec. 9, 1922, NGA.

189 *"Contents of the Mansion"*: *The Times*, Mar. 1, 1923, and *Daily Telegraph*, Feb. 19, 1923.

189 *"One watching that sale"*: *Daily Telegraph*, June 19, 1920.

190 *"Seldom is a national collection"*: *Saturday Review of Politics, Literature, Science, and Art*, Sept. 14, 1918.

12. ENA IN FULL SAIL: A VELE GONFIE

191 *"sets itself a very high standard"*: *The Times*, July 2, 1925.

192 *"the real John Sargent"*: *Loan Exhibition of Water Colours by the Late John S. Sargent, R. A., at the Claridge Gallery, 52 Brook Street, July, 1925.*

192 *"stark Plantagenet," "a tall, graceful scarecrow," "The audience was stunned"*: Victoria Glendinning, *Edith Sitwell: A Unicorn Among Lions* (Oxford: Oxford University Press, 1981), pp. 53, 109, and 73.

193 *"the earliest and most enthusiastic"*: Francis Toye, *For What We Have Received* (New York: Alfred A. Knopf, 1948), pp. 201–205.

193 *"No. 1 and rightly reserved"* and *"EM—The constant friend"*: Propert quoted in Diana de Bosmelet, unpublished memoir, courtesy of Yolanda Chetwynd, p. 26.

194 *"Cher Maître"*: Ena to Sergei Diaghilev, Sergei Diaghilev Correspondence (1918?–1929), Performing Arts Research Collections, Dance, Lincoln Center Library for the Performing Arts, the New York Public Library. Translation by Marie d'Origny and Jean Strouse.

195 *"not quite clear"*: *The Times*, June 14, 1926.

195 *"a Spanish galleon"*: Sandra Jobson Darroch, *Ottoline: The Life of Lady Ottoline Morrell* (New York: Coward, McCann & Geoghegan, 1975), p. 15.

196 *"Dearest Ottoline," "I admire you," "a really good"*: Ena to Ottoline Morrell, Harry Ransom Center, the University of Texas at Austin, Ottoline Morrell Collection (Manuscript Collection MS-02926).

196 *"The Two Jews"*: Ottoline Morrell, National Portrait Gallery Photographs Collection, Ax141233.

196 *"The Party was rather horrible"* through Mathias address: James Beechey, letter to the editor, "Picasso in London," *Burlington Magazine*, vol. 149, Jan. 2007, p. 42.

196 *"What, one wonders"*: John Richardson, *A Life of Picasso: The Triumphant Years, 1917–1932* (New York: Alfred A. Knopf, 2007), p. 127.

197 *"ART DEALER'S DAUGHTER"*: *Evening Telegraph*, Jan. 8, 1923.

198 *"the cunningly designed"*: *The Times*, Nov. 19, 1926.

199 *"I noticed a tall"* and *"some happiness"*: Glendinning, *Edith Sitwell*, p. 114.

199 *"buried under the earth"*: *Daily Chronicle*, Feb. 7, 1928, in de Bosmelet, unpublished memoir, p. 107.

199 *The two men posed*: *Illustrated London News*, Nov. 14, 1931.

200 *"a kind of high priestess"*: Toye, *For What We Have Received*, pp. 201–205.

201 *"I would like you to read"*: Diana de Bosmelet letter to Anthony and Vicky Mathias, June 1986, Papers of Yolanda Chetwynd.

202 *"Darling, however annoyed"*: De Bosmelet, unpublished memoir, p. 110.

203 *"John dined with me"*: RO-EK, vol. II, *Portraits of the 1890s* (New Haven: Yale University Press, 2002), pp. 61–64.

203 *"I don't share"*: JSS to Ena, April 10, [n.d.], Collection of the author, #30.

203 *"and I have no desire"*: Robert M. Mathias to D. Neave, June 17, 1925; agreement statement as of Oct. 31, 1935; Ena put in half the amount, June 10, 1936. Papers of Julian Mathias.

204 Hall of the Grand Council: RO-EK, vol. VI, *Venetian Figures and Land-scapes, 1898–1913* (New Haven and London: Published for the Paul Mellon Centre for Studies in British Art by Yale University Press, 2009), pp. 64–65.

205 *"A stupendous achievement"*: Ena to David Mathias, Feb. [18, 1936], Papers of the late David and Katherine Mathias.

205 *"artistic temperament"* and *"To the world"*: *The Times*, Mar. 27, 1936.

206 *Mathias wanted Miss Richter's help*: July 10 and 13, 1936, Papers of Julian Mathias and Onassis Library, Metropolitan Museum of Art.

207 *"Her Royal Highness"*: Jan. 21, 1954, Julian Mathias Papers.

13. RUBY: "ENEMY ALIEN"

209 *"well-trained voice"*: *Guy's Hospital Gazette*, July 24, 1909; *France later honored her*: *Le Figaro* and *Le Gaulois*, Jan. 13, 1925.

211 *"Squadrista"*: ACS, Dec. 9, 1939.

211–12 *"She is gravely ill"* through *"Confident that this appeal"*: ACS, Aug. 8, 1940.

213 *"future husband"* and *"companion and nurse"*: ACS, Aug. 13, 1940.

213 *"Writer"*: ACS, Aug. 14, 1940.

214 *"an excellent location"*: ACS, Sept. 10, 1940.

214 *ten thousand lire*: Macerata Police Headquarters, Cabinet Office, #01532, Sept. 4, 1940.

215 *"instances of illness"*: ACS, Oct. 12, 1940.

215 *"severe diabetes"*: ACS, Sept. 21 and Oct. 11, 1940; *bedbugs*: Macerata Police Headquarters, Cabinet Office, #01145, Nov. 11, 1940.

216 *"bright" eyes*: Macerata Police Headquarters, Cabinet Office, #95532, Nov. 13, 1940.

216–17 *Virtually all the detainees*: Anna Pizzuti, private communication.

217 *"Inglese"*: ACS, form 302.

14. "AN AGE ON EDGE"

221 *"No more paughtraits"*: JSS to Ralph Curtis, in Evan Charteris, *John Sargent* (New York: Charles Scribner's Sons, 1927), p. 155.

222 *"I find 'box colour'"* and *"a newly hatched chicken"*: Martin Birnbaum, *John Singer Sargent, A Conversation Piece* (New York: William E. Rudge's Sons, 1941), pp. 10–12.

222 *"Visual sensations,"* *"Only a man,"* *"whole lot en bloc"*: in Erica E. Hirshler and Teresa A. Carbone, eds., *John Singer Sargent Watercolors* (Boston: MFA Publications/Brooklyn, NY: Brooklyn Museum, 2013), pp. 24 and 38.

223 *"I have become prohibitive"*: JSS to Katie Lewis, Bodleian, #226 [Monday 1908?].

223 *"It takes a man"*: JSS to ISG, Oct. 26, 1918, ISGM Archives.

223 *"quite lost his nerve"*: Henry James to William James III, May 13, 1913, in Leon Edel, ed., *Henry James Letters*, vol. IV: *1895–1916* (Cambridge, MA: Belknap Press of Harvard University Press, 1984), p. 674.

224 *"It has neither"*: Richard Ormond, *John Singer Sargent: Portraits in Charcoal* (New York: Morgan Library & Museum/Washington, DC: National Portrait Gallery, Smithsonian Institution, in association with D. Giles Limited, 2019), p. 132.

224 *"I have written so much"*: HJ to William Rothenstein, July 13, 1897, in Edel, *Henry James Letters*, vol. IV, pp. 50–51.

224 *"in spite of the repeated"* and *"Sargent at his very best"*: HJ to Rhoda Broughton, June 25, 1913, in Percy Lubbock, ed., *The Letters of Henry James*, vol. II (New York: Charles Scribner's Sons, 1920), p. 318.

224 *"on whom nothing is lost"*: HJ, "The Art of Fiction," *Longman's Magazine*, Sept. 4, 1884.

224 *"the translation"*: HJ to Edmund Gosse, Dec. 18, 1913, cited by Marc Simpson in Colm Toíbín, Marc Simpson, and Declan Kiely, *Henry James and American Painting* (University Park: Penn State University Press/New York: Morgan Library & Museum, 2017), p. 95.

225–26 *"Her face is like a camellia," "it never gêned," "We used to go"*: Peter Stansky, *Sassoon: The Worlds of Philip and Sybil* (New Haven: Yale University Press, 2003), pp. 144 and 29.

226 *"Sybil is lovely"*: RO-EK, vol. III, *The Later Portraits* (New Haven: Yale University Press, 2003), p. 227.

226 *"Phee-leep"*: Stansky, *Sassoon*, p. 26.

226 *compared him to a fragrance*: Stansky, *Sassoon*, p. 1.

227 *"painting hard"*: JSS to Emily Sargent, Oct. 13, 1914, in RO-EK, vol. III, p. xvii.

227 *"out of all that matters"*: JSS to Sybil Cholmondeley, Countess of Rocksavage, May 5, 1917, in RO-EK, vol. III, p. xviii.

227 *"in the most faultless khaki"*: Stansky, *Sassoon*, p. 76.

228 *"brilliant genius"*: *The Times*, May 5, 1919; *"the most haunting image"*: Theodore Rabb, "John Singer Sargent Visits the Front," *Quarterly Journal of Military History* 11, no. 4 (Summer 1999).

228 *"I am in hot water"*: Charteris, *John Sargent*, p. 209.

229 *"A prominent member"*: Charteris, *John Sargent*, p. 209.

229 *"Fortunately"*: Charteris, *John Sargent*, p. 209.

230 *"a capable and energetic fellow"*: JSS to ISG, April 19, 1923, ISGM, #194.

231 *"real thrill"*: Forbes Watson, "Sargent—Boston—and Art," *Arts and Decoration* (Feb. 1917), p. 197, in Trevor Fairbrother, *John Singer Sargent: The Sensualist* (Seattle Art Museum/New Haven: Yale University Press, 2000), p. 171.

232 *"deafened by the fizz"*: RO-EK, vol. III, p. 39; *"simply a précis writer"*: Virginia Woolf, *Roger Fry: A Biography* (New York: Harcourt Brace Jovanovich, 1940), p. 110; *"blandness"*: *Athenaeum*, May 6, 1905, in RO-EK,

vol. III, p. 142; *"I seem to have been"*: Roger Fry, "J. S. Sargent at the R.A.," *Nation and the Athenaeum*, vol. 38, Jan. 23, 1926, p. 583.

233 *"If sense and modesty"*: Walter Sickert, "Sargentolatry," *New Age*, May 9, 1910.

233 *"I loathe art criticism"*: Woolf, *Roger Fry*, p. 19.

233n *"Roger left for Paris today"*: Vanessa Bell to Clive Bell, in Regina Marler, ed., *Selected Letters of Vanessa Bell* (New York: Pantheon Books, 1993), p. 260.

234–35 *"acid and disobliging"* through *"It ought"*: R. Fry, "The Wertheimer Portraits," *New Statesman*, Jan. 13, 1923, pp. 429–30.

236 *"I am sure"*: Roger Fry, *Transformations: Critical and Speculative Essays on Art* (London: Chatto & Windus, 1926), p. 135.

236 *"hired-gun celebrant"*: Peter Schjeldahl, "The Dazzling Portraiture of Holbein," *New Yorker*, Feb. 28, 2022, pp. 80–81.

237 *"Above all"*: *The Times*, May 3, 1924, in RO-EK, vol. III, p. 266.

237 *"Me . . . a human being"*: E. M. Forster, "Me, Them, and You: Sargent at the Royal Academy," *New Leader*, Jan. 22, 1926.

239 *"There are two kinds of people"*: E. M. Forster, *Howard's End* (1910; repr. New York: Vintage Books, 1921), pp. 267–68.

239 *"an underbred Whitechapel Jew"*: Virginia Woolf to Vanessa Bell, Apr. 28, 1929, in Nigel Nicolson and Joanne Trautmann, eds., *The Letters of Virginia Woolf*, vol. IV, *1929–1931* (London: Hogarth Press, 1975), p. 47.

239 *"Ours is, above all"*: *Saturday Review of Politics, Literature, Science, and Art*, Apr. 18, 1903, p. 484.

240 *"a certain young woman"* and *"Well, what"*: Henry James, preface to *The Portrait of a Lady* (1908; repr. New York: W. W. Norton, 1975), pp. 8, 12.

240 *"more than an individual portrait"*: *International Studio* 4, 1898, p. x., in RO-EK, vol. II, *Portraits of the 1890s* (New Haven: Yale University Press, 2002), p. 124.

241 *"the precarious glamour"*: Elizabeth Prettejohn, *Interpreting Sargent* (London: Tate Gallery Publications, 1998), pp. 7, 72–74.

15. LEGACIES

244 *"The Academy exhibition"*: *Westminster Gazette*, Feb. 3, 1926.

245 *"did not readily apprehend"*: C. H. Collins Baker to Conway Joseph Conway, Apr. 11, 1924, NGA.

247 *"the final word"*: *The Times*, June 26, 1926, p. 10.

247 *"not unfavorably"* and *"I have much pleasure"*: *The Times*, June 28, 1926.

248 *"Critics have not yet decided"*: *Westminster Gazette*, Feb. 3, 1926.

248 *"nearest to oblivion"*: Frederick A. Sweet, *Sargent, Whistler and Mary Cassatt* (Chicago: Art Institute of Chicago, 1954), pp. 8–11.

249 *"re-establish him as an artist"*: Hermann Warner Williams to David Mathias, Aug. 27, 1963, Papers of Julian Mathias.

249 *"We no longer"*: H. W. Williams, *The Private World of John Singer Sargent* (Washington, DC: Corcoran Gallery, 1964).

249 *"complete the Wertheimer collection"*: Robert Mathias to Sir John Rothenstein, 1941, Papers of Julian Mathias.

250 *"splendid"*: Charles Merrill Mount to Diana de Bosmelet, Oct. 24, 1963, Papers of Julian Mathias.

251 *"monstrous violation"*: *Westminster and Pimlico News*, Feb. 18, 1966; *"compel"*: Humphrey Brooke to Anthony R. Mathias, Feb. 7, 1966; *"out of view"*: Anthony R. Mathias to *The Times*, Feb. 11, 1966, Papers of Julian Mathias.

251 *"finest"*: Norman Reid to Anthony R. Mathias, Feb. 11, 1966, Papers of Julian Mathias.

252 *"It's Time to Forgive Sargent"*: Hilton Kramer, *The Observer*, Dec. 8, 1997.

253 *"This is the first time"*: Tate website announcing *John Singer Sargent's Wertheimer Family Portraits*, a Spotlight exhibition, February 2021, https:// tate.org.uk/visit/tate-britain/display/spotlights/john-singer-sargents -wertheimer-family-portraits.

255 *"a magnificent disregard"*: *Daily Telegraph*, June 25, 1906, in RO-EK, vol. VII, *Figures and Landscapes, 1900–1907* (New Haven and London: Published for the Paul Mellon Centre for Studies in British Art by Yale University Press, 2012), pp. 104–105.

255n *"I can't tell you"*: in RO-EK, vol. III, *The Later Portraits* (New Haven: Yale University Press, 2003), p. 223. Private collection.

256 *"liquefaction of clothes"*: *Illustrated London News*, June 8, 1912; Robert Herrick, "Upon Julia's Clothes" (1648).

256 *"a delicious little scallop"*: Adam Gopnik, *New Yorker*, Feb. 15, 1999; *"Maybe Sargent"*: Michael Kimmelman, *New York Times*, Feb. 19, 1999.

Select Bibliography

ARCHIVES

Archivio Centrale dello Stato (Central State Archives, Rome)
Art Institute of Chicago
British Library
Isabella Stewart Gardner Museum, Boston
Lewis family papers owned by Ampleforth Abbey, held by the Bodleian Libraries, Oxford University
The late David and Katherine Mathias, private collection of Wertheimer papers
Julian Mathias, private collection of Wertheimer papers
Metropolitan Museum of Art, New York
National Gallery, London
The Rothschild Archive, London
Waddesdon Manor, Windmill Hill (Rothschild and Colnaghi Archives), Buckinghamshire
Zentralarchiv der Staatlichen Museen zu Berlin (Central Archive of the Berlin State Museums)

BOOKS

Arnold, Bruce. *Orpen: Mirror to an Age*. London: Jonathan Cape, 1981.
Bennett, Shelley M. *The Art of Wealth: The Huntingtons in the Gilded Age*. San Marino, CA: Huntington Library, 2013.
Cannadine, David. *The Decline and Fall of the British Aristocracy*. New Haven: Yale University Press, 1990.
Capogreco, Carlo Spartaco. *Mussolini's Camps: Civilian Internment in Fascist Italy (1940–1943)*. Translated by Norma Bouchard and Valerio Ferme. London: Routledge, 2019.
Charteris, Evan. *John Sargent*. New York: Charles Scribner's Sons, 1927.

Cohen, Deborah. *Family Secrets: Shame and Privacy in Modern Britain.* New York: Oxford University Press, 2013.

Davis, Richard. *The English Rothschilds.* London: Collins, 1983.

Dellheim, Charles. *Belonging and Betrayal: How Jews Made the Art World Modern.* Waltham, MA: Brandeis University Press, 2021.

de Waal, Edmund. *The Hare with Amber Eyes: A Hidden Inheritance.* New York: Farrar, Straus and Giroux, 2010.

Edel, Leon. *Henry James.* Five volumes. Philadelphia: J. B. Lippincott, 1953–1972.

———, ed. *The Letters of Henry James.* Four volumes. Cambridge, MA: Harvard University Press, 1974–1984.

Endelman, Todd M. *The Jews of Britain: 1656 to 2000.* Berkeley: University of California Press, 2002.

———. *Radical Assimilation in English Jewish History, 1656–1945.* Bloomington: Indiana University Press, 1990.

———. *The Last Anglo-Jewish Gentleman: The Life and Times of Redcliffe Nathan Salaman.* Bloomington: Indiana University Press, 2022.

Fairbrother, Trevor. *John Singer Sargent: The Sensualist.* Seattle Art Museum/New Haven: Yale University Press, 2000.

Feldman, David. *Englishmen and Jews: Social Relations and Political Culture, 1840–1914.* New Haven: Yale University Press, 1994.

Fowles, Edward. *Memories of Duveen Brothers.* New York: Times Books, 1976.

Glendinning, Victoria. *Edith Sitwell: A Unicorn Among Lions.* Oxford: Oxford University Press, 1981.

Hadley, Rollin van N., ed. *The Letters of Bernard Berenson and Isabella Stewart Gardner, 1887–1924.* Boston: Northeastern University Press, 1987.

Hirshler, Erica E. *Sargent's Daughters: The Biography of a Painting.* Boston: Museum of Fine Arts Publications, 2009.

Hirshler, Erica E., and Teresa A. Carbone, eds. *John Singer Sargent Watercolors.* Boston: Museum of Fine Arts Publications/Brooklyn, NY: Brooklyn Museum, 2013.

Holmes, Richard. *Footsteps: Adventures of a Romantic Biographer.* New York: Penguin Books, 1985.

Kleeblatt, Norman L., ed. *John Singer Sargent: Portraits of the Wertheimer Family.* New York: Jewish Museum, 1999.

Konody, P. G., and Sidney Dark. *Sir William Orpen: Artist & Man.* London: Seeley, Service, 1932.

McAuley, James. *The House of Fragile Things: Jewish Art Collectors and the Fall of France.* New Haven: Yale University Press, 2021.

McKibbin, David. *Sargent's Boston.* Boston: Museum of Fine Arts, 1956.

Mann, Vivian B., Richard I. Cohen, and Fritz Backhaus, eds. *From Court Jews to the Rothschilds: Art, Patronage, and Power 1600–1800.* New York: Jewish Museum, 1996.

Maugham, W. Somerset. "The Alien Corn." In *First Person Singular, Six Stories Written in the First Person Singular, W. Somerset Maugham.* Garden City, NY: Doubleday, Doran, 1931.

Mount, Charles Merrill. *John Singer Sargent: A Biography.* New York: W. W. Norton, 1955.

Olson, Stanley. *John Singer Sargent: His Portrait*. New York: St. Martin's Griffin, 2001.

Ormond, Richard. *John Singer Sargent: Portraits in Charcoal*. New York: Morgan Library & Museum/Washington, DC: National Portrait Gallery, in association with D Giles Limited, 2019.

Ormond, Richard, and Elaine Kilmurray. *John Singer Sargent: Complete Paintings*. Nine volumes. New Haven and London: Published for the Paul Mellon Centre for the Study of British Art by Yale University Press, 1998–2017.

Ormond, Richard, with Elaine Kilmurray. *Sargent: Portraits of Artists and Friends*. London: National Portrait Gallery Publications, 2015.

Prettejohn, Elizabeth. *Interpreting Sargent*. London: Tate Gallery Publications, 1998.

Ratcliff, Carter. *John Singer Sargent*. New York: Artabras, 1986.

Richardson, John. *A Life of Picasso*. Four volumes. New York: Random House, 1991–2021.

Rothenstein, William. *Men and Memories: Recollections of William Rothenstein, 1872–1900*. New York: Coward-McCann, 1931.

Simpson, Marc, with Richard Ormond and H. Barbara Weinberg. *Uncanny Spectacle: The Public Career of the Young John Singer Sargent*. Williamstown, MA: Sterling and Francine Clark Art Institute, 1997.

Smith, Charles Saumarez. *The National Gallery: A Short History*. London: Frances Lincoln, 2009.

Spalding, Frances. *The Tate: A History*. London: Tate Publishing, 1998.

Stansky, Peter. *Sassoon: The Worlds of Philip and Sybil*. New Haven: Yale University Press, 2003.

Stevenson, Michael. *Art and Aspirations: The Randlords of South Africa and Their Collections*. Cape Town: Fernwood Press, 2002.

Toíbín, Colm, Marc Simpson, and Declan Kiely, eds. *Henry James and American Painting*. University Park: Penn State University Press/New York: Morgan Library & Museum, 2017.

Vignon, Charlotte. *Duveen Brothers and the Market for Decorative Arts, 1880–1940*. New York: Frick Collection, 2019.

Westgarth, Mark. *The Emergence of the Antique and Curiosity Dealer in Britain 1815–c. 1850: The Commodification of Historical Objects*. Milton Park, UK: Routledge, 2020.

Westgarth, Mark. "A Biographical Dictionary of Nineteenth Century Antique and Curiosity Dealers." *Journal of the Regional Furniture Society* 23, 2009.

Wildenstein, Daniel, ed. *Claude Monet: Biographie et Catalogue Raisonné*. Lausanne: Bibliothèque des Arts, 1974–1991.

ARTICLES

Aitken, Charles. "Mr. Asher Wertheimer's Benefaction." *Burlington Magazine for Connoisseurs* 29, no. 161 (Aug. 1916), pp. 216–20.

Forster, E. M. "Me, Them, and You: Sargent at the Royal Academy." *New Leader*, Jan. 22, 1926.

Fry, Roger. "The Stolen Portraits." *Burlington Magazine for Connoisseurs* 10, no. 48 (Mar. 1907), pp. 375–79.

Hall, Michael, ed. "Bric-à-Brac: A Rothschild's Memoir of Collecting." *Apollo* 166, no. 545 (July–Aug. 2007), pp. 50–77.

Pezzini, Barbara. "Days with Velásquez: When Charles Lewis Hind Bought the 'Rokeby Venus' for Lockett Agnew." *Burlington Magazine* 158, no. 1358 (May 2016), pp. 358–67.

Ridge, Jacqueline, and Joyce Townsend. "John Singer Sargent's Later Portraits: The Artist's Technique and Materials." *Apollo* 148, no. 439 (1998), pp. 23–30.

Ross, Robert. "The Wertheimer Sargents." *Art Journal*, Jan. 1911, pp. 1–10.

Sickert, Walter. "Sargentolatry." *New Age*, May 9, 1910.

Stammers, Thomas. "L'exception anglaise? Constance Battersea et la philanthropie artistique des Rothschild d'outre-manche." In *De la sphère privée à la sphère publique: Les collections Rothschild dans les institutions publiques françaises*, edited by Pauline Prevost-Marcilhacy, Laura de Fuccia, and Juliette Trey. Paris: INHA, 2019. Available online at books.openedition.org/inha/11212.

Stansky, Peter. "Anglo-Jew or English/British." In *From William Morris to Sergeant Pepper: Studies in the Radical Domestic*. Palo Alto, CA: Society for the Promotion of Science and Scholarship, 1999.

Turpin, Adriana. "Appropriation as a Form of Nationalism? Collecting French Furniture in the 19th Century." In *Art Crossing Borders: The Internationalisation of the Art Market in the Age of Nation States, 1750–1914*, edited by Jan Dirk Baetens and Dries Lyna. Leiden: Brill, 2019. Available online at brill.com/edcollbook-oa/title/31631?language=en.

Wainwright, Clive. "Curiosities to Fine Art: Bond Street's First Dealers." *Country Life*, May 29, 1986, pp. 1528–29.

Wardleworth, Dennis. "The 'Friendly' Battle for the Mond Bequest." *British Art Journal* 4, no. 3 (Autumn 2003), pp. 87–93.

Weinberg, H. Barbara. "John Singer Sargent, 'Reputation Redivivus.'" *Arts Magazine* 54, no. 7 (Mar. 1980), pp. 104–109.

Weinberg, H. Barbara, and Stephanie Herdrich. "John Singer Sargent in the Metropolitan Museum of Art." *Metropolitan Museum of Art Bulletin*, Spring 2000.

DISSERTATIONS

Gross, Peter. "Representations of Jews and Jewishness in English Painting, 1887–1914." Submitted posthumously in accordance with the requirements for the degree of Ph.D., University of Leeds. Completed August 2003; submitted September 2004.

Maxwell, Christopher L. "The Dispersal of the Hamilton Palace Collection." Submitted in fulfillment of the requirements for the Degree of Doctor of Philosophy in the School of Culture and Creative Arts, University of Glasgow, 2014.

Ripps, M. J. "Bond Street Picture Dealers and the International Trade in Dutch Old Masters, 1882–1914." Submitted to the Faculty of History for the degree of Doctor of Philosophy, University of Oxford, 2010.

Acknowledgments

A great many people have provided invaluable assistance over the course of my work on this book. First and warmest thanks to Jonathan Galassi, my brilliant editor and longtime friend, and to his superb colleagues at Farrar, Straus and Giroux, especially Katie Liptak and Carrie Hsieh. And to Sarah Chalfant at the Wylie Agency, who, with her associate Rebecca Nagel, has been an extraordinary partner all along the way.

For their expertise on Sargent and unfailing willingness to answer questions, I cannot sufficiently thank Richard Ormond, Elaine Kilmurray, and Trevor Fairbrother. Other Sargent specialists to whom I am indebted include Warren Adelson, Teresa Carbone, Caroline Corbeau-Parsons, Stephanie Herdrich, Erica Hirshler, Elizabeth Oustinoff, and Marc Simpson.

Since the records of the Wertheimer firms have been lost and there is no central family archive, I could not have written this book without the knowledge, memories, papers, and friendship of Kay Mathias, an American who married one of Asher Wertheimer's grandsons. Other Wertheimer descendants who generously provided information and documents include Julian Mathias; Yolanda, Natasha,

and Bridget Chetwynd; Diana and Jonathan Mathias; Caroline and Alexander Johnstone; Hugh Wilding; and Rosemary Stein.

Todd Endelman gave me the benefit of his deep knowledge about the history of Jews in Britain. Arthur Goldhammer translated key passages from French, most notably Monet's letters to his wife from London, and offered wise counsel at several points.

For expert critical readings of the manuscript, my heartfelt gratitude goes to Connie Brown, Deborah Cohen, Todd Endelman, Stephanie Engel, Trevor Fairbrother, Arthur Goldhammer, Elaine Kilmurray, Richard Ormond, Peter Stansky, and Lorin Stein.

I owe special thanks to Norman Kleeblatt and Kathleen Adler, who organized the 1999 exhibition *John Singer Sargent: Portraits of the Wertheimer Family*, which traveled in the United States and first brought my attention to these paintings.

Curators, archivists, and librarians who provided essential help with material in their collections include, at Tate Britain: Chris Bastock, Jennifer Carding, Caroline Corbeau-Parsons (now with the Musée d'Orsay in Paris), and Darragh O'Donoghue. At the National Gallery, London: Susanna Avery-Quash and Alan Crookham. At the Rothschild Archive, London: Melanie Aspey and Justin Cavernelis-Frost. At the Windmill Hill Archive, Waddesdon Manor: Bradley Field, Pippa Shirley, and Catherine Taylor. At Halton House: Trixie Brabner. I am grateful as well to the late Jacob Rothschild for his kindness, generosity, and hospitality. At New York City's Metropolitan Museum of Art: Katharine Baetjer, Jason Herrick, Harold Koda, Joan Mertens, Ken Soehner, and Sarah Szeliga. Current and former staff members at the New York Public Library: Annemarie Belinfante, Paul Delaverdac, Rebecca Federman, Rick Foster, Lauren Goldenberg, Clayton Kirking, Thomas Lannon, Melanie Locay, Miguel Rosales, Amanda Segal, Bill Stingone, Ann Thornton, Eleanor Yadin. At the Center for Jewish History and the Leo Baeck Institute in New York City: Frank Mecklenburg and David P. Rosenberg. At the Central Archive of the State Museums in Berlin: Petra Winter.

For help with Italian sources and documents for the chapter on Ruby Wertheimer, I am immensely grateful to Michael Frank, and to Michele Amedei, Elisabetta Beraldo, Mauro Canali, Yasmine Ergas, Sofia Groopman, Andrea Marcucci, and Anna Pizzuti.

Dr. Mirjam Thulin kindly discussed with me her work-in-progress on the early Samson Wertheimer and his family. Timothy Ryan Mendenhall, at my request, translated into English David Kaufmann's 1888 biography, *Samson Wertheimer: Court Factor and Chief Rabbi (1658–1724) and his Children*, which was published only in the old German Fraktur script. The art historian Christopher Maxwell allowed me to read and quote from his excellent PhD dissertation, "The Dispersal of the Hamilton Palace Collection" (2014). Caroline Corbeau-Parsons drew my attention to the Monet letters in volumes edited by Daniel Wildenstein. Vanessa Guignery found Ena Wertheimer Mathias letters to Ottoline Morrell at the Harry Ransom Center, University of Texas at Austin. Emily Brooke Stein did extensive research on objects of fine and decorative art with Wertheimer provenance.

In addition, I am grateful to Hester Abrams, Laura Augustin, Ronni Baer, David A. Bell, Uwe Bergermann, Andrew Berkman, Gail W. Berry, Emily Bilski, Rufus Bird, Emily Braun, Julius Bryant, Jeannie Chapel, Ina Cholst, Louise Cooling, Robyn Creswell, Hernan Diaz, Marie d'Origny, Richard Dorment, Christine Doudna, Kai Drewes, Daniela Eisenstein, James Fenton, David Ferriero, Stefanie Fischer, Steve Fischer, Nicholas Fuller, Susan Galassi, Nicholas Garland, Sarah Gilles, Ira Goldberg, Adrian Goodman, Richard Grand-Jean, Abigail Green, Martina Haggenmüller, Michael Hall, Peter Holquist, Daniel Kehlmann, Christina Koulouri, Anna Krinaki, Hermione Lee, Sara Lipton, Matthew MacDonald, Daniel Margocsy, Christopher Marsden, Meredith Martin, Mark Mazower, Kenneth McConkey, Yair Mintzker, Rebecca Morrin, Tessa Murdoch, Laura Noble, Doron Oberhand, Nicholas Penny, Derek Penslar, Darryl Pinckney, Johannes Reiss, Michael J. Ripps, Priscilla

Roth, Andrew Saint, Caronwen Samuel, Charles Saumarez Smith, Rosalind Savill, Salvatore Scibona, Charles Sebag-Montefiore, Miranda Seymour, James Shapiro, Lottchen Shivers, Thomas Stammers, Oliver Stein, Helmut Steiner, Mark Stevens, Michael Stevenson, Alexander Stille, Jackie Sullivan, John Jeremiah Sullivan, Richard Sylla, Magda Teter, Richard Thune, Judith Thurman, Charles Tucker, Cinzia Virno, Natasha Wallace, Malcolm Warner, Mark Westgarth, Joan Winterkorn, Ruth Bernard Yeazell, Rosella Mamoli Zorzi.

I have quoted from public and private papers by permission of descendants of the Wertheimer and Mathias families and the John Singer Sargent family; the Bodleian Libraries, Oxford University (archives of Lewis family papers owned by Ampleforth Abbey); the Central Archive of the Berlin State Museums; the Harry Ransom Center, the University of Texas at Austin; the Isabella Stewart Gardner Museum; the Metropolitan Museum of Art, New York; the National Gallery Archive, London; the Rothschild Archive, London; the Smithsonian American Art Museum, Washington, DC; Tate Archives; and Windmill Hill, Waddesdon Manor.

For permission to reproduce paintings and photographs, Bridgeman Images; the Mathias family; the Metropolitan Museum of Art; the National Portrait Gallery, London; the New Orleans Museum of Art; the Smithsonian American Art Museum; Tate Britain; Punch Cartoon Library / Topfoto; and private collectors.

Index

Page numbers in *italics* refer to photographs.